PRIVATE VIOLENCE

LATINA/O SOCIOLOGY SERIES
General Editors: Pierrette Hondagneu-Sotelo and Victor M. Rios

Family Secrets: Stories of Incest and Sexual Violence in Mexico
Gloria González-López

Deported: Immigrant Policing, Disposable Labor, and Global Capitalism
Tanya Maria Golash-Boza

From Deportation to Prison: The Politics of Immigration Enforcement in Post–Civil Rights America
Patrisia Macías-Rojas

Latina Teachers: Creating Careers and Guarding Culture
Glenda M. Flores

Citizens but Not Americans: Race and Belonging among Latino Millennials
Nilda Flores-González

Immigrants Under Threat: Risk and Resistance in Deportation Nation
Greg Prieto

Kids at Work: Latinx Families Selling Food on the Streets of Los Angeles
Emir Estrada

Organizing While Undocumented: Immigrant Youth's Political Activism Under the Law
Kevin Escudero

Front of the House, Back of the House: Race and Inequality in the Lives of Restaurant Workers
Eli Revelle Yano Wilson

Building a Better Chicago: Race and Community Resistance to Urban Redevelopment
Teresa Irene Gonzales

South Central Dreams: Finding Home and Building Community in South L.A.
Pierrette Hondagneu-Sotelo and Manuel Pastor

Latinas in the Criminal Justice System: Victims, Targets, and Offenders
Edited by Vera Lopez and Lisa Pasko

Uninsured in Chicago: How the Social Safety Net Leaves Latinos Behind
Robert Vargas

Medical Legal Violence: Health Care and Immigration Enforcement Against Latinx Noncitizens
Meredith Van Natta

Contested Americans: Mixed-Status Families in Anti-Immigrant Times
Cassaundra Rodriguez

Private Violence: Latin American Women and the Struggle for Asylum
Carol Cleaveland and Michele Waslin

Private Violence

Latin American Women and the Struggle for Asylum

Carol Cleaveland *and* Michele Waslin

NEW YORK UNIVERSITY PRESS
New York

NEW YORK UNIVERSITY PRESS
New York
www.nyupress.org

© 2024 by New York University
All rights reserved

Library of Congress Cataloging-in-Publication Data
Names: Cleaveland, Carol, author. | Waslin, Michele, author.
Title: Private violence : Latin American women and the struggle for asylum /
Carol Cleaveland, Michele Waslin.
Description: New York : New York University Press, [2024] | Series: Latina/o sociology |
Includes bibliographical references and index.
Identifiers: LCCN 2023051928 (print) | LCCN 2023051929 (ebook) |
ISBN 9781479824328 (hardback) | ISBN 9781479824335 (paperback) |
ISBN 9781479824342 (ebook) | ISBN 9781479824359 (ebook other)
Subjects: LCSH: Women—Violence against—Latin America. | Refugees—Latin America.
Classification: LCC HV6250.4.W65 C593 2024 (print) | LCC HV6250.4.W65 (ebook) |
DDC 362.87082/098—dc23/eng/20240415
LC record available at https://lccn.loc.gov/2023051928
LC ebook record available at https://lccn.loc.gov/2023051929

This book is printed on acid-free paper, and its binding materials are chosen for strength and durability. We strive to use environmentally responsible suppliers and materials to the greatest extent possible in publishing our books.

Manufactured in the United States of America

10 9 8 7 6 5 4 3 2 1

Also available as an ebook

To the women who endured so much and survived, and to the people who advocate on their behalf and fight for justice

CONTENTS

Introduction: Asylum, Trauma, and Marginalization — 1

1. "Private Violence" and Public Policy — 27
2. "Women Who Are Alone Suffer" — 51
3. Violence at Home — 77
4. Criminalizing Asylum — 101
5. Trauma: Shared Meanings and Healing — 122
6. "If I Offended Your Country, I'm Sorry." — 144

Conclusion: The Architecture of Exclusion — 175

Acknowledgments — 195

Appendix: Methodology — 199

Statutes, Regulations, and Legal Decisions — 213

Notes — 217

Bibliography — 243

Index — 269

About the Authors — 279

Introduction

Asylum, Trauma, and Marginalization

Teresita was nervous. She sat outside an immigration courtroom on a dreary February day in 2020, her hands clasped in her lap. Next to her was her attorney, a balding older man in a black suit. Teresita was only twenty-nine at the time she walked into court to make her case for asylum in the United States. She wore her dark hair up in a bun, a gold cross around her neck serving as a spot of color with a somber, court-appropriate outfit. Missing was her seven-year-old daughter, whom she had to leave behind as she fled for her life after her boyfriend pulled a gun on her, threatening to kill her. In Honduras, Teresita had been a university student studying dentistry; the domestic violence that eventually sent her to the United States to plead for asylum began when the man she thought loved her struck her in the head for returning from classes late. At the time she went to court, she worked in a bakery, a job typical for many women interviewed for this book.

Teresita faced an immigration judge employed by the Executive Office of Immigration Review (EOIR) which is part of the Department of Justice (DOJ). An interpreter sat next to the judge wearing headphones and consuming copious amounts of caffeine: two bottles of dark iced tea. Once the hearing began, Teresita listened to the proceedings through headphones: What she heard at the beginning was an admonition from the judge that she would be subject to deportation for knowingly saying anything false. Then she listened as her counsel told the judge that he wanted his client to be considered for asylum as a member of the following particular social groups:

- Women in Honduras
- Women in Honduras who lack protection from the government

- Women in Honduras who can't protect themselves from abusive men
- Women in Honduras who are viewed as personal property[1]

The judge asked Teresita if she minded having a researcher observe her hearing. Asylum seekers have the right to exclude observers from the courtroom, but Teresita said the researcher's presence would be a support during this difficult hearing. Also present was an attorney for the US Department of Homeland Security (DHS), whose job was to argue that Teresita should be denied asylum. When Teresita was called to the stand, her attorney asked why she needed asylum. She replied that her boyfriend began beating her shortly after they moved in together in 2016, striking her in the face and abdomen with a closed fist. "He said I'm now his property and I have to obey him." She later went to the police—only to be told that she needed to go home and make nice with him. "They said I should go back home and fix it there because it's a domestic issue . . . When I got home, he was waiting there, and he wanted to know why I went to the police." She told the court that he beat her harder than he ever had before. "That day, he slapped me, he kicked me in the stomach. He hit me for everything, whether I said yes. Whether I said no."

What unfolded that day in court resembles thousands of other proceedings occurring across the United States as record numbers of asylum seekers plead their cases before judges in the immigration court system. At the end of 2022, there were nearly 1.6 million people awaiting asylum hearings in the United States; approximately half were waiting for a hearing before an immigration judge in court, and the other half awaited an appointment with an asylum officer at US Citizenship and Immigration Services (USCIS).[2] In fiscal year 2012, the backlog in the immigration courts was approximately 100,000 cases; by FY 2022, it soared to 750,000.[3] As reported by the US Department of State, its sister agency DHS heard 100,000 new credible fear interviews in FY 2019, a 113 percent increase from FY 2015.[4] The tone of this State Department report illuminates how the US government views asylum seekers—as potentially gaming the system: "These new cases added to the lengthy backlog of pending claims, *undermining the integrity of the asylum system* [italics ours]. They delay the grant of asylum to individuals who are legitimately fleeing persecution and have valid claims. Further, such

delays are a pull factor for illegal immigration. By providing protection from removal, they create an incentive for those without lawful status to enter and remain in the United States."[5]

This book centers on the stories of forty-six Latin American women—a handful of the hundreds of thousands awaiting asylum hearings in the United States.[6] It includes ethnographic observation of closed court proceedings as well as analysis of redacted asylum decisions provided to researchers by immigration attorneys. This book does not pretend to be an exhaustive scientific study of the asylum process. Other scholarship examines why asylum outcomes hinge on a judge's bias and personal history, and the immigration court's location, as well as how immigration laws have created a false dichotomy between economically motivated migrants and those seeking protection from violence, including asylum seekers and refugees.[7] This book provides a unique contribution to the scholarship on asylum, Latin American immigration, and the exploitation of women in Central America and Mexico in that it examines how women who suffered "private violence"—trauma at the hands of domestic partners and/or gang members—fought to stay in the United States. In doing so, they found themselves in a unique social, spatial context that is, in many ways, innately political and adversarial. To the first point, we note that the women we interviewed found themselves faced with what Rebecca Hamlin terms a false binary in which refugees are defined as worthy recipients of sanctuary in western, liberal democracies, and those deemed non-refugees are simply migrants.[8]

Asylum seekers do not have immigration status, leaving them marginalized because they have no established right to remain in the United States. Further, as some sociologists and critical geographers contend, the question of sovereign borders in an era of globalization may be specious as humans across the globe are displaced by virtue of war, habitat destruction, and economic instability.[9] For those displaced by "private violence"—the trauma many women we interviewed experienced—the imperative after crossing is to prove that one's situation meets the strict criteria for winning asylum. According to US law, people may be eligible for asylum if they can prove that they have suffered past persecution and are likely to suffer it again if returned to their home country. Further, they must prove that their persecution is based on race, religion, nationality, membership in a particular social

group, or political opinion, and that their government didn't protect them. Thus, the women we interviewed sought to be delineated by extant policy as those worthy of legal inclusion—those who had no choice but to flee and who could prove that fact in court.

The asylum seekers who are the focus of this book not only found themselves in a unique and arguably ill-equipped social spatial context to obtain safety, but they were also fighting to stay in the United States through a fundamentally adversarial judicial process. To win the right to remain in this country, they had to withstand cross-examination by an attorney from DHS, whose job was to impugn the merits of the asylum claim, although the agency can decline cross-examination if they believe the case warrants protection. The women on whom this book focuses found themselves in a system that was initially established to protect victims of state violence, but which now must be stretched to ensure safety for victims of "private" violence—that is, gender-based persecution in countries that are either unwilling or too compromised to protect them.

We also lift the veil on a closed court system. Not only are asylum court hearings closed to the public without the asylum seeker's permission, but written decisions rendered by immigration judges are sealed. Through persistent ethnographic observation and winning the trust of immigration attorneys, we were able to observe thirty-six court hearings and to analyze twenty-one written redacted judicial decisions. This book originated four years ago, when lawyers asked the lead author to conduct pro bono psychosocial assessments on behalf of several women seeking asylum after experiencing gender-based violence in Central America. Listening to the women's stories prompted her to wonder why so many women found they could not be safe from severe violence in their home countries. With the approval of her university's Institutional Review Board, she gained permission from women to conduct research on asylum while cooperating with immigration attorneys in the Baltimore/Washington area to provide pro bono assessments that women could use in evidence during their asylum court hearings.

While the women we spoke to had lawyers, most asylum seekers are not represented by attorneys; in December 2023, only 30 percent of immigrants in immigration court were represented.[10] This was a sharp decline from FY 2019 when 65 percent were represented. Immigrants in

Virginia (44 percent) and Maryland (38 percent) were represented by lawyers at rates higher than the national average as of December 2023.[11] Each woman interviewed sought protection through a process known as defensive asylum, in which an individual is apprehended after entering the United States without authorization and subsequently tells officials that she needs asylum. She may then be given a credible fear interview, in which an immigration official determines whether an individual has a "significant possibility" of convincing a judge that she fears persecution because of her race, religion, nationality, membership in a particular social group, or political opinion.[12] As will be detailed in subsequent chapters, at the heart of these women's claims is the question of trauma by virtue of sexual assault, beatings, threats with weapons including machetes and firearms, incest, home invasion, murder of family members, extortion, and child kidnapping. The research for this book has been bounded geographically to include women who were not detained and whose cases were or are to be heard in either Baltimore or northern Virginia. Asylum seekers who were detained and could not post bond before their case was heard are not included. Neither are the 70,000 people once sent to squalid camps in Mexico near US border towns to await asylum hearings under the 2018 Migrant Protection Protocols, a Trump administration policy requiring asylum seekers to remain in Mexico while awaiting hearings.[13]

The question of trauma—its role in compelling women's migration, often with children in tow, and as evidence in court proceedings—is critical when examining asylum and the increasingly politicized context for asylum claims. After crossing the border from Mexico and being arrested by the US Border Patrol, women had to recount their trauma histories to an official, in some cases by phone, via a virtual video connection, and in other cases in a face-to-face meeting. Most of these women didn't know the official's title or role, just that they had to make an argument that they had a sound reason to fear being returned home. Despite their fear and wariness, the women detailed the violence they experienced to avoid being deported. After being released and retaining an attorney, women then had to tell their trauma stories for a sworn legal statement covering their experiences, a pivotal court document submitted as evidence. They often then told their stories as well to a mental health professional such as a social worker or psychologist to

substantiate their trauma history so that it could be submitted as evidence. "I know it's painful for her to talk about this," one attorney said, referring to her client's history of sexual assault. "But she's going to have to talk about this in a few weeks in a place that's much harder—and that's a courtroom." In court, women recounted their trauma histories in an innately adversarial setting.[14] They gave graphic accounts of brutalization at the hands of gang members and/or the men they once lived with before an immigration judge and the DHS counsel who would cross-examine them. As will be explained in this book, the experience of traumatic violence often overwhelmed clients and those enlisted to support them, including attorneys. But the experience of horrific violence—and the ability to describe it in court—falls far short of the burden required to win an asylum claim.

Expulsions

Globally, as of 2020, 4.6 million people are seeking asylum, an almost tenfold increase over the preceding two decades.[15] Sociologist Saskia Sassen argues that the need for asylum is associated with a swath of phenomena called expulsions that encompasses the forced migration of workers due to economic and technological changes; the relegation of many formerly middle-class people into poverty; truncated social welfare programs; and the displacement of agricultural workers who have lost land due to both trade and environmental policies—to name but a few.[16] In her conceptualization, the escalating rate of asylum claims is viewed as a by-product of titanic changes globally resulting in the maltreatment and displacement of people. "The past two decades have seen a sharp growth in the number of people, enterprises, and places expelled from the core social and economic orders of our time," Sassen says.[17] As noted in recent scholarship, women who flee violence become trapped in a legal system that encourages movement of capital and resources across borders, as well as a select group of welcomed migrants, but which is designed to repel others in the name of sovereign borders.[18] What distinguishes the displacement of people from land, jobs, and homes in this era compared to previous ones is its enormity of scale as well as its subterranean—essentially hidden—nature.[19] "New dynamics may well get filtered through familiar thick realities—poverty,

inequality, economy, politics—and thereby take on familiar forms when in fact they are signaling accelerations or ruptures that generate new meanings."[20] Though this book does not attempt to divine why the ranks of asylum seekers globally has grown exponentially over the last two decades, it does, through the exploration of women's narratives, illuminate the brutality that compels the asylum petitions by women from northern Central America and Mexico. It examines their expulsion from their countries of origin and the process of US asylum court hearings, which in many respects is ill-equipped to manage this new influx of asylum claims. For the women we interviewed, their asylum hearings could lead to a second expulsion by virtue of a judge denying their claims and issuing removal orders.

Statistics breaking down asylum cases by gender are limited: Data on gender in asylum cases are only available for slightly more than 70 percent of cases in fiscal years 2020 and 2021, and prior to that gender was recorded less frequently, prompting analysts to caution against gender-based comparisons or reported outcomes by gender.[21] With that caution pointed out, a well-known database of asylum court hearings noted that women experienced an 11 percent increase in grant rates during the first few months of the Biden administration.[22] That compares favorably to men, who experienced a 5.7 percent grant rate increase in the same period.[23] As stated by the authors, "While tantalizing as these results may seem, especially in light of hotly contentious disputes over *whether some gender-based asylum claims were valid* [italics ours], caution is still warranted" because of the limited available data. Unfortunately, we do not know how many of the female asylum seekers' cases were based on gender-specific claims, making it impossible to situate gender-based claims within the asylum system.[24] The question of how asylum seekers and their attorneys struggle to prove the validity of their claims is a core theme examined in this book.

Statistics on asylum grant rates by country reveal the daunting prospects for the Latin American women we interviewed. Although grant rates improved during the initial months of the Biden administration, only 28 percent of Salvadorans won their cases in FY 2021.[25] Both Hondurans and Guatemalans experienced a 22 percent grant rate, and only 17 percent of Mexicans were awarded asylum in FY 2021.[26] While each of these Latin American countries saw increases in grant rates over

the previous fiscal year, the rates compare unfavorably to an 86 percent grant rate for Russians, 81 percent for Chinese, and 77 percent for Armenians.[27]

While we do not know exactly how many women are granted asylum on gender-based claims, we do know that some Americans think the number should be lower. As noted in recent legal scholarship, gender-based asylum claims are often rejected because immigration judges and asylum officers fear "opening the floodgates" to waves of migrants desperate to stay in the United States.[28] Fear of "opening the floodgates" is a common concern surrounding gender-based asylum claims. Detractors claim that more liberal asylum rules that grant protection to women for gender-based claims will result in large numbers of female migrants making their way to the United States searching for protection. For example, when a woman from Togo was granted asylum after she fled female genital mutilation (FGM) in her home country, critics feared a massive surge of women fleeing from countries that practice FGM.[29] However, those fears did not materialize. Furthermore, Canada recognized gender-based asylum claims in 1993 and has not seen notable increases in the number of women seeking protection based on domestic violence or other gender-based claims.[30] While the statistical data are limited, there is no evidence that legal precedents that loosened restrictions on women fleeing domestic and/or gang violence have resulted in "opening the floodgates." As noted by legal scholar Karen Musalo, "There are many reasons why skyrocketing numbers of women asylum seekers have not resulted from recognition of their legitimate claims to protection."[31] Women often come from countries where they have few rights and limited access to resources; as family caretakers, they face critical choices about whether to bring children and expose them to the dangers of travel with the assistance of human smugglers. Therefore, substantial barriers prevent many from seeking asylum.

Liminality

In many ways, the women interviewed found themselves in the space of "liminal legality" described by Cecilia Menjívar in her seminal examination of how Salvadoran and Guatemalan immigrants negotiated legal categories, including periods in which they would be considered

"illegal."[32] Liminality is a concept used in anthropology to refer to a state at which an individual is on the threshold of change.[33] Menjívar noted that immigrants from El Salvador and Guatemala endured considerable legal uncertainty from policies changing their status over the years, as they negotiated a labyrinthine legal system to avoid falling into the category of "undocumented" and becoming subject to deportation.[34] What resulted were periods in which they were unclassified or between statuses, a state she termed "liminal legality."[35] These in-between states often led immigrants to face hardship when they could not work legally and were subject to deportation orders.[36] As will be seen in subsequent chapters, the women interviewed for this study could work legally as they awaited court hearings, but their situation always felt tenuous by virtue of their working multiple low-paying jobs, having appointments with attorneys to prepare for court, attending mandatory check-ins with US Immigration and Customs Enforcement (ICE) officers, and waiting for a court hearing that they knew would ultimately determine whether they could remain in the United States. Women we interviewed struggled to manage the symptoms from severe trauma that informed their histories while working and preparing for court.

Building on the concepts of liminal legality and illegality, anthropological and sociological analyses of life for Latin American immigrants and others have called for a scholarship that moves beyond legal categorization ("legal versus illegal" or "refugee versus economic migrant") in favor of examining how statuses impose meanings on the lived experiences of people who have been forced to cross borders by clandestine means.[37] An ethnographic study of undocumented migrants in Israel, for example, chronicled how their precarious status not only informed their external categorization, their legal status, and the fact that they could be subject to aggressive policing, but also penetrated how they experienced life internally—including experiencing hypervigilance because of an incessant awareness of possible arrest, and nightmares.[38] The concept of abjectivity—of being cast away and experiencing the most marginalized social status—shows that while migrants may live in a nation, they are prevented from being part of that nation.[39] Abjectivity has been used to understand and explain how the ostracism of individuals affects economic, social, and biological life.[40] Drawing on Michel Foucault's concept of biopolitics, which explores how various societal institutions including

government and economy impinge on bodily autonomy, Roberto Gonzales and Leo Chavez argue that a complex web of government policies experienced at the individual level via immigration court documents, birth certificates, tax forms, and so forth combine to create enormous distress for immigrants—although many can and do contest their conditions, engaging in acts of resistance and at times finding the means to prevail legally and leave behind the condition of abjectivity.[41] "The liminal and unstable nature of abjectivity is both a source of life stress and a condition that allows for the possibility of change, which opens up a space for human action and resistance."[42] In this analysis, we borrow from feminist and critical sociology to illuminate how policies both in Central America and Mexico, as well as the United States, penetrated and delimited life for the women who are the focus of this book.

Women who await asylum adjudications, or appeals following failed applications, arguably exist in a liminal space of constricted existence as they are allowed to work and are unlikely to be deported. But they nonetheless experience a sense of exclusion as they must live with the uncertainty brought by the very idea of potentially losing their case and being under a removal order. Their ability to remain in the United States hinges on a successful fight against removal. In her discussion of Salvadorans, Susan Coutin posited that receipt of work permits offers asylum seekers a sense of social inclusion, in part by virtue of the name associated with these papers: *un permiso* (a permit), which she noted in her ethnographic observation, prompted some to conflate work authorization with legal status.[43] Thus, asylum seekers' status is decidedly less tenuous than that lived by undocumented immigrants.

Winning asylum is a fraught process with few promises, and women who seek asylum occupy a space of legal ambiguity as they await asylum hearings, their lives inevitably defined by this uncertainty. As respondents in defensive proceedings—fighting to have removal orders lifted—their statistical odds are not promising. In FY 2022, 39 percent of asylum seekers in defensive proceedings won their cases.[44] Women who flee domestic and/or gang violence face daunting legal obstacles ranging from judicial bias to slowly evolving case law that still fails to acknowledge the unique circumstances of women seeking asylum because of violence by non-state actors.[45] Their imperative in asylum adjudication is to coax a system designed for survivors of state violence to recognize the

unique circumstances of women who suffered severe battery, rape, death threats, and home invasions by non-state actors. Given this precarity, they have much in common with other classes of migrants who cross international borders and struggle to obtain or to maintain legal status. Our task conceptually then demands delineation of the lived space created and shaped by women seeking asylum from Central America and Mexico. To capture a sense of this space, we first acknowledge its elements: incarceration at the border; popular discourse questioning the legitimacy of asylum seekers who crossed the Mexican/US border; the uncertainty of awaiting asylum hearings; ongoing symptoms from trauma prior to migration; legal outcomes that potentially range from winning a case to deportation to the home country.

Thus, asylum seekers exist in a tenuous space between legal prohibition and legal status, a space we call *compounded marginalization*. This term captures both the quasi-inclusion asylum seekers experience as they are spared deportation and may obtain a work permit, but whose existence is otherwise defined by a protracted legal battle to win relief from removal, as well as racialized conceptions of Latin American migrants as "illegal" regardless of status.[46] The women are marginalized, resulting in their relegation to a position of lesser influence and/or power. Their marginalization is compounded by multiple factors that transcend national borders and include elements of oppression and trauma experienced in their home countries, and in transit, followed by legal uncertainty in the United States. Informing the space of compounded marginalization are three factors related to the lived experiences of Latinas seeking asylum: (1) the asylum system's failure to acknowledge the decidedly public nature of the "private violence" that forces women to seek asylum here; (2) the criminalization of asylum seekers at the border, as apprehensions and detention send a message to both asylum seekers and the broader public that this population is suspect—no matter their reasons for entering the United States without permission; and (3) brutal trauma histories that alter women's sense of safety, leading to depression, nightmares, flashbacks, and a host of symptoms—problems that could persist, in part, because the wider society fails to recognize and acknowledge why these women merit protection.[47]

As we discuss in chapter 1, feminist legal advocates hoped that a series of rulings by the Board of Immigration Appeals (BIA) and the courts,

as well as promises by various presidential administrations, extending protections to asylum seekers who suffered violence by domestic partners would offer a greater certainty of future legal protection.[48] That never came to fruition. Court decisions continue to be inconsistent and arbitrary, leaving women seeking asylum because of rapes, death threats, home invasions, and stalking in a space of legal uncertainty.[49] Dramatically different asylum grant rates by immigration judges, the asylum seeker's country of origin, as well as an asylum seeker's ability to obtain legal representation, gather evidence, and tell a convincing, credible story on the witness stand heavily influence outcomes.[50] Cases based on "private violence"—gender-based brutalization at the hands of domestic partners or gangs—may not reach the stringent legal criteria required in asylum hearings despite new precedents that create space for these claims. But given the factors informing gender-based brutality in women's home countries, including poverty, income inequality, failed states, police corruption, and legacies of war/repression, we ask whether violence informing asylum claims can ever be accurately characterized as solely private.

Women's journeys through the asylum system begin with apprehension and detention at the border, as women suffer lack of access to counsel and interviews to determine whether they will be deported immediately or be allowed to seek asylum. Fingerprinting, jail cells, ankle bracelets, and the requirement to post bond imbue women with a quasi-criminal status. Women frequently complained about Border Patrol officers' demeaning treatment, and assumptions that their asylum claims were fraudulent. Though the women we interviewed were released from detention and allowed to fight for asylum, the initial incarceration and lack of legal rights at the border conveyed a clear message about their tenuous belonging.

Compounded marginalization is ineluctably characterized by a state of being that transcends law, court procedures, and the administrative work required to remain here legally. Permeating women's existence is the aftermath of the trauma that forced them to seek asylum, severe violence inflicted in many cases at the hands of their domestic partners. In interviews, they described dating men who initially seemed kind and loving, only to have their relationships devolve into violence. Women described shame, depression, fear, intrusive memories, nightmares,

insomnia, and flashbacks. One saw her rape playing before her like a movie each time she tried to clean her house. Though the fact of this trauma is well known by women's attorneys, DHS lawyers who serve as de facto prosecutors, and the immigration judges, the reality of the suffering women endure remains far removed from discourse concerning the border and asylum in the United States, as debate over the border centers on the idea of asylum seekers being threats to security.

Thus, women who seek asylum experience the ascription of illegality brought about by arrest and incarceration, followed by the legal precarity informed, in part, by an asylum system that fails to fully acknowledge the root causes of violence experienced by the women we interviewed. As public discourse focuses solely on the border as a security problem, the trauma that forces women to enter the United States without authorization remains unrecognized and unacknowledged.

Gendered Violence

The women at the center of this book found themselves in a system established in the wake of World War II and during the Cold War to protect victims of state persecution, particularly survivors of authoritarian and/or Communist regimes. Today this system must be stretched to ensure safety for victims of less commonly acknowledged forms of persecution—such as gang or domestic violence. Moreover, the line between state and non-state actors is not as clear as originally envisioned, and countries may be unable or unwilling to protect their own citizens through acts of commission or omission. Once asylum seekers leave the countries that fail to protect them, they must negotiate a system that was never designed to protect large numbers of disadvantaged people who need protection and often must seek safety by reaching a border via clandestine means. As argued by David Fitzgerald, human rights principles codified by the United States and other western nations "are subverted by governments that try to keep asylum seekers at arm's length and penalize those who travel without official approval."[51]

Today's asylum system must address women who are fleeing so-called private violence. In our analysis, we contextualize the question of private violence by building on Menjívar's analysis of women's oppression in Guatemala, joining her in using the concepts of symbolic and struc-

tural violence to explain why so many women now must leave northern Central America and Mexico to find safety.[52] We describe how decades-long civil wars, military coups, and the drug war cultivated the conditions for widespread gender-based violence. Critical in this analysis is the understanding of the role that the United States played under multiple presidential administrations to wage wars against the Soviets by proxy, leaving northern Central America haunted by almost unimaginable, grotesque violence by right wing forces and death squads against civilians.[53] We also note the sustained poverty in the wake of neoliberal adjustment projects fostering the conditions for violence, as well as the failure of the states in question to protect their citizens through arrests and prosecution of those who commit crimes against women. Women suffer violence, in part, because police in northern Central America benefit financially from gang crime and states typically neglect to pursue cases against perpetrators of gender-based violence, deliberate acts of neglect.[54]

To win asylum in the United States, an asylum applicant must prove that she faces a well-founded fear of persecution based on at least one of five protected categories that we explain in chapter 1. Where do these categories leave women forced to flee their countries with only what they could carry? Can these categories be stretched to protect women who suffer domestic violence or death threats by gangs? The women interviewed for this book experienced violence in private spheres: at the hands of domestic partners and the fathers of their children, or by the gangs that had taken over their neighborhoods. In some cases, gang and domestic violence merged as women discovered their boyfriends had gang ties and family members who were involved in organized crime.

Twenty years ago, Pierrette Hondagneu-Sotelo called for a convergence of immigration and feminism in research, social movements, and popular discourse:

> While the feminist movement and the immigrant rights movement have changed the landscape of civil rights for women and immigrants in the United States, there have nonetheless been relatively few points of intersection between the two. Why? The feminist movement may have delayed responding to immigrant women's issues partly because immigrants, as a group, have not been a popular or powerful group around which to

rally. Immigrants, although diverse, are commonly portrayed as poor, illegal, ignorant trespassers of national soil and transgressors of national sovereignty.[55]

This discourse casts immigrants in a shadow of continued illegality, rendering them controversial and unsympathetic to large swaths of the American electorate. As undocumented immigrants in general, and Latin Americans in particular, are reviled as dangerous or criminal in political discourse, an understanding of the needs and human rights for asylum seekers becomes elusive. Thus, Latin American asylum seekers function in what amounts to a hidden system, far removed from the notice of many American feminists and potential allies.

Women asylum seekers' lack of visibility and political support becomes more problematic when considered in tandem with the issue of border enforcement. Recently, Rebecca Torres described the efforts of border and US immigration court officials to reinforce the deprivation of rights for women through a range of actions to thwart asylum seeking, including use of family detention.[56] The routine practice of detaining Central American women in freezing cold holding cells, known as *hieleras*, has been argued to serve as an apparatus of racialized and gendered border enforcement policies.[57] These efforts have been reinforced through the illegalization of voluntary migrants, a process that abets the arrest and return of many arrested at the border. This process serves to escalate danger for those who must try to enter the United States without authorization.[58] Still, as noted in recent ethnographies of the Mexican/US migration corridor, even the most besieged actors disrupt and complicate border enforcement, allowing migrants to reject territorial categories and cultivate imaginaries for movement.[59] Such is the case for the women we interviewed, who asserted their need for asylum as they waited to be released by the authorities who detained them. None consented to a voluntary return to their country of origin, although some were pressured to do so.

Once released from detention, asylum seekers were left to settle in cities and neighborhoods unfamiliar to them. Despite having meager incomes from work in restaurants, nail salons, or cleaning services, the women we spoke to were among the fortunate who could hire attorneys to represent them in removal proceedings; most asylum seekers

lack legal representation. The odds of winning these proceedings are not favorable. Legal scholars have noted that refugee and asylum laws were built on the assumption that persecution and violence occur in the public sphere by state actors, not in private homes by intimate partners or by gangs.[60] Moreover, while the refugee definition is gender-neutral, historically it is based on activities considered to be male-dominant. In asylum cases, gender-specific persecution experienced by women, such as rape, typically has been considered to be private rather than political.[61] Since the law does not recognize gender as a protected ground, women seeking asylum must adapt their experiences to the law.[62]

Trauma

Anthropologist Paul Farmer asked, "By what mechanisms, precisely, do social forces ranging from poverty to racism become embodied as individual experience?"[63] For the women who are the focus of this examination, trauma becomes embodied in daily lived experience and is described as a series of symptoms: nightmares, insomnia, vivid and unwelcome memories, efforts to avoid thinking about their traumatic pasts, heightened startle reactions, and depression (among other symptoms). In our conceptualization, trauma is not examined strictly as a psychiatric diagnosis, although some of the women interviewed were found through psychometric testing to be suffering from Post-Traumatic Stress Disorder (PTSD). Here, the act of carrying trauma in the form of repeated nightmares, intrusive memories, and hypervigilance is viewed through the lens of abjectivity and "immigrant illegality."[64] This book examines the experiences of women and the question of illegality and abjectivity through the lived experiences of surviving interpersonal violence prior to migration in the form of home invasions, rapes, robberies, threats at gunpoint, and the possibility of having one's child kidnapped. In women's bodies, the experience of trauma is visceral. "Some days I can be standing at the sink washing dishes and I will see him raping me," a Salvadoran woman said during an interview. Women described fending off trauma symptoms including intrusive memories of threats with machetes as they cooked burgers in fast food restaurants or mopped floors. Here, the "inward parts" are shaped by trauma. This suffering, with a few exceptions, did not receive the attention of practitioners from

helping professions, such as social work. Lacking access to health care and mental health services, and without linkages to organizations that assist immigrants, the women we interviewed went about their days fending off the aftereffects of trauma with varying degrees of success. Interactions with helping professionals were few.

Mercifully, as will be explained in later chapters, these inward parts also were shaped in many cases by the capacity for repair, recovery, and resilience. A twenty-three-year-old from El Salvador who awakened one morning to see her father lying dead from gunshot wounds found solace in long walks and trying new foods in American restaurants. Several women celebrated winning asylum outside of courtrooms by sharing smartphone pictures of their young children, as well as posing for triumphant photos in front of a federal courthouse with family members and an attorney. While attending an immigration protest in front of the White House during the Trump administration, we saw one of the women interviewed holding a sign demanding an end to deportations.

In their analysis of the history of trauma as both a diagnostic category and a signifier for certain social and political rights, Didier Fassin and Richard Rechtman argued that while the understanding and acknowledgment of trauma abet societal support and recognition of one's victimization, it also has eclipsed and essentially homogenized the experiences of individuals who experience trauma.[65] Lost in the categorization of trauma, they argue, is the social and political context of these injuries. Our hope is to illuminate the context from which these asylum claims emerged. We recognize that recounting stories of trauma is fraught with concern for both the women who tell these stories and for the readers who now, by extension, bear witness to their suffering. Though we had to ask women about their trauma, we made the decision to be as judicious as possible in presenting details of the violence they endured. We have endeavored to present sufficient evidence of their experiences prior to migration without indulging in descriptions that might seem gratuitous. We acknowledge that we must balance the risk of presenting the horrific experiences that women described with a sensitivity to readers; this material is admittedly disturbing. At the same time, it is necessary to present a forthright accounting of women's experiences and why they are coming to the United States for safety. Thus, the painful material presented in chapters 2 and 3 is only a shard of the suffering women

described in interviews, court testimony, or in written declarations gathered by their attorneys and shared with us.

We begin with a description of the policies informing the asylum system, followed by two chapters detailing circumstances in their countries of origin that precipitated the violence that forced them to leave. The organization of chapters 2 and 3 reflects how the immigration attorneys with whom we worked closely for four years categorized the women referred to us: as survivors of either gang or domestic violence. Therefore, chapter 2 focuses on the economic and social conditions leading to horrific gang-related crime rates, and chapter 3 examines why such violence touches the domestic sphere. We acknowledge that we talk a fine line in chapters 2 and 3 as we need to detail the very real violence women experience while avoiding calls for law enforcement crackdowns that have been tried only to fail miserably, including suspensions of civil rights and mass incarcerations that have bred more violence.

We're also conscious of the need to delineate clearly that violence is not unique to Northern Central America and Mexico. The women who came to the United States arrived at a time in which women's rights are arguably under attack, as evidenced by the US Supreme Court's recent decision to end reproductive rights, leading some states to enact harsh laws restricting women's autonomy to end an unwanted pregnancy. In addition, we need to note that while women came to the United States because they knew it afforded them considerably more safety than the nations they left, gender-based violence is an issue here, with one in three women reporting violence by an intimate partner and one in seven reporting suffering injuries because of these assaults.[66] We follow the descriptions of the countries of origin with an examination of what happens after women cross the Mexican/US border and begin to be processed as asylum seekers before examining the question of trauma and what happens once women at last have their day in court.

Finally, we note that the forty-six asylum seekers we interviewed are women who identify as such. No transgendered or non-binary asylum seekers were referred to us by attorneys.

Organization of the Book

Chapter 1: "Private Violence" and Public Policy

This chapter focuses on the immigration court and asylum law systems that women must navigate to remain in the United States. We note that the immigration court system is an arm of the US Attorney General, a political appointee who reports directly to the president. Immigration judges work in the DOJ and are supervised by the attorney general.[67] This means that immigration courts and immigration judges are part of the same executive branch that enforces immigration laws and excludes and deports individuals.

The asylum system evolved over the past seventy-five years to provide humanitarian assistance to certain individuals the US government deems worthy of protection. The question of who deserves protection—individuals from which countries and for what reasons—can fluctuate dramatically according to both domestic and foreign policy exigencies. Most changes to the asylum system are not made by Congress, but rather by the executive branch, often in response to migration trends and public opinion. These executive decisions are often subject to legal challenges. This policymaking technique has resulted in wide swings in asylum policy in recent years. Individuals requesting asylum through this constantly changing environment must present significant evidence that they are worthy of protection under the current interpretation of the law while facing multiple obstacles. The government is represented by an attorney, but asylum seekers are not provided with a lawyer and must hire legal counsel at their own expense. In this system, which is often more focused on weeding out fraudulent cases than providing humanitarian assistance to those who deserve it, asylum seekers are arguably in a position of being guilty until proven innocent. It is within this heavily stacked system that the women of this book find themselves.

Chapter 2: "Women Who Are Alone Suffer"

The women we interviewed said repeatedly that they could not turn to police in their home countries for protection from violence by boyfriends or gangs. Most of the women are survivors of rape, extortion, death threats, kidnapping, and assaults, among other crimes perpetrated

by gangs. Gangs, and their attendant violence, are pervasive throughout parts of Mexico and Central America. Gangs control vast areas of territory in lower income neighborhoods while the wealthy live in walled, securitized neighborhoods. In many areas, gangs serve as the de facto state, monitoring who enters and exits their territory.[68] Led by alienated men who grew up in poverty and now have no meaningful hope for remunerative work and, in some cases, as noted by Coutin, include deportees from the United States, gangs operate freely because of a host of social factors, including pronounced income inequality and government corruption.[69] They now operate as patriarchal power structures, or a "system of social structures and practices in which men dominate, oppress and exploit women."[70] These male-dominated criminal organizations bribe elected officials including bureaucrats and police and operate with impunity. They extort businesses while forcibly recruiting members.[71] Women are uniquely vulnerable to their violence as gangs use rape as a weapon of domination.

No single factor accounts for why gangs have become powerful actors. By examining the multiple forces contributing to these phenomena, including economic policies and the legacies of war, we seek to contextualize *why women* are targeted so frequently for violent crime. To analyze women's experiences of gang violence, we deploy feminist interpretations of sociology and critical geography, specifically examining how both states' extra-legal actors contest space, in a context in which capital seeks to abet production and profit.[72] Joining Menjívar, we turn to the work of Pierre Bourdieu, and we argue that women's practice in the fields of work, family, and homemaking are shaped by objective economic realities including access to jobs.[73] At the same time, women's subjective experiences and beliefs delineate decisions, with some coming to be seen as rational and others as unthinkable.[74] It is within this framework that abandoning all that one knows in favor of a perilous quest for asylum comes to be seen as reasonable.

Chapter 3: Violence at Home

We premise our analysis of gender-based violence by domestic partners on two key arguments: (1) "Private violence" is a misnomer as it occurs in social contexts that normalize men's dominance of women, and (2)

Both structural and symbolic violence must be examined to understand the prevalence of gender-based violence that compels asylum. We turn to Bourdieu and feminist scholarship that engages his work to understand the intersection of gender and class in disadvantaging women.[75] Both gender and class determine women's social positions, access to resources, and policies informing gender-based violence.[76] Accruing power within social space entails the subordination or exclusion of certain classes, most critically in the distribution of resources such as education and jobs.[77] Space must be negotiated and interpreted by the most vulnerable, including women who develop survival strategies while caring for and supporting families. We note that women seeking asylum from El Salvador, Honduras, Guatemala, and Mexico have left states where multiple factors are implicated in gender-based violence: poverty, a legal system indifferent to women, and a paucity of social services.[78] In Guatemala, El Salvador, and Honduras, the site of recent civil wars and military coups, the hypermasculinity surrounding militarism as well as the fact that economic and political power are held primarily by men abet male hegemony and the conditions implicated in gender-based violence.[79] Impunity for crimes against women and gender inequality perpetuate violence including rapes and feminicides, a cycle reinforced by emphasis on militarization.[80] State failures to prosecute crimes against women, conditions that have been documented amply in Honduras, Guatemala, Mexico, and El Salvador, abet the normalization of unequal power relations and the subjugation of women.[81]

Women's decisions to flee and seek asylum came by way of intersecting spatial relations: relegation to low-wage labor; inadequate law enforcement and prosecution; and, finally, the intersection and mutually reinforcing relations of public and private systems, determining access to education and jobs, as well as gendered dispositions that inform violence. During our ethnographic work, we saw immigration court hearings in which the idea of a male-dominant, *machista culture* was argued, and its recognition sometimes leads to successful outcomes.[82] In other cases, judges seemingly dismiss the innately political context informing battery and rapes perpetrated by domestic partners, a conceptualization that contributes to the belief that this gender-based persecution is "private violence."

Chapter 4: Criminalizing Asylum

For the forty-six women interviewed for this book, the legal journey to win asylum began with their apprehension and detention after crossing the US border from Mexico. This chapter chronicles the beginning of the legal journey to asylum. Women interviewed for this study engaged a process known as "defensive asylum," in which an individual petitions for asylum after being arrested and being deemed removable from the United States, typically shortly after crossing the Mexican/US border. While in custody, she may then give a statement to an asylum officer from DHS stating why she is afraid to return. If her fear is deemed credible, she is then allowed to remain in the United States to await a hearing to determine if she will be awarded asylum. These interviews often follow a perilous journey to escape the countries that they fled and may have been preceded by violence during human smuggling.[83] Women described having to negotiate interactions with a range of officials including Border Patrol officers, asylum officers and, in a few fortunate cases, mental health and case workers. These interactions led to considerable uncertainty and in all but a few cases, women described giving interviews to officials over the phone to explain why they needed asylum, not knowing what might happen next or whether they would be released. Thus, the tenuous nature of asylum claims-making began at the border, as they waited to see if they would be allowed to remain in the United States.

The experiences of women who cross the border from Mexico to flee violence are informed by two competing policy objectives: (1) border enforcement to ensure national security, and (2) the principle of *non-refoulement* which is to ensure that no one is returned to a country where they will suffer persecution. The reality is a process characterized by "crimmigration"—policies and narratives in which immigration and criminal law are conflated so as to criminalize immigrants.[84] The prioritization of detention and security essentially negates protections women need when crossing the border to seek asylum—an undertaking meant to obtain the safety and protection that their sending countries failed to provide. Women repeatedly described being demeaned and mistreated, including confinement in the *hieleras*, where women were deliberately subject to extreme cold while being denied adequate food. Some de-

scribed being yelled at by officers; others recalled being referred to as dogs while in detention. Such practices stem from racialized narratives questioning the legitimacy of those seeking asylum after crossing the border from Mexico.

Chapter 5: Trauma: Shared Meanings and Healing

We contextualize experiences of trauma for the women interviewed through a lens examining its interplay as both collective experiences and shared meanings, as well as the imprint of pain inflicted upon them as individuals. Violence can emerge as part of everyday life, and it encompasses the suffering caused by social relations that originate at global, national, and local levels, processes that include poverty, lack of access to education and social services, inequitable gender relations, as well as the extreme violence—death threats, rapes, home invasions, kidnapping, and/or murders of family members, and recruitment of children into gangs—that forced the women we describe to seek asylum.[85] Structural inequality and social location inform how suffering is experienced across social groups. While we document individual narratives of trauma and resilience, we argue that understanding trauma as a singular experience, irrespective of the context within which it occurs, is insufficient to truly engage the collective experience of women fleeing gendered and gang violence. Poverty, severe and pervasive gender-based violence, forced relocation, and incarceration merit a recognition of these experiences as cultural trauma.[86]

The question of cultural trauma merges into issues about the diffuse factors forcing migrants across the globe to seek safety because of war, patriarchal supremacy, climate change, neoliberal projects that cause job loss and poverty, as well as the failure of states to protect survivors of gender-based violence who are not recognized for refugee status.[87] Jeffrey Alexander defines a cultural trauma as that which occurs "when members of a collectivity feel they have been subjected to a horrendous event that leaves indelible marks on their group consciousness, marking their memories forever and changing their future identity in fundamental and irrevocable ways."[88] The establishment of a cultural trauma leads to acceptance of responsibility for harms—which can then motivate societies to ensure justice.[89] Cultural trauma includes understanding

how injury shapes identity as groups incorporate and make meaning of shared memories. Injured groups and allies use narratives, art, and political activism to identify the nature of injuries, denote who was injured, and to ascribe blame.[90]

Chapter 6: "If I Offended Your Country, I'm Sorry."

This chapter draws from extensive ethnographic observation of asylum hearings. Women who hope for asylum must build lives following their apprehension at the border, a process that includes finding jobs and housing, raising children, learning new cities or suburbs, and hiring attorneys. And during this flux it is necessary to comply with completing immigration-related paperwork, paying legal fees, and finally, preparing for court—knowing that this process would bring a decision about their worthiness for asylum and legal inclusion. The asylum process is informed by restrictive policies and the assumed ascription of illegality, all processes that we argue delimit their lives as they try to win asylum.[91] To make sense of the court system, we return to our concept of compounded marginalization to examine how asylum seekers experience legal strictures by virtue of a judicial system that doesn't account for the underlying causes of gender-based violence by non-state actors, symbolic ascription of criminal status at the border, as well as the trauma that manifests itself in a host of symptoms.

Women prepare for asylum cases while struggling to sustain themselves with jobs at restaurants or nail salons, often working more than one job to pay rent and legal fees. Many hired human smugglers to travel through Mexico and across the border, and their expenses included monthly payments of $350 to $500 to repay those costs. At the same time, they worked with their lawyers to gather evidence to support their asylum claims such as medical records detailing injuries. One attorney described her clients as feeling grateful to have jobs and noted that most work more than one to cover rent, food, and often, to send money home. They typically live in cramped quarters shared with others but engage these labors stoically and despite histories of severe trauma prior to migration.

Conclusion: The Architecture of Exclusion

Women who win asylum cases often report a sense of relief and safety: No longer fearing deportation or loss of a work permit, they proceed to save money for houses and continue caring for families. Yet, we note continued strictures imposed by law. Many women we met have family members—including children—who remain in the home country, and in some cases, in the same households as the men who battered their mothers. Family separation brings guilt for leaving them behind, even when knowing they have no choice. Clearly, reforms are needed in Central American countries and Mexico to counter the persistent structural and symbolic violence that perpetuates brutalization and fails to protect women. When US officials discuss treating the "root causes" of migration, the conditions informing structural and symbolic violence are rarely considered. We would be remiss if we failed to note US responsibility in contributing to legacies of decades-long violence through civil wars by proxy, drug war engagement, and for collaborating in the promulgation of neoliberal economic policies that disadvantage large swaths of the populace in the nations we have examined. US complicity is necessary to note so that moral responsibility can be ascribed and acknowledgment in the form of meaningful structural change can be made.

Although the asylum system adjudicates individual cases, we note the conspicuously collective nature of these experiences: As the stories of the women reveal, they share brutalization by men against similar backgrounds of social suffering in their home countries. The social conditions informing these experiences reveal common elements: neoliberal adjustment projects perpetuating poverty and income inequality, as well as legacies of both civil wars and drug war violence, all compromising the ability of frail states to impose order and protect their citizenry. Therefore, we believe that remedies for these conditions through policies would begin with a recognition of these experiences of violence and persecution as collective assaults meriting justice.

1

"Private Violence" and Public Policy

Guadalupe, a Salvadoran asylum seeker, was seated for an interview in her lawyer's office in February 2020, dressed demurely in a pink down vest and sweater, a month before the COVID-19 pandemic shut the nation down. She politely described her circumstances. What Guadalupe told was a horrific story: While asleep one Sunday morning, she heard three gunshots. Wanting desperately to believe the sounds were benign, she ran to her brother, who suggested that the noises came from one of the street vendors in her small town who set up stands to sell fruit, pupusas, or clothes. She was not reassured. "I knew in some way that they were gunshots," she said. Within minutes, a cousin showed up at the house in tears, saying that Guadalupe's father had been shot and was seriously injured. Running to the park where her father worked each morning, she found him dead. Later, gang members approached her on the street and at the house to warn her that they would kill her and the family if they cooperated with police. "You will end up in black bags," one gang member said. That left Guadalupe, her mother, and siblings no choice but to migrate to the United States to ask for asylum. Given El Salvador's small size and the gang's ability to track people down in neighboring communities and even countries, the United States offered the most safety despite the journey's distance.

Another woman, Ximena, age twenty-five, fled El Salvador with her four-year-old son after her gang-affiliated partner beat her repeatedly, threatening to cut her tongue out if she told police. Ximena escaped the home they shared to seek safety at her grandmother's house. Her partner stalked her there, standing outside for hours and threatening to take their son. Ximena grew increasingly alarmed as her son began exhibiting behavior learned from his father, calling her a "whore" and mimicking the gestures and gait of a gang member. One day her son picked up a toy gun and screamed at her, "I'm going to kill you!" These experiences are typical of those recounted by the forty-six women interviewed for

this book, women terrorized by gangs, their domestic partners and, in many cases, both. As we show in coming chapters, internal relocation to escape gang or domestic violence usually isn't an option because of law enforcement corruption and ineffectiveness, as well as the widespread belief—often borne out of experience—that internal relocation won't provide safety. Women also described gang members and abusers' efforts to find them in Mexico.

For women from Central America and Mexico who suffer violence at the hands of a domestic partner or gang member, an application for asylum in the United States proffers hope for survival and a future. While a cliché dubbing the United States a "nation of immigrants" persists, most asylum seekers face a path fraught with legal obstacles. The challenges faced by today's asylum seekers are not unique to the United States or even to this period in history. Asylum and barriers to it date to antiquity: Greeks in the fifth century BCE erected a police station in front of the Acropolis to halt asylum seekers from entering the marble edifice, insisting that those seeking sanctuary first offer a convincing narrative explaining why they deserved protection.[1] As noted by David Fitzgerald, "Measures to keep people from reaching sanctuary are as old as the asylum tradition itself."[2] States balance competing imperatives: the wish to be seen on the international stage as a benign protectorate while appeasing the wariness of citizenry toward newcomers. This chapter explores the legal, gendered, and political realities for Mexican and Central American women seeking asylum—a process subject to contestation, ambivalence, and political pressure.

We provide the legal and policy context within which Guadalupe, Ximena, and others fight for protection. We anchor this analysis in recent immigration scholarship examining the marginalization of people who fight for legal status, including the women we interviewed.[3] Over the course of this century, research has probed how laws force migrants into spaces of limited rights and numerous social harms.[4] As a result, there exists an extensive corpus of scholarship delineating how shifting statuses constrict life for those who do not have fully legal status. In their conceptualization, Cecilia Menjívar and Leisy Abrego argue that fragmented immigration policies such as arrests for unauthorized border crossing or employment restrictions cause suffering across multiple life domains, an accretion of laws and policies they term "legal violence."[5]

Drawing on the work of Mary Jackman, Menjívar and Abrego note that legal violence is inconspicuous as it results from socially accepted policies and practices.[6] Such policies seem routine and reasonable to many Americans because they are the law, although they lead to deportation, social exclusion, tenuous legal status, and violations of rights.[7] Positioned outside the law, undocumented immigrants live in a state of legal non-existence; since they are not incorporated into the nation, mundane tasks such as working require clandestine activity.[8] Asylum seekers exist outside the law while at the same time occupying a hyper-legalized space—one in which laws constrict and limit their life options as they enjoy minimal legal protections but abundant restrictions.[9] Efforts to conform and abide by the law, including completing tax forms or obtaining a child's birth certificate, expose people with tenuous legal status to risk and immigration enforcement, causing suffering and limiting opportunity.[10]

But how then do we conceptualize life choices, legal struggles, and social suffering for women seeking asylum? Asylum seekers arguably exist in a tenuous space between legal non-existence and quasi-legal status: They may obtain work permits that must be renewed every two years as they await hearings before an immigration judge.[11] During that time, they receive a reprieve from deportation orders. Susan Coutin has argued that work permits give asylum seekers a sense of economic citizenship and social inclusion, especially in comparison with undocumented immigrants.[12] But winning asylum is a fraught process, and women who seek asylum occupy a space of legal ambiguity and public opposition—a space we call compounded marginalization—as they await asylum hearings, their lives defined by uncertainty. In that way, they have much in common with other classes of migrants who cross international borders and struggle to obtain or maintain legal status.

We examine what it means to be a woman who seeks asylum because of rape, assaults, extortion, and death threats by gangs and domestic partners—social actors largely unaccounted for in the US asylum system. Lula, a thirty-three-year-old Salvadoran whom gang members targeted for rape because she is a lesbian, emphasized that she wants little from the United States beyond safety. "The only thing I want is to be calm and to know if I am going to be in a place where I can work and I can have my little meal. As I tell you, I do not long to have many things,

because I have never had it. I have always been humble and all I want is to be well, nothing more. Being safe, then feeling safe. Security is what I want, peace of mind. It's the only thing," she said.

But Lula and others seek asylum while many American voters clamor for reinforcing the border, and public discourse ignores the gender-based violence that led to their migration. Perhaps the latter point is not surprising: Gender-based violence is historically understood as a family or interpersonal issue, a framing that feminist scholars argue renders the state reluctant to intervene.[13] "Patriarchal systems have traditionally classified violence against women as private, denoting its distance, and to some degree protection, from the legal gaze and thereby from accountability and punishment."[14] Thus, women asylum seekers experience unique legal violence: Popular discourse characterizes asylum seekers as fraudulent or as illegal by virtue of unauthorized border crossings. Their lived realities entail holding down jobs, paying lawyers, and raising children while struggling through the aftermath of trauma unacknowledged by the wider society. Structurally, they must negotiate a byzantine legal system that proffers limited hope for a successful case. Away from the public eye, in law offices and closed courtrooms, they fight for permanent legal status.

Compounded marginalization includes the legal uncertainty they face. As we explain in subsequent chapters, compounded marginalization encompasses carrying the weight of multiple traumatic experiences that cause depression, fear, nightmares, and intrusive memories—symptoms associated with PTSD. Public discourse characterizes them as suspect as political leaders curry favor by conflating them with "illegal immigrants," thus stigmatizing them as unworthy for inclusion. At the border, they are handled as criminals: held in jail cells and fingerprinted even though asking for asylum is legal. Thus, we call this space compounded marginalization to capture the legal right to seek asylum while delineating the precarity caused by social exclusion, the possibility of forced removal if they lose their case, and trauma that remains unacknowledged by the wider society.

"Private Violence"

To understand women's plight, we examine policies and laws informing their odyssey through the asylum system. Some legal scholars note that Western nations built asylum and refugee law on the understanding that state actors perpetrate violence in the public sphere; it did not originate to provide protection to those harmed by non-state actors in the so-called private spheres of domestic partnerships and/or gang violence.[15] Gender-based crimes and persecution, such as rape, have been deemed "private" or "cultural," and not political, and thus do not easily fit within asylum laws. We examine the ostensibly gender-neutral protections for asylum seekers that fail to acknowledge women's experiences, while recognizing that feminist legal advocacy and new precedents are incrementally reshaping asylum law and slowly improving odds for survivors of gender-based violence.[16] Meghana Nayak noted the tenuous nature of gender-based claims: "Due to the politics of immigration restriction and the 'missing' category of gender, asylum/immigration officials and judges put an added burden on asylum seekers with gender-related claims to prove that they are deserving of legal protection."[17]

The accretion of policies coupled with the legal constraints of the US immigration system complicates the struggle for asylum. A lack of congressional action has meant that the executive branch exerts a disproportionate ability to shape asylum law, a key consideration given how a president's failure to acknowledge harms suffered by Mexican and Central American women can create legal barriers. Rulings from the nation's highest immigration court may not be precedent-setting and are often applied inconsistently or arbitrarily.[18] Denial rates vary greatly by court location and individual judges, leading some scholars to label the asylum process "refugee roulette."[19] In one courthouse where we observed hearings, a judge denied all but 4.6 percent of asylum cases, while another granted it to 71.2 percent.[20] While data separating asylum claims based on categories such as domestic/gang violence or political opinion are not available, statistics on grant rates speak to women's precarity.

Numerous barriers impede women's struggle for asylum, and few avenues exist through other means. According to the United Nations High Commissioner for Refugees (UNCHR), 79.5 million people (about twice the population of California) suffered forced displacement

in 2019, and only a tiny percentage of the world's refugees receive the opportunity to resettle in another country.[21] Refugees are people fleeing persecution who receive permission to enter another country for resettlement. Asylum seekers cross the border into another country and then ask for refugee status. The process for obtaining refugee status poses barriers everywhere, and the United States rarely grants it to Central Americans and Mexicans. From FY 2012 to 2021, 3,085 refugees from El Salvador, 530 from Guatemala, and 494 from Honduras were admitted to the United States; no refugees from Mexico had been admitted.[22] This issue isn't unique to the United States. As noted by Fitzgerald in his description of recent Syrian drowning deaths near Greece, deaths could have been averted if more countries allowed people to apply for refugee status at their embassies. "There are very few 'humanitarian corridors' providing a legal way for refugees to travel to a safe country and ask for asylum."[23]

In theory, Central American and Mexican women could attempt to immigrate for reasons unrelated to violence, but legal channels are few, and gendered realties persist: Women typically use the family-based immigration system by relying on male sponsors.[24] Central American women rarely immigrate through the employment-based immigration system; current law gives preference to high levels of formal education and specialized work experience, making receipt of work visas virtually impossible for the very low-income labor and educational attainment that shaped life for all but a few of the women interviewed.[25] With minimal options for winning admission as a refugee or through another channel, and global corridors constricted by unprecedented numbers of people seeking refuge, asylum becomes the lone option for sanctuary from gender- and gang-based violence.[26]

The asylum process is arduous. Women detail trauma—death threats to themselves and family members, assaults, menacing with weapons, multiple rapes—on the witness stand to convince judges that they meet strict legal criteria. As noted earlier, asylum laws were not created for survivors of gender-based violence but for victims of political persecution. These laws have been made more stringent.[27] Adding to legal challenges is the reality that immigration courts have little in common with what Americans know of courtrooms. Asylum seekers are not guaranteed a right to appointed counsel, and the courts that hear these

cases can be politically influenced, thus creating the conditions for compounded marginalization. To help understand the patchwork of policies informing the immigration system, we briefly describe its legal realities.

The US Asylum System

US refugee and asylum law arose from a series of ostensibly gender-neutral policies. Still, a review of asylum history shows the nation's ambivalence about awarding protections. In the early twentieth century, when quotas and literacy tests excluded many immigrants, the United States granted exceptions that allowed certain individuals fleeing religious persecution to enter.[28] Initially, Jewish and Armenian women—particularly survivors of sexual violence—benefited from these exemptions. However, adjudicators would soon treat women's claims of persecution with suspicion and accuse them of attempting to migrate fraudulently. As Yael Schacher writes, "By mid-1921, immigration officials were more interested in investigating cases of women suspected of coming for immoral purposes or of using 'subterfuge' to evade the law, than in considering rape during pogroms as relevant to religious persecution claims."[29]

From the end of World War II until 1980, refugee admissions to the United States came as a series of ad hoc responses to humanitarian emergencies, including large numbers of Jews displaced by Hitler and refugees fleeing Soviet bloc nations.[30] President Truman issued a directive that led to 28,000 Holocaust survivors receiving visas despite congressional efforts to suspend immigration altogether.[31] The Truman initiative was decidedly more humanitarian than the Roosevelt administration's 1939 decision to refuse permission for passengers aboard the passenger ship the *St. Louis* to land on US soil, leading to the deaths of 254 Jews in the Holocaust after the ship was turned away.[32]

As more Cold War era global crises emerged, human rights advocates sought a uniform definition and a regularized system for admitting refugees to the United States. The United Nations' 1951 Convention Relating to the Status of Refugees as well as its 1967 Protocol defined a refugee as an individual with a "well-founded fear of being persecuted for reasons of race, religion, nationality, membership of a particular social group, or political opinion."[33] The criteria omitted gender, a fact reflect-

ing this historical period. As noted by legal scholar Karen Musalo, "The drafting of these treaties preceded the recognition of women's rights as human rights, and therefore, it is not surprising that gender is absent from the list of criteria."[34] In 1980, the US Congress passed the Refugee Act, which codified the Convention and Protocol in the Immigration and Nationality Act.[35] By passing the Refugee Act, the United States accepted the refugee definition and agreed not to return them to dangerous countries, known as the principle of non-refoulement.

Principles and practice can and do diverge, however. Wealthy nations repel asylum seekers from their shores and borders, as demonstrated by the frequency of drowning deaths by Kurds and others trying desperately to reach the Greek island of Kos.[36] In describing the drowning death of a three-year-old off the Turkish coast, Fitzgerald noted that the boy and his family would likely have received asylum had his boat reached Greece. "Unfortunately for them, a system created to keep most refugees from reaching safety in the rich democracies of the Global North worked as designed."[37]

In short, the asylum system's architects never intended to welcome large numbers of people fleeing persecution, and wealthy democracies exert the prerogative to decide who merits protection. Moreover, the United States does not implement policies evenly, with refugee and asylum laws being politicized and racialized. President Reagan ordered the US Coast Guard to block boats leaving Haiti filled with potential asylum seekers trying to escape Jean Claude "Baby Doc" Duvalier's repressive regime.[38] While the United States typically welcomed asylum seekers fleeing Soviet bloc countries, Haitians "were positioned as racialized threats."[39]

The Refugee Act's omission of women and their unique spatial locations prompted feminist scholars to argue that the definition of a refugee is gendered and fails to account for the unique harms that women experience.[40] Since the criteria excluded gender, women's struggle for asylum remains an issue of legal contestation, changing judicial precedents and shifts in executive actions. Over time, the international human rights framework evolved to include women's rights and, in 1985, the UNHCR encouraged recognition that gender-related violence constitutes persecution, and that the particular social group category should include gender-based claims.[41] In 1993, the UNHCR recommended that signa-

tories of the Refugee Convention and/or Protocol develop guidelines acknowledging that women experience persecution differently than men.[42] Musalo explained: "The UNHCR was sending a message to the countries who are parties to the international refugee definition, that they may think there are barriers to protection of women, but really there is a way to understand the refugee definition that includes women. These barriers do not exist and women can be recognized."[43]

As a result, several countries including Canada amended their laws, adding gender as a basis for asylum, but the United States did not.[44] In 1995 the United States responded by issuing guidelines encouraging asylum officers to be sensitive to women's unique trauma and to the cultural issues that might affect their ability to recount events. However, they only applied to asylum officers and are not binding.[45]

Without a statute delineating criteria for gender-based asylum cases, an incremental series of legal decisions and executive actions shapes US asylum law. These emerged in an era when persecutors were defined as governments who punished individuals for their religion, race, nationality, or political views. However, "The world has become a different place, and we live in a different time from that of the post-World War II world. The needs of asylum for women from private abuse and violence have become more globally recognized; yet the asylum law remains the same."[46]

The Refugee Act of 1980 created two paths to permanent humanitarian protection—refugee resettlement and asylum. While the United States can grant refugee status to individuals outside its borders who prove a well-founded fear of persecution, the Refugee Act also states that people on US soil may apply for asylum, regardless of how they entered the country.[47] The Refugee Act requires that asylees prove that they meet the same criteria for protection as refugees. Today, a woman must meet five criteria to receive asylum:

- First, she must prove she has either suffered past harm in her home country or has a reasonable fear of future harm, and that the harm rises to the level of persecution.
- Second, she must prove that she cannot obtain protection in her home country because the government is unable or unwilling to protect her.[48] She must also prove that she cannot relocate to another part of her home country for safety.[49]

- Third, she must prove that she falls into one of the protected groups: race, nationality, religion, political opinion, or particular social group.[50]
- Fourth, she must prove that she suffered or will suffer persecution because of her membership in a protected group, i.e., that there is a "nexus"—a link—between the persecution and the protected ground.[51]
- Fifth, she must prove she is not disqualified by missing the one-year filing deadline or any other bars to asylum.[52]

Even if she proves that she meets all criteria, an immigration judge will also assess the applicant's credibility, meaning that judges exercise latitude in determining whether the applicant is telling the truth.[53]

Asylum applications fall into one of two categories: affirmative or defensive.[54] Affirmative asylum is available for people who are not in deportation proceedings. Although an undocumented migrant can apply, most applicants have temporary status such as a visitor or student visa.[55] In affirmative cases, US Citizenship and Immigration Services (USCIS) asylum officers evaluate applications and conduct interviews.[56] Interviews are meant to be non-adversarial, with the government not represented by a lawyer. Applicants have no right to appointed legal counsel and must bring their own interpreter. We heard different accounts of the affirmative process from lawyers. One attorney argued that an interview before an asylum officer is easier than a courtroom where women face cross-examination by Department of Homeland Security (DHS) lawyers. "It's more like going to the DMV (Department of Motor Vehicles)," he said. Another lawyer said, however, that interviews can last eight hours and cover extremely uncomfortable materials as applicants face repeated questions about the violence propelling their asylum claims. Historically, applicants in the affirmative process are more likely to succeed than defensive applications.[57] As noted by communications scholar Sarah Bishop, there is a "great class bias" in the asylum system, as someone who can afford a plane ticket and a visa can seek affirmative asylum.[58]

The women we interviewed fell on the wrong side of that divide. The Border Patrol apprehended them shortly after crossing the border from Mexico, and they became subject to removal. Even if they sought out Border Patrol officers to ask for asylum, they became subject to deportation, and their asylum claims would be their defense, meaning that

they would have to make a court case against removal.[59] Thus begins the tenuous existence for women seeking asylum, as they face apprehension and the need to defend themselves in defensive asylum proceedings—a process that takes years. While detained, asylum seekers are supposed to be referred to an asylum officer for a credible fear interview to determine whether there exists a "significant possibility" of establishing eligibility for asylum because of persecution.[60] Women who establish a credible fear will face a hearing before an immigration judge.[61]

At least, that is how the system is supposed to work. We spoke to immigration attorneys who told us that their clients never had credible fear interviews at the border. Rather, the Border Patrol detained the women before government officials released them and ordered them to appear in immigration court. In other cases, women are deported without having the opportunity to ask for asylum and receive a credible fear hearing, seemingly in violation of US and international law.[62] A gap exists between law and practice, which may result in additional duress for women fleeing violence. The inability to apply for asylum or a denial and a subsequent deportation could result in death; as noted by Human Rights Watch, 138 Salvadorans deported since 2013 were killed upon their return home.[63]

Immigration Courts

Visible to the public from the National Association of Immigration Judges (NAIJ) website is a slick video arguing the organization's case for immigration court reform.[64] Against the background of images from well-known TV shows and movies, including *Law & Order* and *To Kill a Mockingbird*, NAIJ's president, Judge Ashley Tabaddor, argues: "From the minute we're old enough to watch TV and movies, we develop a mental image of how the US judicial system is supposed to work. On one side is the prosecutor, on the other is a defendant represented by a defense attorney. In the middle is a judge, a neutral arbiter . . . This image is reinforced by what we are taught in school where we are introduced to terms like judicial independence, and we're taught about the separation of powers. Right? Wrong! If you're talking about the immigration courts."[65] As viewers watch Gregory Peck's iconic depiction of Atticus Finch in the background, Tabaddor explains that immigration proceedings are nothing like the courts we see

on screen. "Immigration judges and courts are not in the judicial branch of the government. They are not independent. They are set up in a federal agency: the US Department of Justice."[66] Tabaddor makes a central point: "The US Attorney General, the nation's top prosecutor, heads the immigration courts and supervises the judges."[67] The attorney general may discipline or fire immigration judges, a fact that subjects immigration courts to political influence. They may insert themselves into specific cases, and in the process, switch roles from chief prosecutor to the judge who decides the case, often rewriting the law.[68] In other words, the immigration court system is an entirely different species of court that is highly politicized and defies basic principles of separation of powers and an independent judiciary.[69] Thus, political influence shapes how immigration courts function. The president and the attorney general wield the power to make asylum accessible, and women seeking protection due to domestic or gang violence argue cases in this compromised setting. These realities reflect the idea of compounded marginalization, as outcomes can include deportation to dangerous home countries.

Legal scholar Alison Peck traced the evolution of the immigration court system from the late nineteenth century. When the United States initiated immigration restrictions, federal agents stationed at ports decided who would be admitted, and foreign individuals won the right to appeal decisions.[70] As immigration functions moved from various Cabinet agencies over the course of the next century, immigration courts followed. In violation of the concept of separation of powers, law enforcement tasked with prosecuting violations and immigration judges trying cases remained within the same Cabinet agency.[71] In 1940, the attorney general created the appellate court, the Board of Immigration Appeals (BIA), and gave himself the power to choose its members.[72] He also gave attorneys general the power to refer cases to themselves and thereby set new legal precedent that immigration judges must follow.[73] Attorneys general would later use this authority to overturn key precedents regarding women's ability to apply for asylum for domestic violence and gang violence. In short, presidents and their attorneys general wield more influence to determine asylum outcomes than any other branch of government. "Sitting atop the bureaucracy that manages a massive enforcement regime, the President has considerable capacity to shape immigration policy on the ground according to his worldview,"

and women's place in it.[74] This shifting foundation, subject to a presidential administration's policy agenda, complicates the path to safety.[75]

Zero Tolerance

The women we interviewed fled to the border after surviving rapes, severe assaults, kidnapping, and extortion, often perpetrated by armed men. In this section, we explore how judicial precedents and executive branch policies intersect to inform outcomes for women fleeing severe violence in Central America and Mexico. Since the Refugee Act of 1980 does not list gender as a protected ground, women must generally prove membership in a particular social group—a group with well-defined and visible boundaries, that is socially distinct in the home country. For years, "women" or "women who are abused by their partners" were not accepted by the courts as particular social groups. The challenges of defining the particular social group combined with the fact they were not fleeing government-sponsored violence posed barriers for women. In this section, we trace evolving judicial decisions for women asylum seekers who often must rely on inclusion in a particular social group to win a gang- or gender-based claim, prompting one legal scholar to argue that group membership "remains an especially complicated legal ground."[76]

In 1995, Fauziya Kassindja, a woman from Togo fleeing female genital mutilation (FGM), successfully argued that "young women of the Tchamba-Kunsuntu tribe who have not had FGM, as practiced by that tribe, and who oppose the practice" constituted a particular social group. She won asylum.[77] This precedent would prove salient for female asylum seekers because it established that persecutors could be private actors, and gender could be one element of a particular social group.[78] Since then, several other cases have assisted female asylum seekers in establishing particular social group membership. Over time, as detailed below, case law evolved to define a particular social group and other elements of asylum criteria as they apply to survivors of so-called private violence. This history also illustrates a president's impact on asylum policy, and how partisan preferences lead to uncertainty. Beginning in 1995 with the Clinton administration, a string of decisions in the *Matter of R-A-* (Rodi Alvarado) proved consequential for women who survived domestic and gang violence.[79] Rodi Alvarado Peña fled Guatemala after

her husband used her head to break windows and mirrors, whipped her with a pistol and electrical cords, and dragged her by the hair.[80] She went to the Guatemalan police and courts, only to learn that they would not intervene in domestic violence cases. After fleeing to the United States, she applied for asylum. She provided graphic details of the abuse during her hearing before an immigration judge.[81] The judge granted asylum, stating that, "Guatemalan women who have been involved intimately with Guatemalan male companions who believe that women are to live under male domination" qualified as a particular social group with immutable characteristics.[82] The question of immutable characteristics—meaning those that one cannot change—is a key criterion for winning an asylum case. The judge found that her abuse rose to the level of persecution, and that the Guatemalan government failed to intervene.[83] The former Immigration and Naturalization Service (INS) disagreed, however, and appealed the decision to the BIA (The INS ceased to exist in March 2003, when most of its functions were moved to the newly created Department of Homeland Security).

In its appeal, INS argued that Alvarado was not part of a particular social group and that the violence she endured was not political in nature.[84] In June 1999 the same BIA that granted asylum to Kassindja agreed with the INS, overturned the judge's decision, and ordered Alvarado into deportation proceedings.[85] Legal scholar Musalo argued: "Maybe what's different is that Togo is further away than Guatemala, and female genital cutting looks exotic to people in the US. Domestic violence as a basis for asylum for somebody coming from Central America raises the fear of opening the floodgates. It is important to note that there have always been discriminatory practices against asylum claims from Central America, which are all too much on the resurgence now. So, the BIA reversed the grant of asylum to Rodi Alvarado."[86]

Alvarado's lawyers appealed the decision, but it would take ten more years to resolve the case. On January 19, 2001, during her last day in office, Attorney General Janet Reno reversed the BIA decision in *Matter of R-A-*.[87] Reno remanded the case to the BIA for reconsideration, stipulating that new regulations should be adopted to support assessment of asylum claims for domestic violence applicants.[88] However, the regulations, to this day, have never been finalized. No clear guidance exists delineating how to treat victims of gender-based violence.

President George W. Bush took office and tilted the scales against Alvarado. Attorney General John Ashcroft referred the *Matter of R-A-* to himself, but the newly created DHS filed a brief supporting Alvarado's asylum claim. Ashcroft remanded the case back to the BIA, again with the understanding that regulations on asylum claims for domestic violence would be finalized before the BIA took action.[89] Once again, regulations never came. In 2008, Attorney General Michael Mukasey ordered the BIA to rule on the case regardless of the regulations' status. The BIA, however, declined to issue a precedent-setting decision and remanded the case back to the immigration judge.[90]

The Obama administration promised to issue guidelines for gender-based asylum, raising hopes that domestic violence would be recognized. But again, those regulations never came. The Obama administration did take steps to provide protection to women fleeing "private violence." In 2009, the Obama administration argued that women in domestic relationships or women viewed as property in their domestic relationship could be a particular social group.[91] One case was the *Matter of L-R-*, a Mexican woman who suffered rape and abuse at the hands of her common-law husband.[92] The Bush administration had denied her initial application, and she had appealed to the BIA, where DHS opposed asylum, arguing that the Mexican woman had not met the particular social group criterion. But in 2009, Obama's DHS argued that women who cannot escape severe physical or sexual abuse may constitute a particular social group and that her abuse could be considered persecution.[93] DHS suggested the case be remanded to the immigration courts, and finally supported her asylum. That led to L-R- receiving asylum in 2010, again through a non-precedential decision issued by an immigration judge.[94]

In the meantime, the BIA sent *Matter of R-A-* to a new immigration judge who once again took up Alvarado's asylum case. This time, DHS did not oppose asylum. The judge granted Rodi Alvarado asylum—her second victory at this level. Legally, however, her case failed to resolve concerns for other domestic violence survivors; because the decision came from an immigration judge rather than the BIA, it did not set precedent.[95] Uncertainty for women asylum applicants remained.

In 2014, the BIA issued a precedent-setting decision in the *Matter of A-R-C-G-*, establishing the circumstances under which survivors of

domestic violence may be eligible for asylum.[96] A-R-C-G-, a Guatemalan woman whose husband broke her nose, raped her, and scalded her with paint thinner, received no assistance from Guatemalan police, who refused to investigate a domestic matter.[97] She entered the United States and applied for asylum. An immigration judge denied asylum because he believed that while her abuse constituted persecution, it did not occur because of her gender-based social group (i.e., she failed to establish a nexus between persecution and a protected ground).[98] She appealed her case to the BIA, which determined that "married women in Guatemala who are unable to leave their relationship" constituted a particular social group. Such women carry the immutable characteristic of gender, the court ruled.[99] The BIA also concluded that the group is socially distinct because Guatemala has a culture of machismo and family violence.[100] Critical here is the BIA's conceptualization of Guatemala based on culture rather than the structural conditions—endemic poverty, a paucity of jobs, and the failure of the state to pursue crimes against women—that we explore in the next two chapters. The BIA's decision in *Matter of A-R-C-G-* confirmed that domestic violence could be grounds for asylum, but as noted by Blaine Bookey, considerable uncertainty still informed asylum cases because they hinge on crimes committed by non-state actors.[101] "Cases involving so-called nonstate actors introduce an additional level of complexity to the asylum analysis, as establishing official unwillingness to control a prosecutor, or government inaction, is often significantly more analytically and evidentiarily challenging than proving government action."[102]

Legal scholar Bookey studied asylum outcomes for women in cases adjudicated between 1994 and 2012, concluding that many women were being returned to countries where they faced persecution and death.[103] Bookey and feminist legal advocates once hoped that the BIA's 2014 decision in *Matter of A-R-C-G-* would proffer sufficient protection. Unfortunately, Bookey concluded in the year following that decision, "Arbitrary and inconsistent outcomes have continued to characterize asylum adjudication in this area of the law."[104] Inconsistency and uncertainty would continue into the Trump and Biden presidencies.

"Private Violence": The Trump Era

Former President Donald J. Trump issued more than four hundred executive actions that dismantled protections for asylum seekers, using his executive powers to place new restrictions on asylum.[105] As one legal scholar described it, "The inauguration of Donald J. Trump heralded in an era of anti-immigrant sentiment and actions specifically focused on making seeking asylum more difficult. The sweeping changes to the asylum system, combined with regulatory changes at the granular level, cannot be overstated."[106] The attorney general's referral power became a favorite tool of the Trump administration.[107]

In June 2018, Attorney General Jeff Sessions self-referred two cases (one being *Matter of A-R-C-G-*) so that he could reverse precedent and deny survivors of domestic and gang violence asylum.[108] Sessions ruled that asylum claims based on domestic or gang violence would not qualify as they are not the product of state actors.[109] "The asylum statute does not provide redress for all misfortune," Sessions argued.[110] His decision affected many asylum standards that women had adopted to win cases. For example, he argued that "married women in Guatemala who are unable to leave their relationship" is not a particular social group because it's a product of "private criminal activity."[111] Sessions stated that women should be able to relocate within their own country and stipulated that applicants must prove that internal relocation is not possible.[112] Finally, Sessions argued that asylum is discretionary, and even when a woman proves eligibility, judges should consider other factors such as whether she could apply elsewhere.[113] Further, the Trump administration ruled that "private violence," even if widespread in one's country, is not sufficient grounds for asylum.[114] Subsequent self-referrals of lower court asylum decisions by Trump's Attorneys General consolidated the administration's stance on female asylum seekers. One case decided by Attorney General Barr stressed the distinction between private violence and persecution, finding that "victims of private violence, including domestic violence, will not usually satisfy the requirements for asylum."[115] The scope of these decisions left immigration lawyers distraught. One told us:

> If you read [the decisions], particularly the Sessions decisions, it was like, wait. Hold on a second. You're using this case to overturn *Mat-*

ter of A-R-C-G- and *Matter of A-B-*, and you're saying in general, those fleeing gender and gang related violence won't be eligible for asylum. There's nothing about gangs in this case, right? It's just that you're lumping all of these cases together, and you would like to put up barriers to prevent this whole group of people from coming in and gaining access to protection.[116]

Through these decisions, the administration told immigration judges that most survivors of private violence did not merit protection. Consequently, attorneys had to operate within narrow parameters and find ways to present their clients' cases so that they might win asylum. As one attorney explained:

> Before Trump we had a slice of gender-based asylum law in *[Matter of] A-R-C-G-*. I can only imagine how many lives it saved . . . When Trump took *A-R-C-G-* away, we were now on a sinking ship without any kind of life preserver, lifeboat, anything. With *A-R-C-G-* we had a lifeboat and a life preserver. We just had to figure out how to get our client into the lifeboat . . . It was never easy, but it was possible, and we were winning. Then we lost *A-R-C-G-* and everything went to shit . . . It was heart wrenching to be like, "Yeah, your husband raped you every day for ten years, there's nothing we can do about that."

The Trump administration used a combination of regulations, internal memos and guidance, and executive orders to shape asylum policy.[117] The lengthy list of Trump-era restrictions included:

- A policy whereby Customs and Border Protection officials limited the number of asylum seekers it processed daily.[118]
- The Migrant Protection Protocols that required asylum seekers to remain in Mexico while they waited for their asylum hearing, forcing thousands to wait in dangerous conditions and impeding their ability to retain counsel.[119] Asylum seekers waited for months in squalid camps, unable to enter the United States. More than 40,000 asylum seekers were ordered deported in absentia because they were unable to attend their immigration court hearings.[120]

- A ban on asylum eligibility to anyone who entered the United States at the Southern border after traveling through at least one other country without first applying for asylum there.[121]
- Rejections of applications for petty issues: writing in pen rather than pencil, using a dash rather than a hyphen, or failing to include None or N/A on a line that was intentionally left blank. These rejections meant that asylum seekers had to resubmit their applications, delaying the process by months, and leaving them without work authorization or a hearing date.
- Use of Title 42 of the Public Health Act to close the Southern border to all migrants due to COVID-19, including asylum seekers.[122]

The list above does not include all Trump-era initiatives to undermine asylum.[123] As one scholar said, "This vilification of asylum seekers combined with xenophobic rhetoric led to policy after policy targeting the US asylum system."[124] Statistics from this period show how much influence Trump wielded on the system. In 2018, for example, 65 percent of asylum cases were denied compared to 42 percent six years prior.[125] As is consistent with the concept of legal violence, such executive actions are not focused on the behavior of individuals, but legally and socially exclude a class of people based on characteristics ranging from gender to language to physical appearance.[126]

The Biden Era

President Biden declined to make immigration a campaign centerpiece, but with large numbers of asylum seekers at the Southern border, it continued to be an issue. Biden overturned several of Trump's most draconian policies but nonetheless worked to restrict asylum access. Within days of assuming office, Biden ended the Migrant Protection Protocols, a decision ultimately upheld by the US Supreme Court. In early 2021, Attorney General Merrick Garland vacated the Sessions' decisions on gang and domestic violence that we discussed above.[127] Biden also signed an executive order requiring DHS and DOJ to propose new regulations for women fleeing domestic or gang violence, but there remains no clear guidance on how to adjudicate gender-based asylum claims.[128] Lawyers we spoke to still hope for clear regulations,

first promised decades ago, that would provide instruction on how to prove membership in a particular social group and meet the asylum criteria. One lawyer said, "I think that the regulation would go a long way towards having more uniform decision making," adding that changes to asylum law to address gender would provide clarity.[129]

Not all Biden imperatives favor asylum seekers. Restricted access at the Southern border remains a Biden imperative. Biden's continuation of Title 42 until May 2023 meant that thousands of would-be asylum seekers from Central America couldn't ask for asylum at the Mexican/US border.[130] And proposed new regulations make accessing asylum still more daunting. In February 2023, the president proposed barring migrants who traveled through other countries from seeking asylum unless they can prove that they sought asylum elsewhere first.[131] That point is critical because women from Honduras, Guatemala, and El Salvador travel through Mexico to reach the United States. The proposed regulations also create a fast-track process at the border that allows USCIS asylum officers to decide cases within sixty days. However, the pilot program has resulted in very few asylum grants.[132] Another Biden policy requires asylum seekers to schedule an appointment on a smartphone app before arriving at the border. However, the number of requests is far greater than the number of appointments available, and the system disadvantages women whose abusers may control access to phones.[133] The facial recognition technology also fails to register individuals with dark skin tones.[134] As of January 2024, the Biden administration appears poised to place additional obstacles for asylum seekers in order to reach a deal with Congressional Republicans on aid to the Ukraine and Israel.[135]

Even policy changes intended to reduce deportations and ease Trump-era policies have unintended effects. A Biden administration memorandum to DHS in March 2022 created an immediate impact for many cases we witnessed.[136] Given the 2.1 million immigration cases on the courts' dockets nationwide, Biden ordered DHS to use its prosecutorial discretion to determine whether the agency would pursue deportation against nonpriority removal cases, including asylum.[137] Just as the police do not stop every driver who exceeds the speed limit, and the Internal Revenue Service selects whom to audit, DHS makes decisions

about whom to prioritize for removal.[138] In practice, the Biden prosecutorial discretion policy allows DHS to drop removal proceedings against asylum seekers who haven't committed a crime.[139]

We witnessed how prosecutorial discretion unfolded in asylum hearings. The government offered to drop the women's removal cases, allowing them to maintain work authorization because the asylum application is still open. In these cases, women do not face deportation, but do not have asylum. Some women expressed reservations about halting asylum claims but were encouraged by cautious attorneys to accept the government's offer. For example, a Salvadoran woman who sought asylum after the MS-13 gang killed her uncle and threatened to kill her ex-husband, took the government's offer to dismiss her case. Her attorney argued that she could still apply for asylum through the affirmative process. Although continuing her case meant more legal fees, her attorney argued that it was simply safer not to proceed with an asylum hearing before a judge.

In other cases, women decided not to accept the motion to dismiss and moved forward, pleading their cases before immigration judges. Two women, an adult daughter and her mother, did so against the advice of counsel and won. Because of COVID-19, the woman and her mother appeared with counsel on a TV monitor before a judge who worked in her courtroom. Aside from the TV screen, the trappings of court were familiar: The female judge appeared to be in her forties and wore stylish blue glasses with her black robe. The DHS counsel appeared in the courtroom as well, a man in his thirties dressed in suit and tie. Both women, two Latinas dressed in button-down blouses with their hair pulled back, looked grim as the hearing began. When the judge announced that she was granting asylum, both women wept and hugged. Winning asylum meant relief from deportation as well as the promise of legal permanent residency ("green card") and an eventual path to citizenship.

Finally, one asylum seeker chose to pursue her case, but the judge refused to deliberate it. The attorney and her client appeared vexed by the judge's refusal to hear the case. The judge, the DHS attorney and a Spanish language interpreter were present on the TV screen, while the asylum seeker and her attorney appeared in person. The judge was an

older, balding white man who wore black glasses. Below is an ethnographic account of how the case unfolded in court:

The judge notes that this case has been pending since 2017.

IMMIGRATION ATTORNEY: We would like to move forward based on the specifics of the case and based on the fact that she qualifies for asylum.
JUDGE: The government has asked the court to dismiss the proceedings without prejudice . . .

The judge then proceeds to read the relevant legal document, which appears to be the Biden initiative to stop removal proceedings for cases with no extenuating circumstances, such as an asylum seeker who has committed a crime. The judge tells the asylum seeker and her attorney that he's willing to listen to any argument that they're willing to make. He says,

JUDGE: Being in removal proceedings as you are today . . . It seems unlikely on its face that this action is prejudicial or in any way unfair . . . I'm confident that your attorney will advise you of any rights that you may have . . . I want to make it clear that you are in removal proceedings . . . And are subject to removal proceedings in the United States . . . If I were to accept the government's recommendation, the removal would be lifted.

The attorney for the asylum seeker argues that the government could, at a later date, reinitiate removal proceedings without a grant of asylum.

JUDGE: You wouldn't be in any different situation than you are in today.

The judge granted the asylum seeker and her lawyer ten minutes to step outside and discuss the government's offer. When they returned, the attorney informed the judge they wanted to move forward with the asylum case. The judge responded, "That's not really an option." Thus, on that day, after a five-year wait, the woman would not be granted asylum—or even a hearing to determine whether she met the legal threshold for it. Following the hearing, the attorney explained the consequences

of the judge's actions. "She will have to wait for years with no relief for affirmative asylum," she said, adding that the process to continue with affirmative asylum is lengthy and it requires money. "You're constantly having to pay an attorney," the lawyer said. "She is still undocumented. She will have a work permit that she must renew every two years at a cost of $410. A few years ago, an asylum seeker who applied for working papers could get them in three months but now it's taking about six months," said the lawyer. "And there's problems with employers who don't understand the law. We have to write letters to them explaining they can work legally because they don't understand." Another attorney noted that work permit renewals now face a fourteen-month backlog. Biden's prosecutorial discretion means that some asylum seekers we interviewed may not be forced to make their case for asylum as a defense against deportation. But it also means accepting many more years of uncertainty, as well as fear that they could be identified, arrested, and put into removal proceedings again in the future. Without the security of asylum, their fear of future persecution if they return to their home country remains a possibility.

Conclusion

Legal scholars argue that Western nations built refugee and asylum laws on the understanding that state actors perpetrate persecution in the public sphere, leaving individuals harmed by non-state actors in the private sphere with fluctuating legal guidance.[140] Gender-specific crimes and persecution, such as rape, have been "private" or "cultural," and not political, and do not fit well within the categories. In treating these crimes as private or cultural, the US asylum system fails to fully acknowledge the gendered realities of persecution by non-state actors, thus leaving women subject to severe forms of violence, including rape. This fact characterizes one facet of the space of compounded marginalization: Without new laws or clear guidance opening the door for more approvals of gender-based asylum claims, women from Central America and Mexico who flee violence face more legal challenges in court.

As detailed above, the asylum system could be characterized as volatile, subject to shifting standards according to legal precedent and the imperatives of the Oval Office. As Bishop wrote: "Asylum practice

changes frequently and without public warning, and complex, intersecting variables mean even applicants arriving around the same time from the same nation can experience different outcomes. Factors including the kind of persecution an applicant faced, where they entered the United States, the personal whims of the Border Patrol agents they encountered and the political landscape at the time of their entry will impact what comes next."[141]

Even women with extremely sympathetic and well-documented cases face difficulty navigating the asylum system. Central to the problem is the fact that US asylum laws are complicated when it comes to violence by non-state actors. As noted above, individuals can seek asylum in the United States if they can prove a well-founded fear of persecution in their home country because of race, nationality, religion, political opinion, or membership in a particular social group and that the government is unable or unwilling to protect them. Gender is not referenced in this definition, but through legal battles and advocacy, some survivors of gender-based injury have won asylum and made the case that their gender is an immutable characteristic that renders them a member of a particular social group.[142] Congress has been unable or unwilling to pass new laws that recognize the shortcomings of a law that was passed forty years ago and create new legislation meeting this century's concerns. Instead, women are subject to the decisions of individual immigration judges, changing interpretations of the law, and decisions made by politicians focused on appealing to their constituencies and winning elections rather than humane and effective policymaking. Critically, as noted by Fitzgerald, asylum globally exists not to protect large numbers of people from the global south who need protection in western nations.[143] Instead, the asylum system seeks to sort a limited population that must run a legal gauntlet—if they can cross the border or survive a perilous marine crossing—to prove they are worthy of protection.[144]

2

"Women Who Are Alone Suffer"

Colel grew up in a crowded household that included her siblings and cousins, all indigenous Guatemalans. Her grandparents raised her after her parents migrated to the United States to escape subsistence farming and to send remittances home and support their children. Colel's grandparents safeguarded her, limiting outings to school and to the fields where they worked. "People mistreat indigenous people. They will take children away. My grandparents wanted to protect us," she said. The term "they" merits consideration as it references the genocide of indigenous Mayans during the thirty-four-year Guatemalan civil war, a period of widespread disappearances and mass murders by Guatemala's right-wing forces.[1] Colel grew up speaking both her indigenous language and Spanish. Her education ended with the sixth grade, as her family could no longer fund her education.

At age twenty, Colel worked with her baby strapped to her back to harvest crops for family meals. One day while taking the long walk to the fields, five men ambushed her. One grabbed her baby daughter while two forced her to keep walking. Eventually, two held her down while the other two took turns raping her. The fifth held her child. When they finished with her, they warned that if she reported them, they would find her, kidnap her, and kill her baby. When she returned home, her grandfather urged her to report the crime, but Colel refused, fearing retaliation. Finally, her grandfather went to the police himself. The officers knew of these men and their attacks on women. They told him they would not intervene as they themselves feared these men who had murdered one indigenous woman and "disappeared" another. One month later, Colel's grandfather received a note demanding money. Believing the note came from the same men who assaulted her, Colel made the decision to flee to safety in the United States. "I realized I had to come here to save my daughter," she said. We tell Colel's story because it illustrates the terror driving gender-based asylum claims. Strangers perpetrated

her sexual assault and threats to her baby's life, violence subsequently met with willful neglect by law enforcement.

Women described extortion, rape, kidnapping, and death threats, among other crimes perpetrated by gangs. Gangs, and their attendant violence, are pervasive throughout parts of Mexico and Central America. To contextualize gang violence and to understand why it now serves as a driving force for asylum claims, we examine the political and economic factors that lure young men into organizations that perpetrate such serious crimes. For American audiences, descriptions of gang members readily tap into racialized images invoked by politicians and the entertainment industry in television shows such as *Narcos* and *Breaking Bad*—that of the tattooed Latino 'thug' who deals drugs.[2] These narratives and Hollywood depictions, however, fail to acknowledge the social conditions that lure young men into gangs and abet violence.

In this chapter, we frame gang violence through the social spatial factors perpetuating it: (1) the ascension of neoliberal economic policies undermining hope for alleviation of long entrenched poverty;[3] (2) state failures to ensure that women have equal access to rights and justice;[4] and (3) distrust of law enforcement, including the knowledge that police are involved in gang crime and/or fail to protect crime victims.[5] Throughout this chapter and the next, we underscore the mutual reinforcement of male domination in patriarchal societies and gender-based violence. The structural factors we describe include a lack of economic opportunity and police failure to vigorously enforce laws against gender-based violence, reinforcing the symbolic violence that negates women. As one scholar notes, "Violence against women is a relic of male dominance, legitimized by government policy or government inaction."[6] In this way the victimization of women and girls permeates social space. In this chapter and the next, we also note the legacies of war, dictatorship, and militarized societies in perpetuating the conditions for violent crime against women.

No single factor accounts for the complex interplay of gang recruitment and membership, their criminal activities, and the gender-based violence they routinely perpetrate. Rather, a constellation of reinforcing factors is to blame for the experiences described by the women we interviewed. "Private violence" is never only private. Instead, as we detail, social conditions cultivate the extreme forms of violence that necessitate asylum claims.

In this chapter, we examine the gender-based violence perpetrated by gangs or male strangers that propel women's flight to safety, their migration journey, and applications for asylum. By interrogating the forces contributing to these phenomena, we seek to contextualize why women are targeted for violent crime in Mexico and Central America.

As we explain, women are uniquely vulnerable to gang violence as members often use rape as a weapon of domination. Additionally, gang members force women and girls to be their "girlfriends," making them complicit either by committing crimes themselves or covering for gang members.[7] Some women join gangs but hold positions low in their hierarchical structures.[8] Women's roles as mothers and primary care givers bring additional vulnerabilities as gangs target their children for recruitment and threaten women who attempt to prevent their children from joining. Gangs target female business owners for extortion and punish them for refusal to pay, contributing to women's economic disempowerment. We heard repeatedly from women we interviewed of their susceptibility to harm. As women living in a society characterized by few economic opportunities or protection from violence, chances for escape are virtually non-existent. This is especially the case for single mothers as they lacked a male partner to protect them and believed the police could not be trusted to intervene.

Ariana's story illustrates these troubles. At her asylum hearing, she testified that she owned several apartments where gang members charged her *la renta* (extortion money) on her income. Seeking financial freedom from extortion, she sold the apartments and moved to another town. Unfortunately, the gang found her and demanded continuing payments. One time, gang members arrived at the restaurant, put a pistol to her head, and demanded cash. Another time they came, grabbed her hair, threw her to the ground, and beat her. They wanted her children to become gang members as repayment for what she "owed" them. "Once the kids were on a soccer field and men arrived and talked to them," she said. "I stopped letting them leave the house. The gang got angrier and pursued them and sent messages. If I didn't pay the money or let the kids join the gang, they would kill us."

During an asylum hearing that we observed, her attorney asked her, "How did the gangs call you? Did they have your number?" She replied, "They always get information. I don't know how." She testified that she

contacted the police several times after these incidents, but they only came once. "I went to the police to file a report. They (gang members) were in jail for three days. That's how it is in my country; they detain them a few days and they leave jail even angrier." In her asylum application, the particular social group she claimed membership in for protection was "single mother living under control of gangs." Another woman, Mercedes, testified in her asylum hearing that she opened a small business selling candy to support herself and her children. In my country, she said, single mothers suffer. "We were treated as less," she said. Mercedes described women as feeling humiliated and discriminated against after their husbands left, as well as suffering vulnerability because they no longer had a male partner. Mercedes stated many of the married women she knew believed that as a single woman, "We are going to take their husbands." Gangs made single women living without men easy targets. Mercedes recalled the day gang members entered her home, threw her on the bed, tied her hands behind her back and ransacked the house searching for money. Terrified, she eventually disclosed where she hid some cash. As they demanded to know why she delayed giving them money, she explained that as a single mother she needed it for her children. Enraged gang members ordered her to leave the country within three days, admonishing her that they would kill her and her children if she stayed or went to the police. In response to a question about why the gang targeted her, she replied, "I was the only one. I had a business. I was alone. Women who are alone suffer." She also testified to the difficulty single women have when relocating to other parts of the country to seek safety.

For our analysis of gender-based violence, we turn to feminist interpretations of sociology, anthropology, and critical geography to examine how states and extralegal actors shape space, in a context in which capital seeks to dominate space to abet production and profit.[9] We focus specifically on structural and symbolic violence as drivers of the brutality that forces women to seek asylum. As discussed by Cecilia Menjívar in her seminal study of Guatemalan women, multiple forms of subtle violence create the conditions for extreme violence that compel the need for asylum.[10] These less visible but consequential forms of violence include both the symbolic and structural violence that present themselves as routine and unremarkable.[11] Using the framework initially developed

by Menjívar in her analysis, we turn to Pierre Bourdieu to consider how various forms of violence accumulate in the lives of women.[12] One's position in space is defined not only by income, occupation, and education level, but by other characteristics that are never socially neutral, including gender. Gender- and class-based disadvantage intersect to inform women's subjugation.[13]

Bourdieu described symbolic violence as "a gentle violence, imperceptible and invisible even to its victims, exerted for the most part through the purely symbolic channels of communication and cognition (more precisely misrecognition), recognition, or even feeling."[14] For women, symbolic violence may include messaging that they must dress a certain way to avoid unwanted attention from men and should police themselves to avoid invoking gender-based aggression.[15] Symbolic violence can rob women of voice and agency through messages about socially necessary passivity and deference to men.[16] The invisibility described by Bourdieu originates via social hierarchies and domination that come to be perceived even by those disadvantaged by them as immutable and natural.[17] For the women whose experiences we detail, symbolic violence is not gentle; it is coercive, a product of patriarchy in both the public realm of work and community and in the private sphere of the home, as it informs gendered norms such as expectations for household duties and to serve men.[18] In our work, we heard of this symbolic violence and gendered expectations in Mercedes's story as she described the distrust and suspicion some women experienced as single, when others thought they might encroach upon their husbands. In chapter 5, we describe the childhood experiences of a Guatemalan woman we call Mabela who grew up being ridiculed by adults who said that her mother abandoned her so that she could pursue men, shaming her for her mother's alleged promiscuity. A lesbian woman suffered rapes by multiple gang members who targeted her for her sexuality, punishing her for deviating from gendered power relations in which women are expected to seek men sexually. Symbolic violence—beliefs about how they should be positioned in families as well as how they should express their sexuality—inform women's experiences and arise from asymmetries in power that we describe below.

Women's circumstances and decisions to flee their homes must be understood as a product of the social world around them, a set of social

relations that includes not just economic subjugation but the sustained symbolic negation of women.[19] In this conceptualization, the social space of the women who are the focus of this book is imbued with objective economic realities—forms of structural violence—including access to education and work. Structural violence encompasses unenforced laws against gender-based crime, a lack of social services, inability to access jobs that pay well enough to move away from violent neighborhoods, and inadequate police protection, all reinforcing disadvantage in private spaces including their own.[20] This underlying structural and symbolic violence then undergirds the conditions for the brutal, physical violence perpetuated against women and an associated lack of protection and safety, resulting in women fleeing for their lives. It is within this framework that abandoning all that one knows—the home, community, and family—in favor of a perilous struggle for asylum, comes to be seen as the only tenable option for safety.

Humble Backgrounds

The women we interviewed came from humble backgrounds, as evidenced by their frequent use of the word *humilde* (humble) to describe their origins. While three women pursued university educations, most had to leave school, some as early as first grade, to either help support their families or because parents or grandparents could no longer afford school costs. The women interviewed worked in one of four sectors: (1) small individual or family-run businesses such as roadside food stands; (2) agriculture, an occupation described as *campesino* (peasant farmer); (3) manufacturing for export and/or customer service for US companies; (4) non-waged labor as a homemaker. The lack of educational opportunity, coupled with a paucity of jobs that might provide an opportunity to reside in neighborhoods less vulnerable to crime, ultimately changed the life trajectory for women. These factors further compromised women's agency as gang violence impinged on their ability to earn a living, walk or socialize in public space, and left them exposed to gender-based injury including rape. It is critical in describing these exigencies to acknowledge the factors informing this violence.

Scarcity remained a fact of life as the economic policies and processes of neoliberal capitalism sustained poverty and income inequality. Juan-

ita, a Salvadoran, recalled that her mother was forced to leave her own children in their small village to work in San Salvador caring for others' children. Her father had abandoned them, and her grandmother raised her while her grandfather worked as a *campesino*. By the time her half-brother turned twelve, rumors circulated in their village that he had joined the MS-13 gang. Juanita had a baby at age fourteen, and the father wanted nothing to do with her or their child. She struggled to complete ninth grade, working in the fields harvesting corn and beans early in the morning before class. Later in the day after school, she cooked pupusas to sell at a roadside stand.

Another Salvadoran woman, Maria, described how her family, including two parents and five siblings, raised pigs and sold the bread her mother baked daily. "I was only able to go through school to the second grade because my mother needed me to go retrieve the water since we didn't have plumbing," she said. Her family experienced hunger when her mother became ill with cancer as they had no health insurance and all available cash paid for her mother's medical care. "We suffered because we had nothing to eat. I would cook tortillas because that's what we had. Sometimes there were just eggs when my father was able to get eggs," she said.

Gabriela, a Honduran, grew up with seven siblings on land where her parents cultivated coffee and vegetables both to feed the family and to sell. Her parents stressed the importance of education so, in ninth grade, her parents forced her to relocate on her own to another town as there was no high school in her pueblo. She supported herself stocking shelves in a supermarket and waiting tables at a restaurant. Felicia, another Honduran, described how she, her mother, and a younger sister survived a stretch of homelessness before her mother could buy a small house: a single room with a kitchen and bathroom. Felicia helped her mother cultivate papaya trees while her younger sister stayed indoors preparing food and doing laundry. Both left school in seventh grade to work and support themselves. Lucita, a Honduran woman, held a job in a workshop with a half dozen family members making wooden toys for export. She painted the finishing decorations on the toys. In short, as we describe below, the jobs available to both women and men provide meager wages and subsistence.

Most Salvadorans do not have an opportunity to attend school beyond sixth grade, and almost 25 percent of Salvadoran youth ages 15–24

are unemployed, or not enrolled in school or vocational training.[21] Almost half of Hondurans live below that country's poverty line, with dire conditions in rural Honduras, where nearly 37 percent experience hunger and are characterized as living in extreme poverty.[22] A Guatemalan national survey found 59 percent living in poverty in 2014, with a rate of 79 percent for its indigenous population.[23] In Mexico, the poverty rate was expected to reach 43.9 percent in 2020.[24] Young people's distress can be exacerbated when parental emigration to the United States to support children with remittances forces families apart.[25] Poverty and social disorganization lead young men into gang violence, with disastrous consequences for women who suffer their violence. "The gender-based violence (GBV) that many women suffer at home, in the workplace, in the community and in their relations with the state, violence that is intrinsically linked to deeply entrenched gender inequality and discrimination, economic disempowerment, and aggressive or machismo masculinity."[26]

We can't engage this discussion adequately without addressing the question of individual agency on the part of the men we describe—men who brutalized women to the point that they left families and communities to seek safety in the United States. Certainly, men have choices other than to rape and beat women, or to threaten them at gun point, and many men in Central America and Mexico decline to join gangs or to brutalize women in their domestic partnerships; indeed, men are also presently seeking asylum in the United States because of extortion and other forms of extreme violence perpetrated by gangs. Our discussion of factors precipitating violence calls attention to the social and political contexts shaping the aggressive masculinity noted above as it echoes the robust sociological cannon documenting how social forces shape individual choice.[27] We argue that men might have avoided falling into this aberrant behavior, or faced consequences for it, if the systemic problems that shaped their lives and choices hadn't been in place. In addition, we note patterns of gang conscription that diminish agency for young men, as death is typically the penalty for failure to join, and corrupt police serve as enforcers, as well as engaging and abetting gang extortion schemes.[28] As gang control of neighborhoods has solidified, efforts to recruit children include approaching boys as young as age nine.[29]

Such violence arises from despair. Although the full consequences of civil wars and military coups that we explore briefly in the next chapter

are beyond the scope of this book, we note the description proffered by Deborah Levenson in her study of Guatemalan gangs: In the 1980s, during the civil war, poor and working-class gang members limited themselves to petty crimes against the wealthy, stealing handbags or wallets and using the proceeds to buy consumer goods for themselves and their families.[30] Class solidarity emerged in interviews as young gang members described confining themselves to targeting wealthy tourists or members of the bourgeoise as they rode public transportation and visited Antigua. By 2000, the civil war had ended but hoped-for reforms failed to materialize, leaving in their wake alienated, disenfranchised youth. Lost hope bred social disorganization. "A way of knowing the world and acting within it had been shattered."[31] The class solidarity that once abetted social cohesion and confined crime to petty theft gave way to intense violence as young men grouped themselves in secretive, rival gangs whose raison d'être became the annihilation of their rivals.[32]

For women living in Central America and Mexico, the lack of educational opportunity, coupled with a paucity of jobs that might provide an opportunity to reside in neighborhoods less vulnerable to crime, combine with other social spatial factors to leave them susceptible to gang violence. Not only did women lack the economic resources affording them the ability to move away from areas pervaded by gang violence, they also didn't have protective systems, including gender-specific social support services and responsive law enforcement that might have provided some protection and relief from harm. For many women, their only recourse was to remain inside their home, venturing out only for the most essential errands. This shelter in place strategy arguably contributes to women's oppression, as it limits their ability to fully engage in public life, thus depriving them of access to social networks and jobs in public venues which remain dominated by men. In some *colonias*, gang members serve as sentries, monitoring who enters and leaves public areas. Demands for *la renta* emerged as common experiences, particularly for women who operated small businesses either as sole owners or with family members.

Neoliberal policies ascendant in Mexico and Central America during the last century exacerbate the disadvantages described by the women we interviewed.[33] We use David Harvey's definition of neoliberalism in this conceptualization: political and economic practices that embrace

unfettered trade, privatization, a minimal welfare state, and few market regulations.[34] Critical geographer Doreen Massey notes that the global south, which includes Mexico and Central America, has adopted such policies, leading to a prioritization of production for export over consumption by those who produce food and other resources.[35] "Who ends up poor is not an accident; it is the outcome of deliberate policy decisions that cause and perpetuate social and economic exclusion."[36] An analysis of neoliberalism in Mexico noted that the push for global competitiveness coupled with downsizing of the state led to reductions in subsidies for both industry and agriculture.[37] When women have asylum hearings, Department of Homeland Security (DHS) attorneys ask whether they could relocate in their home country to escape violence. We heard women repeatedly argue that police protection is offered only to the wealthy, or that they could never afford to live in a walled community that protects the affluent from violence. Deeply entrenched poverty existed prior to neoliberalism, but a framing that covers the full spectrum of these issues—colonialism, agrarian economies, food chains contaminated by pesticides, wealth and land concentrated in the hands of the wealthiest—is beyond the scope of this analysis.

Paul Farmer conceptualizes structural violence as those social and economic policies that place vulnerable actors in harm's way, thus causing injuries such as disease and poverty.[38] State and structural violence converge and become mutually reinforcing, including in cases in which the state uses its security forces to quell unrest, or when extralegal actors such as gangs capitalize on the vulnerability of communities where they operate. High rates of poverty, inequality, social exclusion, and alienation spur criminal violence, with the state responding almost predictably by implementing repressive policies to both legitimate themselves and serve the interests of elites as neoliberal adjustment projects leave large swaths of the population without social services or hope of prosperity through work.

Many women interviewed grew up in households with both parents present, while others were raised by grandparents or extended family if parents had migrated to secure work in the United States. A Salvadoran woman recalled being raised by both parents: Her mother worked in a shoe store while her father held a job in a factory manufacturing rubber balls for export. She remembered that her father once bought the family

a television set that the store eventually repossessed. His job, poor salary, and working conditions, are informed by neoliberal policies requiring a low-wage, docile labor force to produce goods and high profitability, thus creating the precarity experienced by the family described here: "I lived with my mom and dad. And we were a very poor family. And dad, he worked a lot for us, I remember. And he indulged us in everything that we wanted. In my childhood, I felt like I was very happy in one part, the only thing is that we were very poor. I remember that my dad would sometimes buy a television, but because sometimes we couldn't pay it, they would come to take the television away and then they would take it back in the store."

Others described being raised by grandparents or aunts and uncles as their parents emigrated to the United States to send money home and support their families. Between 2015 and 2020, 18 percent of El Salvador's gross domestic product derived from remittances sent back from people working outside that country, a percentage that escalated to 25 percent in 2021 due to the COVID-19 pandemic.[39] One Salvadoran woman recalled that she and her four siblings grew up without knowing her father because he worked in the United States.[40] "My father sent us money and at times, my mom would go and wash clothes for people," she said. "It wasn't much money, but it helped." For some, being cared for by extended family produced vulnerability to abuse, including incest. One woman recalled how her gang-affiliated aunt starved her on a diet of green beans while feeding her own children substantial meals. To this day, she can't tolerate the pain of viewing childhood pictures in which she appears emaciated. Such brutality, of course, exists for children growing up within their immediate families whether in Mexico, Central America, or the United States, but we note the susceptibility to maltreatment for some who believed they may have fared better if their own parents had raised them.

Yecica's story helps to illustrate the role that structural violence arising from poverty plays in gang recruitment and violence. She grew up in Honduras, and never knew her father, only meeting him briefly as an adult because he migrated to the United States. Yecica was the second of five siblings. She became responsible for caring for her younger brothers and sisters, preparing the family's meals and cleaning while her mother worked in another city, as the remittances sent by her father proved

insufficient to support the family. Yecica said that due to her family's poverty and her childcare responsibilities, she had to leave school in tenth grade. When Yecica was fifteen, her mother died of complications from HIV/AIDS and she and her siblings went to live in an orphanage. She recalled feeling profoundly sad over her mother's death. At nineteen, she left the institution to work in a textile mill by day and attend night school.

At age twenty-one, gang members killed Yecica's maternal grandfather as he tended bar near her home as punishment for refusing to comply with their demands to pay la renta. Several years later, a younger sister began dating a gang member—an arrangement that Yecica fiercely opposed. She managed to convince her sister to leave the man. Shortly afterward, the ex-boyfriend confronted Yecica and her sister while leaving church one day, drawing a gun, and shooting at the ground to terrify them. They reported the incident to the police, but the officers never arrested the man. That experience of law enforcement's disregard coupled with another instance when Yecica reported her domestic violence with no response left her wary of police.

By age twenty-six, Yecica was operating her own beauty salon from home, providing manicures and styling hair for neighbors. One day while working, she received a call from someone telling her that her brother and a cousin had both suffered gunshot wounds while shopping for a Valentine's Day gift in a small store next to a garage. The cousin died at the scene, and her brother perished shortly after being taken to a hospital. She knew that both boys had defied MS-13's demands that they sell drugs. Yecica learned that a man who owned a nearby car repair shop witnessed both young men fall to the ground as the assailants fled. Yecica, her remaining family, and the garage owner all knew MS-13 was responsible for the killings as it was common knowledge that they controlled the neighborhood. Believing that the police would be impotent against the gang, no one spoke to law enforcement about the murders. Not only did she fear retaliation if she spoke to the police, but she also faced extortion by the gang, which demanded that she pay la renta with the proceeds from her small business. The gang warned that failure to comply would bring consequences to both Yecica and members of her extended family. "They kill people who do not pay. They threatened me with a note saying that if we did not pay, we should

know what was awaiting us. They would hurt us and our children," she said. For Yecica, whose education ended in tenth grade because of her family's poverty, a lucrative job that could have allowed her to move to a more affluent neighborhood not subject to gang activity was beyond reach. As with many women we interviewed, Yecica had tried to support herself with proceeds from a small business, only to become a target of gang extortion.

A Baby Cried

Among the constellation of factors contributing to the struggles facing the women we interviewed is the abject failure of states to adequately respond to violence or their exacerbation of violence by policies that have proven to be deleterious. In this section, we describe state failures and the correlation to gang violence. These failed policies include *Mano Dura* ("iron fist"), a strategy of crime crackdowns deployed earlier in the century. Touted by the governments of Guatemala, Honduras, and El Salvador as their means to eradicating gangs, Mano Dura included state-sponsored violent repression and mass incarceration resulting in prisons becoming organizing sites for extensive extortion rackets.[41]

Human rights groups decried Mano Dura, which arguably arose from efforts by ruling parties to solidify power while ensuring that elites maintained an environment fertile for investment and profitability.[42] We note that there exist distinct histories and cultures in the countries discussed here and we recognize the risk of reductionist conceptualizations by examining common political and economic trends shaping life in El Salvador, Guatemala, Honduras, and Mexico. By way of brief examples, we acknowledge that both Guatemala and El Salvador suffered relatively recent civil wars that brought the brutalization of civilians by the military and death squads—repression that included rape and feminicides as weapons of war. Honduras experienced a military coup in 2009, and with it came a jettisoning of legislation to protect women as well as escalating poverty for women who work in such occupations as street vending.[43] Though Mexico enjoys comparatively more political stability, scholars have argued that a heavily militarized drug war and economic policies including the adoption of the North American Free Trade agreement disadvantage women via depressed wages and esca-

lated violence.[44] While acknowledging the obvious variables among the countries of origin of the women we interviewed, we believe it is imperative to examine the commonalities present in their social contexts as they inform women's flight to safety and asylum.

In her scholarship on the high rate of female homicides in Guatemala, Victoria Sanford argues that states fail to protect women from gender-based murders by declining vigorous investigations and prosecutions of these deaths, thus creating an environment in which women are killed with impunity.[45] Honduras currently has one of the highest feminicide rates in Latin America, a statistic that includes recent assassinations of female political leaders.[46] Between 2005 and 2013, the death rate by violent crime for Honduran women soared 263.4 percent, a stunning statistic given that Honduras had the highest murder rate from 2010 to 2012.[47] According to the World Bank's most recent statistics (2021), the rates of feminicides per 100,000 are as follows: Guatemala, 6.1; Honduras, 6.5; El Salvador, 4.0; and Mexico, 6.2.[48] The World Bank uses the term femicides and defines these as murders of women based on gender, crimes committed against women because of their sex and often in context of a domestic partnership.[49] Men are more likely to be killed in all these countries, as shown in the murder rates per 100,000: Guatemala, 34.1; Honduras; 69.5; El Salvador, 33.5; and Mexico, 50.5. In the United States, the per 100,000 murder rate for men was 10.8 as of 2021.[50] We focus, however, on violence against women due to their unique spatial location and circumstances resulting in a vulnerability to the gender-based crimes of rape, the need to protect children from gang violence and recruitment, and coercion for conscription as "girlfriends" to gang members. While law enforcement studies typically use the term femicide to describe the murder of women in gender-based crimes, we join other scholars in choosing the term feminicide, which speaks to the female condition and to state neglect in protecting women as well as social conditions fomenting the killing of women based on gender.[51]

These crimes against women and girls occur with appalling impunity.[52] One report cited a 3 percent conviction rate for feminicides in Honduras, Guatemala, and El Salvador.[53] An attorney we interviewed emphasized women's unique vulnerability to bodily harm and attendant deprivation of rights, as she reported that 75 percent of the clients she represented in asylum cases were women. All but a very few

suffered gender-based sexual violence such as rape. One analysis of violence against women in Honduras notes: "Although poverty and marginality affect everyone in the country, these conditions impact women and men differently. Both women and men are robbed, extorted, and killed. However, women suffer qualitatively different and more extreme forms of brutality in the form of feminicide and various other forms of gender violence."[54]

The disregard of violence against women and their flight to safety and asylum constituting the heart of this book, occurs despite law-making purportedly designed to stop it.[55] All four nations represented by the women interviewed enacted legislation in this century to protect the rights of women. In 2007, Mexico adopted a law to coordinate enforcement among states, municipalities, and the federal government to prevent violence against women as well as a second law designed to secure reproductive rights and access to contraception.[56] These laws, which followed a 2006 policy designed to ensure equal opportunities for women and to end discrimination on the basis of sex, are not the only legislative efforts enacted in Mexico in this century to protect women.[57] In 2000, Honduras adopted a law prohibiting discrimination based on sex.[58] Honduras amended a 1997 law in 2006 purportedly to strengthen protection for women from domestic violence.[59] Guatemala passed laws to prosecute perpetrators of feminicides, to strengthen domestic violence penalties, and to offer women economic opportunities.[60] Yet, despite these examples of aggressive law-making, violence against women persists. One explanation for the persistence of this violence lies in questions regarding the state's genuine commitment to enforcement. In their examination of Honduras, Menjívar and Shannon Drysdale Walsh argue that laws passed to protect women are essentially performative, enacted to appease international observers, while violence against women persists with impunity.[61] This is an illustration of a country being actively unwilling to protect its citizens despite the passage of laws intended to protect women.

A lack of social services emerged in our interviews as more than an abstract policy concern. Only one woman spoke to an agency serving women survivors of gender-based violence. That finding does not mean that such organizations don't exist; as noted in recent scholarship, networks of activists and non-governmental organizations do intervene

on behalf of women in Mexico and Central America.[62] Nonetheless, our interviews revealed that the women we met never benefited from these services.

To examine how state failure informs the plight of the women, we consider the case of El Salvador. We use El Salvador as an example not to argue that it serves as a better or worse example of state failure than other nations, but because twenty-seven of the forty-six women we interviewed are Salvadorans. El Salvador also serves as an example of unrealized hope. In 1992, the United Nations brokered peace accords to end a twelve-year civil war in which death squads comprised of both state and non-state actors kidnapped, tortured, and killed opponents of the right-wing government with no vindication for survivors.[63] The accords called for sweeping reforms to institutions such as the police force and judiciary, none of which fully materialized, in part because prosecutors and courts failed to bring those accused of atrocities during the war to justice.[64] Five days after the United Nations published its Truth Commission report detailing wartime atrocities, with 85 percent of them linked to the rightist regime's military, the nation's legislative assembly passed a blanket amnesty for those responsible.[65]

In the years that followed, human rights organizations accused the governing, right-wing *Alianza Republicana Nacionalista* (Nationalist Republican Alliance, or ARENA) party of exercising undue influence over both the National Civilian Police (PNC) and courts, resulting in prosecutorial inefficiency and police engagement in crime, torture of detainees, and extra-judicial killings.[66] A civil war in which insurgent combatants—including women guerillas—risked their lives for human dignity such as the right to education, an end to labor exploitation, and access to decent housing and potable water, ended with disillusionment. Although decades removed from the war's end, the Salvadoran police force remains an institution viewed as more responsive to the wishes of political and economic elites than the vulnerable needing their protection.[67] According to one scholar, "Many of the PNC's current problems—notably its poor investigative capacity and abusive tendencies—can be traced back to the government's deliberate efforts to prevent and subvert the formation of an independent professional police force."[68] In 2019, El Salvador elected populist Nayib Bukele to the presidency, a leader whose authoritarian inclinations have led the United Nations to voice concern

over human rights abuses.[69] Following an escalation of gang-related homicides, Bukele in March 2022 won approval from the legislature for a "state of exception," which enabled mass arrests and suspended civil rights.[70] Experiences described by Salvadoran women for this book raise questions about whether that nation can or will protect women's rights.

A redacted asylum court decision shows that in some cases, women's experiences of gang violence rise to the level of persecution in an immigration judge's assessment—thus meeting one standard for winning an asylum claim.[71] In 2012, Yolanda lived in El Salvador and attended a university while living with the grandmother who raised her. The ride to the university took two hours from her home by bus. That spring, Yolanda went to a funeral for an aunt, which was also attended by several MS-13 gang member cousins. There, the cousins searched relatives for tattoos indicating membership in rival gangs. A gang member noticed Yolanda, and after the funeral, began sending her text messages insinuating that he wanted to have a relationship with her, overtures that she refused. Later, Yolanda's gang-affiliated cousin came to see her at the university, an encounter that she found disquieting.

In October 2012, as she left her evening classes, she saw a man standing by a light post. He signaled her to come to him, but she quickly walked away to avoid him. A car stopped in front of her, then men forced her inside, tied her hands and feet, before covering both her mouth and eyes. They drove her to a residence, held her captive for three days, and repeatedly raped her. Men gave her injectable drugs that she believed were tranquilizers. She remembered lying on a dirt floor while hearing a baby cry somewhere. The men finally threw her from a moving car onto a highway, but not before telling her that she needed to leave El Salvador.

Yolanda testified in court that she never reported the kidnapping and rapes to police because she had heard stories that police communicate with gangs and accept bribes. "The respondent has established that she suffered persecution in El Salvador. The harm she suffered—being held captive for three days, during which time she was drugged and repeatedly beaten and raped—rises far above the level of 'mere harassment,' and is serious enough to be persecution," the judge wrote. In his decision, the judge also found that the Salvadoran state's failure led to its inability or unwillingness to protect Yolanda. She merited protection from this state's failure to ensure that she would have a future free from further brutalization.

Men in Charge

Elisa's story illustrates the pervasive distrust of police that women repeatedly described in interviews. It begins in Honduras, where she recalled growing up on a farm in the mountains. "We were a very poor family," she said. Her father worked as a campesino, tending to the owner's cows and growing beans for his family's consumption. Her parents supplemented their income by selling items door-to-door: clothes, perfume, bread, and tamales. The pueblo had no market, so their wares filled a need. "My mother had four children one right after the other, year after year. And because of that, it was very difficult with four children, one after the other. We suffered poverty. But thanks to God, I come from a family that is Christian. And with God at our side, we came out ahead." Elisa completed more formal education than others we interviewed, having finished high school and earning a one-year certificate from a local university in small business management.

Her story as an adult includes multiple rapes by men whom she believes were gang affiliated. At age nineteen, she relocated from her rural home to a city where she found work in a medical clinic answering phones and scheduling appointments. One day she left the clinic to buy lunch at a family-run business down the street. The neighborhood was unusually quiet that day as most people were home from their jobs to observe *Semana Santa* (Holy Week). Elisa described patronizing the business, and what happened that day. She realized that the two men she had witnessed entering the restaurant were staging a robbery:

> I met them [the restaurant owners] because they would make us homemade food, familiar food. So, when I arrived, I saw two men come in with blankets. I thought that since it was a business that sold food, that it was people who were going to leave tortillas or parts of the food. . . . When I arrived and said good morning, one of the men said, "Welcome, come in." But I looked at the lady sitting down, that did not move. I guess they silenced them because none of them gave me a warning or anything. So, I also think that if they had warned me and I ran out, they could have also killed me because the streets are completely deserted and when I entered, they immediately put a gun to my head and threw me face down on the ground.

Four women were there, including a younger woman who struggled to keep her children quiet. Elisa explained:

> It was two older women and there was only one young woman, and there were about four or three children. I don't remember well because the only young woman there had them all [the children] in her arms. So, I don't remember if there were three or four because everything happened so fast that I don't remember. I only know that there were more than two children. She had them all in her arms and had all of them crouching . . . One of the women was in a wheelchair and when I came inside, she was already beaten because she wouldn't stay quiet, and they beat her even when I was there. They hit her on the head with a gun.

After a man knocked Elisa to the floor, he pinned her with his knee to her back before leading her to a back room, where he demanded the inexpensive costume jewelry she wore. The assailant then ripped off her blouse and used it to cover her head. He forced her to the ground, and then raped her. He encouraged his associate to do the same, but the other man screamed that they needed to escape before police arrived. Once the criminals fled, neighbors showed up at the home-based business, having heard screams. Elisa said:

> Before the police arrived, people arrived, I don't know if they were neighbors or family, but a man. This lady had already given me a big t-shirt, I don't know whose it was, and I told her that I didn't want to be there when the police arrived. I was ashamed that a lot of people would know. I did not want anybody to know. Strange, but in that moment, I would think that I should have waited for the police, but in the moment, I just thought that I didn't want anyone to know what had happened to me.

Elisa returned to the clinic, where a horrified coworker tried to comfort her. Elisa described her actions: "When I left [the restaurant], I let it all out. I left crying, crying and I couldn't stop crying. And I arrived at the clinic and when my coworker saw me with another shirt, my hair all over the place and I couldn't stop crying, she got scared and started to ask me what had happened to me. And the only thing I did was lock myself in the bathroom and call my partner at the time, who was my boyfriend."

The boyfriend encouraged her to call the police, but she thought that doing so would be futile. "The criminal never pays for their actions," she said. "Unless you're rich, they'll never look for the person." She knew other women who survived sexual assault and had never seen the perpetrators jailed. Violent crime was pervasive and no one she knew felt protected by the police. Elisa's story is sadly typical as women described hearing stories of crimes that go uninvestigated and unprosecuted, undermining trust in law enforcement and informing spatial practices in which safety must be routinely gauged and evaluated.[72] Women consistently described police as disinterested in protecting them, or as corrupt. Elisa continued working at the clinic, although she began to binge drink on weekends to medicate herself and avoid the terror and traumatic memories left by the rape. She worked at the clinic until it was sold to another physician who cut her hours.

Elisa was twenty-five when she found her next job at a call center for well-known American pizza and fried chicken fast food restaurants. In an interview, Elisa blamed herself for the binge pattern drinking on weekends that she believed obscured her judgment and led to another rape. Her self-blame and self-medicating of the trauma she endured, and its painful sequelae, speak to the question of symbolic violence and how the women we interviewed understood the power dynamics they needed to navigate. In her framing, Elisa "failed" because she fell prey to the men who raped her; women come to understand that it is their responsibility to protect their own physical autonomy, rather than seeing men as responsible for an act of severe sexual violence. Physical violence against women serves to normalize gendered hierarchies, making the subordination of women normative;[73] power relations are internalized by women because inequality in social space is so pervasive as to seem legitimate.[74] Thus, Elisa's story is not pertinent for alcohol use but for the issue of policing and its lack of accountability to those it purports to serve and protect.

One weekend, a friend invited Elisa to a party at a restaurant to watch a soccer game with two men as dates. They picked Elisa up at the house that she shared with her younger sisters. Once they arrived at the restaurant, she noticed that both men were armed. Visible underneath their expensive suit jackets were holsters with guns. Elisa feared that the men were *narcos*, a term she used in the interview. "If I had known they were

narcos, I would never have gone in," she said. She pulled her friend aside at the restaurant, and angrily told her that she didn't like guns and didn't want to associate with men who carried them. Her friend reassured her that they carried guns because they were part of a business organization and needed weapons for self-defense. At the restaurant, the group drank and had a meal while they watched soccer. They then went to a club, where she saw one of the men pull out a large amount of cash wrapped in a rubber band, another indicator, she believed, that these men might be criminals. Elisa told her friend that she wanted to call a taxi and go home. Her friend persuaded her to stay and reassured her that the men would drive her home. Once they left the club, they drove past Elisa's house without stopping. She protested repeatedly that they had missed her house but neither of the men responded. "The driver gave me a real ugly look," she said.

They arrived at a house where the friend and the two men said they all wanted to skinny dip in the pool. Elisa told the group she didn't want to take her clothes off. "I liked to drink but I wasn't up for all of that," she said. Once again, Elisa told her friend she wanted to leave, and they began arguing. Upon hearing the argument, the friend's boyfriend, Luis, put a gun in Elisa's back. "Why is she acting like she runs things here?" he asked. The female friend tried to calm Luis down while the other man tried to reassure Elisa that although Luis could be "grouchy" at times, they would not be harmed. Luis screamed at his male friend, "You don't ever let women run you. You don't ever let a woman be in charge. The men must always be in charge." With his gun, Luis ordered all three back into the car. As he drove, Luis kept the gun in his hand and repeatedly told the group that no woman was ever going to tell him what do. He called the other man "an asshole" for allowing the women to speak.

Eventually, they drove to an apartment where Luis raped her. Afterward, she struggled not to cry and begged Luis to allow her to leave, saying that her sisters would be worried. Luis agreed to let the other man drive her home. On the way back, the man stopped at a gas station where a police car pulled up. The man approached the police car and handed the officer a small envelope—an exchange that Elisa found suspicious. What did this armed man who had just colluded in a rape hand a police officer? How did the officer know to pull over at this moment? And how did they know one another?

A study gauging citizen trust of police in Central America and Mexico reveals that Elisa's concerns are widespread. Almost 70 percent of Guatemalans believe police actively engage in crime.[75] In Mexico, 54 percent say police commit crimes; in El Salvador, 49 percent share similar concerns, as do 47 percent of Hondurans.[76] It would be reasonable, while considering Elisa's witnessing of a questionable exchange between the police officer and a criminal, to wonder whether the police officer might simply be a lone bad actor, or in American parlance, a dirty cop. In our conceptualization, impunity for crimes against women is contextualized by asymmetrical power relations, a product of an enduring familial patriarchal system and male-dominated law enforcement. Large-scale institutions including presidential administrations and legislatures, as well as police departments and prosecutors, are male dominated; law enforcement is more broadly male dominated than many other institutions.[77]

Elisa's story illuminates the reinforcing nature of structural and symbolic violence. Her rapes arguably occurred because the men believed—as decisively articulated by one man—that men should have power over women, including entitlement to rape, an example of symbolic violence. Structural violence is evidenced by the fact that she and others interviewed for this book believed the police did not protect women and could not be trusted to report gender-based violence or to enforce the laws making it a crime. As Kathleen Staudt described, "Violence against women is a relic of male dominance, legitimized by government policy or government inaction."[78]

Human rights organizations and advocates regularly chronicle police failures in Honduras, El Salvador, Mexico, and Guatemala.[79] The conviction that police would either be disinterested in their plight or infiltrated through bribery and threats by gang members deterred all but a few we interviewed from reporting rapes, extortion, home invasions, death threats, and armed robberies to law enforcement. In one case, a Salvadoran high school student suffered a severe beating by two police officers in her remote rural pueblo after she refused to sell drugs on their behalf. The assault left her with a fractured clavicle, and despite the pain, she feared seeking medical care. "It was because of the fear, I don't know," she said, adding that she was afraid the police would grow suspicious if she went to a hospital. "I had a lot of fear because of what

happened." Despite a conspicuous injury—a bone in her chest visibly out of alignment—her distrust dissuaded her from seeking care. Two weeks after the attack, she left for the United States. In another case, a Honduran woman came home from her shift waiting tables to find two men waiting for her, including a uniformed police officer who raped her.

For many, whether in Central America or Mexico, police serve as the face of the state, and thus, the failure of such institutions leaves citizenry alienated. In some instances, police may feel overwhelmed, and in others, they may be corrupt. As explained by one immigration lawyer who handles asylum cases, women try to obtain help from law enforcement only to be turned away. "They'll go to the police station and the police will say, 'You just need to leave. Like, there's nothing we can do to protect you. You just need to leave.' That happens a lot. You hear that a lot. The best thing you can do is leave," the attorney said.

Governed by MS-13

Left in the wake of fragile states, violent crime, and neoliberal policies are women who not only must negotiate the poverty experienced by men in similar material circumstances, but who are forced to contend with the unique disadvantages ascribed by virtue of gender. We tell Alba's story because it typifies the gang violence narratives that we heard repeatedly. A redacted decision written by an immigration judge in 2020 illustrates how totally a gang, MS-13, came to dominate the small city that one Salvadoran woman fled in 2015. Alba told the court that when she wanted to have a birthday party for a child, she had to ask the gang's permission. As a condition, the gang required her to host their male friends at the event. Armed gang members stood as sentries in the neighborhood and routinely collected la renta from stores and roadside stands. Rather than arresting gang members for crimes such as extortion, police officers assisted, at times ordering shop owners to give a gang member "what was his." Alba argued in court that the police received payments from the gang in exchange for ignoring the crimes being committed.

One evening, Alba and her child witnessed a murder. Two people drove by on a motorcycle and a gunman opened fire on a boy. Alba made eye contact with the shooter and recognized him as a man who gave orders to others in MS-13. She later heard that the gang targeted the

boy because his parents had complained to police about MS-13. A week after the murder, gang members showed up at Alba's parents' home and demanded to know her location, saying they needed to speak with her. To avoid further trouble, Alba and her father complied with the gang and went to speak with its leader. The man bragged that he had been in the gang since age eleven and told them that the police do him favors. The man said that he knew Alba had called the police in the past. She assured him that her only call to law enforcement was to request help transporting a sick child to the hospital. The gang leader then put a gun to her temple and warned her that he would kill her the way he had killed the boy she had seen die. "You should not say anything to anyone because the same thing that happened to this boy will happen to you."

A pattern of intimidation followed their meeting: Gang members spent days and nights outside her home, drinking and smoking marijuana. Some did so while reclining on her roof. Alba fled to the United States using a considered method of escape. She walked away from the neighborhood with her child and mother. Her mother carried a basket; under a layer of vegetables were Alba's and her child's clothes. Thus, her mother's basket of vegetables served as a prop to trick the gang into thinking they were leaving the neighborhood on a routine errand. For three days, Alba and her child remained hidden at her sister's house. MS-13 wouldn't find her there because the house was in a neighborhood dominated by the rival Calle 18 gang. Alba waited there for three days while she arranged to hire a human smuggler to lead her to the United States. When Alba called her mother after she reached Guatemala, her mother reported that MS-13 members were spreading rumors through the neighborhood, saying they knew that Alba had left El Salvador, a fact that helped convince the immigration judge that MS-13 tracked her movements. Alba's terrifying circumstances satisfied the criteria for asylum including a well-founded fear of future persecution as evidenced by a threat at gunpoint. She won her case and remains in the United States.

Structural Violence and State Failures

In reading Alba's story, some may argue that the violence she witnessed and experienced isn't unique to her gender, a fact borne out by the statistics cited earlier in this chapter that men are more likely to be murdered

in El Salvador. We argue, however, that women are uniquely disadvantaged by gangs because rape remains a routine weapon utilized in enforcement of gang imperatives, and because gangs are male organizations: an outlet for solidarity, inclusion, and material gain for men. Men can accrue symbolic capital via gang membership: admiration from other young people as well as the potential to dominate the spaces of neighborhood commerce, earning money through extortion.[80] Women we interviewed had endured rapes by men who demanded they become their "girlfriends," including two who suffered this fate as punishment for being lesbians. Alba couldn't be safe at home because gang members intimidated her, going so far as to sit on the roof of her to enjoy alcohol and marijuana while engaging in a campaign of intimidation. Such behavior would not be possible in a state where police enforced laws including those designed to protect women from gender-based assaults.

The violence women endured wouldn't be solved with effective policing alone, however, given the multiple social forces informing life in the countries of origin that are our focus: Structural violence and state failure have become mutually reinforcing, relegating women to low-wage work in factories, call centers, roadside stands/small businesses, or subsistence agriculture. Alienated young men can turn to gangs for safety, social belonging, and income. While elites may be able to protect themselves by living inside walled communities, spaces where a few women we interviewed worked caring for others' children, the less prosperous are relegated to neighborhoods characterized by ubiquitous violence. Further sustaining ongoing gang violence are high rates of poverty and class inequality, conditions that can include lack of access to basic resources such as potable water. As we discuss later, the question of law enforcement responses, or lack thereof, often become pivotal in asylum cases as judges' assessments of whether police can or will protect women if returned to their countries can be instrumental in deciding the merits of an asylum case. What is often not apparent in courtrooms are the ugly intersections of policies and economics informing gang violence. Neoliberal policies including fiscal austerity, a lack of social services, privatization, and free trade have been implicated in intractable poverty and violence. The fact that only one woman we interviewed received the support of an organization or agency specializing in services to survivors of gender-based violence is remarkable.

Patriarchal violence and the use of rape to control and denigrate women are evident in Elisa's story: Men asserted rape as a prerogative and argued for their own dominance while denigrating her entitlement to bodily freedom. Rape certainly isn't unique to the countries in question here, but the lack of arrests and prosecution for such crimes, coupled with absence of a social service infrastructure for women who suffer gender-based violence, arguably abets the perpetration of such crimes. Lacking authority, agency, or meaning in other realms conferring prestige and privilege, alienated young men turn to violence, including that which specifically targets women who remain a rung below their status. In her analysis of highly publicized murders near the Mexican/US border, Staudt argues that such crimes are ultimately the responsibility of the state, as these crimes were initially dismissed, with officials blaming victims for dressing inappropriately.[81] This example illustrates the enduring power of symbolic violence when it comes to women: In an old trope, women must police their own bodies to protect themselves from gender-based violence, and by not doing so they deserve the consequences, thus providing an out for male-dominated law enforcement agencies to avoid pursuing investigations.

We describe the context for acts of extreme violence against women by gang members to support a robust understanding of why these acts occur with such frequency—causing women to leave families, homes, and cultures for an uncertain pathway to asylum in the United States. As we noted in chapter 1, asylum is a Cold War era institution, designed to protect survivors of state-perpetrated violence. Women who flee violence by non-state actors are burdened by having to prove that the violence occurred because they are members of a particular social group; gender itself is not recognized as a protected category. As we describe further, some judges doubted that governments and their law enforcement agencies were unable or unwilling to protect women who reported severe violence, thus serving as an obstacle to winning asylum cases. Women and their attorneys must find ways to contravene asylum law strictures to win protection from severe violence by gang members.

3

Violence at Home

Alejandra, a Guatemalan who came to the United States following severe domestic violence, now awaits an asylum hearing as she works for a pizza shop in the suburbs to support herself and her ten-year-old son. We begin with Alejandra's story because it typifies the women interviewed who migrated to escape a domestic partner's brutality. While in Guatemala, Alejandra tried to find jobs to support herself and leave the man who beat and raped her, but financial independence eluded her. A lack of stable, well-paying jobs thwarted her efforts to escape violence, and thus safety for herself and her son hinged on coming to the United States. When discussing her son's father, Alejandra described him as *machista*, a term we often heard translated as "sexist" or "chauvinist" during asylum hearings. Both the question of machista culture and "private violence" emerged with regularity in immigration court during gender-based violence cases we observed. Thus, we premise our analysis of gender-based violence by domestic partners on two key arguments: (1) that it is essential to examine the structural conditions informing the prevalence of gender-based violence that compels asylum, factors that arguments about machista culture fail to capture adequately; and (2) that "private violence" is a misnomer as it occurs by virtue of social contexts enabling and normalizing men's dominance of women, including entitlement to women as property.

Our theoretical orientation again turns to Pierre Bourdieu as well as to feminist scholarship using his work as it includes the questions of both class and patriarchy.[1] As Bourdieu once famously argued, "Sexual properties are as inseparable from class properties as the yellowness of a lemon is from its acidity; a class is defined in an essential respect by the place and value it gives to the two sexes and to their socially constituted dispositions."[2] In short, both gender and class determine women's social positions, access to resources, and how policies inform the question of gender-based violence. As noted by Beverly Skeggs, gender and

capital shape the social relations in which women's lives are organized and valued; masculinity and higher-class positions bring greater value and respect, establishing privilege in both realms.[3] Expressions of power by dominant actors include the subordination or exclusion of certain groups and classes, most critically in the distribution of resources and jobs.[4] Harms to women are not limited to a lack of tangible material assets; women are injured by an inability to accrue symbolic capital—recognition and acknowledgment by others as important or having value.[5] As we explain in what follows, women's decisions to flee and seek asylum came by way of intersecting spatial relations: relegation to low-wage labor that restricts women from finding safety to escape domestic violence; the state's failure to protect the rights of women via adequate law enforcement and prosecution; and, finally, the intersecting and mutually reinforcing processes abetting male dominance both in the wider society and in the home. Structure—the distribution of jobs and education, the question of whether laws against domestic violence are ignored—reinforces the very idea of male dominance, shaping subjective experiences for both men and women. Whether revealed in the concentration of well-paying jobs and residences behind heavily securitized, walled communities in Mexico and Central America, or in the denial of access to education and employment to the lower classes, the differential use of social space embodies and enforces relations of power.[6] For Alejandra, as we describe in this chapter, her inability to find a job that paid sufficiently complicated her efforts to escape violence. During our ethnographic work, we saw immigration court hearings in which attorneys argued the idea of machista culture, and acknowledgment of this concept sometimes leads to women's success in court.[7] In other cases, judges seemingly dismiss the innately political context informing battery and rapes perpetrated by domestic partners, a conceptualization that leads to the conclusion that women experienced private violence—thus negating the state's responsibility to protect them. Valeria, a fifty-one-year-old Mexican who sought asylum after her husband's severe abuse left her feeling "brainwashed," suffered a denial by an immigration judge who ruled that the assaults she experienced were about a "dysfunctional relationship," rather than persecution, one of the legal standards for asylum. Thus, while culture constitutes an issue for women fleeing domestic violence, a conceptual argument limited to culture dismisses the multiple

structural and political forces implicated in gender-based violence: For example, human rights advocacy in Guatemala has been complicated by debate over whether certain violent acts are the product of common criminals or political actors, an issue with no simple answers because often, no distinction exists between the two that can be empirically verified.[8] Such distinctions are critical.

Consider the situation in Guatemala, in which violence against women arises from myriad forces: a history of Spanish colonialism, a thirty-four-year civil war that the United States waged by proxy against leftist forces, leaving behind a distrust of authorities and ample access to firearms, coupled with destabilizing economic policies promulgating poverty and income inequality.[9] Paula Godoy-Paiz explains, "Guatemala's long history of violence and state repression toward vast segments of its population spanning the colonial period, then through a long line of dictators, and most recently exacerbated by decades of horrific internal armed conflict, is also at the core of persistent and ubiquitous violence today."[10] Armed forces representing the right-wing government used feminicide and rape as weapons of war, and following the war's end in 1996, rates of violence against women soared.[11] The lingering effects of protracted civil wars are evident in steps of gang formation: When police in Los Angeles began investigating unusually cruel crimes by Salvadoran gang members two decades ago, they learned that the young men had received training in brutality at the hands of US Special Forces during the civil war.[12] Today, multiple sources of violence—poverty, a legal system indifferent to women, a paucity of social services—intersect, with the result that women in Guatemala experience not just one form of violence but many that act together; women from El Salvador, Honduras, and Mexico experience brutality from similar forces.[13]

Left in the wake of decades of violence against women is a form of social control that includes the devaluation of women as well as their humiliation, fertile conditions for acts of violence as well as their oppression in the social order.[14] In northern Central America, the site of recent civil wars and a military coup, the hypermasculinity surrounding militarism as well as the fact that economic and political power are held primarily by men inform male hegemony and the conditions leading to gender-based violence.[15] Inequality and the historical impunity for crimes against women sustain gender-based violence including rapes

and feminicides, a cycle perpetuated by emphasis on militarization at the expense of social services.[16] Cecilia Menjívar and Shannon Drysdale Walsh cited both acts of commission such as state-sponsored assassinations of female dissidents, and omission, including the state's failure to prosecute heinous crimes against women, even feminicides, in Honduras that led to impunity for gender-based violence.[17] "These government actions and inactions are linked to intersections among political, social, and economic exclusion that are a consequence and a cause of gendered inequality, creating a particularly violent context for women."[18] Regimes built on militarization cultivate the symbolic violence that disadvantages women: Hierarchy and inequality are normalized in the realms of class and gender domination that subordinate women.[19] Men enjoy varying degrees of power, while women accede but, at times, resist their subordination.[20] Alejandra's story illustrates how women can accommodate subordination before finding the means to resist untenable circumstances.

Virtual Prison

Alejandra had a plan to leave the man who scalded her with hot coffee, then raped her. She hoped to find a job somewhere near her home in Guatemala to earn enough money so that she could escape the house filled with her husband's extended family, a place she described as a virtual prison. Her story illustrates the violence suffered by women we interviewed, while at the same time, shows the challenges women faced in attempting to prove that the brutality they suffered is sufficient evidence to win an asylum case. Alejandra's parents visited her at the home she shared with her domestic partner, and each time, they gave her a new cell phone. "I didn't look good. They would ask me, why was I so skinny? Why did I have bags under my eyes? But I never had the courage to tell them because my husband was always by my side," she said. "I never had the courage to tell my parents what was happening." Her husband, Diego, destroyed the cell phones. On other occasions, Alejandra's father gave her a new cell phone with the money he had earned driving a truck. Diego inevitably confiscated the phone, allowing Alejandra to use it only when he was nearby to monitor her calls. Alejandra pleaded with her mother-in-law to intervene, but she refused:

His family always had a thing where nobody did anything to defend me. Nobody could say to him, look what you are doing is wrong, don't hit her, don't treat her like that. His mother, his father, his siblings, nobody said anything to him because I don't know if it was because they had ... I don't know how to explain it, like they were united among themselves. Nobody said anything to him. I told the lady [the mother-in-law] later, "He hit me." I told her, "He hits me, and you don't say anything to him." And she would tell me, "No, I don't say anything because I don't interfere in your relationship. Your relationship is yours, you have to solve your problems."

Critical for Alejandra's situation was her mother-in-law's assertion that Alejandra and Diego should sort through their problems, an argument that seemingly normalizes the problematic gender dynamics and violence that shaped power relations in their relationship. As Menjívar noted in her analysis of violence toward women in Guatemala, the tacit acceptance of gendered power relations by family members often serves to sustain violence and perpetuate its normalization.[21] Family members are, after all, habituated by the same social structures that marginalize women, including the legacy of feminicides and rape as weapons of a war that persisted in that country for three decades. A legal system that is reluctant to prosecute gender-based violence normalizes it and ensures enduring processes disadvantaging women in families.[22]

Alejandra lived with her husband, her four-year-old son, and fifteen members of her husband's family in a farmhouse. Everyone worked on the same farm, caring for livestock and milking cows. Alejandra finally summoned the courage to ask the owner of the ranch where they worked for a job. The owner lived more than two hours away, in a large city. The woman looked at Alejandra and asked her questions about why she sought employment:

I came after so many problems that I lived with him, after so much violence I had with him, then I got a little courage. I asked the lady where he works (a farm with horses and cows) ... I told her to give me a job where she was. Because with her, I lived in peace. [Before], I only lived with fears and anger. I always said [to myself], "Why can't I do anything for me, for my son?" She told me that she would give me a job, but what

was happening? Why was I looking for a job? So, I didn't want to explain why, I just told her to give me the job.

After that conversation, Diego cornered Alejandra and demanded to know why she had asked for work. The woman wasn't willing to hire Alejandra without Diego's permission. Diego initially admonished her that she was not to work outside of the home as her role was to care for him. Alejandra, however, persuaded him that the family could benefit from the extra income. "I told him it's because you don't give me enough money for food, and our son's clothes," she said. The owner hired Alejandra after reassuring Diego that she would monitor his wife's actions—in other words, to ensure that she wouldn't leave. Although the job cleaning the owner's house required that Alejandra live away from her young son, she took the position. "I worked two months with them, but Diego's family didn't let me take my son. My intentions were to go to work and get my son out of there, but they wouldn't let me take my son. Diego said, 'If you want, you can go work but you will leave my son here.'" Alejandra had come to realize that she needed physical distance, a bus ride of several hours, to protect herself from Diego's violence. It never occurred to her to seek help from the police because she assumed either they would be disinterested or unable to assist her.

An infrastructure of domestic violence shelters or similar supports for women suffering interpersonal violence didn't exist where she lived. Alejandra's employer suspected that she had problems at home and began to ask questions, but Alejandra refused to explain her situation because she feared losing her job. Diego had threatened that he wouldn't let her see their son if she were to disclose his violence. The distrust on the part of Alejandra's employer is notable here, as such views are not uncommon in Guatemala. Suspicion and gossip about women who work for pay is not uncommon in Guatemala, and neither is opposition to a woman's paid employment on the part of a male domestic partner.[23] Alejandra worked two months in this job but missed her son terribly, so she found a job close to home at a gas station. "Then I had a manager at the gas station, and I worked there for two months with her, and I never received a cent. Not one cent in those two months and I would ask her, 'Why?' And she would say, 'Something was lost, and it was deducted from my check. And I never received any money.'"

Alejandra was visibly apprehensive about the interview for this book but gave it, knowing that the information would be entered into evidence to speak to her credibility in an asylum hearing still years away. At the time of the interview, she had been in the United States for three years and had found work at a pizza shop after securing a work permit. She spoke while sitting in a small basement apartment with her son, who was then age seven. The basement apartment was chilly, and Alejandra sat at a small dinette table with a folder that included several pieces of evidence that she had collected for her attorney, including threatening text messages from Diego. She said she didn't intend to seek asylum when she fled Guatemala. "I was just running away from my husband. He made threats over the phone that he was going to take my son away, and that I was going to have consequences for leaving."

By the time Alejandra was interviewed for this book in November 2019, Donald Trump had been president for three years, and the protection that Alejandra sought had been rendered more difficult to obtain. Attorney General Jeff Sessions severely restricted asylum claims based on incidents that he classified under the non sequitur, "private violence." However, because the asylum system is severely backlogged, Alejandra's hearing would not occur until after Trump lost the 2020 election and the next president took office. Although the Biden administration reversed Sessions's decision, Alejandra's fate still hinges on successfully demonstrating the credibility and legitimacy of her claims. Lost in extant US policy debates over asylum—including at times the fine points of case law delineating whether domestic violence rises to the level of persecution—is an understanding of the complex social forces compelling women to flee. "Focusing on men as 'perpetrators' or on their individual acts isolated from a broader context would lead to a facile and misguided analysis that would serve to legitimize and disguise the deeper roots of violence."[24] The legacy of a four-decades-long civil war remains and continues to cause pain; the harms from the war coupled with economic policy and political instability persist in an accretion of social processes that include poverty, severe income inequality, and a lack of access to social services.[25] Violence against women arises as processes embedded in the larger social system, including how jobs are distributed.

In Guatemala, women suffer lack of access to sufficient renumeration for work, as well as forced child labor and loss of education because too

many families simply can't afford tuition and books, or because their wages are needed for survival.[26] Thus, an understanding of gender-based violence must be framed by consideration of spatial practices dominated by capital and women's relegation to entrenched poverty: the suffering that arises when people are deprived of access to wages, food, housing, and health care.[27] Legacies of the civil war, heightened income inequality, and poverty penetrate women's lives, including in intimate domains such as the family. Brutality erupts by virtue of normalized and accepted power relations that proceed on multiple levels, ranging from the wider society and its violence in policies perpetuating poverty, to the insidious emplacement of gendered power relations in households.[28] Multiple factors causing violence range from the civil war's aftermath and continued militarization to centuries-long structural inequity; these forces thus intersect and operate at once, informing life for women.[29] "In heavily militarized societies, patriarchal power regimes are even more prevalent because states' security strategies promote a masculinist understanding of protection as to who should be protected and by whom—and from what."[30]

Violence at Home

Asylum claims typically hinge on narratives that position the United States as a morally superior savior, including a framing that the egregious violence described in this book happens only "in uncivilized countries of origin."[31] Power relations inform conditions forcing women to flee and seek asylum here, while political considerations shape how immigration judges interpret asylum claims. Specifically, we note that asylum emerges in the United States by virtue of policies and judicial decisions that serve multiple ends benefiting the state: border control, the ability to humiliate political adversaries, a wish to portray other cultures as deficient, and a preservation of itself on the world stage of a benign protectorate for those fleeing violence.[32] Still, as we show in this section, the struggle for asylum can be thwarted when a judge views a woman's brutalization as a matter beyond the purview of the state.

Women interviewed for this study described the violence they suffered in the language of interpersonal victimization, or what might be termed private violence: "I had bruises on my mouth, from his hands

around my neck, and all over my body. His rapes were usually violent. " Or "They came to my house, three people from the gang, because they wanted money . . . They told me that if I didn't give them the money, they were going to kill me." But such stories alone may not be sufficient to win an asylum case, as explained in the section below in which a redacted legal decision—meaning one with no identifying information such as names—is analyzed to show how one Guatemalan, Paula, lost her asylum case.

Paula couldn't convince an immigration judge that the police in Guatemala were unwilling to protect her. Her story began when she was fourteen. Paula met a man who was eleven years older and after a brief courtship, he asked her to marry him. Paula's parents opposed the marriage, and a year later, she moved in with him against their wishes. They were never legally married because Paula was too young to consent, and when she reached age eighteen, the man informed her he no longer wanted to be in a relationship with her. She considered herself to be his wife, however, because she lived with him in his parents' house and cooked his meals. The boyfriend, Mario, served in the military. They had a son. When he was on leave, he brutalized her by choking her and striking her in the face. Mario warned her never to report him to the police, saying he would kill her if she did so. Her parents lived twenty-five miles away and wouldn't visit because they disapproved of the relationship. Although she had a phone, he saw to it that she never had minutes available for outgoing calls.

Shortly after their son turned one, Mario beat her and threatened her with a machete. The police once went to the house and called through the door, asking Paula why she was screaming. Mario put the machete to her neck, and as a result, she yelled to the officers that she was alright. He threatened to kill her if she reported him. She finally escaped when she learned that he had met another woman. Paula assumed that Mario wouldn't care if she left him. She took their son and moved in with her parents. Mario responded with a series of threatening messages and by sending her naked photos of their son. Paula reported his behavior to the Department for Family, Peace and Order and received a protective order admonishing Mario to stop harassing her. The order apparently didn't deter Mario, who called and threatened to kill her if she didn't withdraw the order. We note this point because the issue of whether

women contacted law enforcement emerged as a key point in asylum hearings, although these criteria do seem to vary from one courtroom to the next. In some cases, attorneys for the Department of Homeland Security (DHS) used the question of whether women had gone to police to counter asylum claims, arguing that women who didn't seek help from law enforcement shouldn't be awarded asylum. After all, if they didn't seek police assistance, how could they reasonably claim that the government of that country failed to protect them?

As discussed earlier, the Immigration and Naturalization Service (INS) released standards in 1995 to provide asylum officers with guidance for adjudicating asylum cases based on gender, advising them to take domestic violence claims seriously.[33] However, they were not binding, and immigration judges are not required to follow the guidance.[34] As a result of the continuing uncertainty, the lawyers we interviewed were keenly aware of the asylum grant rates of individual judges. Grant rates before judges in Arlington, Virginia, based on data collected between 2016 and 2021, ranged from a low of 3.6 percent for one judge, to a high of 92 percent for another.[35] Legal scholars emphasize a lack of uniformity and consistency in asylum case outcomes, prompting two analysts to characterize the legal process as "extremely convoluted."[36]

Paula told her story in court as her attorney laid the building blocks for how she met the criteria for asylum: (1) She had a well-founded fear of persecution because the rapes she detailed in an evaluation rose to the legal criterion of persecution; (2) The government of Guatemala was either unable or unwilling to protect her; (3) She was a member of a particular social group; and (4) Her domestic partner brutalized her because of her membership in that particular social group. She also had to convince the judge that she was credible and told the truth. Failing to establish any of these facts could mean that a judge would issue a denial of asylum and an order of removal back to Guatemala. The DHS attorney would likely be arguing that Paula did not meet the necessary criteria and should be deported. Thus, as asylum seekers try to prove their credibility and the legitimacy of their gender-based claims, they face the harrowing task of convincing immigration officials or judges that gender violence is not a personal or unfortunate problem but constitutes persecution worthy of protection.

In court, Paula's attorney argued that the abuse she suffered rose to the level of persecution. She argued as well that her client belonged to several particular social groups, including "nuclear family of Mario Mendoza."[37] The judge issued a written decision provided to us by Paula's attorney. In it, the judge stated that they found Paula's testimony, which had been corroborated by family and friends in Guatemala, to be credible. The judge also stated that the harm she experienced reached the threshold to be considered persecution and cited the death threats that Mario made on numerous occasions. But the pathway to asylum posed still more barriers. The judge did not accept that Paula had suffered by virtue of being a member of the particular social group, "women in a domestic relationship." This particular social group was not defined clearly enough, according to the judge. Some people in society might define domestic relationships as simply dating, and others would argue it means marriage. Further, the judge said, there is no indication that the wider society in Guatemala viewed women in a domestic relationship as a distinct group of individuals. The judge did agree, however, that Paula proved her membership in a particular social group by being part of a former domestic partner's nuclear family. "According to the Respondent, Mario Mendoza was known to 'intimidate the community' by shooting his gun in the air in the courtyard of their family's house so that the neighbors would know that he knew how to use weapons . . . Neighbors knew of his violent tendencies, as [Paula] testified that some of them knew that he abused her." In short, this man's violence was conspicuous, and the community knew of Paula's relationship. The conspicuity afforded by this relationship distinguished her as belonging to the particular social group, "Mario Mendoza's nuclear family." The judge also agreed that Paula had been persecuted because of her membership in Mendoza's nuclear family.

Where Paula's case failed was in proving that government officials in Guatemala were unwilling or unable to protect her; therefore, the judge ruled that she had not met the criteria for asylum. The judge noted in his opinion that the Guatemalan government created a Secretariat for Women's Affairs in 2017 to develop policies on women's issues. In addition, the judge said, Guatemala has established specialized courts and prosecution units to address gender-based violence. Under Guatemalan

law, men who injure women can face prison sentences ranging from five to eight years. "Although the government sometimes has trouble enforcing these laws, the record in this case indicates that the government was willing and able to protect the Respondent from the abuse she experienced," the judge wrote. Further, the judge argued that Paula could have contacted the police when her former partner was away to explain that she needed help. In the written opinion, the judge reiterated the fact that Paula received a protection order and that officers came to her house. Paula had also admitted that she never told police that Mario had violated the order, and never sought an extension for the protective order. She also admitted during cross-examination that she had responded to Facebook messages from Mario after she came to the United States with her son. In short, her argument that she was too frightened to follow up with officials didn't impress the judge. The judge ordered Paula removed from the United States, thus imposing a legal barricade to her incorporation into the US civic and social fabric. After the judge's ruling, she went from being an asylum seeker with work authorization, to having an order of removal and facing a return to the country she had fled with her son. Paula could appeal, meaning that she and her son would have to wait many more months, if not years, for the Bureau of Immigration Appeals (BIA) to review her case. In the meantime, she could remain eligible to work legally in the United States to support herself but would need to continue to pay for legal representation.

The Police Laughed

Teresita entered the courtroom wearing a salmon-colored blouse, a black jacket, and a skirt. A small gold cross hung from her neck, and she wore her black hair tied back in a bun. Her attorney, a balding man who appeared to be in his sixties, joined her. Sitting at the opposite table facing the judge's bench was the counsel from the DHS, whose job would be to argue for Teresita's removal and return to Honduras. Teresita was twenty-nine. The courtroom itself could best be described as austere: no windows, a well worn blue carpet, and six rows of benches for observers. The interpreter scrolled through his phone as he waited for the judge to enter. The immigration judge, a man who appeared to be in his forties, entered the courtroom in his black robe and everyone in the courtroom

stood until the judge settled in at the bench. Teresita and her attorney sat with their eyes fixed on the judge. The fieldnotes of Teresita's asylum hearing are presented below to capture the sense of how her case unfolded in court:

> The immigration judge asks Teresita: Is Spanish your best language? Do you understand the interpreter today? She answers affirmatively.
>
> Then he issues a warning: If the application for asylum contains any false information, "You can be barred from ever seeking an immigration benefit again in the United States."
>
> The attorney for Teresita informs the immigration judge that, "The client has recalled more detail of the story and that has been entered into the record." The judge sits reading this on his computer screen. There is a period of silence as he reads. Teresita's attorney enters several documents into the record, a birth certificate, a political magazine from the ruling party in her country of origin, and a statement from a witness as well as a psychosocial evaluation written by one of the authors. He also enters a report on the conditions in her country from the United Nations High Commissioner for Refugees.
>
> The judge then asks the attorney if he would like to have Teresita testify, and she takes the stand, wearing headphones for interpretation.
>
> ATTORNEY: Why are you afraid of going back? Why are you here?
> TERESITA: I was afraid for my life and my loved ones.
> ATTORNEY: When did it all start?
> TERESITA: I met him in March or April of 2015. His name is Juan Padilla. We started getting to know each other like a normal couple . . . Everything went well until we started to live together in March 2016.
>
> The judge asks her to clarify when she met Padilla. She can't remember the exact date, but she thinks it was April 2015. She states that they first had relations in September of 2015.
>
> TERESITA: It was going well but because of my studies at the university, I didn't see him often.
>
> Then their relationship shifted.
>
> TERESITA: He hit me for the first time on March 8, 2016.
> ATTORNEY: What happened that day?
> Teresita states that she came back late from her classes.
> TERESITA: When I came back, he was so mad at me that he hit me in the face with a closed fist.

He hit her three times that day despite her telling him to stop because she was in pain.

TERESITA: He said I'm now his property and I have to obey him.

Thus, a pattern began:

TERESITA: He started hitting me for every little thing.

The judge types this information into his computer as Teresita testifies. There is no court stenographer. The petitioner states that she went to the police about him and told an officer what happened.

TERESITA: When I told him my boyfriend's name, the officer laughed in my face.

ATTORNEY: So when you stated your abuser's name, they laughed at you?

TERESITA: They asked me why I wanted to smear the reputation of a public official in Honduras. I said I wasn't lying. I didn't want to damage a reputation. I just wanted to have my rights heard.

ATTORNEY: Did the officers give you any alternatives?

TERESITA: They said I should go back home and fix it there because it's a domestic issue . . . When I got home he was waiting there and he wanted to know why I went to the police. He told me that as long as his party is in power, there is no one who will be able to protect me.

She tells the court that he hit her harder than he ever had before.

TERESITA: That day, he slapped me, he kicked me in the stomach. He hit me for everything, whether I said yes. Whether I said no.

The judge admonishes Teresita that she is beginning to tell a lengthy narrative. He explains that she needs to only answer the questions.

He tells her:

JUDGE: You're doing a very good job expressing yourself, but you just need to give your attorney the information as it is asked. If he asks the date that you were born, you just give the date. Not where you were born or how you were born or anything about your parents.

With that, the questioning continued.

ATTORNEY: How many times he did rape you?

TERESITA: I don't know the exact number but probably over ten . . . He got to the point where he threatened me with a pistol and told me if I didn't do what he wanted, he could kill me.

She tells the judge that her former domestic partner thrust a pistol to her chest.

We present the field notes in their raw form to give readers a sense of the urgency and immediacy of testimony and proceedings in court. Teresita recounted her partner's abuse with exacting detail. In an interview prior to her asylum hearing, Teresita described her relationship with this government official, an older man she characterized as terrifying. She left Honduras to save herself and protect her family. "It was very violent. A lot of abuse. A lot of torture overall and the fear that because of me, something would happen to my family. I decided to take a path without knowing. Without having anyone here to support me. I think it was all about saving my life and my family."

Teresita's story comprises more than the brutality she endured at the hands of a violent partner. It is best understood as embedded in Honduras's social context, which has been shaped by political, judicial, and law enforcement indifference to violence against women.[38] Although Honduras has ratified treaties and passed laws criminalizing domestic violence, including rape and the murder of women, in practice, law enforcement and courts routinely ignore these mandates.[39] Honduras bolstered its military presence in the name of national security and the war on drugs, while at the same time using force against political opponents—factors that serve to legitimize violence in multiple spheres, including the home.[40] As explained by Bourdieu and Loïc Wacquant, in their conceptualization of symbolic violence, symbols and their meanings win legitimacy as they are accepted as part of the social order.[41] Acts of extreme violence by state actors legitimate violence in the private as well as public realms, including within families. Inequality, sexism, and the legitimation of violence against women become routinized, habituating people such that violence seems unexceptional and is normalized.[42] Human rights organizations identified numerous barriers to women seeking justice in that country, including threats to women by suspects to withdraw complaints, a practice that is often reinforced by the suspect's family members with impunity.[43] Although feminist organizations insist that Honduras provide specialized services to support women in obtaining assistance from law enforcement and the courts, the state has failed to provide them, thus leaving them exposed to gender-based violence.[44]

Teresita experienced this violence in January 2017, when her domestic partner put a gun to her head, ordering her to leave the university and move back home with him. He told her, "Either you do what I tell you, or I'm going to do what I should have done a long time ago because you don't listen to me anymore." She pleaded with him to give her a day to say good-bye to her daughter and her mother. He warned her that she had no more than twenty-four hours to return to him. When she arrived at her mother's house, she told her that she had to leave immediately and go to the United States. Her mother was worried. "She told me, 'How are you going to leave if you don't know the country? We don't know anyone who lives there.' And I told her, 'With God's help I'm going to go.'" Teresita later learned, after she reached the United States and was released from an immigration detention center, that the abuser went to her uncle's house looking for her. Since she hadn't told the uncle anything, he was able to answer honestly that he had no idea where his niece had gone. "My uncle didn't really want to let him in, but he knew how he was, so he did." The uncle reported that Teresita's now abandoned abuser appeared bereft.

> In court, Teresita testified before an attorney from the DHS, who cross-examined her.
>
> ATTORNEY: Are you afraid of going back to Honduras?
> TERESITA: Of course. Because of the torture I suffered there and because he could carry out the threats he made against me.
>
> The DHS attorney asks why she had no medical records, even though she had sought medical attention after he beat her. She had needed stitches twice.
> TERESITA: He would go with me. That way I couldn't say anything.
> And he would make sure where was no record kept.
>
> She used makeup to hide her injuries when she went out in public.
> TERESITA: I don't know how he got the medical records, but when I asked for them, they had disappeared.
>
> She then returned to describing her fear that her abuser would retaliate if she were to be returned to Honduras.

TERESITA: I think right now he's even more upset [because she left]. He's not going to forget. He's very authoritarian. He thinks that I'm his property.

During the cross-examination, the DHS attorney asks Teresita why she didn't go live in another part of Honduras, possibly with family who live farther away from where the couple had been staying. She responds that given this man's ties to the nation's leadership, she would never be safe. She says that no matter what, this man would track her down. After more than two hours, it is time for the DHS attorney to make his closing argument as to why Teresita shouldn't be granted asylum. Speaking from the small table across from the one occupied by Teresita and her lawyer, the DHS attorney—a man with a linebacker's build dressed in a blue suit—presents his argument.

ATTORNEY: None of these particular social groups are recognizable . . . The respondent fears a particular individual . . . There's a legal problem here. The social groups that are listed here are not particular social groups that are recognized. She fears a particular individual . . . He hasn't sought her out now for about two years . . . He hasn't gone looking for her since January 2018.

Teresita's attorney argues that she went to the police, and they didn't do anything to protect her. With that, the two sides rest and await the judge's decision.

The courtroom stayed silent as the judge typed into his computer. There was a whirring that sounded like a fan, and for several minutes, that was the only sound in the courtroom; the whirring sound was coming from the judge's printer. Finally, the judge reached for the document and spoke. He noted that Teresita filed for asylum a year after her arrival, thus satisfying one criterion for a successful case. The judge then went through the list of proposed protected social groups and said that some were too amorphous, too broad, and lacked distinct boundaries. He explained his decision to reject several of the proposed particular social groups by citing failed cases in which petitioners have sought protection by asserting that they were persecuted because of being young Salvadoran men or attractive Albanian women. As noted by one legal scholar, "Knowing how common violence against women is around the world, judges have argued that group size alone proves that a particular

social group like 'women' or 'women in Guatemala' is not 'particular' enough. Applicants are thus discouraged from claiming that they were persecuted because they were women. Instead, they have to resort to much narrower definitions."[45]

At this point in the hearing, it sounded as though Teresita might lose her case but then the judge turned to the fact that the police failed to protect Teresita when she sought their aid. He noted that Teresita sought the protection of police in her country, only to be turned away and told to reconcile differences with her boyfriend, satisfying the criteria for being unable to receive protection from the government. Eventually, the judge accepted that she did meet the criteria for asylum and announced his decision to grant Teresita asylum. As is legal procedure in asylum cases, he asked the DHS attorney if he planned to appeal; in asylum hearings, the government can appeal to have an asylum grant overturned, and these deliberations would be heard by the BIA. The DHS attorney declined the appeal. The judge spoke to Teresita, who was in tears: "I'm sorry this happened to you, but I hope that by having asylum you can begin to recover." For Teresita, the hearing ended with hugs and rounds of congratulations.

"A Dysfunctional Relationship"

When they sought asylum, the women we met did not think of themselves as being members of a "protected class" or "particular social group," and didn't think of themselves as having been targeted because of their membership in that class or group. They weren't thinking about filing deadlines or bars to eligibility for asylum. They were not thinking about their credibility or demeanor. But when they began the asylum process, filled out their asylum applications, and then appeared for their hearing before a judge, all evidence and testimony would become pivotal; failure to meet the legal standards for asylum could result in deportation. We build this discussion on the premise, based on comments made by attorneys we interviewed, that winning asylum through gender-based claims has become more likely in the past two decades, although the pathway is certainly tenuous. Being a woman in and of itself—no matter the intensity or gravity of the violence—doesn't meet the criteria for asylum. To win an asylum case, women and their

attorneys must prove that a woman suffered persecution and/or fears future persecution because of membership in a particular social group (among other criteria). Thus, we witnessed hearings in which attorneys argued that women experienced violence because, for example, they are related to a certain family member, as in the case of a woman targeted for violence because her brother had refused to join a gang. While more likely to be acknowledged than in the past, the tenuous nature of domestic and gang violence claims as a basis for asylum was revealed in our fieldwork. A disgusted immigration attorney complained that one client who endured severe abuse by her husband lost her case because it was heard by Judge [Name Redacted], "Where domestic violence cases go to die." This comment speaks to previous scholarship demonstrating the potential for judicial bias, in part based on a judge's background prior to presiding over immigration cases.[46]

The difficulty of winning domestic violence cases is illustrated by Valeria, who wanted to escape her husband's brutality. She had married a man in Mexico City and planned to stay with him permanently so that her children wouldn't suffer as she had as a child, after her father abandoned the family. Valeria explained her thinking in an interview several months before her asylum hearing:

> Maybe just so you can understand me a little bit, I was left orphaned by my father at the age of two. So, I was not, I did not grow up with a father figure . . . So, I said when I get married, I'm going to have, I'm going to marry someone, but for life. I'm not going to leave my children without a father. So, in that aspect, because, when the beatings started, I did not want my children to be left without a father. I wanted my children to have a home, a family. Until . . . the last time was when, that he hit me, he hit me, and he hit my daughter. Then my daughter got in-between to defend me and that's when my daughter told me, "Mom let's go, leave my dad because this is always going to happen. He hits you and he hits me." He hit both of us. And that's when I decided that no, no more. No more beatings.

Her husband eventually migrated to the United States, but it did not provide relief because he moved his brother into their home. He gave his brother instructions to watch his wife and report on her behavior.

The brother was to tell Valeria's husband if she and her children left the house, as well as other activities such as visitors dropping by. Valeria believed that her husband would one day return home from the United States, and that the beatings would resume. She described as well suffering the psychological injury of daily verbal abuse, all of which left her feeling humiliated. "Pardon these words, but he told me I had a head full of shit," she said. Despite the fact her abusive husband was in the United States, Valeria decided the only way she could be free of her husband's controlling behavior would be to go to the United States and establish herself there. Unfortunately, her asylum hearing didn't go well.

The judge noted in his decision that Valeria had testified under cross-examination that she had gone to the police in Mexico City, after her sister-in-law encouraged her to seek protection. At the time, Mexico City had a single domestic violence shelter, despite being among the most populous cities on Earth.[47] The shelter was situated in a converted house, and women had to show proof that they had filed a case against their abusers in order to access services.[48] On the stand, Valeria told the court that she believes women should be treated equally to men and that she expressed this opinion twice to her husband, who responded by beating her. She testified that her husband believed his wife was his property, and that he also physically abused their daughter. Her attorney argued that Valeria was part of a particular social group, Mexican women, and that she was being persecuted for her membership in this group. A political scientist testified on Valeria's behalf, arguing that gender relations in Mexico are not just social or cultural; they are political because resistance to gender norms is perceived as a transgressive political act, one engaged in opposition to extant power relations. The expert noted that while Mexico has developed a structure of policies to protect women, their execution is inconsistent, in part because of the rampant police corruption in that country. The testimony didn't convince the judge.

He wrote in his legal decision that Valeria didn't prove that her abuser harbored enmity toward Mexican women. Her adult daughter, who now resides in the United States as well, wrote in an affidavit that her father was violent toward her brother as well. "He would hit me and my brother, too, after hitting my mother. I lived through it all my life," the daughter said. The judge argued that because Valeria's husband had also abused her

son, she did not qualify for asylum. In the judge's opinion, Valeria hadn't proved that she was persecuted because she is a woman. For the judge, the violence toward the son diminished Valeria's claim that gender motivated the man's violence. "Despite the evidence of record regarding gender stereotypes and Mr. Ortiz's gender-specific expectations toward the Respondent (Valeria), the record does not show that Mr. Ortiz harmed the Respondent because she was a Mexican woman. Rather, it is evident that he harmed her in the course of a dysfunctional relationship with his family members. Regrettably, the harm to the Respondent at Mr. Ortiz's hands arose out of a personal animus toward the Respondent," the judge wrote in his decision. In short, the judge thought Valeria had suffered by virtue of "private" violence. The phrase "dysfunctional relationship" arguably implies a parity, as if all participants in the family were equally responsible for perpetuating a system of power and abuse.

The judge also denied Valeria's case on other grounds, stating that she had failed to prove that she suffered severe injuries because of membership in several particular social groups, including "Mexican women viewed as property by virtue of their position in a domestic relationship" and "Mexican women in domestic relationships." He argued that the idea of a domestic relationship has different meanings and is therefore inadequately defined. The judge wrote at length about the Mexican government's recent efforts to improve responses to domestic violence, and noted she last sought help from the police in 1991. Finally, he raised the issue of her husband's relocation to the United States. Although her children filed statements with the court stating they believed that their father would return to Mexico, as he had bought real estate there, the judge was not convinced. We note the judge's decision because it shows both the high standards for asylum, including establishing particular social groups, and it demonstrates the judge's unwillingness to view domestic violence as a political issue—one that arises by virtue of the systematic subjugation of women. Lost in the judge's framing is the understanding of violence against women as a product of larger, systemic forces reinforcing disparities that leave women vulnerable to abuse. The judge's decision left Valeria waiting for an appeal before the BIA as she tried to believe she would be allowed to remain in the United States, going about her daily life of work in a Mexican restaurant to pay rent in a suburban Maryland apartment.

In a similar narrative to that of the judge who denied Valeria asylum, former Attorney General Jeff Sessions argued in his decision in the *Matter of A-B-* that asylum "does not provide redress for all misfortune." This was the same decision in which he argued against granting asylum to survivors of domestic assaults as these were the product of "private violence." Clearly, however, domestic violence does not arise solely from interpersonal strife, intemperate spouses, or familial "dysfunction"; it is embedded structurally by virtue of institutions that fail to protect women, or that offer inadequate resources allowing women options for escape, such as well-paid jobs, social services, and domestic violence shelters. Further, it is reinforced in societies destabilized by military conflict, income inequality, and poverty. These realities emerged in interviews with domestic violence survivors for this book, including a woman from Honduras who was one of twenty children. Her father was killed when she was age five, and she was forced to live with a relative. She grew up working on a farm in lieu of obtaining an education, and thus never learned to read or write. A Guatemalan woman, Isabel, described growing up a campesino and tending to crops because her father said, "Girls aren't born to study. They're born to clean and cook for the house." Her father insisted that she work in the fields rather than attend school. Isabel, a dark-haired woman, spoke softly in a Zoom interview during the pandemic, sitting on the bed in a single room that she rented while working in a fast-food restaurant in the Washington, DC, area. Her mother migrated to the United States when Isabel was age five, leaving her in the care of her father. As a child, she suffered four rapes by male relatives. "I was an object to them. I didn't matter to anyone," she said. She reported the rapes to her father, who did not believe her.

Violence as Power

For Valeria, Teresita, and Paula, asylum claims based on domestic violence hinged on whether they could prove that the abuse they suffered prior to migration constituted persecution, and that their maltreatment occurred because of membership in a clearly defined social group—one that could be easily recognized by others in their home countries—and whether the police had been unwilling or unable to protect them. Asylum, the Cold War era process designed to protect victims of state

persecution and violence, must now be sought via narratives that can convince an immigration judge that her suffering wasn't just an unfortunate family matter. While nations such as Honduras have ratified policies to criminalize intrafamilial rape, violence, and murder of women, structural factors, including the militarization of that nation following the 2009 coup, serve to routinize violence; institutions that are supposed to protect them often fail to do so, thus subverting the rights of women to equal justice under the law.[49] In Guatemala, as the state attempts to establish democratic institutions following thirty-four years of civil war and egregious human rights violations against that nation's indigenous population, trust in state institutions remains elusive, perpetuating violence in neighborhoods and communities.[50] An examination of a series of gruesome murders of women in Ciudad Juárez, Mexico, that began in the 1990s and was distinguished by the mutilation of bodies of females as young as age eleven, noted that nation's meager efforts to protect women from violence, including those who endure it in their intimate relationships.[51]

In short, the domestic violence Teresita and others experienced persists because their countries of origin either allow it to go on with impunity or settle for policies that appear suitable on paper but remain essentially unenforced. Abetting the perpetuation of severe domestic violence are multiple spatial practices: Political institutions lose trust because legal rights exist without being buttressed by programs to reduce social and economic inequality, leaving in their wake a fearful and alienated populace, arrangements that are particularly problematic for women.[52] Laws exist on paper alone, and without proactive interventions by the state, patriarchal systems supporting men as heads of household and excluding intrafamilial violence from the scope of government authority allow violence against women to persist. Large-scale violence, including war and political repression, shape individual subjectivity, including how violence is felt, perceived, and navigated by those enduring it—a fact that, lamentably, serves to normalize it.[53]

In this context, the issue of whether domestic violence should constitute a legitimate claim for asylum remains unresolved and deliberately diminished in narratives that characterize it as an unfortunate family matter. Violence erupts in families by virtue of their social, political, and economic contexts, forcing women to flee to the United States after ex-

hausting options for safety at home.[54] It never emerges without a social and political context, and this point raises questions about whether the asylum system here—one that is informed through an accretion of judicial precedents as well as interventions by presidential administrations—has evolved adequately to protect women from Mexico and Central America who come to the United States to flee violent partners. When Valeria experienced beatings in Mexico City in the 1990s, there was essentially no system of supports for battered women such as shelters. Teresita went to the police, only to be turned away and told to reconcile with her partner. When Alejandra has her hearing next year, her outcome will hinge, in part, on whether her attorney can convince an immigration judge that her abuse rose to the level of persecution, that she was abused because of her membership in a particular social group, and that the Guatemalan government was unable or unwilling to protect her—a standard that could go unmet if the judge believes that Guatemala is making a good faith effort to protect women.

4

Criminalizing Asylum

Alejandra, the Guatemalan woman we described in the preceding chapter, finally found the means to escape her violent partner while he was at work. With only one hundred Quetzals saved, the equivalent of twelve dollars, Alejandra packed a bag, gently lowered her son from the window, and then followed behind him. Two hours later, covered in mud from running across the dairy farm in the rain, they reached her father's home. With earnings from his job as a truck driver, her father was able to provide Alejandra with cash to embark on the journey to safety in the United States. Approximately two weeks after fleeing her abusive husband, she and her son crossed the border. And with that, the arduous struggle for asylum began. "When I came to the United States, Immigration detained us. Being in the asylum process, there were various occasions that we had multiple interviews. Each person asked us various questions," she said. "The interview that [immigration officials] conducted was to ask me the reason for me coming to the United States. I told them the reason for coming was for domestic abuse."

Teresita, whom we described in the preceding chapter, fled a violent domestic partner after accepting $300—the only money her Honduran family could spare—to fund her journey to the United States. Entrusting her daughter to her parents, she put her belongings in a suitcase and left town. She dressed herself smartly while rolling a small suitcase behind her. "I was trying to look like a tourist," she said.

Guadalupe's journey to asylum began at age twenty-four. She grew up in a small village in El Salvador and described a peaceful childhood spent climbing trees and caring for the family's chickens and dogs. Her father worked as a plumber and sewed pants to support her and four siblings. Her mother sold handmade souvenirs to tourists, each labeled with the words, "El Salvador." As she grew older, Guadalupe worked as a teaching assistant at a local school. That was before being awakened one Sunday morning by a series of popping sounds, as we described in

chapter 1. Seventy-eight days after her father's murder, after spending much time in panicked hiding, Guadalupe, an older brother, and her seventy-year-old mother decided to make the long journey from El Salvador to the Mexican/US border. They often met other asylum seekers walking toward the United States, and shared strategies to safely reach and cross the border. Following their border crossing, after walking an additional two hours, Guadalupe and her family saw the United States Customs and Border Protection (CBP) ahead detaining migrants and asking for identification. She remembers the desolate stretch of desert was busy that day as dozens crossed, prompting one Border Patrol officer to exclaim, "Oh my gosh!" Guadalupe laughed at the memory. She had no idea where exactly they crossed the border but remembered the cold as they stood, waiting to be transported to a detention facility. As they waited, she listened as migrants from El Salvador, Guatemala, and Nicaragua told Border Patrol officers that they came seeking asylum in the United States.

This chapter traces how women crossed the Mexican/US border and were subsequently apprehended. It examines their initial efforts to contest deportation, as well as attempts to convince US immigration officials that they had a credible fear of future persecution if returned to their countries. We revisit the concepts of symbolic and structural violence to understand how both intersected to inform women's experiences at the border.[1] Structural violence in this context constitutes a series of laws since the 1990s that brought greater criminal penalties for those who cross the border without authorization, escalated militarization of the border, executive branch actions meant to deter asylum seekers, and other laws and processes that Juliet Stumpf called "crimmigration."[2] The concept of "crimmigration" encompasses narratives and policies that conflate criminal law with immigration, a public perception entwining the two that has become more intense with increased immigration enforcement.

Symbolic violence is also evident here. Although the United States enshrines the right to seek asylum in law, apprehensions and incarceration of asylum seekers, coupled with political narratives about the need to "secure the border," arguably ascribe to women who are fleeing unspeakable violence a status as lawbreakers.[3] Routine arrests and detention of asylum seekers thus culminate in legal violence against

this population, processes that cause immediate harm in the form of detainment and punishment, but also threaten long-term outcomes by stigmatizing them as unacceptable for social inclusion.[4] Legal violence includes both the structural and symbolic violence embedded in immigration law and that produce "immediate *social suffering*."[5] The arrest and detention of asylum seekers constitute a key element in our framework of compounded marginalization: Through processes such as fingerprinting, interrogation, and detention, immigration officials and policies attribute a quasi-criminal status to the women we interviewed in the eyes of the broader society. Although the women were not deported after apprehension, we note the symbolic violence of ascribed criminalization as part of compounded marginalization, a social space of limited legal rights, and a dubious reception by the wider society. We show that while facing adverse circumstances, women strove to achieve agency while entangled in a system designed to be deliberately disorienting and frightening. Held in hieleras, the intentionally cold detention cells staffed by CBP, they remained resilient and engaged in communal resistance.

"Catching" Asylum Seekers

The CBP website, which acknowledges violence and the need for asylum as reasons for unauthorized crossing, focuses predominantly on a "crisis" demanding effort to thwart threats to national security.[6] In a photo, brown-skinned people huddle together under the watchful gaze of Border Patrol agents, and a caption beneath notes: "US Border Patrol agents working in El Paso, Texas apprehend 1,036 illegal aliens, the largest single group ever caught."[7] The idea of these people having been "caught" signals an indication of criminal behavior, as police catch suspects in burglaries or carjackings. Dehumanizing elements emerge in this narrative as well: After all, fish may be caught in nets or raccoons in traps. This message fails to convey the fact that some in the photo might need asylum; instead, the Border Patrol consolidates detainees under the banner, "illegal aliens." Crossing the border—no matter the reason—emerges as a threat to national security. Following this mass arrest, CBP chief Carla Provost told a House committee: "Border security is national security—there is no difference—and the crisis on our southwest border

puts our national security at risk."[8] Unacknowledged in this discourse is the fact that seeking asylum is legal.

While immigration law is generally civil in nature, the rhetoric surrounding immigration deterrence and enforcement is rife with references to illegality, criminality, and national security.[9] Immigration enforcement brings with it the hallmarks of criminal law enforcement including apprehension, interrogation, surveillance, and detention. Policing immigration violations has come to resemble criminal arrests and prosecutions, with women being apprehended, shackled, detained, and deprived of food. Some CBP officers call them criminals. Yet, they lack many of the basic rights and protections of criminals, such as a right to appointed legal counsel and presumption of innocence.

States defend borders to establish and maintain sovereignty, thus engaging in a production of social space that emphasizes power and inequality.[10] Deterrence and deportation serve not only to exert sovereign power over those who transgress a nation's borders; the capacity and willingness to forcibly remove people speak to a state's perceived efficiency and thus serve as an integral component of its legitimization in public discourse.[11] The immigration court and policing systems routinize deportations, processes that include the adjudication of asylum hearings where a likely outcome is a removal order. The state emphasizes deportations as a natural consequence for the transgression of borders, although such processes serve the project of statecraft by defining national identity as well as functioning to maintain racial and ethnic homogeneity by labeling Latinos as undesirable regardless of their reasons for coming to the United States.[12] Border enforcement thus serves a performative function: Nations want to be seen as benevolent protectors of human rights while at the same time appeasing electorates through strict migration control.[13]

While Americans generally embrace the "nation of immigrants" moniker, enmity and xenophobia also punctuate US immigration history.[14] Throughout US history, immigrants have been deemed an invasion, a flood, a wave, and other terms that evoke menace.[15] Certain Americans' attitudes toward Latino migrants took a decidedly gendered tone, with Latinas' fertility being considered a threat as nativists argue that high population growth will eventually leading to the "reconquest" of the United States by Latin American nations.[16] These narratives deride La-

tinas because of their fertility, arguing that they will produce too many children and alter both the demographics and culture of the United States—utilizing disproportionate levels of medical care and welfare in the process. Samuel Huntington famously posited the threat posed by Latina migrants in 2004: "In this new era, the single most immediate and most serious challenge to America's traditional identity comes from immense and continuing immigration from Latin America, especially from Mexico, and the fertility rates of those immigrants compared to black and white American natives."[17]

The "anchor baby" narrative augments the Latina fertility threat; Latina women allegedly come to the United States with the goal of giving birth to a US citizen, thereby providing themselves with a path to legal status.[18] This narrative is false, but such attitudes influence asylum seekers' treatment at the border. When women cross the border and ask for asylum, they enter what Nicholas DeGenova and Nathalie Peutz call "the Deportation Regime," in which all who cross the border from Mexico—regardless of the reasons for doing so—are characterized as illegal.[19] Efforts to prevent asylum seekers from reaching the border aggregate them in public perception, and sometimes via policy, with other unauthorized migrants.[20] Thus, at the border, two competing policy imperatives collide: the United States' insistence on arresting and detaining asylum seekers who cross the border from Mexico, and providing humanitarian assistance and welcoming those fleeing persecution. The women we met navigated these competing realities throughout the asylum process. After making the decision to leave their home countries, and in many cases, their own children as well, they undertook the arduous journey across the border. The Border Patrol apprehended and incarcerated them. In what follows, we describe women's encounters with law enforcement at the border.

Coyotes and Alligators

Most women we spoke to did not intend to enter the United States clandestinely and remain here without authorization. Rather, they described searching for Border Patrol agents after crossing the desert. The Border Patrol apprehended Alana, a twenty-eight-year-old Salvadoran, after a frightening crossing of the Rio Grande in a makeshift raft. She didn't

want to cross the river because she could see what she thought were crocodiles in the waters. Alligators inhabit the Rio Grande and its surrounding habitat. Although Alana feared the sharp-toothed reptiles, the coyotes—individuals who help smuggle people across the border—insisted on moving Alana and three other women across. They shoved Alana into a raft. "The boat was almost sinking because it was inflatable and had holes, and it was filling with water. They threw us in the inflatable boat that was already sinking, and there were crocodiles. They were chomping. Somehow, we ended up on the other side." The coyotes who promised to lead them to safety instead left the women stranded. They directed the migrants to follow a light in the distance, which they said was Houston, Texas—a deliberate deception. Houston is almost 400 miles away from the Rio Grande. Alana and the others then negotiated a daunting terrain of mud while they searched for a Border Patrol agent to whom they would turn themselves in and ask for asylum.

The trip across the border invariably left women exhausted and dehydrated. Despite the rigors of the journey, women worked to help one another, as shown by Alana's efforts to aid an injured woman as they walked through mud. Alana recalled the physical stamina required to manage the terrain while she tried to help another woman who had a knee injury walk to safety. "[The coyotes] left us there stranded and so we walked. I came with a girl that I met on the way, and she was hurt so I was supporting her, and we saw the men from Immigration and so we waited so that they would apprehend us." Teresita remembered a man who yelled at others to avoid mistakes that could arise from exhaustion and fear. "He said, 'Don't run! These people have dogs. They will unleash them on you,'" Teresita recalled.

Both the journey to, and heavily militarized law enforcement of, the southern US border pose a deterrent to asylum seekers. Women described fear of the difficult terrain, long distances, and the violence committed against people as they make their way through Mexico and across the United States' Southern border, risks that have been amply documented in scholarship on human smuggling and passages through this migration corridor.[21] Ten of the forty-six women we interviewed left children behind in their home countries so they could avoid putting the children's lives in danger or because they couldn't afford the transportation and coyote fees for the entire family. The journey to the bor-

der, which typically entails reliance on human smuggling networks, is fraught with danger: Criminals prey on migrants, resulting in robberies, kidnappings, and murders. Gender-based crimes are routine.[22] Coyotes profit from increased enforcement, treating migrants as cargo and forcing them into substantial debt to smuggling networks.[23] Migrant deaths along the Southwest border have increased because, "The hardening of the border at one location will lead migrants to shift to new, less patrolled, likely more remote and riskier crossing sites, and to make more frequent use of coyotes."[24] The International Organization for Migration (OIM) Missing Migrants Project recorded an average of 457 migrant deaths and disappearances annually between 2014 and 2021, making the Southwest border the "deadliest land crossing in the world."[25] According to government figures, more than 560 migrants died in fiscal year 2021, and more than 800 perished in fiscal year 2022.[26]

Jacinta's story illustrates how women weighed the calculus of risk when deciding whether to bring children. She left a seventeen-year-old daughter, an eleven-year-old son, and a four-year-old daughter in El Salvador. Although her husband had never abused her children, he repeatedly raped Jacinta before threatening her with knives and finally at gunpoint, leaving her too frightened to sleep. "I just couldn't take it anymore," she said. She talked to her children about her plan to escape, assuring them that their lives would be better if they didn't have to witness the violence. Her husband told her that he would go to the police and have her arrested for kidnapping if she tried to bring her children with her. "I left with a pain in my soul because I had to leave my children. I had a four-year-old little girl." In 2019, her eldest child joined her in the United States.

Although we did not ask women to describe migration, several offered descriptions of their journeys, and we note that they speak to their determination to reach the United States as well as to structural factors shaping their experiences. After deciding she needed to escape her abusive husband in El Salvador, twenty-seven-year-old Amaia began a process described by many we interviewed: She asked relatives in the United States for money to pay coyotes and/or for public transportation to reach the Mexican/US border. She also sold off what possessions she could to finance her journey. She and her six-year-old son traveled by bus through Mexico, then waited fifteen days in a house operated

by coyotes for their turn to cross the border. "During this time, there were a lot of restrictions because there were a lot of people waiting and they hadn't brought a lot of food," Amaia said. "At times, there was only enough food for one person, so I gave what I had to my son." Amaia recalled that older boys took charge of ensuring that her six-year-old could traverse the terrain, at times carrying him.

Ines, who sought asylum because of gang violence in Honduras, said she traveled through Mexico and across the border with her two children, ages fifteen and four. Ines recalled the violence she witnessed. "I crossed Mexico with two children, young ones, exposing me to something happening to us, because Mexico is really difficult to travel through. There, we encountered a lot of trauma, one that you never think you're going to live through. It's a country that is very violent, and there were people who were horrible. It was only a week, but the most horrible was to cross through Mexico," she said. For many, the terrain itself seemed impenetrable. Alondra recalled spending seven days walking through the desert, a journey that required stepping through cacti. She thought that she would never reach the United States and would be left to die in the desert. By the time the Border Patrol arrested her, she was fainting repeatedly. She had no skin left on either foot; cactus needles pierced the skin all over her body. Crossing the border in dangerous locations and traversing hazardous terrain becomes the only option for reaching the United States because of policy decisions stiffening border enforcement and forcing migrants into clandestine, dangerous routes through Mexico that leave them exposed to robberies, rapes, and extortion. Such conditions arise by virtue of an emphasis on national security at the border, coupled with the logics of capitalism in which human smuggling renders people a commodity.[27]

Detention and Deterrence

Amaia and her six-year-old son followed the coyotes who told them to move toward a stable in a field where cows grazed. Once inside, they hoped to rest on straw there, but they suddenly heard helicopters flying overhead. Stepping outside, they saw that the stable had been surrounded by Border Patrol agents. "They told us not to move and they were pointing at us with their pistols. My son was crying. I am never

going to forget it. Because they pointed at us with their pistols and my son was good and nervous and couldn't stop crying," Amaia said. With that, Amaia described a scene that we heard about repeatedly in interviews: They were loaded into a Border Patrol van and taken to a temporary holding cell, like a local jail where people arrested for criminal violations are held until they are charged with a crime. Once they reached detention cells, guards confiscated sweaters and sweatshirts worn by adults but allowed the children to keep theirs before leading them into the hieleras—cells named for the Spanish word for ice box or freezer. Temperatures inside these facilities are so cold that both guards and detainees use the word hielera to describe where people sleep on concrete floors with only aluminum blankets for warmth.[28] The lights are often kept on all day, so detainees do not know whether it is night or day. Women repeatedly described the conditions as onerous: so cold that they all had to huddle together for warmth, with meager food ranging from a thin sandwich three times daily to only juice and a cookie three times daily for one detainee. A case manager who works at a non-profit legal and social service agency said women frequently congregate near the toilet because the plumbing provides the most warmth available. In the worst incident the case manager described, women finally urinated and defecated on themselves in a desperate effort to stay warm. Women noted crowded conditions. "There was one toilet there in the cell, and it's right there where the whole world sees you when you're using it," one woman said.

Camila, a forty-six-year-old Salvadoran who crossed the border in 2018 with her sixteen-year-old son, described her first few hours in the United States: "So, the first day I stayed in this room filled with people, and a lot of women with kids, and I stayed in a corner. I spent the night there. The following day they moved me to another room. It was the same thing, a lot of people, a lot of women, a lot of kids, no space. And then they took me to a very cold room, I was there alone. No food, no blanket."

She spent seven days apart from her son, not knowing his location. She was moved again to a room crowded with mothers and small children. "The person in charge would go by the cell and would only give food to the kids. And the adults, we were hungry," she said. "They told us the food was only for the kids, no adults." Women complained that food

was never adequate for adults, although children sometimes received rations such as take-out pizza. Women told the case manager referenced above that they had been served frozen food while sitting in the hielera, with no means to heat it.

The CBP Detention Standards mandate that detainees be granted access to drinking water, snacks, and meals, as well as personal hygiene items such as toilet paper. Legal mandates can be ignored, however, especially with the tacit blessing communicated via US public discourse and policy. "Law enforcement agencies do not systematically record discriminatory practices because many such practices are legitimized, occur outside public view, and are not employed against the general White middle-class population."[29]

Guadalupe, the Salvadoran who migrated with her mother and brother following the shooting death of her father, recalled that once they reached a Border Patrol station, officers checked their hair for lice. If they found any, the officers asked, "Why didn't you bathe?" Officers asked this question knowing that women travel weeks or months to reach the Mexican/US border, often sleeping on the ground. Guadalupe found herself trying to comfort her seventy-year-old mother as they witnessed the handling of other detainees. One woman appeared to have crossed the border while pregnant. "There was a woman who had been walking the same time with us, but I don't know if she was coming pregnant, I don't know. But she sat down on a chair, and then [the officers] told her to stand up and grabbed her by the hand. They grabbed the chair and told her that they had to throw out the chair," Guadalupe said. "They said that they needed to throw out the chair because she could have had some infection." They forced her to stand while ridiculing her with the idea that she could be bringing disease into the United States.[30]

Teresita, the Honduran who escaped domestic violence by posing as a tourist, recalled asking a guard for a tampon, only to be told: "This isn't a hotel." As she tried to sleep huddled with others on a concrete floor, Teresita felt relieved that she had left her five-year-old daughter behind. "I remember thinking that she would have had to go through all of that," she said. Older male children were housed separately, causing worry. Women say they are kept awake by light that burns all night or, in some cases, experience darkness throughout their stay, which scares children, the non-profit organization case manager said. Bed checks at odd hours

of the night also disrupt sleep. Several women described being moved from the hieleras to *perreras*, the Spanish word for dog kennel. The perreras are chain-link fenced cells used to detain people; they are typically overcrowded and have thin mats where people sleep.[31] The terms hielera and perrera speak to a deliberate practice of dehumanization stemming from racialized policies and discourse questioning motives for both asylum seekers and migrants seeking work.

Racialized narratives, coupled with policy, render the border untenable for asylum seekers. As this chapter shows, the policy imperatives of deterrence, enforcement, detention, and security eclipse the protections one might expect when considering the meaning of asylum and its implicit promise of safety and protection. Put another way, women who cross the border to seek asylum, often accompanied by children, are treated as criminals. Such treatment is not simply another unfortunate turn in life for women who need asylum: It results from an accretion of policies, including those limiting opportunities to migrate to the United States lawfully, few opportunities for refugee resettlement, and tightening asylum policies. While US law maintains it is legal to apply for asylum regardless of how one arrives in the country, the result of border policies is to ascribe criminal status even to those who have entered the United States to flee persecution.[32]

Feeding the "Dogs"

The CBP Detention Standards require that detainees be held in the hieleras no longer than three days, and thus women found themselves moved next to either a detention center or a perrera before being placed in a detention center for a longer stay preceding their release. Women described their circumstances—multiple transfers to various facilities, a lack of knowledge about asylum procedures—as disorienting, and their accounts sometimes led to varying descriptions of detention conditions, credible fear interviews, and bond payments. Border officials transferred Alondra, who said her feet resembled raw meat after both her shoes and skin were shredded by cacti, to a medical facility, where she received treatment before being released from custody. Alondra's treatment seems relatively humane. By contrast, another asylum seeker spent a month in a detention center where guards announced mealtimes

by saying, "It's time to feed the dogs." A Guatemalan woman housed in the perrera with her one-year-old infant described deliberate mistreatment. The guards denied her baby medical care when she spiked a high fever. "They looked at her and told me she seemed fine and told me to take off some of her clothes and that this is normal for children," she said. Luckily, another detained woman had somehow managed to hide several over-the-counter capsules in her long, thick hair. The smuggled medication lowered the baby's temperature.

In what follows, we describe how a constellation of processes—stays in detention centers, mistreatment by guards, bewildering paperwork, interviews with government officials, and a lack of access to legal representation—can be used to dissuade asylum seekers from remaining in the United States. Many women said they didn't know about asking for asylum: They just knew that they needed to escape gender-based violence. The Border Patrol asked why they had come to the United States. When they reported their stories of severe violence at the hands of gangs and domestic partners, some CBP officers provided misinformation as well as derision. One asked Teresita, "Do you know that you committed a crime?" He referred to her having crossed the border without authorization to ask for asylum. A guard told Guadalupe, "You all came here for nothing because in two days you're going back to your country." Other women reported that the officers told them they should apply for asylum. "The truth is, I had no idea that political asylum exists," said a Guatemalan who fled the domestic partner who threatened her life. "[The Border Patrol] told me I had to apply for asylum. After that, I began to ask, 'What is asylum?'" She came knowing only that she had to flee Guatemala and hoped for safety in the United States. Others who spoke to officers were told they would be sent home, even after explicitly stating that they needed asylum. "One officer told me, 'Everyone is saying they need asylum now and it's just a lie,'" said one Salvadoran woman. "The officer said that we're all lying." Such accounts are arguably confusing: In one case, a woman learned about asylum for the first time after talking to a Border Patrol officer. Another was accused of lying. Such accounts speak to the positionality of asylum seekers in comparison to the authorities charged with handling them: With luck, that encounter can be relatively benign, and without it, it can be replete with deliberate misinformation and degrading treatment.

Immigration attorneys who work for non-profits near the border argued that conditions in detention focus on the single imperative of deliberately deterring people from remaining in the United States, regardless of their reasons for coming. Some women we interviewed were offered so-called voluntary departure, a policy that allows migrants to leave the United States without a formal removal order and the penalties that come with deportation.[33] Women refused to sign voluntary departure documents—an act of resistance that became key to remaining in the United States. Border Patrol and Immigration and Customs Enforcement (ICE) agents often pressure asylum seekers to sign papers ordering their own removal from the country, according to immigration attorneys we interviewed. "They're often insisting that they sign various documents, and that they can't read, and that are not translated for them," said an attorney who handles asylum cases. "And some [of the documents] are benign, and other things are not," she said. The accounts given by the women we interviewed and the attorneys who represent them echo recent scholarship describing the border as chaotic for asylum seekers, a place where they encounter uncertainty and anxiety.[34]

The relocation of asylum seekers from hieleras and perreras to longer-term detention facilities by border officials generates additional confusion and anxiety. Late-night bed checks, multiple transfers to various facilities, and even changes in such policies as whether detainees are given an extra piece of fruit during the day conspire to make detention disorienting, explained one case manager working for an organization near the border. With several exceptions, women described staying in detention facilities for approximately one month while waiting to hear whether they had passed their credible fear interviews (if they received one) as well as for their families or friends to help them post bond. Border Angels, a non-profit serving migrants and asylum seekers, reports that the usual bond for people who are arrested after crossing the border is $1,500, although some pay considerably more.[35] With few exceptions, women didn't know the roles of those who oversaw their confinement. A Salvadoran recalled being in a dormitory where workers gave her English-language papers and told her that she needed to find a lawyer once she was released. One woman said a psychologist spoke with her while in detention. Compounding the confusion are changes to the asylum process, often by virtue of executive actions, court deci-

sions, and legal interpretations. "So those rules change so frequently," an immigration attorney with a border region a non-profit said, "And what we hear from our clients is that they're often told or explained parts of asylum, or their process, from GEO [private prison] guards or even sometimes from ICE officers and, whether that's in good faith or not, it's also confusing."

The United States manages an immense immigrant detention system that includes a network of for-profit detention centers operating under contract by the Department of Homeland Security. The DHS also contracts with state and local jails and prisons to hold asylum seekers and other immigration detainees alongside criminals. These detention facilities house approximately 350,000 migrants annually, or 30,000 daily, frequently detaining asylum seekers together with non-citizens who migrated for other reasons, as well as those who committed crimes in the United States and are in removal proceedings.[36] For-profit detention conglomerates such as GEO Group, CoreCivic, and LaSalle Corrections have driven advocacy to increase detention, profiting from the warehousing of migrant adults, children, and families.[37] Ixema's story illuminates the question of how incarceration at the border shapes asylum claims. Ixema and her husband fled gang violence in Honduras: MS-13 threatened to rape her if they didn't comply with gang demands to use her husband's large motorcycle to commit crimes. After traveling to the United States and being apprehended at the border, Ixema faced a $12,000 bond and was held six months while she waited for family members and friends to collect enough money to facilitate her release. That process took place despite what a Border Patrol officer said to her husband initially upon their arrest: "We were told that they weren't taking any asylum cases, and that we should just leave." After the hieleras, the Border Patrol placed Ixema in a detention facility, but officials then transferred her to a jail in Pennsylvania where she lived in a large cell with thirty-eight other women. None were allowed to leave the cell, which had one small window. She described the conditions: "And there it was like a prison. It wasn't familiar. The first place I stayed there was like a television and there were things like crocheting, things like that. Then they took me to a place that only had a cell, nothing else. There, I'm not sure how long they kept me there. Then they took me to Pennsylvania, and that's where I was most of the time."

Each transfer happened late at night, adding to her anxiety. Ixema's experience echoes the statements from lawyers and social service providers near the border—that the treatment asylum seekers experience is designed at best to be disorienting and at worst, so odious as to compel them to leave. Her husband, whom she was separated from following her apprehension, complied with the Border Patrol's wishes and agreed to be deported to Honduras, despite knowing he would return to a neighborhood dominated by MS-13. She explained the strain detention and pressures by Border Patrol agents put on her marriage:

> I don't know why he [her husband] wanted to go back, maybe the confinement, I don't know. But when he told me that we should go back, I said no because I was afraid . . . He said, no that I had to go with him to Honduras, and I told him no. So, there another problem started for me because he left, and he got upset because I didn't go back with him. Then I had another problem because that's when he started calling me, threatening me, things like that because I let him go there alone. Then problems started with him. I told him that I was not going back there.

Ixema and her husband divorced after he returned to Honduras.

Despite the vicissitudes of confinement, women found ways to sustain themselves. Teresita, the Honduran who fled a domestic partner who had put a gun to her head, recalled how she took charge of greeting new women as they arrived at the detention center. "I was very friendly. There were some new people who came, I was in charge of taking them to their room and I tried to talk because I felt that it was helping me," she said. Teresita had no family in the United States to post her bond, so a Salvadoran woman who befriended her called her family to ask for assistance. The friend called a boyfriend in Maryland; he spoke to Teresita over the phone and made a promise: "He said, 'Don't worry. We're going to turn things around for you. We're going to pay your bail.' My bail was $1,500 and I didn't have the money. And he told me, 'We're going to bring you here.' I was so happy . . . They paid my flight. They paid my bail. They brought me here (to Maryland). And when I got here, they took me to the lawyer. They're my family here."

Waiting for Release

Carina, a Salvadoran who sought asylum following MS-13 death threats, remembers being bused to a courtroom with one hundred others; there, officials ordered her to admit to entering the country without authorization. If she failed to admit having entered illegally, she was told, she would be held for two months before being deported. Carina recalled never being asked her reasons for migrating. She spent her time in custody working for meager wages, and she described her days. "I worked inside the detention center. If we got up early at four in the morning, they would pay us two dollars daily. If we worked in the afternoon, they would pay us one dollar a day for cleaning. On the twenty-first day, I had finished cleaning inside my room, and they [guards] called me." They asked her the address of an uncle in the United States who had agreed to post bond. A guard explained that she would be released: "On the twenty-second day, they released me and told me congratulations. They took us to an ICE office, where they gave us (she and other detainees) paperwork which stated that we should be present at all court dates. They let us borrow the phone so we could call our families, so that they could purchase the [airline] ticket for us to get to them. That's all that happened."

Most women described having multiple interviews, initially by CBP officers while detained in the hieleras and later by officials in the detention centers. For most, the stay in detention culminated in an interview with immigration officials by phone to determine whether they would be allowed to seek asylum and remain in the United States. As we noted previously, there often exists a gap in how asylum law is supposed to work and its actual functioning. Credible fear interviews are often administered to detainees to determine if they have a "significant possibility" of establishing eligibility for asylum if she were allowed to plead her case before the judge.[38] We asked women if they had undergone credible fear interviews, and they responded that they had given interviews about their need for asylum. They were not told the reasons for these interviews or who would conduct them. The interviews usually lasted one to two hours as women described the rapes, assaults, extortion, and death threats that forced them to leave their countries.

With the exception of a few who had no interviews, it appears that women demonstrated a credible fear of persecution to an asylum officer and thus would be allowed to plead their cases before an immigration judge. United States Citizenship and Immigration Services instructs asylum applicants to provide as much detail as possible during credible fear interviews. The women we interviewed described giving straightforward, factual answers detailing rapes, stalking, gangs, and extortion. These interviews determine whether they would be deported or allowed to remain in the United States to argue their cases—possibly a life and death decision. Women did not have legal representation and had to speak to asylum officers using an interpreter. As noted before, this interview typically took place over the phone.

Esmerelda, a Salvadoran who crossed the border in 2017, recalled passing time in a detention center after learning she would give a credible fear interview to determine whether she would be allowed to remain in the United States. Some women were given interviews within five to ten days of arrival, but Esmerelda had no idea why she waited three weeks. Unlike most we interviewed, Esmerelda had her credible fear interview in person:

> We were in a small room, in a small office. There was only the person who was interviewing me, with the translator on the phone. It was a woman. She didn't have a uniform. It was normal, day clothes. And the truth is, she only told me I would do the fear interview, and what were the reasons I couldn't return. And then she became very serious. She didn't show any, no emotion. She was always very serious, and she limited herself to the questions she had online and on paper. She did not comment on anything. She did not add anything to what was written. She only asked, I answered. She asked the next one (question), I answered and that was it.

Officials told Esmerelda that she would receive a letter with a decision on the results of her credible fear interview. They returned her to the detention center to wait. One day, guards took her to a room to sit with others as an official read the letters to detainees who sat in chairs, nervously waiting to hear if they would be deported. He read the letters aloud, as detainees learned whether their fears were deemed credible

and how much bond they would need. Although Esmerelda's interview was unusual by virtue of being face-to-face rather than by phone, it was typical in many ways. She carried the burden of convincing an official that she faced persecution if returned to El Salvador. And once out of custody, her movement would continue to be monitored by DHS. Methods of surveillance after detention vary. For example, several women were forced to wear ankle bracelets, which ICE views as an alternative to confinement, although most did not.[39] Others must attend regular check-ins with ICE officers or submit to visitation by the agency at their homes. Yet some are released without any form of surveillance, with the expectation that they simply show up for their court hearing. Experts we spoke to could not explain the lack of consistency that women experienced, other than to speculate that individuals processing them at the border may have perceived differing needs for monitoring or that resources varied at different locations in the interior.

Hardening the Border

A robust scholarship exists examining the contradictions of border policing in an era characterized by the displacement of millions globally; factors informing this annual displacement include economic fluctuations precipitating job loss and access to resources, land rendered non-arable by climate change, war and destabilized nations in the Global South, as well as the violence and persecution necessitating asylum claims.[40] Citing United Nations High Commissioner for Refugees statistics, Saskia Sassen noted that an estimated 42.5 million people were displaced in 2011, a total that includes 895,000 seeking asylum globally.[41] Resettlement programs and pathways for entering countries as refugees are sparse. Only 1 percent of those needing resettlement as refugees receive it.[42] This displacement and movement of people across borders are often met by nations' escalated efforts to fortify borders and to view even the most beleaguered with hostility. "Most countries do not allow asylum at their embassies, and it is not routine practice anywhere. There are very few 'humanitarian corridors' providing a legal way for refugees to travel to a safe country and ask for asylum."[43]

Thus, asylum seekers at the Mexican/US border become ensnared by vigorous, militarized policing practices that include use of infrared sen-

sors, motion detectors, reinforced steel fences, floodlights, video surveillance, drones, cameras, gamma ray sensor armed patrols, and dogs.[44] Border enforcement apparatus augments the pernicious terrain of the Rio Grande and Sonoran Desert that also serves to repel those seeking asylum. Both immigration enforcement and detention have increased exponentially in recent decades. Unable to pass comprehensive immigration reforms to fix the underlying contradictions of the US immigration system, law-making and rhetoric center on hardening immigration laws.[45] Today, immigration enforcement agencies receive more funding than all other federal law enforcement agencies combined.[46]

The trend toward heightened border enforcement began with the North American Free Trade Agreement, a benchmark effort in neoliberal policy-making that led to the displacement of Mexican workers and a dramatic increase in the number of unauthorized immigrants at the border.[47] In response, the United States launched Operation Gatekeeper, part of a larger border control strategy based on the principle of "prevention through deterrence."[48] These efforts were intensified by the terrorist attacks of 9/11, resulting in unprecedented resources being spent on immigration enforcement, including a large share at the Southern border.[49] In 2011, the United States imposed deterrence policies including criminal charges, detaining migrants for longer periods, and returning them to more remote areas.[50] The Border Patrol sought to make repeated efforts to cross more dangerous and expensive, a process that serves not only to fortify the border but to make those who cross it, for whatever reason—including seeking asylum—suspect.[51]

Mexico vigorously patrols migration routes along the corridor running north through that country, efforts that are encouraged by the United States to deter Central Americans from reaching the border.[52] Such efforts are designed to thwart people from reaching the United States to ask for asylum without violating the refoulement principle, that is, returning people to nations where they could suffer persecution. In Mexico and other nations globally, policing and deterring unauthorized migration begin far from the border. As argued by David Fitzgerald, asylum seekers across the globe increasingly encounter deterrence— what some have labeled "remote control" enforcement—in countries and areas far from their own borders.[53] For example, in 2014–2015, the United States launched initiatives to halt the flow of unauthorized mi-

grants, including children, from Central America by arresting suspected human smugglers, as well as providing training and equipment to the governments of Mexico, Guatemala, and El Salvador to police human smuggling operations.[54]

Border enforcement strategies now actively seek to deter asylum seekers at the Southern border, reflecting popular will to halt asylum from Central America, Africa, and the Caribbean. This trend reflects the United States' dubious asylum history. Very few Jews fleeing Nazi Germany received authorization to enter the United States, the most well-known being the passengers of the *St. Louis* who were not allowed to land on US soil.[55] Since the 1980s, multiple administrations have restricted fleeing Haitians from arriving to apply for asylum.[56] In the 1980s, the United States deemed Salvadorans and Guatemalans fleeing civil wars "economic migrants" and not bona fide asylum seekers.[57] In 2014, because of the number of unaccompanied minors crossing the Southern border, President Obama ordered "aggressive steps" to deter asylum seekers from leaving Central America.[58] As discussed in chapter 1, the Trump administration took pride in dismantling the asylum system, and the Biden administration, while overturning some of the previous administration's policies, has worked with Mexico and other nations to maintain and build upon other deterrence mechanisms.[59]

Ascribed Criminal Status

Women seeking asylum suffer the full weight of the deterrence and enforcement mechanisms discussed in this chapter, despite their need for humanitarian relief from persecution. The experiences of women who cross the border from Mexico to the United States to flee violence are informed by two competing policy objectives: (1) border enforcement to ensure national security, and (2) the principle of nonrefoulement, which became US law in the Refugee Act of 1980 to ensure that no one is returned to a country where they will suffer persecution. As this chapter illustrates, imperatives of enforcement and security essentially negate the protections one might hope for when women cross the border seeking asylum—an undertaking meant to obtain the safety and protection that their sending countries failed to offer. Housing asylum seekers in hieleras, perreras, and long-term immigration detention

centers effectively ascribes them criminal status as they are housed in deplorable conditions with no legal representation. Women repeatedly described being demeaned and mistreated, including accusations that they are bringing disease into the United States as well as being told by arresting officers that they would soon be returned to the countries that they fled. Some described being yelled at by CBP officers; others recalled being referred to as dogs while in detention. Such practices stem from racialized narratives questioning the legitimacy of those seeking asylum after crossing the border from Mexico. Both gendered and racialized narratives inform how Border Patrol officers and guards at detention facilities treat asylum seekers. Latino migration is delineated as a social problem, with Latinos themselves deemed a threat to white hegemony.[60] Among the narratives emerging that label women as unacceptable for social inclusion is the idea that they produce too many children, and that they deliberately conceive children on US soil to avoid deportation. Such characterizations not only impugn women's fitness as potential citizens but also undermine their identities as mothers via the implication that they produced children as a currency to obtain a benefit. Although women interviewed described having to negotiate uncertainty coupled with the degradation of the hieleras, perreras, and other detention centers, other narratives emerged as well. Women described refusing to sign documents they could not read, as well as having refused to consent to being returned home. While one woman's husband finally grew so weary of confinement that he agreed to be returned to their country of origin, she chose to stay to fight for asylum.

5

Trauma: Shared Meanings and Healing

The question of trauma—whether it goes unrecognized as well as who makes determinations about its meanings and consequences—is socially contested. A review of gender-based trauma and society's responses illustrates this point: Responding to police indifference and failure to vigorously investigate the murders of hundreds of women and girls found dead in and around Ciudad Juárez in Mexico, families started a social movement to call attention to the feminicides.[1] They organized vigils and marches and created public art. Activists painted pink and black crosses on walls, buildings, and telephone poles around the city to call attention to the murders, memorialize the dead women, and demand recourse.[2] Gender-based assaults occur with grueling regularity, as evidenced by accounts in Guatemala (feminicide), Bosnia (rape camps), India (bride burning), and the Congo (genital mutilation), among others. In some cases, states recognize trauma, awarding certain designations to victims as in Bosnia, where children who are the product of wartime rape are now classified as civilian victims of war.[3] Recognition of damages can come without reparations, as in Bosnia, where the same children who received designation as civilian victims of war did not win the right to scholarships, which they sought. In other cases, recognition of collective trauma proves elusive. The kidnapping and trafficking of an estimated 200,000 Korean women into sexual slavery for the Imperial Japanese Army during World War II remain unacknowledged by the Japanese government as survivors and their supporters seek compensation.[4] As recently as 2021, Japan asserted that it was not obligated to pay reparations for the dwindling ranks of survivors.[5] Now, in the United States, the question of gender-based violence in Central America and Mexico is decided case-by-case in asylum proceedings, and as discussed previously, requires that women meet exacting legal criteria.

In this chapter, we contextualize traumatic experiences for the women interviewed through a lens examining trauma as collective experiences

with potentially shared meanings, while acknowledging the imprint of pain inflicted upon them as individuals.[6] We also note its appallingly routine nature: As described by medical anthropologist Arthur Kleinman, violence can emerge as part of everyday life, and it encompasses the suffering caused by social relations that originate at global, national, and local levels, processes that include poverty, lack of access to education and social services, inequitable gender relations, as well as the extreme violence—death threats, rapes, home invasions, kidnapping, and / or murders of family members, and recruitment of children into gangs—that forced the women we describe to seek asylum.[7]

Structural inequality and social location shape how social groups experience suffering, facts that prompt some theorists to warn that mass violence, dislocations, and trauma are likely outcomes as many states become increasingly less capable of protecting their own citizens, troubling aspects of governance informed to a large measure by minimally regulated neoliberal projects.[8] Recent scholarship probes the question of citizen insecurity, that is, a widespread perception of vulnerability to crime and violence because of state failures to meet the obligation to protect citizens from harm.[9] As noted by Kleinman: "The suffering that results from political violence includes a range of traumas: pain, anguish, fear, loss, grief, and the destruction of a coherent and meaningful reality . . . In this period we are also increasingly aware of the violence that accompanies social disorganization and political dissolution . . . The frailty of the nation-state and of the transnational world in which we now live suggests that violence and terror will mark any new world order that might ensue."[10] Kleinman's remarks alluding to the frailty of the nation state seem particularly relevant here, as the women we interviewed need asylum not because of state violence toward its citizenry but because states failed to protect them from gender-based harms.

Our interviews revealed substantial trauma histories.[11] How then do we understand and respond to their suffering? In this chapter, we describe their perceptions of trauma and their coping strategies, and we detail the impact of bitter pasts: nightmares, depression, fear, intrusive memories, and distrust of others. However, this is not the end of their stories. Despite their traumatic life histories, women secured housing, found jobs, paid immigration attorneys, and gathered evidence for asylum hearings. They raised children and, in many cases, established

relationships with new partners they described as caring. While we document individual narratives of trauma and resilience, as well as symptoms associated with PTSD, we argue that understanding trauma as a singular experience, irrespective of the context within which it occurs, is insufficient to truly understand women's suffering.[12] Further, defining trauma solely as an individual injury deprives survivors of the potential for reparation, shared narratives, and recognition afforded by acknowledging their trauma as a cultural experience.[13]

In his seminal work on cultural trauma, Jeffrey Alexander defines this phenomenon as that which occurs "when members of a collectivity feel they have been subjected to a horrendous event that leaves indelible marks on their group consciousness, marking their memories forever and changing their future identity in fundamental and irrevocable ways."[14] The process of establishing a cultural trauma, when successful, leads to acceptance of moral responsibility for harms—which can then motivate societies to acknowledge injury and ensure justice. Cultural trauma doesn't speak to suffering or symptoms following harms; rather, it speaks to how understanding of injury shapes collective identity as groups are forced to incorporate and make meaning of shared memories.[15] Injured groups and their allies transform suffering into cultural trauma by articulating narratives of destructive social processes including identifying the nature of these injuries, defining who was injured, and assigning blame.[16]

Poverty, severe and pervasive gender-based violence, forced relocation, and incarceration merit recognition as cultural trauma, a shared understanding of traumatic events that can eventually lead to activism, recognition, and reparations.[17] By creating a cultural trauma, horrific experiences move from the realm of individual suffering to recognition through deliberate and difficult political work.[18] As the term culture implies, symbols and narratives must be developed to facilitate a shared understanding of traumatic experiences and often involves the engagement of political leaders, intellectuals, and artists who become instrumental in conveying messages and meanings about the afflicted group's experiences—ultimately demanding justice through an adversarial process as events and their meanings are defined and negotiated.[19] A cultural trauma constitutes "a narrative about a horribly destructive social process, and a demand for emotional, institutional, and symbolic

reparation and restitution."[20] It emerges as the fruit of a protracted and shared collective process to demand that the wider society recognize a group's experience of trauma, and to ensure justice, such as reparations.

The process of successfully transforming victimization and injury to a cultural trauma requires a decision by those who have suffered harm to define and publicly claim the suffering, key steps in a movement to demand recognition and reparations. Although this process may seem straightforward, it is fraught with questions. In ascribing blame for the Holocaust, debate centers on whether all of Germany should be held responsible, or does the culpability lie solely with the Nazi regime?[21] Why did the killing of three million Chinese soldiers and twenty million civilians during that nation's War of Resistance Against Japan spark little public recognition, even among subsequent generations of Chinese?[22] Debates in the United States over cultural traumas and their recognition illustrate the contested nature of these questions. Even the United States' participation in the trans-Atlantic slave trade, the genocide of indigenous Americans, and Japanese internment raise questions about culpability, reparations, and the enduring effects of trauma.

The women we interviewed experienced trauma that remains to be conceived, narrated, and recognized as a cultural experience. Barriers to such recognition include defining culpability: Are violent domestic partners or gang members alone responsible for the suffering they endured? Or are the failed states they fled, and the nations—including the United States—who waged civil wars by proxy in Guatemala and El Salvador to blame? Is Mexico responsible for its prolonged reluctance to protect women from gender-based violence? What of the everyday forms of violence referenced by Kleinman that arguably inform the women's circumstances, harms ineluctably tied to the poverty and economic policies that create the conditions for routinized gender-based violence?[23] For the creation of a cultural trauma, women who survive these experiences would need the opportunity to engage in a collective, shared discussion about the violence they suffered, and to develop a common understanding of what these events mean for their own identity.

Key to our analysis is recognition of the asylum process itself and how it informs understanding of trauma for the women who are the focus of this book. Asylum cases, as we discuss in chapter 6, are adjudicated individually, with each applicant carrying the burden of proving

that her traumatic experiences constitute persecution, as well as other legal criteria that we will explain in more detail. With women struggling to prepare their individual cases, which will later be heard in a closed courtroom, the potential for shared narratives and demands for recognition though cultural trauma are diminished. As argued by Alexander, "For traumas to emerge at the level of the collectivity, social crises must become cultural crises. Events are one thing; representations of these events are quite another. Trauma is not the result of a group experiencing pain. It is the result of this acute discomfort entering into the collectivity's sense of its own identity."[24]

Each woman lives with the aftermath of having suffered numerous traumatic experiences prior to migration. This book was conceived after an author began conducting pro bono assessments for women seeking asylum at the request of immigration attorneys who needed these documents as evidence in court. A diagnosis of PTSD helps support a woman's case by substantiating that she does have a cluster of symptoms borne of immense suffering. In short, an asylum seeker can be seen as credible in stating that she suffered trauma if a document from a professional exists to chronicle symptoms and their diagnostic implications. We argue for an understanding of trauma that examines the social forces underpinning the violence women experience—a product of both structural and symbolic violence, factors that are arguably lost when trauma is conceived solely as a mental health issue. As noted by Kleinman, "The problem with mapping distress in the mind of the individual is that such a cartography tends to overlook the fact that the causes, locus, and consequences of collective violence are predominantly innately social."[25] This chapter examines how women understood the trauma they endured, before exploring the broader question of how asylum policy, which centers on questions of harms to individuals, constrains the potential for consideration of trauma as a cultural experience.

Nightmares, Memories, and Lost Trust

Complaints about fear, insomnia, and nightmares arose frequently in interviews. Alejandra, the Guatemalan who fled the farm where her husband repeatedly beat and raped her, noted that she had begun taking her seven-year-old son to see a psychotherapist because his

witnessing of abuse left him distressed. His fear for his mother's safety caused him to check on her in the bathroom to make sure she was alright. Delfina, a Salvadoran who fled with her brother after MS-13 repeatedly tried to conscript him, described a nightmare in which she walked into a room to find a headless body slumped in a corner. She struggled to relax and admitted feeling on edge incessantly. Valeria, the Mexican woman who awaited a Board of Immigration Appeals decision on her domestic violence asylum claim, reported suffering depression. "I feel like a failure," she said, noting that she blamed herself for having been with an abusive partner.

In her description of gender-based violence in Guatemala, Cecelia Menjívar wove together consideration of violence in multiple forms to understand the subjugation of women that enables gender-based violence and encompasses a much broader swath of suffering.[26] As discussed by Menjívar, multiple forms of subtle violence, including both the structural and symbolic, create the conditions that give rise to the extreme violence that forces women to flee home.[27] These forms of violence include structural (that caused by poverty, lack of access to education, social services, etc.) and symbolic violence, a concept that explains how women internalize sexism, inequality, and daily acts of humiliation and in the process, come to see them as normal.[28] Symbolic violence is produced and deemed normative as it arises through power differentials between social groups, an arrangement that benefits dominant classes and groups but that are accepted by those injured by it.[29] This form of violence is cunning and subtle, as it is shaped via social conditions that are prevalent in everyone's environment, informing how one functions in the world. People, for example, see symbols of wealth and social status accrued by others and are habituated to believe that their disadvantaged social location is normal. Women are taught to sacrifice their needs for others and see this disposition as an immutable reality.[30] Women endure "veiled violence in forms of social control of women that result in devaluation, humiliation, a lowered gaze, the kind of violence that does not shock the observer because it is part of the everyday but that is deeply connected to the more noticeable acts that inflict physical injury because both kinds of violence arise from the same structures."[31] The social world, with its inequities and degradation, results not from a deliberate effort to impose symbols on others as a strategic effort to

ensure subordination but rather from the functions of daily life.[32] The descriptions given by women of trauma illustrate the insidious nature of subjugation. Valeria recalled feeling "brainwashed" by her abusive husband. She called herself a failure, despite establishing herself in a safe home in the United States, working for a restaurant, and finding joy in caring for her grandchildren.

Catalina, a Salvadoran who fled her former partner's repeated rapes, began to perceive this violence as routinized, saying that the traumatic incidents "became almost normal to me." She explained that she would "heal myself and try to go on with my life." Catalina managed to leave her abusive partner, although she had to travel to his house to claim her baby after he took possession of him for a month. She moved to another location where she hoped he wouldn't find her and then opened a small store selling tortillas, pupusas, and small non-food items. For three years, she lived a relatively prosperous life. That ended when the MS-13 gang ordered her to close the store so that it wouldn't compete with other shops under gang control. Catalina had the wherewithal to strike a bargain with the gang: She would stop selling phone chargers and close on Sunday as well as pay forty dollars weekly in extortion money. Phone chargers were highly profitable. If she closed her store permanently, she told gang members, she wouldn't be able to pay them the forty dollars weekly they could "earn" if she remained open. Unfortunately, her troubles didn't end then. After three years, her former domestic partner found her and tried to kill her by drowning her in a bathtub. Her older son intervened and stopped the attack, shouting at his father, who relented.

Catalina finally came to the United States with her children after a family member was murdered by MS-13 and she and others received death threats. Although she had found safety in the United States, the trauma remained in the form of intrusive memories, a common PTSD symptom: "I feel sometimes like a movie is like it just plays out in front of me. I have nightmares at night, and I still remember everything as if it's happening to me. I feel everything, I could be doing anything, I could be cleaning or cooking and then it just played out like a movie in my mind, and I see everything." For Catalina and some others interviewed, the trauma borne of subjugation and that ultimately manifested in brutality penetrated their inner worlds, constituting a barrier to a sense of

safety they sought in the United States. Women suffered by virtue of both severe violence that led them to seek asylum, and its more insidious structural and symbolic forms.

Within the narratives offered by women, however, is language sufficiently evocative to manifest a cultural trauma as defined by Alexander, should survivors of the asylum system find the resources to engage in the requisite narration and organizing.[33] Belinda, a woman who left El Salvador with her two-year-old following a home invasion in which gang members demanded money, said that the same men still show up at her mother's house regularly to demand sums ranging from thirty to fifty dollars. "They're like ghosts. They show up and just go in and out of her house," she said. "My mother has chickens and sometimes they'll decide they want one. She has no choice but to give it to them." The gang members' stealth, and the fear they cause, prompted Belinda to describe them as apparitions, capable of haunting her mother as they extort money and livestock. Catalina compared her intrusive memories to watching a movie, trauma so vivid she saw it repeatedly as she tried to clean the house and go on with her day. Her description reveals trauma's capacity to stalk survivors long after the violence ended. Valeria felt "brainwashed," a state of feeling that implies loss of oneself amid grinding, ongoing trauma. Such images reveal shared experiences: Although each woman suffered violence individually, their experiences are decidedly similar, with trauma revealing itself in intrusive memories, fear, and at times, helplessness. Establishing a cultural trauma requires more than injury and victimization; it demands the shared understanding of what certain events mean to a group. Traumas are socially constructed and thus must be narrated and imbued with shared meanings for the group in question.[34] Whether trauma is recognized by the wider society hinges not on the nature of injury and its intrinsic suffering, but on whether those who have experienced trauma can summon resources and authority to convincingly disseminate their claims, as well as society's receptivity to the messaging.[35]

Though the question of empathy isn't raised in Alexander's conceptualization of cultural trauma, it is implied in his unpacking of the steps that led to the recognition of the Holocaust, including the personalization of this mass trauma and its victims.[36] Narratives such as the publication of Anne Frank's *Diary of a Young Girl*, proved instrumental in

humanizing those who experienced the Nazi death camps.[37] Persecution and mass murder came to be understood by virtue of dramatic narratives. "Rather than depicting the events on a vast historical scale, rather than focusing on larger-than-life leaders, mass movements, organizations, crowds and ideologies, these dramas portrayed the events in terms of small groups, families and friends, parents and children, brothers and sisters. In this way, the victims of trauma became everyman and everywoman, every child and every parent."[38] In the narratives offered by Valeria, Catalina, and Belinda, they are potentially sympathetic figures: women who could be someone's mother or sister—women whose experiences could invoke empathy and an understanding of why they need asylum.

Alone, Separated

The women we interviewed expressed relief to be free of gangs that infiltrated the streets where they lived, the police who neglected to protect them, and the men who battered and/or raped them. Their departure, however, came at a cost as many left behind family and friends, and in some cases, children. Many stated that their sense of community and belonging had been fractured prior to leaving by gangs that made them too frightened to socialize on street corners or by domestic partners who restricted their movement. Maria, the Salvadoran whose family suffered poverty after her mother's diagnosis with cancer, recalled her sadness over leaving her family and country. "I felt alone, separated. My parents are now old. From time to time, they help my brothers. And then I had to come to this country to support my children because I had no one to help me. No support from anyone to get ahead," she said. "I am a father and a mother to them."

In this passage, we focus on two women whose stories illustrate how the role of trauma and community in childhood informed their lives in adulthood, including the struggle for asylum. Mabela grew up in Guatemala, where her father's family worked as campesinos on a large *finca* (plantation). Both parents left to work in the United States when she was an infant. She learned through stories told among relatives that her paternal grandparents took the money that her parents sent home, leaving the children with inadequate food and clothing. What unfolded was a

childhood that robbed her of safety and left her subject to the grinding, structural, and everyday violence of relatives who failed to care for her, adults who took the side of her father as her parents' marital problems became widely known, and her father's insistence that she be prohibited from finishing school.[39] Her parents returned when she was still very young, although she couldn't recall the age. Her mother returned to the United States when Mabela was seven. Her father blamed his children for his wife's abandonment, while the paternal grandparents told her that her mother had left to look for men. This shaming of her mother's sexuality, and statements about her assumed promiscuity, spread through the town, prompting neighbors to tell Mabela and a sister that her mother had made her an orphan and that the police should arrest her mother for abandoning her children. "They began to say to us that you're orphans, and that she had abandoned us. That your mother doesn't want you. They began to say words that we didn't like."

Her father also closed her avenues to obtain an education. "He took away our notebooks. It was when we had to do our homework, he would tell us, 'You were not born to study. You were born to make food.'" Such was the everyday violence, the embedded symbolic violence that informed her father's attitudes toward girls' education and the neighbors who accused her mother of promiscuity.[40] At age eight, her father sent her and a sister to live with members of his extended family, where she was raped by an uncle, two cousins, and an aunt's boyfriend. When she and her sister went to the police as adolescents to report the abuse, the officers told them they shouldn't issue the complaint because it would lead them to be taken into custody by the government. Mabela thought about killing herself.

The incest left her wary of men, and the trauma manifested itself in chronic pain in her uterus and vagina. She saw a doctor, who examined her and found nothing wrong physically, leaving her to wonder why the pain persisted. She described how incest affected her: "When men look at you, they want to have sex with you and all that. Only that happened, where I lived, they only looked at me like that. I did not know why, they just looked at me like that. Why did they look at me like that, and they only tried to find that in me? And I just, what's going on? Why did men only look at me like that? So, I couldn't figure out in that moment why, and I never told anyone about my life."

Mabela had no community to turn to for protection, or even to help her make connections that would have provided her with a sense of belonging. Repeated sexual assaults by male family members caused her to suffer shame. She and her sister finally decided they would only be safe from her father's family if they left Guatemala. They entered the United States in 2016, and, as she waited for an asylum hearing, Mabela worked at a chain restaurant and studied English. "I want the same thing anyone would want," she said, referring to her asylum case. "I want to study and finish my education which I didn't have a chance to do before. I want to be safe. I want a peaceful life with security."

Renata, a Salvadoran who sought asylum following a kidnapping, rapes, and death threats by the MS-13 gang, recalls how she began trying to make sense of her life at age fourteen. By then, her mother was in her second marriage, the second relationship that forced Renata to witness domestic violence. She found purpose outside of her home, volunteering for an organization that did outreach for young people at risk of becoming caught up in gangs: "When I was fourteen years old, I was involved with a group of young people who also worked for a long time, like on the streets, talking about prostitution, about drugs and how they can help them get out of this. And also [out] of extreme poverty in the poorest and oldest areas of my country."

Renata volunteered with the group until age twenty-two, when she found a job as a security guard for a small organization serving survivors of domestic violence. Renata's job was to greet women as they entered the office and escort them to speak to a social worker or psychologist. Inevitably, women talked to her as they waited for appointments. The women told her why they sought help. She heard about gender-based violence as well as psychological abuse and efforts by men to ensure that women never achieved financial independence. She described how her work there influenced her thinking. "I received the women when they came to request some type of service. I was the first one who was receiving the first women who came seeking help. But in a way I also ended up getting involved when listening when they were waiting, for the reasons why they came," she said. Renata then realized the nature of the gender-based violence she saw as a child. "Everything was fine or normal," she recalled thinking as a child. "At least it is what one thinks, that everything is normal." Renata realized that what she

witnessed in the home growing up was aberrant. Her mother suffered through both psychological abuse and deliberate economic deprivation by her domestic partners.

Renata came to the United States with the two children she raised on her own. She and her stepfather happened to witness gang members setting fire to a house near where they lived, killing a boy inside. The police wanted both Renata and her stepfather to testify against the gang, but her parents feared for her life and thus, only her stepfather appeared in court. He was shot to death two years later. Gang members began harassing her, demanding that she help them traffic guns and drugs, which she refused to do. She avoided leaving the house as much as possible, but she couldn't remain indoors indefinitely. The threats and violence ended when she fled El Salvador after suffering a gang assault that left her with three fractures of the mandibula. Renata never went to the police because she believed they were corrupt and incapable of protecting her. When Renata sat for an interview in fall 2022 in preparation for her asylum hearing, she completed a scale to measure her PTSD symptoms, a document that would help corroborate her claim that she needed asylum because of past gang persecution. She had a high score on the instrument, indicating that she probably has PTSD.

But there was more to her story than trauma and symptoms. Renata had become an activist. Her immigration attorney referred her to an organization that advocates for women seeking asylum, so as she awaited her own hearing, she traveled to Capitol Hill with other volunteers: "Since I was in the country, I had some time doing activism with some organizations talking about what the process is like within the detention centers, so that some changes could be made, and medical care improved. Or why women come to seek asylum. Many come for domestic violence, but in our country, violence is normalized, and we think it is normal for something to happen to all of us at some point."

Renata found community in adolescence through a group that engaged in community outreach with other adolescents who might be lured into commercial sex work and drugs, work that she engaged in for eight years. As an adult, she spoke with women who sought services for domestic violence, learning along the way that her mother's experiences of subjugation and violence did not have to define her relationships or those of the children she now raises as a single parent in the

United States. "I broke the cycle," she said, referring to domestic violence. Finally, she worked with other women and their US allies even as she prepared for her own asylum hearing and worked a job as a banquet manager to advocate for others in detention centers. She transformed her suffering into resistance and advocacy.

Jobs, Housing, and Children

Catalina, the Salvadoran described earlier, wept during segments of the interview that focused on how the trauma affects her today, although she described the traumatic experiences themselves with equanimity.[41] We tried to avoid asking women to detail trauma during interviews although many described the violence they suffered anyway. Catalina cried while saying that she never feels in control of her life. "First of all, excuse me for getting so nervous," she said. "What I try to keep inside of me came to my mind here, excuse me." A sense of lost control and the inability to quell memories and nightmares haunted Catalina. Still, she managed to bring two children to the United States and persuade immigration officials to allow her to stay to pursue an asylum case. When interviewed, she lived in a major city on the East Coast and held a job in a supermarket's produce department. The job sustained her during the pandemic, a point worth emphasizing because we interviewed her via Zoom during the COVID-19 quarantine, a time when many found themselves unemployed. Her mood brightened when asked about her three children, ages seventeen, fourteen, and three: "They are doing very well here. Before [the pandemic] they were going to school, but now they're home. I buy them everything they need, and we have a house. We have water and lights. They are very happy here. They have everything they could need, that's what they have here."

Belinda, the Salvadoran who fled gang violence, crossed the border while pregnant. She shared an apartment with a woman who looked after her two young children as she worked six days weekly in a chain burger restaurant, leaving the house at 6 am and returning after 11 pm. While at work, Belinda placed a Facetime call with her older son every day after school. "The truth is that with my children, I am like a camera. The truth is that there I am quite, quite on top of them, controlling how they are. And my oldest son, when he gets home from school, I do

the video call. 'Are you home, how are you?' I am super vigilant with them," she said.

Hearing stories of how women persevered despite suffering repeated incidents of trauma unimaginable to many was heartening. One respondent, however, never overcame her trauma.[42] Jimena grew up during the Salvadoran civil war. She recalled that in fifth grade, a teacher had to corral the students back into school as guerilla warfare broke out. The students ran back to the school as combatants died on the streets. We interviewed Jimena in a prison, where she was incarcerated after having been convicted of assaulting an adolescent relative, leading to genital injury. Jimena denied her culpability during the interview, which was conducted prior to an asylum hearing. Jimena wore a blue prison uniform and black glasses. Sitting in a prison classroom, she described her mood as *"más o menos,"* which in this context means mediocre. We asked about her childhood in El Salvador, where she assisted her mother by selling fried food, cut fruit, and bagged soda during soccer games and before school. At approximately age thirteen, Jimena was selling yucca fritters, snacks, and soda on the street when a Salvadoran police officer kidnapped and raped her. He held her captive for three months in a house he shared with his sisters until she managed to escape.

The officer felt entitled to her, and so he showed up at her house and seized her again, shooting his gun to fend off her father who tried to protect her. This time, he took her to a motel. He let her leave the next day but showed up at her house nightly. Jimena's parents went to the police, who characterized their colleague's behavior as a "family matter." The officer's violence only ended when the family received a restraining order. Jimena's life trajectory is unsettling but perhaps not surprising. As noted by scholars of violence: "We all know, as though by rote, that wife beaters and sexual abusers were themselves usually beaten and abused. Repressive political regimes resting on terror/fear/torture are often mimetically reproduced by the same revolutionary militants determined to overthrow them."[43]

And so it was with Jimena, despite her family's efforts to protect her. As a prisoner who is forever designated a registered sex offender, the state relegated Jimena to an abject status, the lowest and most wretched among us—those who have been thrown away.[44] Her relegation to abjectivity followed the state's disinclination to protect her from one of its

own, during an era when the contours of Salvadoran life were shaped by the civil war, which began when she was a child.

Trauma and "Illness"

We conducted these interviews at the request of immigration attorneys, who needed pro bono psychosocial assessments to document asylum seekers' credibility and to ascertain the impact of trauma. Proving that asylum seekers had suffered trauma is critical, given that possibility of future persecution is the standard for awarding asylum. Traumatic experiences become evidence of potential future persecution as women must convince judges that they will again suffer severe violence if returned. Women must also show that they are credible when giving testimony in court. The DHS attorneys function as de facto prosecutors in court. During cross-examination, women must be able to provide detailed testimony about their experiences; mistakes about dates, or statements that contradict written documents provided to the court, can prove deleterious in an asylum hearing.[45] As has been established empirically, trauma can fracture memory and be a barrier to providing accurate, detailed testimony.[46]

While most women complained of intrusive memories from traumatic events, others admitted difficulty recalling certain aspects of their experiences. The fact that women must relay their trauma stories repeatedly, at the border at the behest of hostile Border Patrol officers, in credible fear interviews that many must give as a condition for release, and to their attorneys as well as social workers, psychologists, and/or psychiatrists brings potentially more suffering with each retelling. In addition, asylum hearings occur years after a woman leaves her country, which could make it difficult to remember minor details, which then becomes an issue in court. The trauma itself might not be forgotten, but mistakes in such details as dates can be used to impugn a woman's credibility on the witness stand. One attorney interviewed said that a male immigration judge and a male DHS attorney questioned her client's credibility after learning that the woman, who had been diagnosed with PTSD and depression, had disclosed only one of two gang rapes to her therapist. The judge questioned the client for thirty minutes regarding why she hadn't told anyone about the second rape. After the hearing,

the attorney shared her frustration, texting a colleague, "What could she have possibly said to satisfy him? Is [the judge] so confident that he knows what it's like to be gang raped that he's so certain he would have behaved differently?" Despite the concerns about her credibility, the woman was granted asylum. But she asked her attorney, "Why are men like this?" The attorney described it as "proof that our male dominated culture does not value or trust women . . . It was painful to be a woman in that moment."

Other issues complicate the question of trauma, including failure to scaffold the issues of violence and persecution without sufficient attention to their context. Issues of structural and symbolic violence, and the conditions that abet the suffering of egregious levels of gender- or gang-related violence, can be lost amid the language of health care. The psychosocial assessments we conducted with women came from worthy intentions. Attorneys needed to prove women's violent experiences met the legal standard for persecution: severe trauma that would re-occur if forcibly removed to their countries of origin. In this context, trauma stories become a commodity of exchange in which survivors of violence must recount their experiences of violence in exchange for benefits such as being granted asylum.[47] "Their trauma stories become the currency with which they enter exchanges for physical resources and achieve the new status of refugee. Increasingly, those complicated stories, based in real events, yet reduced to a core cultural image of victimization, are used by health professionals to rewrite social experience in medical terms."[48] Key to our argument is the understanding that trauma constitutes more than a diagnosis; it arises from social contexts that precipitate human suffering, including poverty and the failures of states to protect women from gender-based violence that compel them to seek asylum.

In the metropolitan areas on the East Coast where women sought asylum, psychologists routinely charged $2,000 to $3,000 for these assessments, substantial sums for women who worked as housekeepers or in restaurants. Given that women needed these assessments for court, the narratives of trauma, discussion of symptoms, and use of validated scales to verify diagnoses of PTSD and depression were unavoidable. Women must prove before a court that they have been victimized, and establishing that fact often entails the use of diagnostic instruments and discussion of symptoms to prove, in essence, that women did truly suf-

fer these traumatic incidents prior to seeking asylum. In addition, their attorneys must elicit thorough, detailed stories about the violence they experienced as part of the evidence that is then submitted to the immigration judge prior to the asylum hearing. Women tell the stories of what they experienced at the hands of domestic partners and/or gangs, and these discussions are augmented by evidence submitted to the immigration judge documenting conditions in Honduras, El Salvador, Guatemala, and Mexico to make the argument that a forced removal would bring a return to persecution. We argue that trauma and its injuries to mental health are substantial. Descriptions of depression, panic, intrusive memories, nightmares, insomnia, and flashbacks emerged repeatedly.

We argue, however, that the individualized nature of asylum claims limits opportunities for understanding and narrating trauma as a cultural experience, whereas humanitarian protections such as Temporary Protected Status (TPS) acknowledge widespread suffering affecting groups of individuals in their countries of origin.[49] Renata described engaging in activism with other asylum seekers and their allies, and there exist Facebook groups for Spanish-speaking people that provides information about asylum and where they can offer one another support. We emphasize that few avenues exist at present for public-facing narratives by women seeking asylum here, in part because of the nature of asylum policy and their life circumstances. Women who are raising children while working low-wage jobs, paying attorneys, and often, sending money home to families, have limited time and resources for such engagement. A recent public opinion poll found that 55 percent of Americans support giving asylum to those who arrive at the border if they can prove they are fleeing persecution.[50] There are differences across party lines, with 71 percent of Democrats supporting asylum, compared to 55 percent of independents and 45 percent of Republicans.[51] It is highly unlikely that many polled understand the conditions forcing the escalation of asylum claims, and much discourse around conditions on the border still conflates those seeking asylum with immigrants, particularly under the umbrella of illegality.

The barriers to recognition and creation of a cultural trauma on the part of women crossing the border to seek asylum are many. Transforming individual experiences into a cultural trauma hinges on survivors'

capacity and resources to share their experiences and frame compelling narrations, and on the willingness of the wider society to acknowledge their suffering.[52] In addition, a perpetrator must be identified. Thus, the obstacles to recognition of a cultural trauma for the women we interviewed are many: A lack of a clearly defined perpetrator, fraught circumstances for women that limit the potential for organizing and sharing of narratives, and finally, lingering ambivalence and racism toward those crossing the border from Mexico, no matter the circumstances. Turning trauma into a cultural phenomenon is a complex process, and one that, regrettably, may never happen. Alexander notes how other traumatic events, including the 1937 massacre of Chinese civilians in Nanjing by the Imperial Japanese Army, went without recognition in the West, in part because racist tropes about the "barbarians" in the East eclipsed the potential for empathy and recognition.[53] The intensely racialized narratives about Latino men in political discourse and in television programs allows the United States to ignore the conditions that force women to flee Central America and Mexico, absolving it of responsibility for historical legacies of civil wars, the drug war, as well as neoliberal trade policies that exacerbate poverty and inequality.

"I Just Can't"

While this book focuses on the trauma experienced by women seeking asylum, we point out that hearing stories of rape, battery, and death threats bleeds into the consciousness of immigration attorneys and judges—processes that may lead to a combination of professional burnout, secondary trauma, and compassion fatigue.[54] Maya Pagni Barak explained: "The pressures of the system are also felt by immigration attorneys, most of whom are overworked, underpaid, under resourced, and charged with protecting their clients from deportation, a fate that for some clients is akin to a sentence of death."[55]

To prepare for court, attorneys must ask each client to tell her story of trauma in exacting detail, a painful process for both the lawyers and the women they represent. Often, to ensure sufficient detail as evidence, this story is told multiple times. Over the course of their relationship, lawyers must request and review evidence of persecution, listen to clients' stories, and provide comfort to traumatized survivors. As one lawyer

explained: "When it's a client, especially in the current system, you're talking about a relationship that endures years. You're spending hours and hours and hours with a person preparing their case. You read their horrendous psychological evaluation. You know, we are like deeply embedded in that person's life . . . I don't really do domestic violence cases anymore, and there's a reason. I don't want to do them anymore. I'm done. I can't. Like I can't. I just can't do it anymore."

Similarly, immigration judges hear the stories and read the documentation of thousands of asylum seekers relating their horrific experiences, and it may eventually weigh on them. The former judges we spoke to explained that they may hear three to four asylum cases a day, and thousands over the course of their careers. One former judge described how the accumulation of trauma over time affected her. "You don't really know until it's built up. There were some things that I just couldn't, like TV shows or movies that I could just no longer read or watch. It's like, God, I hear this all day every day, multiple times a day, and I just can't."

Attorneys described deploying self-care strategies that included never giving a cell phone number to a client and relying on conversations with one another that sometimes led to tears. One became a long-distance runner. Others refuse to discuss their work; others lean on friends and colleagues. One lawyer remarked: "For immigration attorneys, particularly those of my generation, there aren't a lot of bright lines separating our careers from our personal lives. We rely on each other a lot. I've called friends from the court parking garage after a particularly traumatic case, crying, and they've called me in turn to ask, 'Hey, what's your capacity for violence today? Because I just had a horrible case I need to get off my chest.'"

Finally, one attorney explained that there is yet another type of trauma that takes its toll:

> The more difficult trauma to deal with, and the kind of trauma that sometimes makes me want to stop practicing, is the injustice trauma. Like the constant losing. The constant need to convince a judge that a man rapes a woman because she's a woman. That is exhausting, and I haven't found a way to make that easier. If and when this career becomes too much for me, it will be the systemic trauma that does me in, not the violence.

US Responsibility

The question of potential cultural trauma becomes complicated by the diffuse factors forcing migrants across the globe to seek safety because of war, patriarchal supremacy, climate change, neoliberal projects that cause job loss and poverty, as well as the failure of states to protect survivors of gender-based violence who are not recognized for refugee status. These are forms of both structural and symbolic violence that go unrecognized, but that cause immense suffering.[56] Although we note the risks and limitations to seeing trauma as only a medical problem, we must acknowledge that women reported struggles with symptoms, such as an intrusive memory of a rape while trying to engage in routine tasks such as housework, depression, or relentless shame. We hope that our interviews and ethnographic accounts of the women could serve as one step in a sequence of many needed to prompt recognition of the factors causing women to flee and to seek asylum. Such recognition is pivotal for ameliorating suffering and constructing policies to ensure their safety. In considering Alexander's definition of trauma as that which arises when group members have been subjected to horrific events that imprint themselves in a lasting way, such that their future identity shifts irrevocably, we can see how the women who are the focus of this book do not experience this suffering alone. They share commonalities, having been brutalized because of structural, every day, and gender-based violence; what has yet to take place is a telling of these narratives, the work that could lead to recognition of trauma by policymakers and the wider society. The United States has not taken full responsibility for its role in Central American civil wars and violence in the twentieth century, nor for its treatment of asylum seekers from that area. However, in at least one case the US government did settle a lawsuit forcing immigration officials to reevaluate asylum decisions. In the 1980s, thousands of Central Americans fled to the United States because of the civil wars we noted previously. The Reagan administration believed the Salvadorans and Guatemalans who sought asylum were "economic migrants" and did not qualify for asylum, unlike Nicaraguans and individuals from Communist countries who were believed to be escaping persecution. A coalition of religious and advocacy organizations filed a lawsuit accusing the US government of discriminatory treatment of certain Salvadoran

and Guatemalan asylum seekers. A coalition of advocates for asylum seekers argued in *American Baptist Churches v. Thornburgh*, that the US Attorney General and the INS failed to acknowledge the persecution experienced by asylum seekers from El Salvador and Nicaragua, a case that the plaintiffs won.[57] The victory allowed approximately 300,000 Guatemalans and Salvadorans who had been denied asylum or were removed from the United States to reapply for asylum and receive work authorization.[58]

Consideration of the work that began in the 1980s on the part of activists and church congregations to create sanctuaries for Guatemalans and Salvadorans fleeing civil wars could be instructive in laying the groundwork for recognition of the asylum seekers who are the focus of this book. As noted by Susan Coutin, sanctuary activists engaged with survivors of these civil wars to draw public attention to human rights abuses engaged by the right-wing military regimes by the United States, some even taking the personal risk of traveling to these countries in the hope that an international presence would attenuate violence.[59] Survivors of right-wing violence who sought asylum encountered pressure to agree to be removed from the United States and incarceration, as did many women we interviewed. Coutin's description of sanctuary efforts reveals the problematic nature of moving trauma from an individual or even collective experience to a cultural phenomenon. Some congregations only offered sanctuary to Central Americans willing to give public testimony and engage in advocacy to prevent further human rights abuses, while others argued that this restriction was unethical.[60] Despite these issues, the sanctuary movement brought public attention to human rights abuses such as death squads as activists worked together with Central American survivors of atrocities to raise awareness. Advocacy included changes to immigration policies to protect survivors of violence. Legislation did come to fruition in the form of the Nicaraguan Adjustment and Central American Adjustment Act (NACARA) of 1997, which granted lawful permanent residence to Nicaraguans, Salvadorans, and Guatemalans whose asylum hearings had been backlogged.[61]

In today's context, Coutin notes, immigrant youth debate whether to engage the "respectability politics" of presenting only public-facing narratives of the "good immigrant" who works hard and endorses American values, versus the more radical position of advocating for inclusion

of those who might have a criminal history. Thus, movements to turn trauma into a culturally shared understanding encounter obstacles. But such work is arguably necessary to move questions of incorporation and inclusion for women seeking asylum from hidden courtroom deliberations to a public understanding of the issues that brought them here. Steps to improve outcomes for Central American and Mexican asylum seekers would require the cultivation of narratives explaining the routinized, gender-based violence that women flee. Artists could engage the stories of women to present them for consumption by mass audiences, and political leaders could relay these narratives in hearings to bring the trauma into public awareness, the first steps toward creation of a cultural trauma. Extant symbols such as the Statue of Liberty and the idea of the United States as a refuge for the persecuted could be invoked in narratives framing the necessity of asylum for women escaping violence. Finally, the stories told by women could raise public awareness—all part of the necessary political work of creating a cultural trauma.

6

"If I Offended Your Country, I'm Sorry."

Nine years after fleeing her gang-affiliated boyfriend's brutality, Milagros faced an immigration judge who would decide her fate. She came to court dressed modestly, with her hair tied back. The immigration judge tried to reassure Milagros that he didn't need to hear details of her extensive trauma history, telling her that he had read the documents explaining the violence she suffered. Milagros struggled to keep her composure despite the judge's reassurances. She did end up telling fragments of her story; a successful asylum court case hinges, in part, on testimony and whether the judge believes the woman is telling the truth: "The gang members hung out a lot at our house. They scared me. I thought they might do something to me. He (her domestic partner) became aggressive with me after spending time with them (other gang members). He hit me. He told me that, 'I belonged to him only.'"

In El Salvador, she said, "Men prevailed, and women were secondary." Her partner viewed her as his property, Milagros said. She had tried to leave him many times, but he threatened to kill her if she tried again. She stopped attending school because his beatings left her face bruised and swollen. Once she went to report him to the police, but the officers laughed at her. She returned home. When she told her partner she was pregnant, he hit her hard in the abdomen and called her *a puta* (whore). He claimed the child was not his. "He said I was nothing," she said, relaying the story through tears on the witness stand. "I was garbage. He said he would take the child and kill me."

Milagros initially fled to Mexico, only to learn that the former domestic partner had traveled to her family's home in El Salvador and demanded to know her location. She soon heard that the ex-partner's gang friends went to Mexico to find her. With that, Milagros left Mexico and crossed the border into the United States, where she asked for asylum. Through an interpreter, Milagros pleaded to the judge:

With all my heart and before God, I ask you do not separate me from my children. I have a home here with them. It cost me a lot to achieve it. Especially for my son who knows nothing. He thinks I'm here today for a traffic ticket. I don't want him to know what happened to me. I don't want him to have that impression of me. I don't want him to have bad habits. He loves soccer. He's doing well in school. He worries about me. He helps me. I beg you not to deport me. I have three kids I love very much. My six-year-old writes me notes saying he loves me. I appreciate the opportunity to be here. If I offended your country, I'm sorry. I just want to work and buy a house. I have half of the money saved for a house. I don't want my children to suffer like me. I want them to be safe, have a good education. Thank you.[1]

Milagros won asylum. Her victory meant relief from deportation, and the promise of legal permanent residency (a "green card") as well as a path to citizenship if she learns sufficient English and meets other naturalization requirements. Her statement to the judge speaks to this chapter's core argument: that both symbolic and structural violence reveal themselves in asylum.[2] Although people have the legal right to ask for asylum, the process of winning it reflects a legal disadvantage. They carry the burden of proving that they meet the stringent criteria for asylum, and they wage these legal battles in a period in which public opinion is not on their side.[3] Structurally, the legal adjudication of asylum encompasses the sorting of worthy and unworthy individuals, welcoming some while classifying others as suspect.[4] Symbolically, people can be classified as unworthy of inclusion through such processes as detention.[5] "Through the probing of human bodies, a boundary between legitimate and illegitimate members of the community is established. This process depends on a truth regime already in place, a regime that classifies some bodies as genuine."[6] Thus, the women we interviewed must prove that despite being in removal proceedings, they merit protection.[7]

Milagros's narrative reveals this framing: She apologized for possibly having offended the nation, a reference to crossing the border without authorization. Her case hinged on meeting the stringent legal criteria for asylum, but she wanted it known that her goals and dreams align

with American values: hard work, home ownership, and raising a son who behaves himself. In this interaction, we see not only a legal process but the question of symbolic violence as Milagros wanted to reassure the court that she wasn't a criminal, and that she and her family would be worthy of inclusion.[8] As with others we met, Milagros experienced apprehension at the border, and during incarceration and placement in removal proceedings, legal procedures, and symbolic designations that label them with questionable status. What became evident in her statement to the court is that the asylum process marginalizes women both in the eyes of the wider society and in their own frame of reference. Milagros feared having offended the nation by crossing the border to save her own life.

Recent immigration scholarship has sought to better understand more subtle social harms experienced by immigrants through theorizing the legal or slow violence of the immigration system.[9] This scholarship probes how the legally recognized and seemingly legitimate regulations and processes of the immigration system inflict duress through barriers to employment, obtaining work authorizations, social exclusion, and the terror individuals feel when they learn that they or their family members no longer have legal status.[10] We use these conceptualizations to understand the social harms experienced as women await and experience asylum hearings. Maya Pagni Barak termed the legal processes that we describe below the "slow violence" of the immigration system, injuries that are often invisible because they accumulate slowly and over time through fears of deportation or the anxiety of an approaching court date. "Masked in the mundane, these harms are easily overlooked, ignored, and excused."[11]

Women seeking asylum must build lives following their apprehension and detention at the border, a process that entails finding jobs, securing housing, raising children, learning new cities or suburbs, and hiring attorneys, all while waiting years for a single date in court to determine whether they can remain in the United States with legal status. And amid this flux exists the necessity of completing immigration-related paperwork, paying legal fees, and finally, preparing for court—knowing that this process would render a decision about their worthiness for asylum. The asylum process is informed by restrictive policies and the assumed ascription of illegality, all processes that shape their lives as

they try to win asylum.[12] The pathway to asylum is characterized by the legal violence of policies as well as the US assumption of asylum seekers as outsiders, those who must prove their worthiness for legal and social inclusion.[13] In their conceptualization of legal violence, Cecelia Menjívar and Leisy Abrego drew upon conceptualizations of structural and symbolic violence to delineate how the accumulating effects of more stringent immigration laws and enforcement in recent years have been deleterious to those without legal status, or whose status may be in flux.[14]

Building on this scholarship, we use the concept of compounded marginalization to explain the unique social space of asylum seeking. Compounded marginalization differs from legal violence and liminal legality in that asylum seekers do not experience shifting status or drift into illegality unless they violate the law or fail to comply with orders to meet with immigration officials or appear in court.[15] However, their existence is marginal: It is constricted by a judicial system that fails to account for the underlying causes of gender-based violence by non-state actors, thus constituting a structural barrier to incorporation. It entails the symbolic violence of an ascribed criminal status at the border and with ongoing interactions with law enforcement.[16] Finally, it encompasses the trauma that manifests itself in a host of symptoms that go unrecognized by the wider society.

We argue that intersecting forces inform the space of compounded marginalization: stringent criteria for winning asylum; the stress of hiring attorneys and keeping track of court dates; mandatory check-ins with Immigration and Customs Enforcement (ICE) agents; and even seemingly mundane processes such as trips to courthouses to complete paperwork without knowing English and having minimal if any awareness of the court system. Building on Menjívar and Abrego's concept of legal violence, we acknowledge that symbolic violence includes the lived ascription of illegality. For example, one woman had to wear an ankle bracelet for a year and felt humiliated, as it malfunctioned in a grocery store, causing other customers to stare. Although legally present as an asylum seeker, the beeping ankle bracelet symbolized criminal status. Symbolic violence encompasses the routine language in courtrooms that carries ominous weight.[17] Women are referred to as "aliens" and proceedings open with an immigration judge who declares that the hearing is part of "continued

removal proceedings."[18] Women described dread as their court dates drew near, knowing that a court hearing could end with a removal order from the United States. Many complained of worsening symptoms from trauma such as insomnia, depression, and anxiety.

Drawing from the conceptualization that Gonzales and Chavez brought to describing 1.5- generation Latino immigrants (those who arrived in the United States as young children) who learned of their undocumented status in adolescence, we describe how gathering evidence, completing forms, working long hours to pay lawyers as well as other expenses, penetrated and delimited women's lives as they awaited asylum hearings.[19] Gonzales and Chavez note that the routine practices associated with immigration law have a profound impact on those who must abide by them, saying that these statutes and the work to abide by them "make their lives miserable, constrained, limited, invisible or differently visible, stigmatized, feared, and even dangerous."[20] Asylum seekers find themselves inhabiting a social space similar to that described by Gonzales and Chavez, one in which lives are shaped by social control and regulation as they complete documents to maintain "legality" and prevent deportation.

Policies and procedures as simple as completing "routine" immigration forms serve a purpose: They bind people to the state and its authority even as doing so facilitates their oppression.[21] Encounters with the US asylum system demand abiding by regulations such as mandatory check-ins with ICE agents, court appearances, and the timely completion of forms and appointments such as the I-589 Application for Asylum and Withholding of Removal form. Form I-589 is accompanied by twelve pages of boxes to complete and instructions in English, and it must be completed within one year of arriving in the United States.[22] This form includes a written statement of reasons for needing asylum. Failure to complete it within a year can disqualify an asylum claim. In short, the process to receive asylum is onerous. The vagaries of navigating the asylum system prompted Teresita, the Honduran who escaped a public official's repeated rapes and beatings, to say: "We are not criminals and do not treat us as criminals. We are human beings with such a desire to live, to give our loved ones the best. Give us more support, above all. The question of physical, mental health. People who work hard have a right to be in this country too. Because we are human beings like everyone."

Teresita and others typically spent five years or more awaiting the court date, known as a merits hearing, that would determine their fate. The immigration court hearings we observed occurred in unassuming buildings that could be home to traffic or small claims courts. When they arrive, asylum seekers pass through a security checkpoint like those at an airport, loading purses, belts, and other items into a tray to be x-rayed. Hand sanitizer and asthma spray raise sufficient concern to be inspected by hand. Once through security, asylum seekers meet attorneys in a waiting room where a clerk sits behind plexiglass. Lawyers file papers there. A phone that links to an automated translation service is mounted on a wall next to the booth where the clerk works. The waiting rooms are often crowded with Latino families and their attorneys. Mothers tend to infants in strollers. Black attorneys speaking French huddle with clients from Africa. Immigrants can be seen filling out forms from the metal racks that line one wall.

Women show up for court in the nicest clothes they own, which sometimes means clean jeans and a pressed blouse. They pull their hair back and rarely wear lipstick or large jewelry, muting their sexuality. They face immigration judges who preside over small courtrooms lined with blue rugs and decorated with items such as framed photos of the US Constitution or the Statue of Liberty. The courtrooms look like any other people see on television: Attorneys from both sides sit at desks facing the judge, near a witness stand and another stand for an interpreter. Women wear headphones in court to hear the interpreter. Of course, the pandemic altered proceedings. During that time, visitors had to find a spot on a bench that wasn't roped off by blue tape, separating everyone by six feet. Department of Homeland Security (DHS) attorneys cross-examined asylum seekers via a speaker phone, although respondents and their counsel appeared in person. By the time vaccinations became prevalent, some judges opted to deliberate cases remotely, and every courtroom now has a television screen. We observed hearings that were fully online via WebEx or conducted in a hybrid format with a DHS attorney and an interpreter on a television screen in the courtroom where the judge, the respondent, and her lawyer appeared in person. Whatever the format, the hearings proved frightening for the women.

As discussed in chapter 1, immigration judges are employees of the executive branch, which also employs attorneys from the DHS.[23] This

means that the women we interviewed are apprehended, detained, charged, prosecuted, and now judged by the federal government's executive branch. The immigration judges they face are not independent judges of the government's judiciary branch. This arrangement violates the core principles of separation of powers and leaves judges subject to the president's orders, such as former Attorney General Jeff Sessions's ruling that "private violence" shouldn't be grounds for asylum.

ICE at the Door

Ines raised two sons in Honduras until 2014, when a gang attempted to recruit her oldest boy. She knew that young men don't have a choice when it comes to gang recruitment, as avoiding these overtures can result in death. So, Ines packed what she could carry and led her two sons on a journey through Mexico to the United States, where the Border Patrol arrested them. Her husband already lived in the United States and had temporary protection from deportation, having been awarded Temporary Protected Status (TPS) following Hurricane Mitch. The Border Patrol arrested Ines and her sons shortly after they crossed the border, and her husband posted bond to secure their release. Ines came to the mid-Atlantic with her sons. She knew she had to follow the instructions she had received at the border to show up at immigration court with both sons, then ages four and fifteen. As instructed, she showed up at a crowded courtroom. She first signed a book in court to register herself and on behalf of her two sons to note that they were present for the hearing as required. She described the court visit:

> I went in front of the judge without a lawyer and with nothing. I went with my two children in front of the judge, I signed a book. And the judge asked me if I had a lawyer, and I told him no. So, then he said, "Okay, in your next, in your next court [appearance] you have to show up with a lawyer." I left after I finished court, and I went to my house. And supposedly after I left, [court officials] called one of my sons and afterwards they called the other one. But since I didn't know about those things, I didn't know anything. I had left with my two sons.

She and her sons returned home, and Ines thought she had done as instructed. But she hadn't. The judge expected her sons to appear before him separately, but Ines didn't realize that. Ines's lawyer later explained that the judge thought they hadn't been in court and ordered them removed. Her next appointment was an ICE check-in, which is routine for asylum seekers. There, an ICE officer informed her that both sons were under removal orders because they failed to appear in court. Ines explained, "The official of immigration told me that supposedly, that my children had deportation. I told him, but since I went to court and I said, the judge, there are cameras there, he can see that I entered with my two children to court. There I went in front of him, I told him, I even signed a book, my son signed, and I signed for my younger son. I also told him my sons' names, I said. How we had been present." Referring to an official document, the ICE agent told her again that both of her sons were under removal orders for failing to appear in court. Terrified that her sons would be deported, Ines called her husband and the two quickly found an immigration attorney:

> The next day at night we were in the apartment where we lived, and the immigration officers came. In the evening, about seven, eight o'clock at night. And they rang the doorbell of the house. And then, well, we didn't open because we were afraid, and my husband looked out the window. Because it was two floors, then he saw that we could see the floor above and saw that they had like immigration vests. They were like three immigration officers. They were looking to supposedly to, to detain the boys. So, immediately I called, no, my husband called [law firm name] that same night. And they told us not to open that door, to only pack a suitcase with the most necessary clothes.

The attorney told Ines's husband to remain quiet and to not answer the door. He said he would stop by later that night and would take her away with the children. Ines told the story:

> After about two hours, I left discreetly with the children. And I walked down the street and there was a car waiting for me [from the law firm] and I got in. I got in the car, and they took me with my two boys. Without

a suitcase and without anything. Then my husband took the suitcase out and left in his car and we had already arranged where we were going to meet. And I spent two months out of the apartment fleeing for the boys, there in [city name]. I stayed in two hotels, first in one hotel and then we were in another hotel. And I didn't take the children to class because they told us that we had to, that the immigration officers could take them out of school. That I had to, I had to wait until the deportation of the two boys was no longer there, so that I could walk freely with the children on the street or at school with the boys.

After two months, her attorney managed to straighten out the legal misunderstanding and the two boys were allowed to remain in the United States as they awaited their family's asylum hearing. Ines described how she felt when ICE came to her door: "Imagine, I had no one to take care of my children in Honduras because I came here for them, fleeing, and to have them deported? It would have been something terrible because I was here and my husband as well. Who was going to take care of my sons? And later to come fleeing for them, for their wellbeing."

We interviewed attorneys who described the series of legal check-ins, some at home and most at courthouses, as part of a deliberate strategy to deter people from seeking asylum. One lawyer said asylum seekers may have to wear ankle bracelets for the first year in the United States, and often are subject to other restrictions such as having to be home by 8 pm, which can limit employment for people who might otherwise work at restaurants. Regular check-ins with ICE officers often cause fear, said an attorney, who also noted that minor mistakes can cause serious legal trouble, as evidenced by Ines's experience. And although the check-ins become less frequent (six months as opposed to monthly) over the years as they await the asylum hearing, women nonetheless report that they cause duress.

People in defensive asylum proceedings typically wait five years for their hearings, and during that time, they must avoid even minor legal trouble. As one attorney said: "It really stresses people out because a person can't make a mistake . . . Sometimes people get detained because they were driving without a license, or their insurance was expired. It creates a culture of fear that goes beyond just being law-abiding." For asylum seekers and other non-citizens, "crimmigration" means that rou-

tine encounters with police for infractions that would result in no more than a traffic ticket and a nuisance for a citizen can impact their asylum cases or result in deportation.[24]

The work to abide by asylum system requirements such as ICE check-ins goes on for years. Court backlogs have grown exponentially in recent years. Unlike in criminal courts, asylum seekers do not have a right to a speedy trial.[25] Currently there are more than two million cases pending in the immigration courts—nearly 75,000 in Virginia where Milagros's case was heard.[26] Of those, approximately 35,000 are asylum cases;[27] 4,700 asylum case respondents are Honduran, 7,700 are Salvadoran, and 3,600 are Guatemalan.[28] In the Baltimore court, the total backlog is 28,300, of which 10,000 are asylum cases.[29] There, approximately 1,700 Hondurans, 4,900 Salvadorans, and 1,700 Guatemalans await asylum hearings.[30] Consequently, asylum hearings are frequently rescheduled, leaving asylum seekers adrift for years, often spanning presidential administrations; someone who applied for asylum during the Obama presidency likely had an asylum hearing during the Trump or Biden administrations. Presidents and their Attorneys General have frequently changed the interpretation of the law around gender-based asylum, so an eventual hearing under a new administration can influence a case's impact.

There are other obstacles in asylum cases. The women we spoke to legally have the right to an attorney, but there is no government-appointed public defendant available to them as these are civil procedures. Having an attorney present in court is only possible if they can find pro bono representation through a non-profit or a university-run law clinic, or else pay for legal representation on their own. Attorneys typically charge between $10,000 and $12,000 for an asylum case, and availability of pro bono assistance is often very limited.

Watching news or reading social media, one might believe that Central American women arrive at the border with a strong understanding of the US asylum process and how to manipulate it to their benefit.[31] But our interviews with female asylum seekers reveal a different reality. Women generally arrive with virtually no knowledge of immigration law. Few know what asylum is, let alone how to shape their life experiences into a successful asylum claim. These women learned some from television or the radio, but mainly acquired knowledge from fellow mi-

grants, friends, and family, and occasionally from Border Patrol agents or social workers while incarcerated. As Barak stated, "More often than not, immigrants assembled a patchwork of informal immigration knowledge vis-à-vis the stories they heard both before and after coming to the United States."[32]

Fortunately, the women we met could hire lawyers who determined that they had a case for asylum, and then helped the women shape narratives, mete out relevant details, file the necessary documentation, prepare for court, and represent them on one of the most crucial days of their lives. Women said they typically pay $400 to $500 per month in legal fees. We found the women interviewed through lawyers, and the fact of having legal representation distinguished them from most Central Americans and Mexicans seeking asylum. Nationally, individuals from Mexico and Central America in removal proceedings—a category that includes defensive asylum cases—are much less likely to have lawyers than those from other parts of the world. For example, one study found that only 30 percent of Guatemalans and 40 percent of Salvadorans in removal proceedings were represented by attorneys, compared to 71 percent of Indians and 92 percent of Chinese.[33] People who go to court with counsel are five times more likely than their unrepresented counterparts to obtain relief from deportation.[34]

Women prepare for asylum cases while engaged in quotidian tasks, often working more than one job to pay expenses such as rent and legal fees. Many hired human smugglers to travel through Mexico and across the border, and their expenses include monthly payments of $350 to $500 to repay those costs. And, working with attorneys, they gather evidence. One attorney described her clients as follows:

> Immigrants, fleeing their homes for many reasons, have one big thing in common: They are so grateful to be in the United States. They come here and often live in what most Americans would consider to be subpar conditions and work, often more than one, arduous, low-paying job. And yet, they're grateful to be here, to have the work, and the safe place to live. They work really hard and without complaint. They are grateful for the work and their homes, as modest as they often are. They take pride in and care for their homes. Those homes are often tiny apartments shared with too many people. They scrimp and save to be able to send money home

to family. They share the wealth they have, the wealth of being in the US. Many parents come here to support their children back home, children who were sick and needed medicine they couldn't afford in their country, or children they want to give a better life to. It breaks my heart to think what it must mean to realize that the best you could do for your child would be to live far away from them and send them money. The stories of my clients are love stories, the greatest love stories that aren't told. They come here out of love for their family, out of fear for their lives, and they engage in extraordinary acts of love, of sacrifice, all notwithstanding the many traumas that they encounter along the way to the US and are subjected to the indignities and dehumanization of the immigration system.

Given the intimate and complex nature of the women's circumstances, the bond between the attorneys and their clients can be strong. The lawyers we spoke to worked with their clients for years, staying in touch with them through multiple jobs and residences, and even marriages and the births of children. To prepare for court, asylum seekers meet with lawyers multiple times to give a sworn statement about the violence they experienced, to provide names and contact information for witnesses who might be able to corroborate their stories, as well as to provide birth certificates, police reports, and medical records. Non-citizens do not have automatic access to their own immigration records and must file Freedom of Information Act (FOIA) requests to obtain relevant documents from the government, such as transcripts of credible fear interviews.[35] A lawyer described the lengths to which a Central American client went to retrieve documents from the remote town that she had fled. A simple phone call or an email was not possible, so she asked friends and family to drive to various locations. The lawyer described her client's efforts:

> She explained this sort of very elaborate chain of people that she had organized. You know, "You give the documents to so and so. We'll get the documents to you and, so we'll drive to get the documents there. They will take the documents here. That person will take the documents to the one person who has a computer to scan and to email it to us. And then that person will also hand it over to another person who will then mail the official documents." So not only did she get the documents quickly—

she figured out a way to get them emailed to me—but she also made sure that I got the originals as well—which were important to present when we actually went to court, because they had like a seal and the wet signature and all that stuff. So, she created this sort of web of people to be able to get the documents to us.

Obtaining evidence proved even more challenging for Constanza, a Guatemalan who needed medical records documenting a hysterectomy following a gang rape that caused severe bleeding. The surgeon had died, and hospital personnel informed her that his records were no longer available. "No one can give her those records and she has tried. Her mom has tried. She has made many calls, and she even hired an attorney from Guatemala, and she paid him to get those records and he couldn't get them," her lawyer said. Lacking the ability to obtain the records, the lawyer told Constanza to have an ultrasound to prove that her uterus was gone. The attorney also encouraged Constanza to have family members write letters attesting to the former partner's history of violence. They did so. Unfortunately, neighbors were too frightened of these violent men to provide letters. One Salvadoran, Adriana, used her wits to obtain crucial evidence before she left the country. She surreptitiously recorded her violent domestic partner with her phone as he threatened to cut out her tongue if she reported his abuse to the police. Adriana also recorded his mother as she warned Adriana that people who take a stand against the Calle 18 end up in body bags. The recordings became evidence in an asylum hearing that Adriana finally won.

High Costs

As noted above, Adriana won asylum, but Constanza still awaits her day in court. Statistically, the odds do not favor her because overall, fewer than half of all asylum applicants are successful, and as noted previously, asylum seekers from northern Central America and Mexico fare poorly compared to those from Russia or China. As noted previously, presidential administrations enjoy broad authority to influence asylum outcomes. In September 2018, then Attorney General Sessions addressed newly hired immigration judges and said, "The majority of

asylum claims are not valid."[36] He told judges that if they did their job, "The number of illegal aliens and the number of baseless claims will fall."[37] Former Senior Advisor Stephen Miller, who authored much of Trump's immigration agenda, said that Trump-appointed judges should "create more integrity in the asylum process" because, "Most of the people that are coming unlawfully between ports of entry on the southwest border are not eligible for any recognized form of asylum. There should be a very high rejection rate."[38] Immigration attorneys and former immigration judges whom we interviewed offered candid assessments of how Trump shaped outcomes, which we focus on here because many of the hearings we observed occurred during his presidency. We also note the Trump legacy because it speaks to the possibility that the election of another far-right president could bring similar actions in the future. One former judge noted: "During the Trump Administration, there were a lot of lifetime government employees who had no immigration experience who were appointed to become immigration judges. And they had no idea what they were doing. They knew nothing about immigration law."

Immigration attorneys voiced considerable angst about the odds they faced in court during Trump's presidency, as well as when facing his appointees who remain on the bench. One attorney said of the judges, "They were so blatantly biased against our clients." The overall grant rate initially improved under the Biden administration, with 46 percent receiving asylum in fiscal year 2022—a 10 percentage point increase over the previous fiscal year; asylum applicants from El Salvador, Guatemala, Honduras, and Mexico were all slightly more successful in FY 2022.[39] Even so, the odds remain unfavorable, and it is perhaps not surprising that women expressed fear as hearing dates drew near. A day of ethnographic observation in February 2021 revealed the daunting nature of asylum cases, as we have described in noting the stringent criteria required for winning and the fact that a substantial majority of Central American and Mexican cases are denied. One morning, an attorney sat outside a courtroom awaiting a hearing for a father and his two children. It was at the height of the pandemic, and he wore a mask as everyone else did that day. He sat next to an eight-inch-thick stack of legal documents, scrolling through his phone as he expressed worry that the cli-

158 | "IF I OFFENDED YOUR COUNTRY, I'M SORRY."

ents wouldn't show up for their hearing because they feared the verdict. The following is excerpted from fieldnotes from that day:

At 10:35 am, the attorney tells me,

ATTORNEY: I'm going to see what happens.
When we enter the courtroom, the clerk asks him,
CLERK: Did she show?
ATTORNEY: It's they, and no they didn't.
He steps out of the courtroom to see if the client has arrived with the children, but no luck. The immigration judge enters the courtroom and asks the attorney,
JUDGE: Have you heard from them at all?
ATTORNEY: I spoke with them two weeks ago and they said they would be here. Would it be OK if I go and look for them again and make a call? They may be on their way.
The judge then takes a recess. In a few minutes, the attorney returns and mutters to the clerk:
ATTORNEY: Oh man . . . It's bad."
The judge returns and asks the attorney:
JUDGE: Any luck tracking them down?
ATTORNEY: No, and they're not answering their phones either.
The judge asks the attorney if he's aware of any traffic problems, but with the pandemic traffic is nonexistent.
The judge says,
JUDGE: I'm afraid we're going to have to move forward.

He then issues a removal order.

In the case referenced above, a family that had invested in retaining counsel and presumably had gathered documents such as birth certificates as well as evidence opted not to appear in court—putting themselves in legal jeopardy if ICE were to seek their arrest. A failed asylum hearing may result in a continued order of removal, a fact that may prompt some to avoid the hearing out of fear.[40] That same day, another attorney discussed the vicissitudes of asylum cases. He was an affable man with a Spanish accent and thick dark hair who wore a mask decorated with the name of

his law firm and its phone number. The lawyer complained about a case that his client lost, one involving gang extortion. He explained that he and his client had thirty days to appeal and if they didn't, a warrant could be issued for her arrest. His client wore an ankle bracelet, making her easy to track. He also said that a warrant might not be issued, and that she could simply live without documentation. "Then they're in hiding," he added. The removal order lodged in absentia was not the only such case we witnessed. In summer 2022, we watched a hearing in which an immigration judge said that a notice to appear had been mailed in January to a woman who had survived gang violence. Without the respondent present, the judge ordered her removed. Perhaps this woman feared the verdict or even just the idea of interaction with the immigration court system. It is also possible that she did not receive the notice about her hearing, which is a common problem, according to attorneys we interviewed.

Whether arrest warrants would be issued for the women who lost asylum hearings or received removal orders in absentia remains an open question. At the end of some hearings with asylum denials, immigration judges warned women that if they failed to present themselves to ICE after receiving a removal order, they would be fined $1,813 per day—an admonition designed to have them comply if summoned by ICE. Lawyers emphasized, however, that the women wouldn't be priorities for arrest and removal, as ICE tends to focus on deporting people with criminal histories. Just as the IRS prioritizes select taxpayers for audits, ICE does not seek removal of all who fail to win asylum.[41] Women who lost cases experienced similar circumstances to those Gonzales and Chavez described, as they engaged the daily practices of activities work and attending to family to find solace and fulfillment despite their precarious legal status.[42] Valeria, the Mexican woman who lost her domestic violence asylum case and now awaits a BIA review, described working four days weekly at a restaurant where she need made dishes such as pupusas, work she enjoyed. She spent her time off caring for her grandchildren:

> I work four days a week. The days that I rest, I try to stay, for me to stay, to stay, to take care of my grandchildren. It's like I forget, I distract myself with my grandchildren. I go out with my daughter. For me here, my family is here, which is my daughter, her husband and my grandchildren. We go on vacation, but all as a family. And that is, how do I tell you? It's, that

is my distraction because I don't go out, I don't have a partner, I only live for my grandchildren and my daughter, and my son who is, who is far away that comes to visit me.

Valeria insisted that losing her appeal wouldn't force her into hiding; in fact, she would continue to focus on work and family. She said, "I have never thought of that—of leaving. But there are people who tell me don't stay here, go to another state, hide so they don't find you. I mean, I don't have a reason to do that because I don't, um, I don't have a reason to hide it. I simply came here to this country, I wanted to work . . . I don't have to go hiding."

Their Days in Court

One day, an attorney coached her twenty-five-year-old Guatemalan client on how to answer questions as they waited to enter the courtroom. The lawyer wore a mask that said, "Kindness," and her client wore jeans, a sweatshirt, and sneakers. She had no coat, despite the presence of snow on the sidewalks that day. The lawyer admonished her client to answer the questions succinctly and to not elaborate. "This isn't the day to talk and talk," she said. She told her to take her time and to think about each answer. If she needed time to think, she said, reach for a glass of water. It was not clear how much instruction the client could take in, as she was visibly agitated, shaking her feet and moving her hands up and down her thighs. Once in court, she described multiple traumas: an uncle who sexually assaulted her, a former domestic partner who raped her and threw her baby during a fight, a series of events that preceded gang extortion. Near the end of her testimony, her attorney asked if she had anything else she wanted to tell the court. The woman responded, "I would like to add that my situation in the United States has brought me peace. I feel peaceful here," she said. Although the DHS attorney questioned her repeatedly about why she never reported her domestic assaults to the police, the judge ruled that she was credible and met the legal threshold for membership in a particular social group, Guatemalan women, and that her persecution was because of her group membership. After explaining her reasoning to the two attorneys, the judge addressed the woman. The following is from our fieldnotes:

JUDGE: Congratulations, to you and your daughter. We are very happy to have you in the United States.

The judge smiles and asks the client if she wants to say anything. The woman is in tears:

CLIENT: I just want to say that it's unbelievable to me that I am able to talk to a judge in the United States. It's just unbelievable because I would be unable to talk to the police in Guatemala. I just have no words to express the thanks I have for me and my daughter. She will be very happy. She's even learning English.

JUDGE: That's wonderful!

Implicit in this statement is the idea of subject formation as a worthy American, which encompasses an appreciation of justice unattainable in Guatemala, attention to family, as well as English acquisition. Judges often ended hearings by telling the women who had been awarded asylum to always obey the law and to pay taxes. In the legal sorting of worthy versus unworthy individuals, the young Guatemalan with a toddler at home had prevailed. She and her lawyer convinced a judge that she met the stringent legal criteria mentioned earlier: that she has a well-founded fear of persecution if returned; that she cannot obtain protection in her home country because the government is unable or unwilling to protect her; that she suffered persecution because of political opinion and/or membership in a particular group. The following story shows the exacting nature of these legal standards.

In March 2023, a Salvadoran woman, Lía, faced a judge in a fully virtual courtroom. Lía, who wore her wavy black hair pulled back, stared somberly on screen in a separate square from her attorney, a blonde woman who joined the hearing from her office. A DHS attorney appeared before a blue background, and finally, the judge, a white man who appeared to be in his fifties, joined. His camera showed him seated at the bench flanked by the American flag. The judge began by asking the two attorneys if they had a chance to discuss the case. Judges routinely started hearings by asking attorneys to settle as much as possible outside of court so that some issues could be resolved without lengthy deliberation. The two lawyers had not spoken, so he

gave them ten minutes to talk and clicked out of WebEx. The DHS attorney raised the question of whether the abuse Lía suffered as a child was relevant, given that her case hinged on her former domestic partner's abuse. Lía's lawyer countered that it spoke to the general concern of gender-based violence in El Salvador. Once the judge returned, he said to the respondent, "Thank you for your patience. We went through some legal issues as to how we're going to discuss your case today. I am now going to put you under oath." With that, Lía raised her right hand and swore to tell the truth, the whole truth, and nothing but the truth.

The judge told her, "If you file for asylum and lie on the application, you can be permanently barred from receiving any immigration benefits. Do you understand that?" She said she understood the admonition, which we heard at the start of each hearing. The judge asked if her application was true and if she would swear to that. She did so. The judge had other instructions for the respondent. "I want to talk to you about how I want you to give your testimony. First, I want you to know that you're under oath," he says, adding that it's the same as being on the stand in courtroom. He told her to "Answer only as it is asked by the attorneys. Do not give extra information.... Answer in short sentences as I am doing right now. And then after the interpreter interprets what you have to say, you can finish." It was then time for her lawyer to ask questions through an interpreter:[43]

> ATTORNEY: Why are you applying for asylum in the United States?"
> RESPONDENT: Because I came running away from Miguel Alvarez.
> ATTORNEY: Who is this individual?
> RESPONDENT: The father of my daughter.

The attorney asks the respondent when she first met him, and she supplies the date.

> ATTORNEY: What did you first think of him?
> RESPONDENT: That he was a good person and that he would go to church.

She asks how the relationship began, and the respondent said he would wait for her to get off work at the store where she was employed, and they would talk. The attorney asks how he treated her initially.

RESPONDENT: Everything was good. He would treat me well.

The lawyer asks when it changed.

RESPONDENT: When I told him I was pregnant.

The attorney asks about his behavior then. She said that he became very angry and beat her. He told her that she needed to have an abortion. The attorney asks what he beat her with.

RESPONDENT: His hands, his feet, and the belt of his pants.

The lawyer asks where on her body he hit her and she said,

RESPONDENT: All over my body but he would concentrate on my stomach because I believe he wanted me to have an abortion . . . He would come over to the store where I used to work and bang me against the wall and the door.

Lía detailed the history in response to her attorney's questions, how he wore long sleeves to hide his MS-13 tattoos. When she realized his affiliation, she was terrified. "He would tell me when he was going to the store that he was being paid to kill and he would carry weapons," she said. Lía never reported his assaults to the police because he had bribed them, including giving an officer a motorcycle. Miguel eventually left El Salvador after a warrant was issued for his arrest for raping a twelve-year-old girl. The arrest did not spare her from his violence. At Miguel's behest, gang members showed up at the store where Lía worked to threaten her. "He would send the friends to beat me where I used to work." The gang members told her that Miguel was their friend and that they were prepared to kill for him. Miguel was eventually arrested in the United States and deported to El Salvador for the rape of the child.

ATTORNEY TO LÍA: Did you have any contact with him?
RESPONDENT: Yes, for two years. When he got to the prison, he started threatening me and telling me to deposit money for him.

The attorney asks how they communicated.

RESPONDENT: Through the phone at the prison.

The attorney asks what Miguel said to Lía and she relayed his threat to kill her, and to "do something" to their daughter, to her son, and to the rest of her family. The attorney asks whether the calls were recorded, and she responded that they don't record the prison phone calls there.

ATTORNEY: What did he want?
RESPONDENT: For me to deposit money for him so that he could buy clothes, shoes, food, everything.

The attorney asks if she ever visited him.

RESPONDENT: Yes, I would go to visit him.
ATTORNEY: Did you bring him things?
RESPONDENT: Only soap, food, clothes, and the personal things he would ask for.
ATTORNEY: Did you want to bring him things?
RESPONDENT: It was mandatory. I had to take care of my children and feed them. It was a burden. It was a load and a cause of pain and distress for me.
ATTORNEY: So why did you do that?
RESPONDENT: Because he would force me . . . He would send somebody with a phone and I would need to answer and they (gang members) would put a weapon to my head . . . They would always say that Miguel wasn't playing and they would put him on the phone and he would say they were going to put me in a box and send me back home to be buried.

Finally, Lía testified that Miguel demanded prison visits. In view of the guards and other visitors, he hit her and grabbed her by

the throat, threatening to kill her. "It was a big room where there were people. There were guards, and they wouldn't do anything. They would always see him and then turn a blind eye," she said. Miguel also demanded conjugal visits, which took place in a smelly room with toilets, and a thin mattress atop a bunk made of bricks. Although the room had curtains over the windows, they were insufficient, giving men including guards a view of the sex that he demanded. Lía told the court that she had acquired a sexually transmitted disease that necessitated a surgical procedure that caused her to leak urine for fifteen days. The attorney asked how long this pattern continued, and she responded that it ended only when she left El Salvador.

> ATTORNEY: What would happen if you went back to El Salvador?
> RESPONDENT: I will get killed and I will be one more person killed in El Salvador.

The attorney asks if she could live in another part of El Salvador and Lía responds that Miguel could always find her. He knew people who could track her down even when he was detained. She added that El Salvador is small, so it's not as easy to hide there.

Lía's lawyer asks if the police would help her. She said she could go to the police, but they would release him after seventy-two hours. The attorney asks why she thinks they'd do that.

> RESPONDENT: The police are corrupt and if he found me, I wouldn't have the time to call them because he would kill me.

The judge calls a ten-minute break. He could be heard releasing an audible sigh as he rose from his chair.

It is impossible to know what the judge was thinking when he sighed, but attorneys and former judges told us that they often struggled with the trauma they heard during testimony and in preparing for court. Once court resumed, it was time for the lawyer representing DHS to cross-examine Lía. DHS's strategy centered on questioning why Lía hadn't sought police protection, and whether the fact of her domestic relationship was known.

DHS LAWYER: How many times did you report this behavior to the police?
RESPONDENT: Never. Because they would always report back to him.
DHS LAWYER: But you said he would be held for seventy-two hours.

She asks how the respondent would know that he would be held for seventy-two hours if she never called the police. She said that's the policy in El Salvador, to detain someone for seventy-two hours.

DHS LAWYER: Why did he treat you this way? Did he ever say why he was doing it?
RESPONDENT: Yes, because he wanted me to have an abortion.

The DHS lawyer asks why he continued to treat her this way after her daughter was born.

RESPONDENT: Because he wanted things when he was in prison and he saw me as a vulnerable person.
The DHS lawyer asks if she ever lived with him.
RESPONDENT: No.

The DHS lawyer asked if other people knew she was in a relationship with him, and she said that only people in the store knew of him. She had kept the relationship a secret from her family, except for a single uncle. DHS's strategy centered, in part, on questioning whether her beatings and rapes occurred because she was in a well-known relationship with Miguel, a particular social group her attorney sought to have recognized.

DHS LAWYER: And you testified that you visited him in prison.
RESPONDENT: Yes, he would force me.

The DHS lawyer asks if there were ever times that she didn't go to the prison.

RESPONDENT: Yes, I would get sick out of the fear . . . And then I wouldn't go.
DHS LAWYER: What did he do if you didn't go?
RESPONDENT: He would beat me more the next time.

Finally, Lía's lawyer made her closing argument, stating that her client had testified credibly and consistently. She recounted her former domestic partner's legacy of beatings and rapes. "Rape is an inherently gender-based crime," she said. "He viewed her as property, as someone he could control and do what he wants with . . . He doesn't recognize her right to live independently . . . He's beating her. He's raping her . . . The prison officials are watching it and they aren't doing anything to protect her." She also asks for Lía to be considered for relief under the umbrella of political opinion, as she had opposed having an abortion and refused to do so, a decision she paid for with assaults.

When it was time for the DHS attorney to summarize why Lía should be removed from the United States, she waived giving an oral argument. The judge then told everyone that he needed twenty minutes to deliberate and return with a verdict. Twenty minutes later, everyone clicked back into WebEx, except for the judge. People stared into the screen as the bench remained empty. Fifteen minutes later, the judge could be seen returning to his seat. He thanked everyone for their patience. The following is from the fieldnotes:

> The judge says there are issues in granting asylum. "In this case, I would be willing to grant asylum for El Salvadoran woman only." He says that the political opinion of her opposition to having an abortion only applies in cases in which abortion is used by the state as a form of population control, and notes that this is an issue in China. "But that is not viable in this case."
>
> He also questioned whether it was known that Lía and Miguel had a relationship. "He treated her like his property or a prostitute, but they never lived together," the judge said. He notes a legal precedent which dealt with Guatemalan women in a domestic relationship, in cases in which the relationship was public such as a marriage. He said he struggled during his deliberations to decide whether she qualified for protection as a Salvadoran woman. He said that the "reasons for that are from the excellent brief put together by the respondent's counsel." He notes that there is a *"machista* culture" in El Salvador.
>
> "Did he persecute her because she's a woman?" he says, "This looks like private violence for the most part."

The judge characterized the violence Lía suffered in the home and at the store where she worked as "private violence," a characterization that dismissed the realities of the political and social factors informing gender-based violence. He noted that just because DHS decided to waive and defer to the court doesn't mean he would grant asylum. He argued that as a judge, he is the gatekeeper and the one who decides what are legal grounds for asylum. What was relevant for asylum, he said, were the rapes at the prison because the guards—agents of the Salvadoran state—did nothing to protect her. "He did treat her as his property," the judge says. "The government was unable or unwilling to protect her while she was in prison. They knew what [Miguel] was doing." The judge characterized his decision as a "close call," and he lauded Lía's evidentiary material for convincing him that she merited protection as a Salvadoran woman. Had Lía not been beaten and raped in front of prison guards, she would have lost her case.

The obstacles to winning asylum are in evidence in the following example, in which a woman's attorney decided it would be better to accept the government's offer to drop removal proceedings than try for asylum.[44] Itzel, a Guatemalan who escaped violence from her domestic partner, came to court one day, only to find that she couldn't understand the interpreter who spoke her indigenous language.[45] The judge phoned a translation service and said, "We have an alien here who speaks [language redacted]." The interpreter, who was based in New York, found himself trying to explain the respondent's answers as she spoke through a mask. Her attorney argued that the translation issues disadvantaged her client. The hearing took place in November 2020, months before vaccines were distributed, so both the interpreter and the DHS attorney appeared via phone. What follows are the fieldnotes documenting the exchange in court.

> INTERPRETER: I am not understanding everything the first time . . . I am having a hard time understanding what the respondent is saying and am having difficulty explaining it to her.
> ATTORNEY: I don't see how this fundamentally fair to my client.
> JUDGE: What if we have the same problem with every single interpreter we have here?

The attorney asks the judge to allow the interpreter to explain the problems.

INTERPRETER: [Respondent] has a very limited vocabulary and I have to explain everything in several different ways.
ATTORNEY: Your honor, I'm not sure if this is fair to my client . . . I want to make sure she has her day in court.
INTERPRETER: It makes it even worse because with the masks, everything is muffled.

The judge suggested using a different interpreter via telephone so that the hearing could proceed. The interpreter said that the same problem would exist; they would need to ask the same question three or four different ways for the respondent to understand the questions. The DHS attorney agreed that it might be best to postpone the hearing until an interpreter could appear in person. "If you're not showing up in person, then why would an interpreter show up? What do you want me to do?," the judge said to the DHS lawyer. In a pointed exchange, he asked the woman's attorney if she planned to object to every interpreter brought to court. The hearing was postponed, and Itzel eventually accepted prosecutorial discretion, ending the removal proceedings. Women we interviewed had hoped for asylum rather than prosecutorial discretion because a new US president could initiate removal again. The attorney said that prosecutorial discretion was best, given that this judge rarely rules favorably in asylum cases. By accepting the government's offer, the woman would still have the option of seeking asylum affirmatively in an interview with an asylum officer, but this might take a long time and be expensive if she continues to retain her attorney.

In immigration court, interpreters take an oath to "interpret and translate accurately." Because none of the women interviewed speak English fluently, interpreters play a key role, as they become the women's voice. Interpreters must ensure that all communication between the judge, lawyers, and respondents is repeated accurately in both English and the respondent's language. This means interpreters must know how to translate everything from legal terminology to local slang and must be able to relay respondents' detailed accounts of trauma in English.

Sometimes it means stopping a weeping, emotional testimony and asking the respondent to repeat a word. At times, interpreters halted the proceedings to look up a word in a dictionary. This task is made even more difficult when the hearings are remote, and interpretation must be done through video technology.[46]

Observing asylum hearings in immigration court, the authors became aware of the difficulties involved in interpretation as well as the critically important role that interpreters play. Women seeking asylum were asked to tell their stories and were frequently quizzed by attorneys and judges regarding specific dates, locations, individuals present, and other details. The court needed the full story, but DHS and judges often tested women to determine whether they were credible. DHS attorneys want to catch inconsistencies in a respondent's story to call her credibility into question and to argue that her case does not meet the strict criteria for asylum. If an interpreter misstates a name or date or location, it can make the respondent appear less credible. As a Spanish speaker, one author recalls several times when she believed the interpreter had not faithfully translated the respondents' words. The judges we spoke to made it clear that some interpreters were better than others and developed good working relationships with favored interpreters. One judge explained: "We had one [interpreter] who was just amazing, so anytime he was in my courtroom I was thrilled. And then there were a couple of others who were really good. And then there were a couple who were okay. And then I had a . . . a Chinese language case where I had to dismiss an interpreter because of how bad she was." Another former immigration judge recounted an instance when she was forced to disqualify an interpreter after hearing multiple errors as the interpreter switched between English and the judge's native language.

Credibility issues emerged at a hearing observed in 2020 for Victoria, a Guatemalan woman who sought protection after witnessing her cousin's gang murder in her small village. On the witness stand, she described seeing the shooting as she crossed a bridge. She said she saw the shooter, and subsequently received threats via phone calls and text messages. The threats forced her to stay indoors with her infant daughter. Victoria described the gang threats on the witness stand: "They said, 'We think you ran because you spoke to the police.'" She said she tried to tell the caller that she had not gone to the police because she was terrified

that if she had, the gang would kill her and her daughter. "I had to move constantly, every three months . . . I changed my phone number every time I moved." The threats came via texts and phone calls. According to Victoria, the gangs told her, "We're going to find you and the first thing we're going to do is take away your daughter and kill her for vengeance." The judge questioned the woman's testimony that the gang threatened her after she spoke to police, an issue that she had not included in her written evidence to the court.

> JUDGE: That seems fairly important, pretty serious. So, I'm wondering why that is not something that you put in your application? . . . That wasn't in your application. That would be a pretty critical part of your claim that is missing.

Victoria, the respondent, states that she did put it in her application. There is a pause in the discussion as the judge pages through her statement, looking for the description of the gang's accusation that she had already gone to the police. Included in her evidence were letters from her partner and her father describing the gang threats. Apparently, there was no mention of the gang's belief that she had reported the murder to the police. The judge wanted to know why.

> RESPONDENT: I believe my dad said that I would be killed.
> JUDGE: Do you know why your father didn't mention that? And why your partner didn't mention that?
> RESPONDENT: We didn't remember it.
> JUDGE: What suddenly makes you remember it now?
> RESPONDENT: I remembered it when I spoke with my father last night.
> JUDGE: And what made your father suddenly remember something like this?
> RESPONDENT: He was wishing me luck and he said he'd forgotten to mention those things.

The judge found Victoria to be only partly credible, meaning that he doubted part of her testimony. He also questioned whether the gang's phone calls and text messages rose to the level of persecution. No gang members threatened her in person or used a weapon, as many women

we interviewed discussed. The judge also questioned the merits of several proposed particular social groups: Guatemalan crime witness, witness of gang crimes in Guatemala, gang crime witness reputed to have reported a crime. He argued that the concept of crime would be too broad to define a social group. The judge ruled that crime can encompass a wide range of behavior including petty theft, assault, a hit and run, vandalism, and drunk driving. "A gang member could steal soda or push someone out of the way. It's so broad it doesn't create well-defined boundaries. These are not well-defined social groups," he said. With that, the woman was ordered removed from the United States.

Despite formidable odds, women and their attorneys sometimes managed to fit their stories appropriately within the confines of asylum law to win gender-based claims. Yesenia, a Honduran, faced a judge in a fully virtual hearing to argue that she needed asylum after having been gang raped twice by police officers in her home. She appeared on screen with her black hair pulled back, wearing a white blouse with lace. The judge, a slender, middle-aged white man, admonished the attorneys to try to avoid asking her details about the rapes to protect her from re-experiencing traumatic material on the witness stand. He told them to focus on the legal grounds for her asylum claim.

Her attorney told the court that she would be arguing that Yesenia suffered persecution by virtue of her imputed feminist political opinion. Yesenia was nineteen when she came to the United States. In Honduras, she worked in a restaurant for five years in the hope of earning sufficient money to pay for an education; she moved away over the objections of her parents. Yesenia told the court she had been spotted by police at a checkpoint as she walked home from the restaurant where she worked nightly. She stated that she came home from work one night to find that two uniformed officers had broken into her apartment. They raped her. She reported the crime, only to be raped again by police eleven days later. Through an interpreter, Yesenia's lawyer asked why police targeted her.

> RESPONDENT: In my community, there is this way of thinking, a chauvinist way of thinking that women can't have their own things.

> The attorney asks if there was any other reason. She stated that when she placed a complaint,

RESPONDENT: They thought it was feminist of me to defend myself.

Her attorney asks whether she thinks anyone else should have the right to make decisions about her own body.

RESPONDENT: You can't allow anyone else the right to make decisions about your own body.
ATTORNEY: Are you a feminist?
RESPONDENT: Yes, because I was trying to be independent and I was trying to defend myself.
　　The attorney asks if it's seen as a feminist act to file a police report following a sexual assault in Honduras.
RESPONDENT: Yes, it is seen as a feminist act.

The judge asked for a five-minute recess to deliberate. He returned and announced that there was no question that the harm Yesenia suffered rose to the level of persecution, and that he would be inclined to grant asylum because of her imputed feminist political beliefs. These included the fact that she wanted to go to school without parental support and her belief that women should have control over their own bodies. He then congratulated her for winning asylum and advised her to discuss the next steps toward legal permanent residency ("a green card"). And he told her, "You must always obey the laws and pay your taxes."

　　Asylum cases are never simple. Yesenia's case, however, revealed certain facts that worked in her favor in a courtroom: Her assailants were uniformed police officers, a fact that helped her make the case that the state would not protect her. Further, she had lodged a complaint, which the judge believed was sufficient to document her imputed feminist beliefs. Finally, the judge believed her testimony, a key consideration in an asylum case.

A Legal Obstacle Course

To win asylum, the women we spoke to must traverse a legal obstacle course and work with their attorneys to ensure that their stories and trauma meet the legal criteria for asylum. Furthermore, they must prove their credibility, including obtaining evidence: letters from family

members or neighbors who might have witnessed domestic violence or a gang threat; medical records; and on the occasions which seemed to be few, proof that they had trusted the police enough to seek their protection. The legal standards to win an asylum case are onerous, as evidenced in Lía's court appearance. Had there been no representatives of the Salvadoran state (prison guards) watching as she was beaten and raped, she likely would have lost her case. That is despite the fact that her former domestic partner's gang associates doggedly threatened her.

While they await their hearing, women's days are marked by work, maintaining households, raising children, and often, sending money home to family members, all while finding and paying for lawyers. Women who lost their cases, including Valeria, would continue to work and raise families, although they would do so at society's margins. As such, they would experience what Barak termed "slow violence," that which is not dramatic, but which is caustic emotionally, as uncertainty and a tenuous legal status characterize their lives in the United States.[47] The journey to asylum is fraught. As we noted in Ines's story, even routine legal appearances can lead at worst to a nightmare scenario in which ICE agents show up to arrest children, and at best, to the legal violence and anxiety of interacting with authorities who are skeptical about their reasons for being in the United States.

Conclusion

The Architecture of Exclusion

Belinda, the Salvadoran who came to the United States with her two-year-old son after a home invasion by the Calle 18 Gang, won asylum in a hearing where a law student who helped represent her wore festive candy corn earrings to mark the upcoming Halloween holiday. We interviewed her three years later, when she described her life now: Her construction job pays twenty-five dollars per hour and allows her to support three children while saving for a house. She works eight to eleven hours daily pouring concrete; her mother has migrated to the United States and lives with her to care for the children while Belinda works. We asked how she celebrated the win in court that allowed her to work and live in the United States. "We went out to eat pupusas, and well, we gave thanks to God for what had happened," she said. She described how winning asylum has shaped her thinking and her life:

> Well, the truth is that it has been a great opportunity because not all people have this privilege of really living here without worry, right? That, well, they can catch you, they can send you to your country. And many times, well, you leave. You know your children, or your things. Everything you have done here. So, really that uncertainty, well, it's eliminated or removed. Because, well, you can say, ok I'm going to be here, and really, I have, I'm legal and everything. And well, I can opt for many other things, for example, my own house, because I really want my own house too. I'm working for that.

Belinda's description of her life post-asylum includes the elimination of uncertainty associated with a forthcoming asylum hearing and, perhaps more important, the confirmation of her own state of legality. Although it is legal to seek asylum in the United States, the processes we describe,

from apprehension and detainment at the border, to routine check-ins with ICE and preparation for court, underscore how tenuously women perceive their status until winning asylum. Belinda developed a plan for what she would do if she had lost her case: She would send her mother and children to another Central American country that she hoped might put them in less immediate danger than what they experienced in El Salvador. She planned to remain in the United States and work to send them money, before eventually joining them. If that had been the case, Belinda knew her opportunities would be sorely limited because she would be subject to an order of removal and would lose her status as an asylum seeker, unless she appealed the judge's decision. "It is really awful to be here without papers. It is very difficult," she said.

Sara, a Guatemalan who won asylum based on both gang and domestic violence, works in food services and cares for her two children, a four-year-old girl and a new baby. She views winning asylum as a force for stability in her life and a relief, as she no longer fears deportation or living without legal status. When interviewed, her boyfriend supported them with earnings from construction work. Although she feels safe after winning asylum, the memories linger:

> Almost all of the memories that I have of Guatemala are very bad and every time I remember, and hear Guatemala mentioned, suddenly, I always associate it with very sad things . . . The only thing I miss from Guatemala is my grandmother, because my grandmother is mom, dad and grandmother to me. I mean, I grew up with only my grandmother. And if for some reason I wanted to go back to Guatemala, it would only be because of my grandmother. We almost always talk by video, but sometimes it's very difficult for me because the place where she lives . . . It takes a lot for the internet to work. So, it's easier for us to just talk than to see each other over video. And sometimes seeing her is more difficult for me because she cries a lot because she is very sick. So, that leaves me feeling even more sad. Many times, I prefer not to see her and just, well, talk to her, and when I feel that things are getting like really sad, well, I just tell her that I will call her another time, and that's all. I still have a hard time handling that.

Others who had hearings did not receive asylum, as we noted with Valeria, who now awaits a decision before the BIA. Ines, the Honduran

whose sons narrowly escaped arrest by ICE, also lost her asylum case and awaits review by the BIA. When women lose an asylum case, they enter a liminal gray space of constricted existence, a space of limited work opportunities, with few if any legal rights, and where they are viewed by the wider society as "illegal."[1] While they await hearings or BIA appeals, they are shielded from arrest and removal, and work permits can be renewed during the appeals process. But what is the quality of this existence?

Women fled to the United States following repeated acts of violence that included rapes and death threats, as well as gang attempts to conscript children. Some left children behind with relatives because they either feared the journey to the United States would be too dangerous or they simply couldn't afford to bring them. The Border Patrol apprehended and incarcerated them. Women who seek asylum arguably suffer disadvantage as public discourse consistently focuses on border security, rather than on the reasons people might have for seeking protection. Such narratives cast asylum seekers in a shadow of assumed illegality, making them controversial and unsympathetic to some Americans.[2] Because undocumented Latino immigrants are reviled as criminal in public discourse, an understanding of asylum seekers becomes elusive. Thus, Latin American asylum seekers seek legal protection in what amounts to a hidden system, far removed from the notice of Americans.

One goal of this book is to illustrate the asymmetry between women who need asylum and the system designed to afford them protection. We argue that the US asylum system is a Cold War era relic created to protect survivors of state persecution, but that now must increasingly be accessed by those victimized by private actors. Indeed, the system's legal strictures work to repel large numbers of asylum seekers from the Global South who seek protection in western democracies, whether large numbers of Central Americans or Mexicans at the US border, or desperate Syrians aboard vessels in the Mediterranean.[3] The system is designed instead to sort out those deemed worthy of protection from those who could be dismissed legally as merely migrants, with the burden falling on individuals to prove worthiness of asylum claims.[4] As noted by Meghana Nayak, nations including the United States use the asylum system to further their own aims on the global stage by sorting out what constitutes persecution rather than mere gender-based vio-

lence; deciding who would be a worthy citizen; and finally, positioning themselves as innately "better" in comparison with other countries.[5]

While we focus on women from northern Central America and Mexico, we hope that this book serves as an invocation for further research to understand how asylum may work for men, or for people from other parts of the globe who need protection because of weak or failed states. The women we interviewed sought asylum at a particularly precarious time: States increasingly seek to harden borders in response to increased migration flows, and 4.6 million people worldwide are seeking asylum, ten times as many as sought it just twenty years ago.[6]

Despite recent court rulings that should protect some women fleeing domestic and gang violence, the US asylum system has not evolved sufficiently to protect women who suffer rapes, death threats, stalking, battery, and extortion—all crimes that occurred in nations with attenuated trust in law enforcement and destabilization that arguably arises because of legacies of civil war and military repression, drug war violence, and high poverty rates.[7] We argue that "private violence" is a misnomer and that the migration flows from these nations are, in fact, precipitated by public factors.

Conceptually, we note that the displacement of women from Central America and Mexico is the result of convergence of factors that include both structural and symbolic violence.[8] In analyzing women's need for asylum, we turn to Pierre Bourdieu to consider how class and gender inform women's social positions, including access to resources such as education and jobs.[9] Masculinity and higher-class positions bring more value and respect to men, a factor informing male dominance and privilege.[10] As noted by Cecilia Menjívar in her analysis of violence against women in Guatemala, gender-based violence arises because of both structural and symbolic violence.[11] Structural violence includes inequality in the distribution of jobs and education, and the question of whether laws against gender-based violence are ignored; the inability of women to escape their material circumstances coupled with their inability to find safe haven from violence serves to ensure their subjugation. We rely on feminist interpretations of sociology, anthropology, and critical geography to consider how states and extralegal actors shape space, specifically structural and symbolic violence as drivers of the brutality that force women to seek asylum. The narratives given by women we

interviewed focused on multiple experiences of horrific violence, but we emphasize the context for these experiences, including the symbolic violence toward women that is unremarkable and routine, conditions in which women are devalued in comparison to men. Though Bourdieu described symbolic violence as "a gentle violence," we emphasize that the outcomes of this violence are consequential as they ultimately serve to inform the brutality that forces women to seek asylum.[12] Social hierarchies that disadvantage women come to be seen as natural, as facts of life, and therefore go unquestioned.[13] For the women we met, symbolic violence was a coercive product of patriarchy that emerged in multiple realms: work, community, and family.

Purgatory of Place

Asylum seekers exist in a tenuous space between legal prohibition and legal status, a space we call compounded marginalization. To anchor our understanding of compounded marginalization, we draw on conceptualizations that emerged this century to delineate how immigration status forces migrants into spaces of social harms, limited rights, and both economic and legal precarity. As noted in her discussion of how liminal legality affects the lives of Central Americans in the United States, Menjívar argued that many migrants move through legal gray spaces between either having legal status or lacking it.[14] To avoid deportation, they find themselves engaged in an onerous legal process that involves legal fees, completing forms, filing photographs and more, with the result that some entrepreneurs such as notaries established businesses catering specifically to these needs. Menjívar noted that Central Americans' outcomes in realms ranging from work to artistic expression hinge on maintaining legal status, which can prove elusive. "Legal categories mark immigrants not only as nonnationals but also as deportable, and these categories become marks of exclusion. Not all groups have equal access to permanent statuses, an aspect of immigration law that undermines the assumption of equality of status and belonging in citizenship."[15] The complex processes of obtaining and maintaining legal status include keeping up with documents such as tax forms, immigration court documents, and work permits, all of which involve contact with a government authority that causes forms of subjugation ranging

from emotional distress to potential arrest and deportation, as noted by Roberto Gonzales and Leo Chavez.

In their conceptualization of legal violence, Menjívar and Leisy Abrego argue that immigration law encompasses both structural and symbolic violence, with migrants suffering long periods of time being undocumented with virtually no avenues out of that status, resulting in exploitive working conditions, family separations, and deportation risks. Critically, immigration laws create a hierarchy ranging from the undocumented to the quasi-documented to the documented, with the result that one's opportunities and access to resources are informed by their place in that ranking system. Women seeking asylum occupy a preferred status to those with no documentation as they can obtain work permits. They experience a reprieve from deportation orders as they await a hearing. We use the term, preferred status, to capture both the quasi-inclusion asylum seekers experience as they are spared deportation and can obtain a work permit, but whose existence is otherwise defined by a protracted legal battle to win relief from removal as well as racialized conceptions of Latino migrants as "illegal" regardless of status.[16] Three elements inform the concept of compounded marginalization: (1) the asylum system's failure to acknowledge the structural conditions and decidedly public nature of the "private violence" that forces asylum claims; (2) the criminalization of asylum seekers in their treatment at the border, as apprehensions and detention send a message to both asylum seekers and the broader public that this population is suspect—no matter their reasons for crossing the border; (3) histories of brutal trauma that may alter one woman's sense of safety, leading to depression, nightmares, flashbacks, and a host of symptoms—problems that could persist, in part, because the wider society fails to recognize and acknowledge why these women merit protection.[17] We describe this space of compounded marginalization, in part, as an invocation to future research on other groups seeking asylum in the United States, including men from Central America and Mexico who come here for protection from gang violence. While this book has focused on women who suffered violence by non-state actors in Central America and Mexico, our hope is that this framework is useful for survivors of similar violence in other regions. Asylum law emerges from an international acknowledgment that there are people fleeing their countries who cannot return home, and that it is

receiving nations' responsibility to avoid returning people to countries where they face persecution. The women we interviewed experienced trauma in their home countries, and we acknowledge that they are not unique, unfortunately, in needing the protection asylum can offer.

We argue that because of trauma histories, symbolic ascription of criminal status in their treatment at the border coupled with anti-Latino migrant sentiment, as well as limited options for winning asylum cases, women exist in a state of compounded marginalization. The US Border Patrol apprehends and detains them. While at the border, they experience verbal derision and deprivation of rights, including pressure to agree to be deported—no matter their reason for having entered the United States. They receive treatment befitting criminals, including fingerprinting and incarceration, which Meghana Nayak argues is a deleterious practice: "The detention of asylum seekers is a violation of their human rights, particularly if they have fled persecution, did not know how to affirmatively apply or to apply for refugee status from abroad, and have no idea why they are being fingerprinted, handcuffed, and put in correctional facilities."[18] That point cannot be over-emphasized, given the legal violence that sustains it, as practices of arrests and detention of people seeking safety from violence go unquestioned in public discourse.[19] As we noted in chapter 4, the women faced the conditions described above by Nayak. They described crossing the border and knowing that they had little choice but to flee their circumstances.

Once released, the women we spoke to receive work authorization, and often held multiple jobs to support themselves and their families, as well as to pay debts to both lawyers and human smugglers. Some women become subject to government surveillance as they either wear ankle bracelets or attend frequent check-ins with ICE officers. For years, they wait for a hearing before an immigration judge who holds the power to grant asylum, but only if women prove that the violence that they endured was sufficiently severe and meets the narrow criteria for asylum imposed by immigration laws, judicial opinions, and the current presidential administration. In short, they experience what we call compounded marginalization They are subject to discriminatory and racialized conceptions of Latino migrants as "illegal" regardless of immigration status. They reside in the United States as asylum seekers during a particularly intense period of politicization of immigrants in

general, and asylum seekers specifically, and palpable public discontent over their presence.

These women endure this adversity while continuing to live with the trauma caused by violence experienced in their home countries, often at the hands of intimate partners and known individuals. While their asylum hearing brings the possibility of winning protection, it often requires re-living the worst moments of their lives and sharing intimate details in a courtroom with government representatives who may be hostile toward them.

Women in the asylum system face a range of outcomes: (1) a lost case in which an asylum seeker becomes subject to removal and may appeal to the BIA; (2) receipt of a form of prosecutorial discretion; and finally, (3) a successful claim, meaning they no longer face removal from the United States and now have a path to legal permanent residency ("a green card") and citizenship. We briefly unpack the implications of each outcome in what follows.

Being denied asylum is the worst outcome. A lost case means that an asylum seeker failed to convince the judge that her trauma met the legal requirements for asylum. The judge may not have believed that the violence was due to a woman's membership in a particular social group, or the judge might not concur that it is unsafe to report crimes to the police. As demonstrated in a redacted legal decision in chapter 3, the judge may believe the country of origin is trying to protect women from persecution, even though gender-based violence is endemic there. In other words, the judge didn't believe the woman was traumatized *enough*, or in the *right* way. Or they simply may not have found the woman's story credible. A recent report summarized the specificity of American asylum law in the following way: "Under domestic asylum law, immigration judges may simultaneously conclude that a person is likely to be killed if deported to their home country, and that the person nevertheless does not qualify for asylum because they will be killed for the wrong reason, or by the wrong person."[20] In gender-based claims, that "wrong person" could be a domestic partner or a gang member, agents who in the eyes of some judges commit heinous crimes deemed "private violence."

Some women appeal the judge's decision to the BIA, but this step almost always requires money for additional legal fees, unless the appellant can access pro bono counsel or proceeds without an attorney. And

the outcome, typically decided several years later, poses renewed uncertainty. Women who await appeals following failed applications arguably exist in a space of constricted existence as they are allowed to work and are unlikely to be arrested by ICE and deported. But they nonetheless experience a sense of exclusion as they typically engage in low-wage work and must live with the uncertainty brought by the very idea of potentially losing their case and being under a removal order. Thus, asylum seekers who appeal remain in a state of compounded marginalization as they continue to battle for legal status and to avoid being returned to danger. It also means that they will likely not be able reunite with their children or other family members who remain outside the United States, and the trauma caused by family separation continues to haunt them.[21] Some choose not to appeal an asylum denial and join the ranks of the unauthorized immigrant population. As we described earlier, friends encouraged Valeria, the Mexican who fled severe domestic battery and lost her case, to go underground to avoid being found.

Women who accept prosecutorial discretion—relief from a removal order—continue to be constrained, their lives marked by uncertainty.[22] These women could join the ranks of the undocumented immigrant population, faced with limited work opportunities and access to health care, and the ongoing possibility of deportation. Or they could seek affirmative asylum, a process that includes the applications, fees, and legal bills we described earlier. One woman we met agreed, after being encouraged by her attorney, to accept prosecutorial discretion. The government dropped its removal proceedings against her, but she understood that she didn't have the protections of asylum, including a pathway to legal permanent residence or citizenship. "I feel like everything fell apart. Like being undocumented, let's say like not having papers, or to have, ones like this, everyone asks for a Social Security number." Although she retained her work authorization, the permanency she hoped for eluded her and she could become subject to a removal order.

And then there are the fortunate women who are granted asylum by the immigration judge or after appeal to the BIA, women who successfully convinced authorities of their need for protection. Women who win asylum understandably feel tremendous relief after the decision. The attorneys we spoke to say their clients described it as "a brick lifted off her chest" and "finally being able to sleep through the night." As asylees, they

can envision a future for themselves and their families. As Belinda's story illustrates, she could be free of the threat of deportation and check-ins with ICE officers. But many attorneys also described their clients' feelings as bittersweet. One lawyer explained, "Even after they've won, they still feel really rejected, they still feel really persecuted by the courts and their persecutor in their home country. Every once in a while, I'll have a client who truly feels at peace with their win and feels at peace with their past. It doesn't happen very often, but when it does, it feels really nice." These feelings are even more complicated by the fact that, while winning asylum ends one protracted and arduous legal process, other legal obstacles remain. Upon a grant of asylum, women are classified as asylees and may work in the United States without continually renewing a work authorization.[23] They are eligible for certain public benefits including Social Security Income (SSI), Medicaid, and Food Stamps for seven years after winning asylum.[24] After a year, an asylee may adjust her status to legal permanent residence and obtain a green card.[25] However, while it should be a simple process, long processing backlogs mean that it may take years to receive a green card.[26] This means she will have to wait even longer to enjoy the benefits of legal permanent residency, including the ability to petition to bring additional family members to the United States and to become a naturalized US citizen.[27]

There are other immediate concerns that punctuate their daily existence. When applying for asylum, women can include a spouse and unmarried children living in the United States on their applications. If she wins, those family members also receive asylum. But many women we met had children and family members who remained in the home country, often in the same communities or even the same households as their abusers. Family separation means pain for women who suffer guilt for leaving family members behind, despite knowing they had no choice. To bring children to the United States, women must submit to yet another arduous legal process. They cannot travel to their home countries to see children because doing so could lead to a revocation of asylum; receipt of asylum is premised on the understanding that a woman faces grave danger if she were to return to her home country. So even after the US government has granted asylum, women must begin a new struggle to protect their children. This begins by filing a new form and undergoing a process that can take years.[28]

As of January 2024, US Citizenship and Immigration Services (USCIS) needed 29 months to process applications to bring children here.[29] Once USCIS approves the application, children must appear for an interview at the US embassy or consulate and undergo a medical exam at the family's expense. Children also need a passport to enter the United States, and, in domestic violence cases, this fact can create barriers as fathers can oppose surrendering children to their mothers. One attorney explained: "That's not necessarily going to be possible because you have to have both parents sign off and then you're going back to the abuser and asking him to essentially do something to help the kids to leave. It can be a very dangerous and fraught situation. You usually end up having to pay off the abuser in some kind of shady way. It's really stressful."

Once the legal process ends, the family must arrange and pay for transportation. Because of these delays, attorneys told us that they have begun to file *mandamus*—a demand for action due to a violation of the Administrative Procedures Act to expedite the process.[30] But this means that women must continue to pay legal fees and submit to yet another legal procedure to reunite with their children. One attorney interviewed in 2022 told us: "I don't like to even let my clients dwell on the fact that if they win asylum then they can bring their kids because the process is so heinously slow it would break my heart to watch them wait four years for their trial and then wait four years for their kids to come here . . . I just say 'I can't bring your kid here lawfully for a very long time.' For example, I have a case right now. This woman won asylum in 2017 and her ten-year-old son is not here yet."

In addition to difficulties around reuniting with their children, asylees experience other issues. Their past trauma may continue to haunt them well beyond their hearing date.[31] Moreover, the pressure of living in the United States with little formal education, minimal command of English, and having to provide for themselves and their families is inescapable. Separated from family and suffering trauma, asylees may feel great loss. The attorneys we spoke to noted that asylees must acknowledge that they have chosen the United States over their home country. The asylum process has forced them to denounce their home countries to win their cases. One lawyer described this condition as a "purgatory of place"—neither completely in the United States nor in their home country.

As noted in our delineation of compounded marginalization, the pervasive nature of trauma in the lives of women serves to cause suffering, which potentially remains even after successful asylum hearings. Few women interviewed had received any mental health services to address trauma as wait lists for free or sliding-scale services make obtaining assistance problematic, especially for low-income workers who have minimal if any health-care coverage. Social work, a profession that began in service to immigrants most famously at Chicago's Hull House, seems to have minimal interaction with asylum seekers, a problem in the United States and other western nations.[32] In the United States, clinical social workers rely largely on insurance payments to cover their services, leaving the most disadvantaged with minimal access to assistance.[33] In its mandate for the value of service embedded in the Code of Ethics, the National Association of Social Workers encourages clinical practitioners to donate some portion of their time to pro bono treatment.[34] Social work's response to this population's needs could be traced to the lack of organizations that exist in certain regions to serve immigrants, a problem cited by the Brookings Institution earlier this century when anti-immigrant legislation was passed in localities as Latino immigrant populations swelled.[35] The Brookings Institution cited a lack of social workers to help incorporate new immigrants into the fabric of these communities.[36] Asylum law and an inadequate social service infrastructure have left women in an arguably untenable position, although some clinical guidance does exist to inform social work practice with asylum seekers as well as for psychologists to conduct evaluations for court.[37] We hope this book encourages more research in the social work discipline to ascertain why few asylum seekers seem to be accessing the support of practitioners: potential explanations range from inadequate health insurance, lack of knowledge about services, to potential distrust and embarrassment. Women may simply want to avoid discussing their trauma histories, and therefore research needs to be undertaken to determine how to allay such fears and conduct assertive outreach with this population.

A Path Forward

Clearly, reforms are needed in Central American countries and Mexico to counter the persistent structural and symbolic violence that renders women subject to violence and fails to protect them. When US officials discuss treating the "root causes" of migration, the conditions leading to structural and symbolic violence are rarely considered. We would be remiss in failing to note US responsibility in contributing to legacies of decades-long violence through civil wars by proxy, drug war engagement, and for collaborating in the promulgation of neoliberal economic policies that disadvantage large swaths of the populace in the nations examined. US complicity must be acknowledged so that moral responsibility can be ascribed and acknowledgment in the form of meaningful structural change can be made. During our work, we read copious accounts of how neoliberal economics disadvantage poorer nations globally, but there appears to be little written on how to regulate the businesses that benefit from paying poverty-level wages or how to change the policies promoting these asymmetrical economic arrangements. We note this as an invocation to research by economists and other experts in global policies to map how to create these necessary reforms. Discussion of such reforms needs to become part of the national debate over immigration and asylum; thus far in the United States, dialog by the nation's leaders has been limited to border security with virtually no acknowledgment of the conditions forcing migration flows. Women should have the freedom to live peacefully without fear of persecution in their home countries, but as we have shown throughout this book, the need for asylum will continue if the conditions at home, including poverty and state failures to prevent harm to vulnerable populations, continue to fester.

We wrote this book in the hope of expanding dialog about the forces compelling the need for asylum from northern Central America and Mexico. A look at Biden administration initiatives affecting asylum seekers entering through the Mexican/US borders reveals plans for a deterrence-focused approach. In April 2023, the Biden administration announced new measures to deal with an expected surge of asylum seekers hoping to enter the United States after the expiration of Title 42, the public health measure that Trump had used to close the bor-

der during the COVID-19 pandemic. DHS and the Department of State warned that, "The lifting of the Title 42 order does not mean the border is open."[38] Rather than focusing on offering humanitarian protection to those fleeing persecution, DHS Secretary Alejandro Mayorkas, who had personally benefited from US humanitarian protections after his family fled Cuba following the revolution, rationalized this approach by saying, "Those who arrive at our border and do not have a legal basis to stay will have made the journey, often having suffered horrific trauma and having paid their life savings to the smugglers, only to be quickly removed."[39]

The US government will also open Regional Processing Centers (RPCs) in several Latin American locations including Guatemala, where would-be migrants could be screened for eligibility to migrate lawfully rather than risking deportation after crossing the Mexican/US border. El Salvador, Honduras, and Mexico will not be sites for RPCs. The United States also vowed to double the number of refugees it would accept from Latin America and the Caribbean annually, with the Biden administration allowing the entry of approximately 30,000 people per month from Venezuela, Nicaragua, Cuba, and Haiti who have US sponsors. However, there are no plans to expand this program to the countries where the women we interview fled.[40] The Biden administration also announced that 1,500 troops would be sent to the Southern border to perform administrative duties and support functions for US Customs and Border Protection (CBP).[41] Initial reports indicate that the number of people being allowed to apply for asylum at the Southern border is indeed lower; the share of migrants who pass their initial asylum interviews fell from over 80 percent to below 50 percent.[42] As we noted in chapter 1, the Biden administration also released final rules implementing restrictions on asylum.[43] Under the Biden protocols, migrants who express a fear of returning to their home countries would receive a credible fear interview within twenty-four hours after apprehension, and additional asylum officers and immigration judges would be deployed to process asylum claims more quickly. As we noted previously, migrants from Central America and Mexico—including those who need asylum—must use the CBPOne mobile app to schedule an appointment at the border and at the RPCs. Unfortunately, the app has proven to be unreliable, and appointments are extremely difficult to obtain. Women have been beaten and raped

near the Mexican/US border while waiting for CBPOne appointments.[44] These rules have been challenged by immigrant advocates.[45]

Republicans and immigration restrictionists immediately dismissed the new actions as inadequate to deter border crossings, while immigrant advocates expressed concerns that these measures do not protect those fleeing persecution, fail to provide sufficient due process, and are simply a continuation of the Trump-era assault on asylum.[46] The National Immigrant Justice Center stated, "The Biden administration has officially abandoned its commitment and obligation to rebuild the US asylum system and uphold our country's historic commitment to offer refuge to people fleeing persecution."[47] With respect to women fleeing domestic and gang violence, the new measures provided little protection. Secretary of State Blinken avowed that the United States will engage in expedited resettlement processes to protect vulnerable groups, "Including religious minorities, political dissidents, LGBTQI+ persons, *and survivors of gender-based violence* [italics ours]."[48] But no further details were provided. The reality is that women whose male partners control their access to cell phones and transportation will struggle to book appointments on the apps, and to escape their homes to attend a refugee screening at an RPC. A survivor of severe and persistent gender-based violence who is not designated a refugee by the RPC will still be forced to find the means to survive. Without reliable avenues to safety in her home country, she will still be left with the need to find protection elsewhere. If she survives the gauntlet and makes her way to the Mexican/US border, she faces the harsh US asylum system and, without access to an attorney, women will be challenged to make a case for protection, given the onerous standards for asylum. And with no additional changes to the statutes, regulations, and guidelines regarding asylum or refugee status for victims of "private violence," they will face an extremely difficult path to protection in the United States.

Mayorkas acknowledged the need for greater reforms, saying, "We cannot do everything that we need to do until Congress provides the needed resources and reforms."[49] Throughout this book, we have argued that presidents exert disproportionate influence over how existing laws are enforced; presidential administrations decide how to implement immigration laws and policies, qualifications for immigration judges,

legal parameters for judicial decisions, which migrants to prioritize for deportation, and how gender-based asylum cases will be treated, to name a few. As we saw in chapter 1, presidents and their administrations have diverged on their approaches to asylum, including how to engage gender-based asylum claims specifically.

The attorneys we met discussed the need for strong regulations and guidelines to clarify how women can meet the asylum criteria in cases of domestic and gang violence. As one lawyer explained, "There have been regulations in the works for more than twenty years, and I think that the regulations would go a long way towards having more uniform decision making."[50] However, the content of rules and regulations are determined by the administration that writes them, and they are interpreted by the courts and may be challenged legally. Moreover, this attorney noted that as arms of the Department of Justice, immigration courts and judges are not independent, and in many cases, are disinclined to support asylum: "You can't just give the same body of adjudicators a new rule and expect them to do better. I mean, we just have the bench stacked with restrictionists who are not fairly applying the law, who have no desire to do that. So, a new rule is only going to go so far." The attorneys argued for the creation of an independent court as one remedy, a structural change that would remove judges away from oversight by the president or attorney general.[51] This change would help courts function with the independence that is inherent in the idea of a judicial branch that functions separately from both the president and Congress.

In addition, it is unlikely that executive actions alone will result in the changes needed to offer greater protection to survivors of "private violence." While an amenable administration can issue guidance that encourages greater asylum grant rates for these women, Congress needs to enshrine protections in law. For example, the Refugee Protection Act, introduced in Congress in 2022, would address some barriers to asylum enacted in recent years; it would prohibit barring individuals who travel through another country to reach the United States (such as crossing through Mexico from Guatemala) from seeking asylum and prohibit prosecuting asylum seekers for illegal entry.[52] It was these prosecutions, and subsequent detentions, that led to thousands of parents being separated from their children during the Trump administration.[53] Notably, it would establish in US law that asylum seekers fleeing persecution by

non-state actors may meet the criteria for asylum, a provision that does not currently exist.[54] It would also modify current law to clarify several important legal standards that have proven difficult for women fleeing "private violence" to meet. It would clarify that a particular social group can be clearly identifiable regardless of how many people belong to it.[55] It would also modify the requirement that asylum seekers prove that their membership in a particular social group is "at least one central reason" for the persecution—a burden that applicants have found difficult to meet. For example, under current law, a woman must prove that *one central reason* her husband beat her was because she is a member of a particular social group such as "married woman in Guatemala." We have seen that, in some cases, judges do not accept that their membership in a particular social group is "one central reason" for persecution. Rather, the judges conclude that men beat women because they are violent men. The Refugee Protection Act would require membership in a particular social group to be "at least one reason" for the persecution—a slightly lower standard to meet. The Guatemalan woman in our example would have to show that her membership in a particular social group was one reason for the persecution, not one "central" reason. Also relevant to the women in this book, it would require judges to make credibility assessments with appropriate cultural sensitivity consistent with current scientific literature on how trauma affects memories and truth-telling.[56] While these changes might seem minute and insignificant on one hand, and overly complicated on the other, they illustrate the struggles women and their lawyers face while trying to meet the asylum criteria. Asylum seekers must provide evidence proving that they meet very exacting criteria while, at the same time, different courts and judges may interpret the criteria differently. Therefore, codifying these provisions into law would provide greater clarity and certainty for asylum seekers and their attorneys. It would also narrow the parameters within which a presidential administration could create asylum policy.

While some women must flee to save their lives, others who suffer violence by gangs and/or intimate partners do not, for one reason or another, choose to leave their home country and seek asylum. Countless others live in compromised states, nations crippled by legacies of protracted wars, severe income inequality, and ineffectual law enforcement, and suffer the consequences in their daily lives. They may not feel the

need to flee for their lives but may want a better life in the United States. For those who choose not to seek asylum, there may not be an option to emigrate. The US immigration system prioritizes family reunification, labor needs, and provision of humanitarian protection, but the women we spoke to had only one avenue. The US government could reform the system to allow more people to come lawfully to the United States through family petitions or employment opportunities.[57] Such reforms would be consistent with US values and would circumvent many of the aspects of compounded marginalization experienced by asylum seekers. Unfortunately, Congress and the administration do not appear to be willing to take those steps.

Global Considerations

We consider a central point made in chapter 5 about how traumatic experiences are understood by both those who survive them and the wider society. The women we interviewed ostensibly survived these experiences as individuals: They suffered rapes and beatings in homes. Gang members put guns to their heads while they worked in stores or kidnapped them. In two cases, police officers raped with impunity. Women then migrated individually, at times hiring smugglers to survive one of the world's most dangerous migration corridors.[58] Decisions to flee extreme violence often preceded escape from their countries that by necessity came within days or weeks to ensure their safety. Once across the border, they were detained and processed, individually, in the manner of criminals. They then struggled through the asylum court system as individuals, retaining counsel, filing necessary applications, and securing evidence as they worked and cared for families.

Although the asylum system adjudicates individual cases, we note the conspicuously collective nature of these experiences: As the stories of the women reveal, they share brutalization by men against similar backgrounds of social suffering in their home countries. The social conditions informing these experiences reveal common elements: neoliberal adjustment projects perpetuating poverty and income inequality, as well as legacies of both civil wars and drug war violence, all compromising the ability of frail states to impose order and protect their citizenry. Therefore, we believe that remedies for these conditions through poli-

cies would begin with a recognition of these experiences of violence and persecution as collective assaults meriting asylum.

Beyond the proposed legislation described above, Congress and the international community must acknowledge the titanic shifts compelling asylum since the Cold War and codify law to reflect the needs of asylum seekers who are not fleeing state-sponsored persecution. Broader imaginaries seem to be beyond the range of public discourse on asylum, with the factors shaping the need for this protection continuing to be ignored. As we noted earlier, global migration—including those who need asylum—has expanded exponentially, with wars, the gutting of social welfare programs, economic and climate-related population displacement forcing unprecedented numbers across international borders.[59] Even if Congress were to approve the legislation described above, we note that the fundamental architecture of the asylum system would continue to serve as a deterrent to large numbers of people who need protection.[60] Cases would continue to be adjudicated individually in a hidden system, limiting the potential for collective recovery from unspeakable harms. The fact that large numbers of people in the Global South desperately need safety—and often will die trying to reach it—remains hidden in political discourse among leaders in western democracies. Until this reality is brought into the debate, the logical fallacy of sovereign borders in a time of unprecedented displacement including the need for asylum will remain unaddressed: a corrosive family secret among the West's most prosperous nations.

As we wrote this book's conclusion, a boat carrying an estimated 750 people sank near the coast of Greece, and the popular press used the terms migrants and refugees to describe those who perished. In the United States, this disaster received comparatively little coverage as media outlets turned their attention to the implosion of a tourist submarine near the *Titanic*'s hull, a tragedy that claimed five lives. We can't help but chasten the Global North as both governments and media outlets continue to ignore the desperation of those who seek refuge, whether at the Mexican/US border or in the Mediterranean. Globally, besieged populations try desperately to escape untenable circumstances—often with tragic consequences. It is time to broaden the scope of debate around asylum and migration flows to comprehensively account for the needs of these populations.

ACKNOWLEDGMENTS

This book would not have been possible without the support and assistance of many individuals.

We want to thank Amy Best, Blaine Bookey, Sarah Brenes, Susan Coutin, Naomi Farber, Rich Furman, Roberto Gonzales, Lindsay Harris, Cecilia Menjívar, Roberta Spalter-Roth, and James Witte for graciously reading all or parts of our manuscript and providing invaluable feedback. We appreciate the time and energy you devoted to this endeavor. It has been our pleasure to work with our editor, Ilene Kalish, our editorial assistant Veronica Knutson, senior production editor Alexia Traganas, design and production manager Charles B. Hames, sales and marketing director Mary Beth Jarrad, publicist Sydney Garcia, marketing assistant Michelle Duran, cover designer Dave Strauss, copyeditor Karen Verde, and everyone else at New York University Press who was essential in getting this book published. We appreciate the help of editorial assistant, Yasemin Torfilli, formerly of New York University Press. We express our heartfelt thanks to our publicist, Angela Baggetta.

We are grateful for the help provided by graduate research assistants in the Department of Social Work at George Mason University, especially the assistance in the last critical year of our endeavor. Joanna Marlen Flores and Paola Gonzalez Cifuentes assisted in interviews, transcribed audio recordings, and validated the Spanish language translations that appear in this book. All graduate assistants over the course of several years proved capable and engaged, as they had to also bear witness to the suffering described by the women whom we interviewed. We thank Stephanie Cornejo and Alejandra Velasco for their earlier work on the project.

We thank Executive Office of Immigration Review press officer Kelly Nance for providing us with schedules of asylum court hearings for women from Mexico and Central America to support our ethnographic engagement.

Without the support of a number of well-respected immigration lawyers, this book simply would never have come to fruition. We thank Jorge Alejandro Morales Benitez, Elizabeth Carlson, Anarida Delaj, Dean Eyler, Rina Gandhi, Payman Habib, J. Traci Hong, Laura Jacobson, Gabriela Q. Kahrl, Yanmin Lin, Jill Marmol, André Albuquerque Matias, Michelle N. Méndez, Jennifer Molina, Anam Rahman, Ilyce Shugall, Maura Stein, Maureen Sweeney, and Shoba Sivaprasad Wadhia. We thank members of the organization, Refugee and Immigrant Center for Education and Legal Services, including Javier O. Hidalgo, Alexandra, Cohen and Briana Perez.

These names are only a partial list of the legal experts who assisted with this book, and therefore, quotes that appear in the narrative should not be assumed to be linked to any of these individuals.

Carol Cleaveland would like to thank Naomi Farber for being a mentor since early in her graduate education, and for providing wisdom and thought-provoking questions for the draft. She is indebted to Elijah Anderson for his mentorship over the years and for inviting her to present the research for this book to his students and colleagues in the Department of Sociology at Yale University. Cleaveland is grateful to the Department of Social Work and College of Public Health at George Mason University for providing funding for the graduate research assistants as well as granting a research leave to complete the book. She would like to thank Amy Best of the Department of Sociology at George Mason University for reading our draft proposal. Cleaveland thanks Jim Witte, director of the Institute for Immigration Research, for reading an early draft. She very much appreciates the feedback from Roberta Spalter-Roth, who helped support the development of our critical feminist framework.

Cleaveland would like to thank the Department of Social Work at George Mason University for inviting her to present this work before students and is grateful to have the opportunity to guide students in their education. She is blessed to be part of a professional discipline that embraces human rights and social justice as core values and is deeply indebted to the friends at the university who have supported her over the years.

Finally, she would like to thank her beloved partner, Eugenia Argires, for her kindness and support throughout this endeavor. Cleaveland truly appreciates her willingness to read drafts with a critical eye.

Michele Waslin would like to thank Erika Lee of the Immigration History Research Center for her unfailing support of this project, for empowering her, and for giving her the tools needed to be successful. Both authors are especially grateful to the IHRC for providing the funding for an online workshop to discuss the manuscript with esteemed colleagues and experts. Waslin also offers thanks to her former colleagues at the Institute for Immigration Research at George Mason University for providing her a path forward and supporting her research.

Waslin would also like to thank the faculty and staff of the University of Minnesota College of Liberal Arts, the Law School, and especially the James H. Binger Center for New Americans for answering questions and providing assistance. Thank you as well to The Advocates for Human Rights for being a resource and for allowing her to participate in the immigration court observation program. The experience has been vital to her understanding of immigration law and immigration court procedure.

Waslin would also like to thank her former colleagues at the American Immigration Council, UnidosUS, and the Illinois Coalition for Immigrant and Refugee Rights, who taught her everything she knows about immigration law, policy, and research and instilled in her a deep commitment to immigrants' rights. The immigrant policy and advocacy community has been an important part of her life for many years. Since her first internship at the National Immigration Forum in 1989 until the present, she has been in awe of the passion, dedication, and optimism of the many colleagues she has encountered. It has truly been a pleasure to experience the last three decades of immigration history with this extraordinary group of advocates and experts. She is especially grateful for the support of Walter Ewing, an excellent writer and editor who inspired her and made her a better writer and who left us far too soon.

She is forever indebted to her husband Kenneth Clair for his love and support. Thank you for sharing life's adventures.

APPENDIX

Methodology

In her seminal study of undocumented immigrants living in Israel, anthropologist Sarah Willen called upon researchers to engage in critical phenomenological examination of the condition of "illegality," to abet an understanding of the social harms experienced by people who must negotiate life without legal status.[1] Willen advocated this approach to understand both how people experienced "illegality" as a legal status and how it informed one's very existence in the world.[2] We borrow from this approach to make sense of the asylum seeker experience: from the violence that compelled migration, to the treatment at the border, and finally as women negotiated the legal system. Although asylum seeking is legal, we argue that women's existence as they engage in the process of negotiating the system bears striking similarities to "illegal" status in that it imbues their embodied experience and their way of being in the world. "Illegality affect(s) not only the external structure of migrants' worlds but, can also extend their reach quite literally into illegal migrants' 'inward parts' by profoundly shaping their subjective experiences of time, space, embodiment, sociality, and self."[3] Thus, we situate this study in the canon of critical phenomenology which is designed to understand lived experience as it is shaped and informed by historical, economic, political contexts.[4]

We acknowledge at the outset that this project demanded that we find an adequate framework to make sense of horrific stories told by women in recounting violence and trauma. It also called for understanding the more mundane aspects of the lives they left behind in Guatemala, Honduras, El Salvador, and Mexico, as well as how they experienced immigration detention, the asylum court system, and efforts to build new lives in the United States. Phenomenological inquiry is centered on the understanding that people have motives, interests, and subjective under-

standings of their world, commonly referred to by the adherents of this approach as *lived experience*.[5] Thus, we seek to build on previous conceptualizations of phenomenological research that emphasize the position that social reality is neither fixed nor objective; rather, it originates via human activity.[6] As is consistent with this approach, our job was to suspend our own assumptions both in deciding the questions asked and in the analysis of data to understand and be faithful to these lived experiences. We acknowledge as well that a more traditional phenomenological approach is inadequate here as it doesn't account for how lived experience is shaped by structures such as neoliberal economies, failed states, corrupt police, patriarchy, and immigration and asylum law—all factors informing life for the women who are the focus of this book.[7] As noted by Lisa Guenther, critical phenomenology is necessary to understand how social structures penetrate the consciousness of social actors, naturalizing and normalizing power relations.[8]

Critical phenomenological research entails examination of social phenomena by considering how economic, political, and historical contexts shape lived experiences.[9] Similar to other phenomenological approaches, critical phenomenology requires understanding how people interpret their lived experience, while at the same time engaging in a systematic examination of how one's lives are shaped via economic, political, and legal frameworks.[10] Guided by critical theoretical principles, including an understanding of how life unfolds for those thrust into society's margins by virtue of immigration status, race, language, or gender, researchers explicitly engage the broader political and economic contexts in which phenomena emerge. A critical approach requires acknowledging that, "The categories of experience, selfhood, personhood, and subjectivity are cultural and historical in nature; that what we take as 'experience' or 'agency' are born of a gamut of cultural, political . . . and environmental forces."[11] In this case, the political forces include asylum policy and laws that informed how women experienced apprehension at the border, interviews that they gave while incarcerated, and finally as they retained lawyers, prepared for court, and underwent hearings.

As Robert Desjarlais noted, a critical approach shares many elements with other interpretations of phenomenology, a form of inquiry that includes numerous conceptualizations.[12] Similar to other forms of phenomenological research, a critical approach calls for a close and im-

mersed engagement with people who can describe their lived experience to understand how they make meaning of it.[13] Thus, a critical phenomenological approach supports understanding how trauma, fleeing violence, experiencing incarceration, and going through the asylum process shape women's experiences and perceptions. Our goal in interviewing the women who seek asylum was to understand how this process shaped their lived experiences in multiple domains: experiences of violence prior to migration; apprehension and detention at the border; the asylum legal process; and finally, how the rebuilt their lives in the United States as they held down jobs, raised children, and worked with lawyers.

THE PROJECT'S ORIGINS

The germination of this project began in 2015, when an immigration attorney asked Carol Cleaveland to write a psychosocial assessment for a Salvadoran woman who had been trafficked into a brothel in El Salvador.[14] She escaped and came to the United States but suffered severe PTSD. Cleaveland met with the woman and an interpreter one dreary March morning in a law school conference room; she listened to the woman's story of her past child abuse, an adolescence in which she was desperate to escape her home life, and a relative's willingness to traffic her into a brothel. She wrote an assessment to be included with her chain of evidence for a hearing before an immigration judge. The woman won her case, a testimony to the diligence of her legal team, which included law students and a supervising attorney. The question of asylum—who should receive it and under what circumstances—received little attention in popular discourse at this time, despite a surge of children from Central America arriving at the Mexican/US border the previous year, an issue that was then termed "a humanitarian crisis."[15] Most of the 68,540 children who arrived there came from Honduras, sent by parents desperate to ensure their safety.[16]

As Cleaveland continued to sporadically conduct these assessments over the years, she became increasingly horrified by the stories she heard of rapes and battery by domestic partners and gang members. She decided to study the question of asylum seeking by women from Central America and Mexico, and as is consistent with the spirit of phenomenological research, formulated two overarching research questions: (1) How did women interpret the events that caused them to seek

asylum?, and (2) How did women experience the asylum process after arriving in the United States? She soon found that accessing asylum seekers isn't easy. The initial recruitment strategy entailed asking immigration attorneys to refer women for interviews in exchange for a $30 gift card stipend. This strategy proved fruitless. Finally, a prominent attorney asked, "Would you be willing to do assessments for court as part of your research?" She referred to psychosocial assessments, a social work protocol that entails gathering a thorough life history from the client dating back to childhood, as well as mental status assessment to discern how trauma is affecting current functioning. It also includes explicit delineation of the client's strengths, such as work ethic or insight. She agreed to this approach, which would entail reading a consent that allowed both interviewing as part of research and the completion of interviews for evidence. After having this protocol vetted and approved by the George Mason University Institutional Review Board, an attorney distributed an email to immigration lawyers in the Washington, DC, and Baltimore, Maryland, areas, announcing that pro bono evaluations would be available for clients as part of a research project. That led to phone calls from immigration attorneys, and during these conversations, she explained the nature of the research and listened to their needs for an assessment. These conversations helped cultivate relationships with lawyers.

As Cleaveland began to conceptualize the book, she asked Michele Waslin to collaborate with her because she knew she needed a bona fide expert in asylum and immigration policy, given that these policies are subject to frequent shifts and are exceedingly complex. She asked Waslin to join her so that the book would have sufficient policy depth and accuracy. The decision to ask Waslin to co-author proved fruitful, given that as the initial draft was completed, Title 42 ended and US immigration officials stoked public fear about the potential for a surge in border crossings, including on the part of asylum seekers. Asylum policies did shift substantially in the year that this book was written, and thus policy expertise was imperative. As will be described below, Waslin designed the semi-structured interview protocol used for interviewing attorneys and retired judges. She engaged in ethnographic observation of asylum hearings and interviewed ten immigration lawyers and judges.

INTERVIEWS WITH WOMEN

We recognize that the approach of coupling research with the completion of an assessment for court could raise questions about dual roles in research, and thus we emphasize that the consent clearly stated that women could withdraw from the research at any point and still have the evaluation submitted into evidence. The consent form included a statement that women could decline to answer any question. We also emphasized that even if a respondent opted to withdraw from the project at any point, the assessment would be submitted on her behalf to her attorney, and that she would still receive the $30 gift card stipend.

The need for substantial human subjects' protections also called for using sworn declarations gathered by attorneys to avoid having to ask women for detailed descriptions of the trauma that motivated their migration and asylum seeking. That strategy limited questions to women's childhoods, their work histories, and current living situations including child-rearing and jobs. Despite efforts to protect women from having to recount detailed trauma histories, many began presenting this material anyway. We suspect that they needed to talk and they perceived us as sympathetic listeners.

To document whether women had PTSD, the empirically validated PTSD Checklist-Civilian Spanish version was used.[17] The PCL-C, a twenty-item validated scale, was developed by the US Department of Veterans Affairs (VA) for detection of trauma symptoms. The scale covers symptoms associated with PTSD such as nightmares, intrusive memories, physical reactions such as sweating/difficulty breathing, insomnia including early morning wakefulness, flashbacks, avoidance of potential triggers, difficulty concentrating, depression, and heightened startle responses. Respondents are asked to identify intensity of feelings ranging from 1 (no symptoms) to 5 (extreme symptoms).[18] We hope that in following this protocol, which provided women with more court case evidence, we were able to contribute to successful outcomes in asylum hearings. As we noted earlier, credibility is a criterion in the adjudication of asylum proceedings, and thus an instrument that measures symptoms could be helpful in explaining problems with memory associated with trauma, as well as reinforcing the fact that trauma did actually occur.[19]

If women were visibly upset at the end of the interview, Cleaveland and her research assistants asked about coping strategies. Women described taking walks, talking with coworkers, and playing with children as some of the means they used to negotiate a host of PTSD symptoms. We encouraged them to utilize those resources, and offered to link them to non-profit social service agencies that offer pro bono or sliding scale psychotherapy services. All of them declined, typically stating that issues such as time constraints or lack of access to public transportation would be barriers. Two women had already seen mental health professionals prior to the assessment and stated that they found the experience to be useful.

Interviews were designed to ascertain how women understood their lived experience prior to migration, so we asked about their childhoods, the towns they grew up in, and their education. We elicited details about the jobs they held prior to leaving to ask for asylum. These details were essential to make sense of the circumstances of women's lives beyond the violence that compelled them to seek asylum, as they came from states with compromised economies, legacies of war, and inadequate or corrupt law enforcement. Their perceptions of life prior to migration emerged in open-ended questions such as, "Tell us about your childhood," which led to women's descriptions of separation from parents because of forced migration for economic reasons, or discussions of the jobs their parents worked selling items in small villages or working in fields. We always asked about their perceptions of law enforcement for two reasons: (1) Very few of the women went to the police to report gang or domestic violence, and we knew that an immigration judge could use this reticence to seek police assistance as a reason to deny an asylum case. (2) We wanted to understand the nature of this distrust, so we asked women to tell us what they had heard about police from friends and family. Occupational questions led to descriptions of low-wage labor.

To understand arrest and detention, we asked the women to describe what happened after they crossed the border. We found it necessary to use follow-up questions to elicit details, particularly about the interviews they had given prior to release, in order to understand what types of questions they were asked and the conditions for these interviews, such as whether they were conducted by phone. We then progressed

sequentially into their lives post-release, including their efforts to find work, maintain stable housing, and raise children. Women brightened considerably when asked about children; they were quick to describe academic success and English language acquisition.

As stated before, we tried to avoid asking questions about their traumatic experiences and relied on sworn declarations provided by attorneys to attain that data. Women were asked about their hopes and dreams if they receive asylum, as well as what they wished Americans would understand about the process of seeking asylum. It appeared that women found these questions to be empathic, and thus they closed every interview by thanking us. At the conclusion of each interview, we asked the respondent if she would be willing to allow us to observe her asylum hearing. Women were surprisingly receptive, stating that they appreciated the support. Anxious women often greeted us with hugs at the courthouses before hearings. One woman interviewed later withdrew consent to have her hearing observed, a decision relayed by her lawyer several months after the interview. The lawyer explained that her client was so anxious about the hearing that she didn't want her own husband present. Unfortunately for the woman, a hearing that had been scheduled for 2022 ended up being postponed to 2024. "She isn't going to be happy about this," the lawyer said. "She wants to have it over with."

We initially conducted interviews with asylum seekers in person at a site chosen by the respondent. On occasion, that meant a woman's home but more commonly, we interviewed in law offices where attorneys provided conference rooms for privacy. Once the COVID-19 pandemic began in March 2020, we were forced to conduct interviews by Zoom. Typically, a research assistant worked with each woman to explain how to download and use the application on her smartphone. None of the women interviewed had access to a computer. Zoom interviews offered a window into women's lives as we saw women endeavoring to keep children out of the room. Often children were curious, and we found ourselves waving at them. On many occasions, we noticed that children's artwork was taped to walls in the rooms where women met with us. One woman who dreamed of becoming a veterinarian sat in a chair flanked by her two cats.

INTERVIEWS WITH PROFESSIONALS

The authors understood that speaking to immigration attorneys who represent female asylum seekers and immigration judges responsible for adjudicating the cases would be critical to revealing the breadth of the asylum process and its impact on a variety of participants. We asked the attorneys about their process for identifying clients, the nature of their relationship, how they prepared the asylum application and other court documents, how they prepared themselves and their clients for the asylum hearing, and how they reacted after the judge's decision. We also asked their opinions on the state of gender-based asylum law and their recommendations for improvements. We asked immigration judges about their experiences with gender-based asylum cases and their reactions to recent policy swings emanating from the executive branch.

Furthermore, previous scholarship has examined how "trauma is embedded in the practice of immigration law, especially for attorneys who represent clients seeking humanitarian and discretionary immigration relief."[20] We sought to understand how attorneys were impacted by their extended relationships with women who had experienced unimaginable trauma and shared those histories with them. We also wanted to learn how judges fared after hearing hundreds of women share their traumatic histories in the courtroom and then making decisions about their credibility and determining the women's futures in the United States.

We created a semi-structured interview guide that included questions about their immigration practice, their perceptions of the asylum system and the immigration courts, their relationships with their clients, and how their work with female asylum seekers has affected their lives outside of work. The two former immigration judges we interviewed were also asked about their dockets, their experiences working within the immigration court system, and about their reasons for stepping down from the bench. The interviews were conducted via Zoom in 2022 and early 2023 and typically lasted one hour. They were recorded and transcribed. While we did not name the attorneys in the book, we did ask them to approve each of their quotes prior to inclusion. In addition to these ten semi-structured interviews, both authors had informal conversations with attorneys and judges while observing immigration court hearings.

POSITIONALITY

The lead author of this book, the researcher responsible for interviewing the women, is a white American of British descent who grew up speaking English and learned Spanish as her second language. The second author is also white, an American of Eastern European descent who speaks Spanish fluently and has traveled extensively through Latin America. Part of the research task was to put respondents at ease, a challenging task given the subject matter. The introductions and connections through lawyers proved invaluable, as the attorneys had explained that we sought to help them by providing evidence through the use of the assessments. Given that neither author is Latina, the assistance of Spanish-speaking research assistants was arguably essential in closing several gaps: language, as the first author's Spanish is heavily accented and can include, at points, gaps in vocabulary; age, as the first author was often thirty years older than all but a few respondents, who were in their twenties and thirties. Thus, we believe the presence of young Latinas at the interviews helped put respondents at ease.

ETHNOGRAPHY

In her discussion of ethnography, Beverly Skeggs argued that feminist scholars principally concern themselves with how power works, and how it can be challenged.[21] An asylum merits hearing offers a window into a system of markedly different power relations. A single immigration judge wields the power to decide whether a woman who suffered severe violence and trauma will be granted reprieve from potential deportation. The language heard in courtrooms illustrates this power: Judges are invariably referred to as "the court," a term that illustrates their power in these hearings. Courtrooms are places of ritualized deference: In our own conversations with judges, we used the phrase, "your honor," and watched as attorneys asked permission to approach the bench or complied with little argument when a judge instructed them to change their manner of questioning a witness.

Skeggs noted that feminist ethnography is characterized by many methodological traditions commonly associated with ethnography, including fieldwork over a prolonged period; involvement of the researcher in participation and observation; conducting research in set-

tings where participants are engaged, with an understanding of how the context informs what is being observed.[22] The question of context speaks to our earlier discussion of critical phenomenology as we sought to understand how immigration and asylum law defined life circumstances for the women in question, as well as how country conditions informed the violence they suffered.

Critically, feminist ethnography abets a process whereby participants can assist in establishing the research agenda.[23] In our work, the immigration attorneys who represented the asylum seekers in court arguably served as the intermediaries in the process of establishing a research agenda. They emphasized in conversations what we should consider when interviewing a certain client or writing her evaluation. They emphasized concerns about the immigration judicial system and barriers to asylum, which helped us formulate questions to respondents. Attorneys vetted each psychosocial assessment and then returned it for edits.

At the end of interviews with women, we asked if they had concerns or if there were other issues we failed to note. Women were forthcoming when asked about their concerns with the asylum system. We argue that this process—one in which we supported women by providing evidence for their hearings—is consistent with Skeggs's conceptualization of feminist ethnography. By providing evaluations, we actively engaged in a process to help women win asylum, thereby supporting women in challenging the Department of Homeland Security's efforts to have them deported.

Gaining access to asylum hearings is a taxing process. Asylum seekers decide whether they will allow visitors to observe, and gaining access required approaching asylum seekers as they waited outside courtrooms for their hearings to begin. Our access came by a combination of observing hearings for women whose assessments we had completed, and by simply showing up at the immigration court and hoping to be allowed inside. We contacted the Executive Office for Immigration Review (EOIR) press office to obtain schedules for when women from Central America and Mexico would have asylum hearings, and then showed up to court on those days. That would seem like a straightforward process, but our observations revealed that court cases often were canceled with no notice. On occasion, we arrived at court only to learn that a judge

had canceled his docket because of illness, or hearings had been postponed for reasons that we could never ascertain. The press office could not provide us with names of attorneys or asylum seekers, so when a hearing was canceled, we had no way of finding out why or when they might be rescheduled.

On the days when we went to court, we wrote extensive fieldnotes about the security screenings, waiting areas, and huddles we observed between lawyers and their clients. Navigating the two courthouses meant checking in at the desk where a clerk sits behind plexiglass and spends most of her day cataloguing documents given to her by lawyers. After one case, we posed for pictures with an asylum seeker, her attorney, and her children outside of a courthouse after the woman celebrated her win, all in masks as COVID-19 still posed a danger. At times, we chatted with affable judges, who asked questions about our research. Our time at courthouses gave us a sense of how daunting navigating the asylum system can be for women: Clerks are Americans and are not bilingual, so questions must be answered by calling a translation service over a phone on a wall by the clerk's desk. When possible, we helped Spanish speakers in the waiting areas as they struggled to complete English-language forms or find their way around. Security guards wielded considerable authority in waiting areas, and we complied with instructions about where to sit or to throw away a cup of coffee that wouldn't be allowed in the waiting area. On occasion, these instructions seemed arbitrary: One security guard ordered Cleaveland to move from one empty waiting area to another.

We were permitted to observe thirty-six asylum hearings and ceased observation after we had reached saturation, having seen hearings that resulted in awards of asylum as well as orders of removal. We watched five hearings that ended in a respondent accepting the prosecutorial discretion option, meaning that the government would drop its case against them. These hearings, unlike merits hearings that typically lasted four hours, were usually over within twenty minutes. Fieldnotes in courtrooms required copious note-taking. We were careful to put quotations marks around those statements that we knew were captured accurately, while settling for paraphrasing other parts of the proceedings. Fieldnotes were typed from handwritten notes immediately after leaving the courthouse so that details would not be lost.

"Courtwatching" is an increasingly common practice that involves efforts to observe the day-to-day work of decision-making in the justice system and can contribute to the documentation and interpretation of the "dense spaces" of courtrooms and explore questions of visibility, publicness, witnessing, and embodiment in the courts.[24] By writing about immigration courtroom proceedings, we brought visibility and publicness to proceedings that are typically not open to the public, and that very few members of the public have observed. As courtroom observers, the authors were also witnesses who, as Luc Boltanski emphasized, were not "simple reporters" who describe objectively what they have seen; rather, we were "introspectors" who bring emotion into our accounts.[25] And while we were most often physically present in the courtroom, we also witnessed how hearings, or parts of hearings, were held remotely via video, and how disembodied, remote participation in and observation of proceedings does affect them. Ultimately, we recognized that by observing, we were adding a new element to the courtroom that could have an impact on the proceedings. One former immigration judge explained that as a judge, one actively has to work at not thinking about the observers in court. She told Waslin that, "You should know that [the judges] are not going to look bad in front of you. When there's an observer, things are different. Having an observer really changes dynamics."

DATA ANALYSIS

All interviews that had been conducted in Spanish were transcribed verbatim by research assistants who are native Spanish speakers. Spanish-language transcripts, redacted legal decisions, and fieldnotes were coded in Atlas.ti using raw coding such as "threats by partner," "fear of police," and "job in USA" to stay close to the data and to avoid interpretation before grouping of themes.[26] The lead author coded all interviews line by line and followed the same procedure for the fieldnotes and redacted legal decisions provided by lawyers. The data for this book were coded during an initial round to develop both raw codes and parent themes. In an effort to ensure staying true to the raw data, the lead author coded the data a second time six months later to develop a code book and parent themes. This procedure allowed her to see whether there was divergence from the initial coding scheme. The

codes proved similar and lead led to the creation of a 170-word code book that was used to develop parent themes.

Goals for analysis were to: (1) bracket to reduce the risk of bias and assumptions; (2) develop themes while acknowledging complexity; and (3) identify exceptions to patterns. Bracketing requires effort to suspend assumptions, a task that often is achieved via the use of raw codes to create parent themes.[27] The goal was to use codes to remain close to the words used to describe events, or embedded in legal documents, before interpreting findings. Use of literal terms such as "death threat," "fear of police," "threat with weapon," and "USA job" were used to ensure that the analysis remained close to the data. Literal codes reduce potential for overreach in interpretation and for ensuring reliability in coding semi-structured interviews.[28] The authors had two native-born Spanish-speaking research assistants agree upon all direct quotes that appear in this book. Consultation with multiple sources for translation has been recommended in anthropological research to avoid idiosyncratic interpretation and understandings.[29]

STATUTES, REGULATIONS, AND LEGAL DECISIONS

5 Fed. Reg. 3502
8 C.F.R. § 208.12 Reliance on Information Compiled by Other Sources
8 C.F.R. § 208.13(b)(3) Establishing Asylum Eligibility
8 C.F.R. § 208.14 Approval, Denial, Referral, or Dismissal of Application
8 C.F.R. § 208.20 Determining If an Asylum Application Is Frivolous
8 C.F.R. § 209.2 Adjustment of Status of Alien Granted Asylum
8 C.F.R. § 209.2(f) Decision
8 C.F.R. § 235.3 Inadmissible Aliens and Expedited Removal
8 C.F.R. § 1003.1(h)(1)(i) Organization, Jurisdiction, and Powers of the Board of Immigration Appeals
8 C.F.R. § 1208.4(a)(2)(A) One-Year Filing Deadline
8 U.S.C. § 1158(a)(1) Authority to Apply for Asylum
8 U.S.C. § 1158(d)(2) Asylum Procedure, Employment
8 U.S.C. § 1158(d)(5)(A)(iii) (2009) Asylum Procedure, Consideration of Asylum Applications
8 U.S.C. § 1158, Section 208(b)(1)(B)(iii) Conditions for Granting Asylum, Burden of Proof, Credibility Determination
8 U.S.C. § 1225(b)(1)(A)(II) Inspection by Immigration Officers; Expedited Removal of Inadmissible Arriving Aliens; Referral for Hearing
8 U.S.C. § 1229c Voluntary Departure
8 U.S.C. § 1254a Temporary Protected Status
28 U.S.C. § 1361 Action to Compel an Officer of the United States to Perform His Duty
42 U.S.C. § 268 (1953) Quarantine Duties of Consular and Other Officers
Abay v. Ashcroft, 368 F.3d 634 (6th Cir. 2004)
American Baptist Churches v. Thornburgh, 760 F. Supp. 796 (N.D. Cal. 1991)
Asylum and Withholding Definitions, 65 Fed. Reg. 76588 (proposed Dec. 7, 2000)
Balogun v. Ashcroft, 374 F.3d 492 (7th Cir. 2004)
Decreto No. 57–2002. Republica de Guatemala: Reforma al Codigo Penal, Decreto Numero 17-73 del Congreso de la Republica. (Decree No. 57–2002,

Republic of Guatemala: Reform of the Criminal Code 17–73 of the Republic [Defining the Offense of Discrimination Including Discrimination on Grounds of Gender]). 11-09-2002. http://scm.oas.org

H.R. 9685 Refugee Protection Act of 2022, 117th Congress, 2nd Sess., December 2022.

INS v. Cardoza-Fonseca, 480 U.S. 421 (1987)

Ley Contra Femicidio y Otras Formas de Violencia Contra La Mujer (The Femicide Law and Other Forms of Violence Against Women). Decreto 22–2008. Artículo 20.02-05-2008 (Guat.). www.oas.org

Ley Contra La Violencia Doméstica (Law Against Domestic Violence). Decreto 250–2005. 15-11-1997. últimas reformas 11-03-2006 (Hond.). www.oas.org

Ley de Asistencia y Prevención De La Violencia Familiar (Law of Assistance and Prevention of Family Violence). Diario Oficial de la Federación [DOF] 08-07-1996. Últimas reformas DOF 05-04-2017 (Méx.). www3.contraloriadf.gob.mx

Ley de Igualdad de Oportunidades para la Mujer (Law on Equal Opportunities for Women). Decreto 34–2000, 22-05-2000 (Hond.). www.acnur.org

Ley General de Acceso de las Mujeres a Una Vida Libre de Violencia (General Law of a Woman's Right to a Life Free of Violence) [LGAMVLV]. Diario Oficial de la Federación [DOF] 01-02-2007. Últimas reformas DOF 08-05-2023 (Mex.). www.oas.org

Ley General Para La Igualdad Entre Mujeres y Hombres (General Law for Equality Between Women and Men) [LGMIH], 02-08-2006. Diario Oficial de la Federación [DOF]. Últimas reformas DOF 31-10-2022 (Mex.). www.diputados.gob.mx

Ley General Para Prevenir, Sancionar y Erradicar Los Delitos En Materia De Trata De Personas y Para La Protección y Asistencia A Las Víctimas De Delitos (General Law to Prevent, Punish, and Eradicate Crimes Regarding Trafficking in Persons and for the Protection and Assistance of Victims of These Crimes), 14-06-2012, Diario Oficial de la Federación [DOF]. Últimas reformas DOF 05-04-2023 (Mex.) www.diputados.gob.mx

Lopez Galarza v. INS, 99 F.3d 954, 958 (9th Cir. 1996)

Matter of A-B-, 27 I&N Dec. 316 (A.G. 2018)

Matter of A-B-, 28 I&N Dec. 307 (A.G. 2021)

Matter of A-C-A-A, 28 I&N Dec. 84 (A.G. 2020)

Matter of Acosta, 19 I&N Dec. 211, 233 (BIA 1985)

Matter of A-R-C-G- 26 I&N Dec. 388 (BIA 2014)
Matter of E-A-G-, 24 I&N Dec. 591 (BIA 2008)
Matter of Kasinga, 21 I&N Dec. 357 (BIA 1996)
Matter of Laipenieks, 18 I&N Dec. 433, 457 (BIA 1983)
Matter of L-E-A-, 28 I&N Dec. 304 (A.G. 2021)
Matter of R-A, 22 I&N Dec. 906 (BIA 1999)
Matter of S-A-, 22 I&N Dec. 1328 (BIA 2000)
Matter of S-E-G-, 24 I&N Dec. 579 (BIA 2008)
Nicaraguan Adjustment and Central American Relief Act (NACARA), Pub. L. 105–100, Title II
Public Health Service Act of 1944, 42 U.S.C. § 265 (1944)
REAL ID ACT of 2005, Pub. L. No. 109.13, 109th Cong. Section 101 (a)(3)(B)(i)
Refugee Act of 1979, Pub. L. No. 96–212, 94 Stat. 102
S. 1033 Secure America and Orderly Immigration Act, 109th Cong., 1st Sess., May 2005
S. 1348 Comprehensive Immigration Reform Act of 2007, 110th Congress, 1st Sess., May 2007
S. 2454 Securing America's Borders Act, 109th Congress, 2d Sess. March 2006
United Nations General Assembly Res. 36/29, para. 1 (Oct. 18, 1985)
US Department of Homeland Security Supplemental Brief, *Matter of L-R-* (BIA April 13, 2009)

NOTES

INTRODUCTION

1. When possible, direct quotes are used in reporting ethnographic observation, noted with quotation marks. When proceedings moved too quickly, comments are paraphrased.
2. Transactional Records Access Clearinghouse, *A Sober Assessment*.
3. Transactional Records Access Clearinghouse, *A Sober Assessment*.
4. US Department of State, *Report on Proposed Refugee Admissions*, 6.
5. US Department of State, *Report on Proposed Refugee Admissions*, 6.
6. Transactional Records Access Clearinghouse, *A Sober Assessment*.
7. Miller et al., *Immigration Judges*; Hamlin, *Crossing*.
8. Hamlin, *Crossing*, 3.
9. For example, see Sassen, *Expulsions*; Massey, *For Space*; Fernández-Kelly and Massey, "Borders for Whom?"
10. Transactional Records Access Clearinghouse, "Too Few Immigration Attorneys."
11. Transactional Records Access Clearinghouse, "Too Few Immigration Attorneys."
12. US Citizenship and Immigration Services, "Obtaining Asylum in the United States."
13. American Immigration Council, *Fact Sheet: The Migrant Protection Protocols*, 1.
14. Lens, *Poor Justice*, loc. 155 of 5884, Kindle edition.
15. UN Refugee Agency, "Figures at a Glance 2020."
16. Sassen, *Expulsions*, loc. 53 and 89 of 4834, Kindle edition.
17. Sassen, *Expulsions*, loc. 40 of 4834, Kindle edition.
18. Oishi, *Women in Motion*.
19. Sassen, *Expulsions*, loc. 116 of 4834, Kindle edition.
20. Sassen, *Expulsions*, loc. 151 of 4834, Kindle edition.
21. Transactional Records Access Clearinghouse, *The Impact of Nationality, Language, Gender and Age on Asylum Success*.
22. Transactional Records Access Clearinghouse, *The Impact of Nationality, Language, Gender and Age on Asylum Success*.
23. Transactional Records Access Clearinghouse, *The Impact of Nationality, Language, Gender and Age on Asylum Success*.
24. Transactional Records Access Clearinghouse, *The Impact of Nationality, Language, Gender and Age on Asylum Success*.

218 | NOTES

25 Transactional Records Access Clearinghouse, *The Impact of Nationality, Language, Gender and Age on Asylum Success*.
26 Transactional Records Access Clearinghouse, *The Impact of Nationality, Language, Gender and Age on Asylum Success*.
27 Transactional Records Access Clearinghouse, *The Impact of Nationality, Language, Gender and Age on Asylum Success*.
28 Imbriano, "Opening the Floodgates or Filing the Gap"; Gomez, "Last in Line."
29 Musalo, "Personal Violence, Public Matter," 48.
30 Musalo, "Personal Violence, Public Matter."
31 Musalo, "Personal Violence, Public Matter," 48.
32 Menjívar, "Liminal Legality," 1001–1037.
33 Menjívar, "Liminal Legality."
34 Menjívar, "Liminal Legality."
35 Menjívar, "Liminal Legality."
36 Menjívar, "Liminal Legality."
37 Coutin, *Legalizing Moves*; Menjívar and Abrego, "Legal Violence"; Gonzales and Chavez, "Awakening to a Nightmare."
38 Willen, "Toward a Critical Phenomenology of 'Illegality.'"
39 Willen, "Toward a Critical Phenomenology of 'Illegality.'"
40 Chavez, *The Latino Threat*; Gonzales and Chavez, "Awakening to a Nightmare."
41 Gonzales and Chavez, "Awakening to a Nightmare." For more on biopolitics, see Foucault et al., *The Birth of Biopolitics*; Foucault, *Discipline and Punish*.
42 Gonzales and Chavez, "Awakening to a Nightmare," 259.
43 Coutin, *Legalizing Moves*, 59.
44 Transactional Records Access Clearinghouse, *Speeding Up the Asylum Process*.
45 Hueben, "Domestic Violence and Asylum Law"; Bookey, "Domestic Violence as a Basis for Asylum"; Bookey, "Gender-Based Asylum Post-Matter of *A-R-C-G-*," 2.
46 De Genova, "The Legal Production"; Chavez, "The Condition of Illegality."
47 For discussions of how trauma is exacerbated by hostile reception for asylum seekers, see Carswell et al., "The Relationship"; Li et al., "The Relationship"; Silove et al., "No Refuge from Terror."
48 Bookey, "Domestic Violence as a Basis for Asylum"; Bookey, "Gender-Based Asylum Post-*Matter of A-R-C-G-*."
49 Bookey, "Gender-Based Asylum Post-*Matter of A-R-C-G-*."
50 Ramji-Nogales et al., "Refugee Roulette"; Bishop, *A Story to Save Your Life*.
51 Fitzgerald, *Refuge Beyond Reach*, loc. 143 of 9270, Kindle edition.
52 Menjívar, *Enduring Violence*.
53 Levenson, *Adiós Niño*, 24–27.
54 Menjívar and Drysdale Walsh, "The Architecture of Feminicide."
55 Hondagneu-Sotelo, "Feminism and Migration," 111.
56 Torres, "A Crisis of Rights and Responsibility."
57 Riva, "Across the Border and Into the Cold."
58 Sharma, "Anti-Trafficking Rhetoric."

59 Brigden, *The Migrant Passage*; Coutin, "Smugglers or Samaritans"; Coutin, "Contesting Criminality."
60 Tichenor, *Dividing Lines*; McKinnon, *Gendered Asylum*.
61 McKinnon, *Gendered Asylum*; Warren, "Women Are Human."
62 Llewellyn, "(In)Credible Violence."
63 Farmer, "On Suffering," 261–262.
64 Willen, "Toward a Critical Phenomenology of Illegality"; Gonzales and Chavez, "Awakening to a Nightmare"; Coutin, *Legalizing Moves*; Calavita, "Immigration."
65 Fassin and Rechtman, *The Empire of Trauma*.
66 National Coalition Against Domestic Violence, "National Statistics."
67 Peck, *The Accidental History*.
68 Manwaring, *A Contemporary Challenge*, 9.
69 Coutin, "Falling Outside."
70 Walby, "Theorising Patriarchy," 214.
71 Jütersonke et al., "Gangs."
72 del Carmen Gutiérrez Rivera, "Security Policies"; Rahbari and Sharepour, "Gender and Realisation"; Alfaro, "Feminist Lefebvre?"
73 Bourdieu, *Distinction*, 511.
74 Bourdieu, *Outline of a Theory of Practice*, 82.
75 Skeggs, *Formations*.
76 Skeggs, *Formations*.
77 Kitchin, "'Out of Place'"; Saatcioglu and Corus, "Exploring Spatial Vulnerability"; Alfaro, "Feminist Lefebvre?"; Sassen, "Women's Burden."
78 Drysdale Walsh, "Engendering Justice."
79 Pain, "Intimate War."
80 Drysdale Walsh and Menjívar, "What Guarantees Do We Have?"; Menjívar and Drysdale Walsh, "The Architecture of Feminicide"; Staudt, *Violence and Activism at the Border*; Hume, "The Myths of Violence."
81 Drysdale Walsh and Menjívar, "What Guarantees Do We Have?"
82 Husk, "Curing What Ails US "; Marzouk, "Ethical and Effective Representation."
83 Cleaveland and Kirsch, "They Took All My Clothes"; Vogt, "Crossing Mexico."
84 Stumpf, "Crimmigration" ; Menjívar et al., "The Expansion of 'Crimmigration.'"
85 Kleinman, "The Violences of Everyday Life."
86 Alexander, *Trauma*, 29.
87 Sassen, *Expulsions*; Massey, *For Space*.
88 Alexander, *Trauma*, 6.
89 Alexander, *Trauma*, 21.
90 Alexander, *Trauma*, 37.
91 Gonzales and Chavez, "Awakening to a Nightmare"; Menjívar and Abrego, "Legal Violence."

CHAPTER 1. "PRIVATE VIOLENCE" AND PUBLIC POLICY
1 Fitzgerald, *Refuge Beyond Reach*, loc. 103 of 9270, Kindle edition.
2 Fitzgerald, loc. 103 of 9270, Kindle edition.
3 Menjívar, "Liminal Legality"; Coutin, *Legalizing Moves*; Gonzales and Chavez, "Awakening to a Nightmare."
4 Gonzales and Chavez, "Awakening to a Nightmare"; Menjívar and Abrego, "Legal Violence."
5 Menjívar and Abrego, "Legal Violence," 1383.
6 Jackman, "Violence in Social Life"; Menjívar and Abrego, "Legal Violence," 1383.
7 Menjívar and Abrego, "Legal Violence," 1386.
8 Coutin, *Legalizing Moves*, 30–47.
9 Menjívar and Abrego, "Legal Violence."
10 Gonzales and Chavez, "Awakening to a Nightmare," 258.
11 Asylum applicants may apply for an Employment Authorization Document (EAD) 150 days after filing a completed asylum application, and then USCIS has 30 days to adjudicate the EAD. See 8 U.S.C. § 1158(d)(2)(2009) and 8 U.S.C. § 1158(d)(5)(A)(iii)(2009). Thus, asylum applicants may receive their EAD after their application has been pending 180 days. The EAD asylum clock measures the number of days that an asylum application has been pending in order for the applicant to be eligible for work authorization. The EAD asylum clock may stop, and the applicant may stop accumulating time for a variety of reasons, including requesting a continuance in order to find an attorney, meaning that applicants may have to wait longer than 180 calendar days. For more information, see US Citizenship and Immigration Services, "The 180-Day Asylum EAD Clock Notice."
12 Coutin, *Legalizing Moves*, 59–61.
13 Musalo, "A Short History."
14 Youngs, "Private Pain/Public Peace," 1209.
15 McKinnon, *Gendered Asylum*, loc. 152 of 4068, Kindle edition.
16 Edwards, "Transitioning Gender."
17 Nayak, *Who Is Worthy of Protection?*, loc. 112 of 6700, Kindle edition.
18 Ramji-Nogales et al., *Refugee Roulette*.
19 Ramji-Nogales et al., *Refugee Roulette*.
20 Transactional Records Access Clearinghouse, *Judge-by-Judge Asylum Decisions*.
21 United Nations, "Global Issues: Refugees."
22 US Department of Homeland Security: Office of Immigration Statistics, *Refugees and Asylees*, 14D.
23 Fitzgerald, *Refuge Beyond Reach*, loc. 119 of 9270, Kindle edition.
24 Balgamwalla, "Bride and Prejudice"; Calvo, "Spouse-Based Immigration Laws"; Calvo, "A Decade of Spouse-Based Immigration Laws."
25 Cleaveland, "How the Immigration and Deportation Systems Work."
26 Sassen, *Expulsions*, loc. 764 of 4834, Kindle edition.

27 Coutin, "Falling Outside."
28 Schacher, "Return of the Repressed."
29 Schacher, "Return of the Repressed," 382.
30 Schacher, "Return of the Repressed"; Cox and Rodríguez, *The President and Immigration Law*; Tichenor, "Two-Tiered Implementation."
31 American Presidency Project, "Harry S. Truman."
32 Ogilvie and Miller, *Refuge Denied*.
33 United Nations Conference of Plenipotentiaries, *Convention*; General Assembly, *Protocol*.
34 Musalo, "Personal Violence, Public Matter," 46.
35 Refugee Act of 1980, Pub. L. No. 96–212, 94 Stat. 102.
36 Fitzgerald, *Refuge Beyond Reach*, loc. 2 of 9270, Kindle edition.
37 Fitzgerald, loc. 151 of 9270, Kindle edition.
38 Loyd and Mountz, *Boats, Borders, and Bases*, loc. 53 of 7065, Kindle edition.
39 Loyd and Mountz, loc. 52 of 7065, Kindle edition.
40 Gerken, "Credibility"; Zeigler and Stewart, "Positioning Women's Rights."
41 See United Nations G.A. Res. 36/29, para. 1 (Oct. 18, 1985). Also see Musalo, "The Struggle for Equality"; Musalo, "Personal Violence, Public Matter."
42 Musalo, "Personal Violence, Public Matter," 46.
43 Musalo, "The Struggle for Equality," 533.
44 Harris, "Untold Stories"; Tahirih Justice Center, *Ensuring Equal and Enduring Access to Asylum*.
45 Coven, "Considerations for Asylum Officers"; also see Llewellyn, "(In)Credible Violence," 172; Barreno, "In Search of Guidance."
46 Hueben, "Domestic Violence and Asylum Law," 469.
47 8 U.S.C. § 1158 (a)(1).
48 See *Balogun v. Ashcroft*, 374 F.3d 492 (7th Cir. 2004).
49 The adjudicator must determine whether safe relocation is possible and, if so, whether it is reasonable that the asylum applicant relocate. See 8 CFR 208.13(b)(3).
50 This statute does not list gender as a protected ground, and women who seek asylum based on gang-based or domestic violence generally cannot argue that they qualify because of their race, religion, nationality, or political opinion. This means they must prove they are members of a "particular social group." The courts defined a particular social group as "a group of persons all of whom share a common, immutable characteristic." See *Matter of Acosta*, 19 I&N Dec. 211, 233 (BIA 1985). Decades later the BIA added "social visibility" and "particularity" to the definition of particular social group. See *Matter of S-E-G-*, 24 I&N Dec. 579 (BIA 2008); *Matter of E-A-G-*, 24 I&N Dec. 591 (BIA 2008). For more background on particular social group, see National Immigrant Justice Center: A Heartland Alliance Program, *Basic Procedural Manual*, 15–16.
51 REAL ID ACT of 2005, Pub. L. No. 109.13, 109th Cong. Section 101 (a)(3)(B)(i) states that all asylum applicants must prove that race, religion, nationality,

membership in a particular group, or political opinion "was or will be at least one central reason for persecuting the applicant." For more on nexus, see National Immigrant Justice Center, *Basic Procedural Manual*, 14.

52 The asylum application must not be "frivolous," meaning that elements were deliberately fabricated. See Determining if an Asylum Application is Frivolous, 8 C.F.R. § 208.20. Applicants must also prove by "clear and convincing evidence" that they filed their asylum applications within one year of the date of their last arrival in the United States. See Filling the Application, 8 C.F.R. § 1208.4(a)(2)(A). There are exceptions in cases where the circumstances have changed enough to affect the applicant's eligibility for asylum or there are extraordinary circumstances that delayed the filing of the application. This list is based on Center for Gender & Refugee Studies, *Asylum: Frequently Asked Questions*.

53 8 U.S.C. § 1158, Section 208(b)(1)(B)(iii). Scholars and practitioners have shown that the demeanor of a victim of trauma, torture, or domestic violence can be inconsistent with expectations of how a victim "should" behave. Women who have experienced trauma, particularly those from other cultures, may not establish eye contact, may not speak chronologically, may have a flat affect, or otherwise present themselves in a manner that a judge may find non-credible. See Llewellyn, "(In)Credible Violence."

54 American Immigration Council, *Asylum in the United States*.

55 American Immigration Council, *Asylum in the United States*.

56 Jurisdiction, 8 C.F.R. § 208.12; Establishing Asylum Eligibility, 8 C.F.R. § 208.13; Approval, Denial, Referral, Or Dismissal of Application, 8 C.F.R. § 208.14.

57 Baugh, *Refugees and Asylees: 2021*, fig. 5.

58 Bishop, *A Story to Save Your Life*, loc. 180 of 5760, Kindle edition.

59 Nearly all non-citizens who cross the US-Mexico border seeking asylum are subject to a form of expedited removal. Under expedited removal, immigration officers may order the deportation of people arriving at the border without a hearing before a judge, an attorney, or any right to appeal. See Inadmissible Aliens and Expedited Removal, 8 C.F.R. § 235.3.

60 8 C.F.R. § 235.3.

61 While it did not apply to the women we interviewed, a new rule implemented in 2022 allows ICE to refer individuals with positive credible fear determinations to be referred to USCIS for a non-adversarial asylum merits interview. See US Department of Homeland Security, *Fact Sheet*.

62 Harris, "Withholding Protection."

63 Human Rights Watch, "Deported to Danger."

64 National Association of Immigration Judges, "National Association of Immigration Judges."

65 National Association of Immigration Judges, "The Immigration Courts," posted October 8, 2019, YouTube video, 0:00–0:36, https://youtu.be/wfZtqHtNyTY.

66 National Association of Immigration Judges, "The Immigration Courts." YouTube video, 1:01–1:13.

67 National Association of Immigration Judges, "The Immigration Courts," YouTube video, 1:18–1:23.
68 Marouf, "Executive Overreaching."
69 Peck, *The Accidental History*; National Association of Immigration Judges, "The Immigration Courts," YouTube video.
70 Peck, *The Accidental History*, 54–58. Also see Katz and Olivares, "A Look at Immigration Courts"; Robbins and Archambeault, "Dysfunction."
71 Peck, *The Accidental History*, 6.
72 5 Fed. Reg. 3502.
73 Organization, Jurisdiction, and Powers of the Board of Immigration Appeals, 8 C.F.R. § 1003.1(h)(1)(i) (2016). Also see Peck, *The Accidental History*, 8–9.
74 Cox and Rodríguez, *The President and Immigration Law*, loc. 215 of 9351, Kindle edition.
75 Waslin, "The Use of Executive Orders."
76 Jutt, "Build Back Better," 566.
77 *Matter of Kasinga*, 21 I&N Dec. 357 (BIA 1996).
78 Musalo, "Personal Violence, Public Matter," 47.
79 *Matter of R-A-*, 22 I&N Dec. 906 (BIA 1999). For a fuller account of the *Matter of R-A-*, also see Bookey, "Domestic Violence as a Basis for Asylum"; McKinnon, *Gendered Asylum*.
80 *Matter of R-A-*, 22 I&N Dec. 906 (BIA 1999), 943.
81 *Matter of R-A-*, 22 I&N Dec. 906 (BIA 1999), 910.
82 *Matter of R-A-*, 22 I&N Dec. 906 (BIA 1999), 911.
83 *Matter of R-A-*, 22 I&N Dec. 906 (BIA 1999).
84 Bookey, "Domestic Violence as a Basis for Asylum," 113; For a full timeline of *Matter of R-A-*, see Center for Gender & Refugee Studies, "*Matter of R-A-*."
85 Bookey, "Domestic Violence as a Basis for Asylum."
86 Musalo, "The Struggle for Equality," 535.
87 Bookey, "Domestic Violence as a Basis for Asylum," 114.
88 Bookey, "Domestic Violence as a Basis for Asylum"; Also see Asylum and Withholding Definitions, 65 Fed. Reg. 76588 (proposed Dec. 7, 2000).
89 Bookey, "Domestic Violence as a Basis for Asylum," 115.
90 Bookey, "Domestic Violence as a Basis for Asylum," 116.
91 Bookey, "Domestic Violence as a Basis for Asylum."
92 US Department of Homeland Security Supplemental Brief, *Matter of L-R-* (BIA April 13, 2009). For a full timeline of this case, see Center for Gender & Refugee Studies, "*Matter of L-R-*."
93 US Department of Homeland Security Supplemental Brief, *Matter of L-R-* (BIA April 13, 2009).
94 Center for Gender & Refugee Studies, "*Matter of L-R-*."
95 Center for Gender & Refugee Studies, "*Matter of L-R-*."
96 *Matter of A-R-C-G-*, 26 I&N Dec. 388 (BIA 2014).
97 Bookey, "Gender-Based Asylum Post-*Matter of A-R-C-G*," 5.

98 Bookey, "Gender-Based Asylum Post-*Matter of A-R-C-G-*," 5–6.
99 Bookey, "Gender-Based Asylum Post-*Matter of A-R-C-G-*," 5–6.
100 Bookey, "Gender-Based Asylum Post-*Matter of A-R-C-G-*," 8.
101 Bookey, "Gender-Based Asylum Post-*Matter of A-R-C-G-*," 9.
102 Nanasi, "Domestic Violence Asylum," 746.
103 Bookey, "Domestic Violence as a Basis for Asylum."
104 Bookey, "Gender-Based Asylum Post-*Matter of A-R-C-G-*," 2.
105 Bolter et al., *Four Years of Profound Change*, 144.
106 Harris, "Asylum Under Attack," 128.
107 Attorneys General Jeff Sessions and William Barr and Acting Attorneys General Matthew Whitaker and Jeffrey Rosen self-referred 17 cases—more than the Obama and George W. Bush administrations. See Pierce, *Obscure but Powerful*, 7; Also see Marouf, "Executive Overreaching."
108 Sessions vacated the BIA's decision in *Matter of A-B* and overruled the BIA's decision in *Matter of A-R-C-G-*. Ms. A.B. was a Salvadoran woman who endured years of abuse from her husband and fled to the United States, where she was denied asylum by an immigration judge in 2015. She appealed to the BIA, which reversed the decision in 2016, finding she qualified for asylum under the precedents that had been set. Sessions reversed the BIA's decision in *Matter of A-B-*, thereby denying her asylum. See *Matter of A-B-*, 27 I&N Dec. 316 (A.G. 2018). Furthermore, Sessions overturned the precedent that had been set by the BIA in *Matter of A-R-C-G-*, claiming the BIA had erroneously "recognized an expansive new category of particular social groups based on private violence."
109 *Matter of A-B-*, 27 I&N Dec. 316, 316–346 (A.G. 2018).
110 *Matter of A-B-*, 27 I&N Dec. 316, 316–346 (A.G. 2018).
111 *Matter of A-B-*, 27 I&N Dec. 316 (A.G. 2018), 325.
112 *Matter of A-B-*, 27 I&N Dec. 316 (A.G. 2018), 345.
113 *Matter of A-B-*, 27 I&N Dec. 316, 316–346 (A.G. 2018).
114 US Immigration and Customs Enforcement to All OPLA Attorneys, memorandum, "Litigating Domestic Violence-Based Persecution Claims Following *Matter of A-B-*."
115 *Matter of A-C-A-A-*, 28 I&N Dec. 84 (A.G. 2020), 25.
116 The names of all attorneys and former immigration judges we interviewed have been redacted to protect their privacy and in accordance with the George Mason University Institutional Review Board.
117 Harris, "Asylum Under Attack."
118 Hoffman, "Metering Guidance Memo." We note that the Obama administration first used metering in 2016. See American Immigration Council, *Metering and Asylum Turnbacks*.
119 McAleenan, Commissioner of CBP, to Todd C. Owen, "Implementation of the Migrant Protection Protocols."
120 Bolter et al., *Four Years of Profound Change*, 34 and 81.

121 Executive Office of Immigration and US Citizenship and Immigration Services, "Asylum Eligibility and Procedural Modifications." The administration also signed agreements with several Central American countries directing asylum seekers to apply in those countries, regardless of their inadequate asylum systems, rather than traveling to the United States. See US Department of Homeland Security Office of Strategy, Policy, and Plans, "Agreement Between the Government of the United States of America and the Government of the Republic of Guatemala"; Department of Homeland Security Office of Strategy, Policy, and Plans, "Agreement Between the Government of the United States of America and the Government of the Republic of Honduras."

122 Public Health Service Act of 1944, 42 U.S.C. § 265 (1944); Quarantine Duties of Consular and Other Officers, 42 U.S.C. § 268 (1953).

123 For a complete list, see Bolter et al., *Four Years of Profound Change*, 144.

124 Harris, "Asylum Under Attack," 185.

125 Transactional Records Access Clearinghouse, *Asylum Decisions and Denials Jump in 2018*.

126 Menjívar and Abrego, "Legal Violence."

127 *Matter of L-E-A-*, 28 I&N Dec. 304 (A.G. 2021); *Matter of A-B-*, 28 I&N Dec. 307 (A.G. 2021).

128 Biden Jr., "Executive Order on Creating a Comprehensive Regional Framework."

129 The Refugee Protection Act, which addresses several of the issues surrounding asylum, was first introduced in Congress in 1999, and has been re-introduced at least seven times, but has not passed and become law. See Schacher, "Refugee Protection Act of 2022."

130 Since March 2020, more than 2.5 million expulsions have occurred under Title 42. See US Customs and Border Protection, "Nationwide Encounters" (select "Title 42" under "Type of Encounters" on website). Also see Beitsch and Bernal, "Biden Embraces Trump's Title 42"; Schacher, "Biden's Announced Asylum Transit Ban."

131 US Citizenship and Immigration Services, Department of Homeland Security; Executive Office for Immigration Review, Department of Justice, "Circumvention of Lawful Pathways, a Proposed Rule."

132 American Immigration Council, *Beyond a Border Solution*.

133 See US Customs and Border Protection, "CBP One Mobile Application." Thank you to Blaine Bookey for pointing out the gendered implications of this policy.

134 del Bosque, "Facial Recognition Bias."

135 Aleaziz, "Here's How a Border Deal Could Affect People Seeking Asylum in the U.S." *New York Times*, Dec. 15, 2023. www.nytimes.com.

136 Mayorkas, "Guidelines for the Enforcement of Civil Immigration Law"; Doyle, "Guidance to OPLA Attorneys."

137 Wadhia, "Prosecutorial Discretion in the Biden Administration: Part 5."

138 Cox and Rodríguez, *The President and Immigration Law*, loc. 111 of 9351, Kindle edition. Also see Waslin, "The Impact of Immigration Enforcement Outsourcing."
139 Wadhia, "The Role of Prosecutorial Discretion in Immigration Law." There are multiple forms of prosecutorial discretion. Administration closure effectively puts the case on hold, the asylum application remains pending, and the woman can continue to renew work authorization. A dismissal means the government has chosen not to prosecute the case and the removal order is no longer in effect. However, it means that there is no pending asylum application and the respondent is no longer eligible for work authorization. These women may file for affirmative asylum, which would open a new asylum application and once again make them eligible for work authorization until the affirmative case is heard by the asylum officer.
140 Doyle, "Isn't Persecution Enough."
141 Bishop, *A Story to Save Your Life*, loc. 64 of 5760, Kindle edition.
142 Musalo, "A Short History."
143 Fitzgerald, *Refuge Beyond Reach*, loc. 149 of 9270, Kindle edition.
144 Nayak, *Who is Worthy of Protection?*

CHAPTER 2. "WOMEN WHO ARE ALONE SUFFER"

1 Jan Perlin, "The Guatemalan Historical Clarification Commission Finds Genocide," *ILSA Journal of International & Comparative Law* 6, no. 2 (Spring 2000): 389–414; Roth, foreword to *Annihilating Difference*.
2 Wolf, "Mara Salvatrucha."
3 Staudt, *Violence and Activism at the Border*, loc. 190–203 of 2132, Kindle edition.
4 Menjívar and Drysdale Walsh, "The Architecture of Feminicide"; Staudt, *Violence and Activism at the Border*, loc. 1652 of 2132, Kindle edition.
5 Cruz, "Police Misconduct"; Shorack et al., "A State of Mistrust."
6 Staudt, *Violence and Activism at the Border*, loc. 436 of 2132, Kindle edition.
7 López et al., "Exit as Care."
8 Pedraza-Farina et al., *No Place to Hide*, 77.
9 del Carmen Gutiérrez Rivera, "Security Policies"; Rahbari and Sharepour, "Gender and Realisation"; Alfaro, "Feminist Lefebvre?"
10 Menjívar, *Enduring Violence*, loc. 41–42 of 6134, Kindle edition.
11 Bourdieu and Wacquant, *An Invitation to Reflexive Sociology*, 273; Bourdieu, *Outline of A Theory of Practice*, 190–197.
12 Bourdieu, *Distinction*, 163–165.
13 Menjívar, *Enduring Violence*, loc. 30 of 6134, Kindle edition.
14 Bourdieu, *Masculine Domination*, 2.
15 Lumsden and Morgan, "Media Framing"; McRobbie, "Notes on 'What Not to Wear.'"
16 Lumsden and Morgan, "Media Framing."
17 Bourdieu, *Outline of A Theory of Practice*, 171–183.
18 Skeggs, *Formations*, 60.

19 Skeggs, *Formations*, 74.
20 Farmer, "An Anthropology of Structural Violence."
21 Organization for Economic Co-operation and Development, "Key Issues Affecting Youth in El Salvador."
22 Instituto Nacional De Estadística, *Revisión de la Metodología*.
23 Taft-Morales, *Guatemala*.
24 Seelke, *Mexico*.
25 Schmalzbauer, "Disruptions, Dislocations, and Inequalities."
26 Prieto-Carrón et al., "No More Killings!," 26.
27 Caputo-Levine, "The Yard Face"; Desmond, "Becoming a Firefighter"; Willis, *Learning to Labor*.
28 Bruneau et al., *Maras*, 128.
29 Arana, "How the Street Gangs Took Central America."
30 Levenson, *Adiós Niño*, 66.
31 Levenson, *Adiós Niño*, 72.
32 Levenson, *Adiós Niño*, 92.
33 Menjívar, *Enduring Violence*, loc. 191 and 343 of 6134, Kindle edition; Paley, "Drug War as Neoliberal Trojan Horse."
34 Harvey, *A Brief History of Neoliberalism*, 1–3 and 65–66.
35 Massey, *For Space*, 83–85.
36 Menjívar and Drysdale Walsh, "The Architecture of Feminicide," 234.
37 Correa-Cabrera, "Mexico's Economic Dilemmas."
38 Farmer, "An Anthropology of Structural Violence."
39 Seelke and Klein, *El Salvador: In Brief*.
40 For more discussion of disruption to Central American families caused by poverty and income inequality, see Abrego and Hernández, "#FamiliesBelongTogether," loc. 4476 of 15617, Kindle edition.
41 Wolf, *Mano Dura*, loc. 195 of 7368, Kindle edition.
42 Wolf, *Mano Dura*, loc. 226 of 7368, Kindle edition.
43 Ronderos, "Poverty Reduction, Political Violence"; Jokela-Pansini, "Spatial Imaginaries."
44 Staudt, "Gender, Governance, and Globalization"; Correa-Cabrera, "Security, Migration, and the Economy."
45 Sanford, *Textures of Terror*, 14.
46 Blume et al., "Honduran Women Leaders."
47 Americas Program, "Status of Violence."
48 Americas Program, "Status of Violence." See graph and chart from World Bank, "International Homicides, Female."
49 World Bank Group, *Gender Data Portal*, "International Homicides, Male." Stats are updated with 2021 figures.
50 World Bank Group, *Gender Data Portal*, "International Homicides, Male."
51 Y de los Ríos, preface to *Terrorizing Women*; Castañeda Salgado, "Feminicide in Mexico."

52 Moodie, *El Salvador in the Aftermath of Peace*, 113–177; Jokela-Pansini, "Complicating Notions."
53 Center for Gender & Refugee Studies, "Central America: Femicides and Gender-Based Violence."
54 Menjívar and Drysdale Walsh, "The Architecture of Feminicide," 222.
55 One recent argument suggests that as governments in Latin America have moved from authoritarian governments to fragile democracies—hindered by neoliberalism and the remnants of dictatorships' police forces—nations now suffer violent pluralism, in which violence by state and non-state actors is mutually beneficial and reinforcing for certain sectors. These forms of violence range from extra-judicial lynchings of suspected criminals, gangs, state brutality in crime crackdowns, and the utilization of private security forces, by elites depending on local contexts. See Arias and Goldstein, *Violent Democracies*.
56 Ley General de Acceso de las Mujeres; Ley de Asistencia y Prevención De La Violencia Familiar.
57 Ley General Para La Igualdad Entre Mujeres y Hombres ; Ley General Para Prevenir, Sancionar y Erradicar.
58 Ley de Igualdad de Oportunidades para la Mujer.
59 Ley Contra La Violencia Doméstica.
60 Ley Contra Femicidio y Otras Formas de Violencia Contra La Mujer; Gobierno de la República de Guatemala; Decreto No. 57-2002, Republica de Guatemala.
61 Menjívar and Drysdale Walsh, "The Architecture of Feminicide."
62 Blacklock and Crosby, "The Sounds of Silence," 56–62; Staudt, *Violence and Activism at the Border*, loc. 182–183 of 2132, Kindle edition.
63 Wolf, *Mano Dura*, loc. 567 of 7368, Kindle edition.
64 Wolf, *Mano Dura*, loc. 2880 of 7368, Kindle edition.
65 Wolf, *Mano Dura*, loc. 820 of 7638, Kindle edition.
66 Wolf, *Mano Dura*, loc. 1693 of 7368, Kindle edition.
67 Pedraza-Farina et al., *No Place to Hide*; Moodie, *El Salvador in the Aftermath of Peace*.
68 Wolf, *Mano Dura*, loc. 844 of 7368, Kindle edition.
69 Seelke and Klein, *El Salvador*.
70 Seelke and Klein, *El Salvador*.
71 As noted earlier, immigration lawyers shared 21 written decisions by immigration judges, which were shared in redacted form for our analysis.
72 Moodie, *El Salvador in the Aftermath of Peace*, 110–112.
73 Menjívar, *Enduring Violence*, loc. 5146 of 6134, Kindle edition.
74 Bourdieu, *Distinction*, 511.
75 Cruz, "Police Misconduct."
76 Cruz, "Police Misconduct."
77 Staudt, *Violence and Activism at the Border*, loc. 358 of 2132, Kindle edition.
78 Staudt, *Violence and Activism at the Border*, loc. 436 of 2132, Kindle edition.

79 Human Rights Watch, "Honduras" ; Pedraza-Farina et al., *No Place to Hide*; Human Rights Watch, "Mexico"; Hite and Montenegro, "Guatemala's Corrupt."
80 Bourdieu and Wacquant, "Symbolic Capital and Social Classes." Bourdieu identified economic capital (e.g., wealth), linguistic (e.g., vocabulary/ "proper" accent) social (e.g., social networks), cultural (e.g., knowledge of art and taste), symbolic (e.g., prestige), among others. See Bourdieu, "The Forms of Capital."
81 Staudt, *Violence and Activism at the Border*, loc. 29 of 2132, Kindle edition.

CHAPTER 3. VIOLENCE AT HOME
1 Skeggs, *Formations*, 75 and 90.
2 Bourdieu, *Distinction*, 105.
3 Skeggs, *Formations*.
4 Sassen, "Women's Burden." Also see Atkinson, "The Social Space."
5 Bourdieu, *Pascalian Meditations*, 284.
6 Glebbeek and Koonings, "Between Morro and Asfalto"; Kitchin, "Out of Place"; Saatcioglu and Corus, "Exploring Spatial Vulnerability." Alfaro, "Feminist Lefebvre?"
7 Husk, "Curing What Ails US," 5; Colbert, "Murder and Machismo"; Marzouk, "Ethical and Effective Representation."
8 Godoy, "La Muchacha Respondona."
9 Godoy, "La Muchacha Respondona"; Drysdale Walsh and Menjívar, "What Guarantees Do We Have?"; Menjívar, *Enduring Violence*.
10 Godoy-Paiz, "Women in Guatemala's Metropolitan Area," 29.
11 Godoy-Paiz, "Women in Guatemala's Metropolitan Area."
12 Levenson, *Adiós Niño*, 41.
13 Drysdale Walsh and Menjívar, "What Guarantees Do We Have?"; Menjívar and Drysdale Walsh, "The Architecture of Feminicide"; Staudt, *Violence and Activism at the Border*, loc. 143 of 2132, Kindle edition; Hume, "The Myths of Violence."
14 Menjívar, *Enduring Violence*, loc. 230 and 232 of 6134, Kindle edition.
15 Pain, "Intimate War"; Adelman, "The Military."
16 Alvarez, "No Safe Space"; Torres, "State Violence."
17 Menjívar and Drysdale Walsh, "The Architecture of Feminicide."
18 Menjívar and Drysdale Walsh, "The Architecture of Feminicide," 223.
19 Alvarez, "No Safe Space."
20 Hondagneu-Sotelo, "Gendered Transitions."
21 Menjívar, *Enduring Violence*, loc. 2331 of 6134, Kindle edition.
22 Drysdale Walsh and Menjívar, "What Guarantees Do We Have?"
23 Menjívar, *Enduring Violence*, loc. 3331 of 6134, Kindle edition.
24 Menjívar, *Enduring Violence*, loc. 226 of 6134, Kindle edition.
25 Menjívar, *Enduring Violence*, loc. 715 of 6134, Kindle edition; Owen et al., "A Geographic Analysis."
26 Menjívar, *Enduring Violence*, loc. 731 of 6134, Kindle edition.
27 Farmer et al., "Structural Violence and Clinical Medicine."

28 Walby, "From Private to Public Patriarchy."
29 Carey Jr. and Torres, "Precursors to Femicide"; Ruiz, "No Justice for Guatemalan Women"; Ogrodnik and Borzutzky, "Women Under Attack."
30 Jokela-Pansini, "Complicating Notions of Violence," 848.
31 Nayak, *Who Is Worthy of Protection?*, loc. 1976 of 6700, Kindle edition.
32 Nayak, *Who Is Worthy of Protection?*, loc. 1976 of 6700, Kindle edition.
33 Coven, "Considerations for Asylum Officers."
34 Barreno, "In Search of Guidance"; McKinnon, *Gendered Asylum*, loc. 142 of 4068, Kindle edition.
35 Transactional Records Access Clearinghouse, *Judge-by-Judge Asylum*.
36 Zeigler and Stewart, "Positioning Women's Rights."
37 Our observation of court hearings and review of redacted legal decisions revealed that attorneys sometimes listed as many as a dozen particular social groups in the hope that the judge would accept one that meets the legal criteria for asylum.
38 Jokela-Pansini, "Complicating Notions of Violence."
39 Menjívar and Drysdale Walsh, "The Architecture of Feminicide."
40 Jokela-Pansini, "Complicating Notions of Violence."
41 Bourdieu and Wacquant, *An Invitation to Reflexive Sociology*.
42 Bourdieu, "Gender and Symbolic Violence"; Menjívar and Drysdale Walsh, "The Architecture of Feminicide."
43 Menjívar and Drysdale Walsh, "The Architecture of Feminicide."
44 Menjívar and Drysdale Walsh, "The Architecture of Feminicide."
45 Gerken, "Credibility," 262.
46 Ramji-Nogales et al., *Refugee Roulette*.
47 Olavarrieta and Sotelo, "Domestic Violence in Mexico."
48 Olavarrieta and Sotelo, "Domestic Violence in Mexico."
49 Jokela-Pansini, "Complicating Notions of Violence"; Menjívar and Drysdale Walsh, "The Architecture of Feminicide."
50 Godoy, *Popular Injustice*.
51 Staudt, *Violence and Activism at the Border*, loc. 146 of 2132, Kindle edition.
52 Obinna, "Seeking Sanctuary"; Van Damme, "Corruption, Impunity and Mistrust."
53 Kleinman, "The Violences of Everyday Life."
54 Drysdale Walsh and Menjívar, "What Guarantees Do We Have?"

CHAPTER 4. CRIMINALIZING ASYLUM

1 Bourdieu, *Outline of A Theory of Practice*, 190–197; Farmer, *Pathologies of Power*, loc. 1653 of 5969, Kindle edition.
2 Stumpf, "The Crimmigration Crisis."
3 Menjívar and Abrego, "Legal Violence."
4 Menjívar and Abrego, "Legal Violence."
5 Menjívar and Abrego, "Legal Violence," 1383.
6 Davis, "Border Crisis."
7 Davis, "Border Crisis."

NOTES | 231

8 Davis, "Border Crisis."
9 Coutin, "The Rights of Noncitizens in the United States."
10 De Genova and Peutz, *The Deportation Regime*, loc. 1910 of 9566, Kindle edition.
11 De Genova and Peutz, *The Deportation Regime*, loc. 428 of 9566, Kindle edition.
12 Chacón and Coutin, "Racialization Through Enforcement," 168–169.
13 Loyd and Mountz, *Boats, Borders, and Bases*, loc. 1647 of 7065, Kindle edition.
14 As Erika Lee explained, "Americans have labeled immigrants threatening because they were poor, practiced a different faith, were non-white. They have argued that immigrants were too numerous, were not assimilating, were taking jobs away from deserving Americans, were bringing crime and disease into the country, had dangerous political ideals, were un-American, or event hated America." See Lee, *America for Americans*, 3.
15 Santa Ana, *Brown Tide Rising*. Recently, the "Great Replacement" theory, a belief that policies deliberately encourage non-white immigrants to undermine white hegemony, moved from the deep recesses of conspiracy theory websites to visibility, as it is now repeated by mainstream politicians and pundits, including in congressional hearings. See Oh, "When Republican House Judiciary Committee Members Amplified White Nationalist Conspiracy Theories." This theory brought deleterious consequences in El Pason in 2019, when a mass shooter cited it before killing dozens of Latino people, including children.
16 Chavez, "A Glass Half Empty," 177.
17 Huntington, "The Hispanic Challenge," 32.
18 Lederer, "Anchor Baby."
19 De Genova and Peutz, *The Deportation Regime*, loc. 5924 of 9566, Kindle edition.
20 Loyd and Mountz, *Boats, Borders, and Bases*, loc. 685 of 7065, Kindle edition. "The deployment of a dichotomous migration discourse of rescue versus deterrence, good versus bad migrant, and bona fide versus bogus refugee is a well-rehearsed, racializing discourse long applied to people crossing borders. Such dichotomies of who deserves welcome and care versus who deserves punishment and exile animate differential inclusion and exclusionary migration practices."
21 Brigden, "Gender Mobility"; Vogt, "Crossing Mexico"; Coutin, "Being En Route"; Cleaveland and Kirsch, "They Took All My Clothes."
22 Coutin, "Being En Route"; Cleaveland and Kirsch, "They Took All My Clothes."
23 Massey et al., "Why Border Enforcement Backfired."
24 Massey et al., "Why Border Enforcement Backfired," 1564.
25 International Organization for Migration, "Latest Migrant Tragedy in Texas"; Missing Migrants Project, "4,530 Missing Migrants Recorded."
26 Rose and Peñaloza, "Migrant Deaths."
27 Vogt, "Crossing Mexico."
28 Riva, "Across the Border and Into the Cold."
29 Romero, "Crossing the Immigration and Race Border," 29.
30 Historian Alan Kraut coined the term, "medicalized nativism," to characterize the ways in which disease stigma is applied to certain immigrant groups based

on race and class. Early in the twentieth century, public health officials required Chinese migrants arriving at Angel Island to produce a stool sample, a procedure not usually required for Europeans at Ellis Island. Border officials subjected Mexican male laborers crossing the border in El Paso to a fumigation process in which they were doused in kerosene, while upper-class Mexicans crossing the border by train received no similar treatment. See Kraut, *Silent Travelers*; Markel and Stern, "The Foreignness of Germs."

31 Hennessy-Fiske, "Border Patrol's Largest Holding Area."
32 Riva, "Across the Border and Into the Cold."
33 8 U.S.C. § 1229c. Individuals who are ordered removed from the United States are not admissible to the United States for 5, 10, 20 years or permanently, depending on the reason for deportation. Reentry after deportation without authorization could result in federal criminal charges for illegal reentry as well as removal to the country of origin without the chance to see an immigration judge. However, those who accept voluntary departure are not subject to an automatic bar against legally returning to the United States in the future.
34 Bishop, *A Story to Save Your Life*, loc. 456 of 5760, Kindle edition.
35 Border Angels, "Bond Program."
36 Gilman and Romero, "Immigration Detention, Inc."
37 Cho, "More of the Same."
38 See 8 U.S.C. § 1225(b)(1)(A)(II). In some cases, individuals who reenter the United States after being removed, or those with criminal convictions, may be subject to a "reasonable fear" interview with an asylum officer, and must prove there is a "reasonable possibility" that she will be persecuted in her home country on the basis of one of the protected grounds. For more information about the credible fear interview, see American Immigration Council, *Asylum in the United States*.
39 US Immigration and Customs Enforcement, "Alternatives to Detention."
40 Sassen, *Expulsions*; Johnson, *Borders, Asylum and Global Non-Citizenship*.
41 Sassen, *Expulsions*, loc. 730 of 4834, Kindle edition.
42 Fitzgerald, *Refuge Beyond Reach*, loc. 133 of 9270, Kindle edition.
43 Fitzgerald, *Refuge Beyond Reach*, loc. 118 of 9270, Kindle edition.
44 Michalowski, "Border Militarization"; Heyman, "Constructing a Virtual Wall."
45 There have been several attempts to pass comprehensive immigration reform legislation in the 2000s. These bills generally include a legalization of the current unauthorized immigrant stock, updates to the family- and employment-based immigration laws, and additional enforcement mechanisms and resources. Several of these bills have been bipartisan, but Congress has failed to pass them into law. See S. 1033 Secure America and Orderly Immigration Act; S. 1348 Comprehensive Immigration Reform Act of 2007; S. 2454 Securing America's Borders Act. Also see Chishti et al., *Rethinking the U.S. Legal Immigration System*.
46 Migration Policy Institute, "U.S. Spends More on Immigration Enforcement." For a discussion of the dramatic escalation in funding for border enforcement, see

American Immigration Council, *Fact Sheet: The Cost of Immigration Enforcement and Border Security*.
47 Fernández-Kelly and Massey, "Borders for Whom?"
48 Meissner et al., *Immigration Enforcement in the United States*, 24.
49 Meissner et al., *Immigration Enforcement in the United States*, 18.
50 Meissner et al., *Immigration Enforcement in the United States*, 18.
51 Coutin, "Confined Within"; Capps et al., *Advances in U.S.-Mexico Border Enforcement*, 4.
52 Vogt, "Dirty Work, Dangerous Others."
53 Fitzgerald, *Refuge Beyond Reach*, loc. 161–180 of 9270, Kindle edition; Zolberg, "The Archaeology of 'Remote Control.'"
54 Fitzgerald, *Refuge Beyond Reach*, loc. 1495 of 9270, Kindle edition.
55 United States Holocaust Memory Museum, "Holocaust Encyclopedia: Voyage of the St. Louis."
56 Kerwin, "The Faltering US Refugee Protection System."
57 Abrego, "On Silences."
58 Obama, "Letter from the President."
59 For example, see White House, "Mexico and United States."
60 Rumbaut, "Pigments of Our Imagination."

CHAPTER 5. TRAUMA: SHARED MEANINGS AND HEALING
1 Staudt, *Violence and Activism at the Border*.
2 Staudt, *Violence and Activism at the Border*.
3 Trial International, "Children Born as a Result of Wartime Rape."
4 Amnesty International, "South Korea."
5 Amnesty International, "South Korea."
6 In his efforts to understand how trauma affects individuals and groups following disasters, sociologist Kai Erikson delineated individual and collective trauma, describing the former as "a blow . . . to the structures of the mind—that results in injury or some other disturbance. Something alien breaks in on you, smashing through whatever barriers your mind has set up as a line of defense. It invades you, possesses you, takes you over, becomes a dominating feature of your interior landscape, and in the process, threatens to drain you and leave you empty." By comparison, he defined collective trauma as that which destroys the tissues of social life that bind people together, leaving people without a community that would be a source of social support, shared culture, norms, routines, and memories. See Erickson, *A New Species of Trouble*, 29.
7 Kleinman, "The Violences of Everyday Life."
8 Massey, *For Space*, 99–103; Sassen, *Expulsions*, loc. 194–208 of 4834, Kindle edition.
9 Humphrey, "Citizen Insecurity in Latin American Cities."
10 Kleinman, *Writing at the Margin*, Kindle location 2259 of 4104.
11 Most women described relatively happy childhoods despite financial precarity. While we were mindful to refrain from asking about trauma beyond what was necessary to complete reports to the immigration court system in support of asylum claims, some women did disclose enduring incest and other forms

of mistreatment as children. Some also described the fracturing of families, as poverty forced one or both parents to migrate to the United States so they could send money home. Child abuse and family disruption did not drive their asylum claims, however. Their need for asylum came as a result of the violence described in chapters 2 and 3, traumatic experiences that were followed by degradation and mistreatment in the United States after crossing the border.

12 Jenkins, "The State Construction of Affect," 139. Studies of mental health among asylum seekers globally repeatedly cite detention, hostile reception, and post-migration issues such as difficulty in security jobs and housing as issues exacerbating symptoms in these populations. See Carswell et al., "The Relationship"; Crepet et al., "Mental Health and Trauma"; Taylor et al., "Loss, Grief, and Growth"; Wilson and Drozdek, *Broken Spirits*.
13 Alexander, *Trauma*.
14 Alexander, *Trauma*, 1.
15 Alexander, *Trauma*, 26.
16 Alexander, *Trauma*, 21.
17 Alexander, *Trauma*, 53.
18 Bartmanski and Eyerman, "The Worst Was the Silence."
19 Demertzis, "The Drama of the Greek Civil War Trauma."
20 Alexander, *Trauma*, 16.
21 Alexander, *Trauma*, 37.
22 Rui Gao argues that Mao Tse-Tung's Communist revolution turned the nation's narrative toward a class analysis, thus neglecting the work associated with creating a cultural trauma identifying the immense harms inflicted by Japan's army. See Gao, "Revolutionary Trauma."
23 Kleinman, *Writing at the Margin*, loc. 1203 of 4104, Kindle edition.
24 Alexander, *Trauma*, 15.
25 Kleinman, *Writing at the Margin*, loc. 2278–2282 of 4104, Kindle edition.
26 Menjívar, *Enduring Violence*.
27 Menjívar, *Enduring Violence*, loc. 2699 of 6134, Kindle edition.
28 Bourdieu, *Outline of A Theory of Practice*, 190–197; Menjívar, *Enduring Violence*, loc. 2030 of 6134, Kindle edition.
29 Bourdieu, "Social Space and Symbolic Power."
30 Menjívar, *Enduring Violence*, loc. 1260 of 6134, Kindle edition.
31 Menjívar, *Enduring Violence*, loc. 199 of 6134, Kindle edition.
32 Thapar-Björkert et al., "Exploring Symbolic Violence in the Everyday."
33 Alexander, *Trauma*, 35–39.
34 Alexander, *Trauma*, 15–30.
35 Alexander, *Trauma*, 17.
36 Alexander, *Trauma*, 65.
37 Alexander, *Trauma*, 66–67.
38 Alexander, *Trauma*, 65.
39 Scheper-Hughes, *Death Without Weeping*.

40 Scheper-Hughes, *Death Without Weeping*, loc. 3279 of 8966, Kindle edition.
41 Although Carol Cleaveland avoided asking women to detail traumatic experiences in favor of using sworn statements and/or affidavits, women often disclosed more details. In addition, to ensure a thorough report to the immigration judge, Cleaveland asked women if they needed to add anything to the statements provided by their attorneys.
42 To make sense of the next story presented here, we turn to the work of Nancy Scheper-Hughes, who developed the concept of everyday violence to speak to the invisible suffering endured by those in poverty and on society's margins, the deaths of infants, malnutrition, and routinized degradation that produce harms but are perpetuated by society's elites. See Scheper-Hughes, *Death Without Weeping*, loc. 3078–3863 of 8966, Kindle edition.
43 Scheper-Hughes and Bourgois, *Violence in War and Peace*, 1.
44 Gonzales and Chavez, "Awakening to a Nightmare."
45 Meffert et al., "The Role of Mental Health Professionals," 479; Memon, "Credibility of Asylum Claims."
46 Van der Kolk, "Trauma and Memory"; Van der Kolk, "The Body Keeps the Score."
47 Kleinman and Desjarlais, "Violence, Culture, and the Politics of Trauma."
48 Kleinman and Desjarlais, "Violence, Culture, and the Politics of Trauma," loc. 2278 of 4104, Kindle edition.
49 8 U.S.C. § 1254a. The Secretary of Homeland Security may designate a foreign country for TPS due to conditions in the country (such as armed conflict, environmental disaster, or other extraordinary and temporary conditions) that temporarily prevent the country's nationals from returning safely or where a country of origin is temporarily unable to handle the return of its nationals. Deferred Enforced Departure (DED) is similar, but derives from the president's foreign policy authority rather than statute. Individuals from designated countries who are already in the United States who are granted TPS are not removable and may obtain employment authorization. See US Citizenship and Immigration Services, "Temporary Protected Status."
50 Aleaziz, "Americans Still Support Asylum."
51 Aleaziz, "Americans Still Support Asylum."
52 Alexander, *Trauma*.
53 Alexander, *Trauma*, 121.
54 Harris et al., "Vicarious Trauma," 25. Also see Harris and Mellinger, "Asylum Attorney Burnout"; Lustig et al., "Inside the Judges' Chambers."
55 Barak, *The Slow Violence of Immigration Court*, 2.
56 Bourdieu, *Outline of A Theory of Practice*, 190–197; Farmer, "An Anthropology of Structural Violence."
57 760 F. Supp. 796 (N.D. Cal. 1991).
58 US Citizenship and Immigration Services, "American Baptist Churches v. Thornburgh (ABC) Settlement Agreement."
59 Coutin, "Borders and Crossings."

60 Coutin, "Borders and Crossings," loc. 878 of 15617, Kindle edition.
61 Pub. L. 105–100, Title II.

CHAPTER 6. "IF I OFFENDED YOUR COUNTRY, I'M SORRY."

1. Ethnographic accounts of court hearings are included here. In some cases, the proceedings unfolded too quickly to be sure about the accuracy of quotes. In those cases, we do not use quotation marks in presenting the ethnographic data.
2. Menjívar and Abrego, "Legal Violence"; Barak, *The Slow Violence of Immigration Court*; Menjívar, "Liminal Legality."
3. Heyman et al., "Bordering a 'Crisis'"; Torres, "A Crisis of Rights and Responsibility."
4. Zylinska, "The Universal Acts."
5. Zylinska, "The Universal Acts."
6. Zylinska, "The Universal Acts," 526.
7. Hamlin, *Crossing*.
8. Bourdieu, *Distinction*, 163–165.
9. Gonzales and Chavez, "Awakening to a Nightmare"; Menjívar and Abrego, "Legal Violence"; Barak, *The Slow Violence of Immigration Court*; Menjívar, "Liminal Legality."
10. Gonzales and Chavez, "Awakening to a Nightmare"; Menjívar and Abrego, "Legal Violence."
11. Barak, *The Slow Violence of Immigration Court*, 153
12. Gonzales and Chavez, "Awakening to a Nightmare."
13. Menjívar and Abrego, "Legal Violence."
14. Menjívar and Abrego, "Legal Violence."
15. Menjívar and Abrego, "Legal Violence"; Menjívar, "Liminal Legality."
16. Bourdieu, *Distinction*.
17. Bourdieu, *Distinction*.
18. Menjívar and Kanstroom, introduction to *Constructing Immigrant "Illegality"*.
19. Gonzales and Chavez, "Awakening to a Nightmare."
20. Gonzales and Chavez, 257.
21. Gonzales and Chavez, "Awakening to a Nightmare."
22. US Department of Homeland Security/ US Citizenship and Immigration Services, "I-589 Application for Asylum and Withholding of Removal Form."
23. Immigration Courts are part of the Executive Office for Immigration Review (EOIR), which is housed under the Department of Justice (DOJ).
24. Stumpf, "The Crimmigration Crisis."
25. American Immigration Council, *Two Systems of Justice*.
26. Transactional Records Access Clearinghouse, *Historical Immigration Court Backlog Tool*.
27. Transactional Records Access Clearinghouse, *Historical Immigration Court Backlog Tool*.
28. Transactional Records Access Clearinghouse, *Immigration Court Asylum Backlog*.

NOTES | 237

29 Transactional Records Access Clearinghouse, *Historical Immigration Court Backlog Tool.*
30 Transactional Records Access Clearinghouse, *Immigration Court Asylum Backlog.*
31 Haggerty, "Haggerty, Tillis, and Colleagues."
32 Barak, *The Slow Violence of Immigration Court*, 78.
33 Eagly and Shafer, "A National Study."
34 Eagly and Shafer, "A National Study."
35 American Immigration Council, *Two Systems of Justice.*
36 Levinson et al., "Special Report."
37 Levinson et al., "Special Report."
38 Levinson et al., "Special Report."
39 Transactional Records Access Clearinghouse, *Speeding Up the Asylum Process.*
40 The issue of missed hearings has become fodder for conservative politicians who have tried to argue that asylum seekers strategically skip them to remain in the United States without authorization. Former Vice President Mike Pence erroneously claimed that 90 percent of people miss asylum hearings, an assertion that was found to be false when fact-checked by the *Washington Post.* In their analysis, the *Post* stated that 6–11 percent of asylum seekers miss hearings. See Rizzo, "How Many Migrants Show Up."
41 Waslin, "The Impact of Immigration Enforcement Outsourcing." Also see Cox and Rodríguez, *The President and Immigration Law.*
42 Gonzales and Chavez, "Awakening to a Nightmare."
43 The courtroom scenes are from fieldnotes taken during ethnographic observation.
44 Attorneys shared twenty redacted legal decisions for clients whom they had represented in court. We coded these using the same approach described for interviews as they helped support our understanding of how judges weighed evidence in asylum cases. We noted that there is a great deal of variation in terms of quality and quantity of information provided by the judges. Generally, they discuss whether the asylum applicant has met all five of the criteria for asylum outlined in chapter 1 and whether the applicant was credible, and then provide their decision. We noted that the decisions typically began with the asylum seeker's stated reasons for needing protection, followed by an assessment of her credibility during testimony and any corroboration of her story. Attorneys told us they asked their clients to obtain police records (if any were available, and often they were not because of the law enforcement fears described above), medical records, and statements from any potential witnesses of the violence they endured. Judges then wrote to whether respondents, as asylum seekers are called in hearings, met the benchmark for having applied for asylum within one year of arriving on US soil. Then judges write to the standards for asylum, including defining terms such as persecution and noting the fact that past persecution can be evidence of future persecution for a woman returned to her home country. The judge then writes to whether she is a member of a well-defined particular social group, and if the harm she suffered was a result of this group membership.

45 We are not stating the indigenous language to protect the woman's identity, as the language in question is not common.
46 Barak, "Can You Hear Me Now?"
47 Barak, "Can You Hear Me Now?"

CONCLUSION

1 Coutin, *Legalizing Moves*; Menjívar, "Liminal Legality."
2 Wasem, "More than a Wall."
3 Fitzgerald, *Refuge Beyond Reach*, loc. 2, 119 and 151 of 9270, Kindle edition.
4 Hamlin, *Crossing*; Nayak, *Who Is Worthy of Protection?*
5 Nayak, *Who Is Worthy of Protection?*, loc. 147 of 6700, Kindle edition.
6 UN Refugee Agency, "Figures at a Glance 2020."
7 Menjívar and Drysdale Walsh, "Gender-based Violence in Central America"; Bookey, "Gender-Based Asylum Post-*Matter of A-R-C-G*"; Wald, "Does *Matter of A-R-C-G-* Matter That Much."
8 Farmer, "An Anthropology of Structural Violence"; Bourdieu, *Outline of A Theory of Practice*, 171–183; Bourdieu, *Masculine Domination*, 2.
9 Bourdieu, *Distinction*, 105.
10 Skeggs, *Formations*, 93.
11 Menjívar, *Enduring Violence*.
12 Bourdieu, *Masculine Domination*, 2.
13 Lumsden and Morgan, "Media Framing."
14 Menjívar, "Liminal Legality."
15 Menjívar "Liminal Legality," 1006.
16 Chavez, "The Condition of Illegality"; De Genova, "Migrant 'Illegality.'"
17 There exists robust and extensive scholarship and trauma symptoms and their potential to persist, especially without treatment. Some studies suggest healing can occur after successful placement as asylees or refugees. Hostile reception has been found to impede recovery from trauma. See Chan et al., "Well-Being After Trauma," 291; Marshall et al., "Mental Health of Cambodian Refugees"; Carswell et al., "The Relationship"; Sangalang et al., "Trauma, Post-Migration Stress, and Mental Health."
18 Nayak, *Who Is Worthy of Protection?*, loc. 1322 of 6700, Kindle edition.
19 Menjívar and Abrego, "Legal Violence."
20 American Immigration Council, *Beyond a Border Solution*, 45.
21 For an example of the impact on children left behind by migrant parents, see Dreby, "Children and Power."
22 As discussed in chapter 1, there are multiple forms of prosecutorial discretion, including administration closure, which effectively puts the case on hold, the asylum application remains pending, and the woman can continue to renew work authorization. A dismissal means the government has chosen not to prosecute the case and the removal order is no longer in effect, but because there is no pending asylum application, the respondent is no longer eligible for work authorization.

If they choose to file for affirmative asylum, a new asylum application would be opened and they would be eligible for work authorization until the affirmative case is heard by the asylum officer. However, long backlogs mean the woman will wait several more years for an asylum interview.
23 US Citizenship and Immigration Services, "Benefits and Responsibilities of Asylees."
24 US Department of Health and Human Services, Administration for Children and Families, Office of Refugee Resettlement, *Benefits and Services*.
25 8 C.F.R. § 209.2.
26 As of the time of writing, processing times for asylees to adjust status were forty months. See US Citizenship and Immigration Services, "Check Case Processing Times."
27 Legal Permanent Residents (LPR) may petition to sponsor spouses, minor children, and unmarried adult sons and daughters for legal permanent residence. Typically, LPRS can apply for naturalization five years after receiving LPR status; however, once an asylee is granted adjustment to permanent residence, the date of admission is given as one year before the date of approval of the adjustment of status, effectively reducing the wait to four years [see 8 C.F.R. § 209.2(f)]. As a US citizen, they may petition for parents, spouses, married and unmarried children, and siblings, travel internationally without restrictions, obtain certain jobs reserved for US citizens, and vote.
28 See US Citizenship and Immigration Services, "I-730 Refugee/Asylee Relative Petition"; Brown and Wheeler, "Immigrating the Spouse and Children."
29 See US Citizenship and Immigration Services, "Check Case Processing Times."
30 28 U.S.C. § 1361. Also see Transactional Records Access Clearinghouse, *Immigration Processing Delays*. They are projecting 7,000 mandamus suits in FY 2023 representing 68.5 percent of all immigration lawsuits filed in federal court. This is an increase from 2,719 mandamus lawsuits in FY 2021 and only 505 in FY 2008.
31 The question of chronic PTSD symptoms is complex and is a focus of ongoing research. Some studies argue that PTSD symptom chronicity depends on numerous mediating factors, including whether the survivor of violence as an adult suffered trauma in childhood, severity of the traumatic experience, as well as psychosocial factors such as poverty. See Breslau, "Outcomes of Posttraumatic Stress Disorder"; Felitti et al., "Relationship of Childhood Abuse"; Felmingham et al., "Duration of Posttraumatic Stress Disorder"; Kaysen et al., "Duration of Exposure."
32 Chantler, "Gender, Asylum Seekers"; Robinson, "Voices from the Front Line"; Briskman and Cemlyn, "Reclaiming Humanity."
33 Specht and Courtney, *Unfaithful Angels*; Strom and Gingerich, "Educating Students."
34 National Association of Social Workers, "Code of Ethics of the National Association of Social Workers."
35 Singer et al., *Immigrants, Politics*.
36 Singer et al., *Immigrants, Politics*.

37 Potocky and Naseh, *Best Practices*; Barber-Rioja et al., *Mental Health Evaluations*.
38 US Department of Homeland Security, *Fact Sheet*.
39 US Department of State, "Secretary Antony J. Blinken."
40 US Department of State, "Secretary Antony J. Blinken."
41 Rascoe and Benk, "1,500 Service Members."
42 Montoya-Galvez, "Migrant Crossings"; Asencio et al., "Refugee Protection Travesty."
43 US Citizenship and Immigration Services, Department of Homeland Security; Executive Office for Immigration Review, Department of Justice, "Circumvention of Lawful Pathways."
44 Kocher, "Glitches in the Digitization of Asylum"; Asencio et al., "Refugee Protection Travesty," 10–19.
45 American Civil Liberties Union, Center for Gender & Refugee Studies, and the National Immigrant Justice Center, *Complaint-East Bay Sanctuary Covenant v. Biden*.
46 For example, see Chatham, "Border Doomsday"; American Immigration Council, *State Department and DHS*.
47 National Immigrant Justice Center: A Heartland Alliance Program, "NIJC Condemns the Biden Administration's Asylum Ban."
48 US Department of State, "Secretary Antony J. Blinken," 8:10.
49 US Department of State, "Secretary Antony J. Blinken," 22:53.
50 As discussed in chapter 1, in 2001, when Attorney General Janet Reno reversed the BIA decision in *Matter of R-A-*, she remanded the case to the BIA for reconsideration, stipulating that new regulations should also be adopted to clarify the process for survivors of domestic violence. These regulations have never been finalized.
51 American Immigration Lawyers Association, "Featured Issue."
52 Refugee Protection Act of 2022, H.R. 9685, 117th Congress, 2nd Sess.; Schacher, "Refugee Protection Act of 2022."
53 When they were prosecuted, adults were detained and children were taken into the custody of the US Department of Health and Human Services, thus separating them from their parents. Some families have still not been reunited. Hesson, "Close to 1,000 Migrant Children Separated."
54 Refugee Protection Act of 2022, H.R. 9685, 117th Congress, 2nd Sess., Section 1101.
55 Refugee Protection Act of 2022, H.R. 9685, 117th Congress, 2nd Sess., Section 1101.
56 Refugee Protection Act of 2022, H.R. 9685, 117th Congress, 2nd Sess., Section 1105.
57 In July 2023, the Biden administration announced a family reunification parole program to allow certain people from Colombia, El Salvador, Guatemala, and Honduras who are in family reunification backlogs to enter the United States as they wait for their chance to apply for lawful permanent residence. While limited in scope, this policy acknowledges that people who have lawful means to immigrate to the United States might still choose to come extra-legally due to lengthy

backlogs. See US Department of Homeland Security, "DHS Announces Family Reunification."
58 International Organization for Migration, "Latest Migrant Tragedy in Texas."
59 Sassen, *Expulsions*, loc. 53 and 89 of 4834, Kindle edition.
60 Fitzgerald, *Refuge Beyond Reach*, loc. 208 of 9270, Kindle edition.

APPENDIX

1 Willen, "Toward a Critical Phenomenology of 'Illegality.'"
2 Willen, "Toward a Critical Phenomenology of 'Illegality.'"
3 Willen, "Toward a Critical Phenomenology of 'Illegality,'" 10.
4 Desjarlais, *Shelter Blues*, 25.
5 Schutz, *The Phenomenology of the Social*; Gurwitsch, *Phenomenology*.
6 Overgaard and Zahavi, "Phenomenological Sociology."
7 Guenther, "Critical Phenomenology," loc. 412 of 10,433, Kindle edition.
8 Guenther, "Critical Phenomenology," loc. 39 of 10,433, Kindle edition.
9 Desjarlais, *Shelter Blues*; Bourgois and Schonberg, *Righteous Dopefiend*; Opalinski, "Pouring Rights Contracts."
10 Kinkaid, "Re-Encountering Lefebvre."
11 Desjarlais, *Shelter Blues*, 24.
12 Desjarlais, *Shelter Blues*; Katz and Csordas, "Phenomenal Ethnography"; Woodward, "Hanging Out and Hanging About."
13 Desjarlais, *Shelter Blues*, 25–27.
14 Carol Cleaveland, who has 20 years' experience as a practicing social worker, conducted the psychosocial assessments and all interviews with asylum seekers for this project.
15 Villiers Negroponte, "The Surge in Unaccompanied from Central America."
16 US Customs and Border Protection, "Southwest Border Unaccompanied Alien Children FY 2014."
17 Bay Area Asylum Mental Health Project, "PTSD Checklist for DSM-5 (PCL-5) Spanish."
18 Bay Area Asylum Mental Health Project, "PTSD Checklist for DSM-5 (PCL-5) Spanish."
19 Grégoire et al., "The Impact of Trauma Exposure."
20 Cartwright et al., "Vicarious Trauma."
21 Skeggs, "Feminist Ethnography," 426.
22 Skeggs, "Feminist Ethnography," 426.
23 Skeggs, "Feminist Ethnography," 426.
24 Gill and Hynes, "Courtwatching."
25 Boltanski, *Distant Suffering*, 43.
26 Boyatzis, *Transforming Qualitative Information*.
27 Boyatzis, *Transforming Qualitative Information*.
28 Campbell et al., "Coding In-depth Semistructured Interviews."
29 Forsyth et al., "Methods for Translating."

BIBLIOGRAPHY

Abrego, Leisy J. "On Silences: Salvadoran Refugees Then and Now." *Latino Studies* 15, no. 1 (April 2017): 73–85. https://doi.org/10.1057/s41276-017-0q044-4.

Abrego, Leisy J. and Ester Hernández. "#FamiliesBelongTogether: Central American Family Separations from the 1980s to 2019." In *Critical Dialogues in Latinx Studies: A Reader*, edited by Ana Y. Ramos-Zayas, and Mérida M. Rúa, Loc. 4412–4802 of 15,617. New York: New York University Press, 2021. Kindle edition.

Adelman, Madelaine. "The Military, Militarism, and the Militarization of Domestic Violence." *Violence Against Women* 9, no. 9 (September 2003): 1118–1152. https://doi.org/10.1177/1077801203255292.

Aleaziz, Hamed. "Americans Still Support Asylum for Immigrants Fleeing Persecution, Poll Finds." *Los Angeles Times*, December 16, 2022. www.latimes.com.

Aleaziz, Hamed. "Here's How a Border Deal Could Affect People Seeking Asylum in the U.S." *New York Times*, Dec. 15, 2023. www.nytimes.com.

Alexander, Jeffrey C. *Trauma: A Social Theory*. Cambridge: Polity Press, 2012.

Alfaro, Claudia Fonseca. "Feminist Lefebvre? Understanding Urbanization Through the Global Intimate." *ACME: An International Journal for Critical Geographies* 20, no. 4 (August 2021): 366–386. https://acme-journal.org.

Alvarez, Linda. "No Safe Space: Neoliberalism and the Production of Violence in the Lives of Central American Migrants." *Journal of Race, Ethnicity, and Politics* 5, no. 1 (March 2020): 4–36. https://doi.org/10.1017/rep.2019.23.

American Civil Liberties Union, Center for Gender & Refugee Studies, and the National Immigrant Justice Center. *Complaint-East Bay Sanctuary Covenant v. Biden: Case no. 18-cv-06810-JST*. May 11, 2023. www.aclu.org.

American Immigration Council. *Asylum in the United States*. August 2022. www.americanimmigrationcouncil.org.

American Immigration Council. *Beyond a Border Solution: How to Build a Humanitarian Protection System That Won't Break*. May 3, 2023. www.americanimmigrationcouncil.org.

American Immigration Council. *Fact Sheet: The Cost of Immigration Enforcement and Border Security*. January 20, 2021. www.americanimmigrationcouncil.org.

American Immigration Council. *Fact Sheet: The "Migrant Protection Protocols."* January 7, 2022. www.americanimmigrationcouncil.org.

American Immigration Council. *Metering and Asylum Turnbacks*. March 8, 2021. www.americanimmigrationcouncil.org.

American Immigration Council. *State Department and DHS Show Welcome Commitment to Addressing Hemisphere-Wide Refugee Crisis*. April 27, 2023. www.americanimmigrationcouncil.org.

American Immigration Council. *Two Systems of Justice: How the Immigration System Falls Short of American Ideals of Justice*. March 2013. www.americanimmigrationcouncil.org.

American Immigration Lawyers Association. "Featured Issue: America Needs a Fair and Independent Immigration Court: AILA Urges Congress to Create an Independent Immigration Court." March 24, 2023. www.aila.org.

American Presidency Project. "Harry S. Truman, Statement and Directive by the President on Immigration to the United States of Certain Displaced Persons and Refugees in Europe, December 22, 1945." www.presidency.ucsb.edu. Accessed March 24, 2023.

Americas Program. "Status of Violence Against Women in Honduras." July 15, 2014. www.americas.org.

Amnesty International. "South Korea: Disappointing Japan Ruling Fails to Deliver Justice to 'Comfort Women.'" April 21, 2021. www.amnesty.org.

Arana, Ana. "How the Street Gangs Took Central America." *Foreign Affairs* 84, no. 3 (May/June 2005): 98–110. https://doi.org/10.2307/20034353.

Arias, Enrique Desmond and Daniel M. Goldstein. *Violent Democracies in Latin America*. Durham, NC: Duke University Press, 2010.

Asencio, Christina, Eleanor Acer, and Rebecca Gendelman. "Refugee Protection Travesty." Human Rights First. July 12, 2023. https://humanrightsfirst.org.

Atkinson, Will. "The Social Space, the Symbolic Space and Masculine Domination: The Gendered Correspondence Between Class and Lifestyles in the UK." *European Societies* 20, no. 3 (July 2018): 478–502. https://doi.org/10.1080/14616696.2017.1371319.

Balgamwalla, Sabrina. "Bride and Prejudice: How U.S. Immigration Law Discriminates Against Spousal Visa Holders." *Berkeley Journal of Gender Law & Justice* 29, no. 1 (Winter 2014): 25–71.

Barak, Maya Pagni. "Can You Hear Me Now? Attorney Perceptions of Interpretation, Technology, and Power in Immigration Court." *Journal on Migration and Human Security* 9, no. 4 (December 2021): 207–223. https://journals.sagepub.com/doi/10.1177/23315024211034740

Barak, Maya Pagni. *The Slow Violence of Immigration Court*. New York: New York Publishing Press, 2023.

Barber-Rioja, Virginia, Adeyinka M. Akinsulure-Smith, and Sarah Vendzules. *Mental Health Evaluations in Immigration Court: A Guide for Mental Health and Legal Professionals*. New York: New York University Press, 2022.

Barreno, Barbara R. "In Search of Guidance: An Examination of Past, Present, and Future Adjudications of Domestic Violence Asylum Claims." *Vanderbilt Law Review* 64, no. 1 (January 2011): 225–269.

Bartmanski, Dominik and Ron Eyerman. "'The Worst Was the Silence': The Unfinished Drama of the Katyn Massacre." In *Narrating Trauma on the Impact of Collective Suffering*, edited by Ron Eyerman, Jeffrey C. Alexander, and Elizabeth Butler Breese, 237–266. New York: Routledge, 2015.

Baugh, Ryan. *Refugees and Asylees: 2021*. Office of Immigration Statistics. September 2022. www.dhs.gov. Figure 5.

Bay Area Asylum Mental Health Project. "PTSD Checklist for DSM-5 (PCL-5) Spanish." May 10, 2019. https://riww.org.

Beitsch, Rebecca and Rafael Bernal. "Biden Embraces Trump's Title 42 with Expansion to Venezuela." *The Hill*. October 18, 2022. https://thehill.com.

Biden Jr., Joseph R. "Executive Order on Creating a Comprehensive Regional Framework to Address the Causes of Migration, to Manage Migration Throughout North and Central America, and to Provide Safe and Orderly Processing of Asylum Seekers at the United States Border." The White House. February 2, 2021. www.whitehouse.gov.

Bishop, Sarah. *A Story to Save Your Life: Communication and Culture in Migrants' Search for Asylum*. New York: Columbia University Press, 2022. Kindle edition.

Blacklock, Cathy and Alison Crosby. "The Sounds of Silence: Feminist Research Across Time in Guatemala." In *Sites of Violence: Gender and Conflict Zones*, edited by Wenona Giles and Jennifer Hyndman, 45–72. Berkeley: University of California Press, 2004.

Blume, Laura, Diana Meza, and Piper Health. "Honduran Women Leaders in the Crosshairs." *NACLA Report on the Americas*. January 31, 2023. https://nacla.org.

Boltanski, Luc. *Distant Suffering: Morality, Media and Politics*. Translated by Graham Burchell. Cambridge: Cambridge University Press, 1999.

Bolter, Jessica, Emma Israel, and Sara Pierce. *Four Years of Profound Change: Immigration Policy During the Trump Presidency*. Washington, DC: Migration Policy Institute, 2022. www.migrationpolicy.org.

Bookey, Blaine. "Domestic Violence as a Basis for Asylum: An Analysis of 206 Case Outcomes in the United States from 1994 to 2012." *Hastings Women's Law Journal* 24, no. 1 (Winter 2013): 107–148. https://repository.uchastings.edu.

Bookey, Blaine. "Gender-Based Asylum Post-*Matter of A-R-C-G*-: Evolving Standards and Fair Application of the Law." *Southwest Journal of International Law* 22, no. 182 (September 2016): 1–19. https://ssrn.com.

Border Angels. "Bond Program: Familias Reunidas Bond Program." www.borderangels.org. Accessed June 23, 2023.

Bourdieu, Pierre. *Distinction: A Social Critique of the Judgment of Taste*. Cambridge, MA: Harvard University Press, 1984.

Bourdieu, Pierre. "Gender and Symbolic Violence." In *Violence in War and Peace: An Anthology*, edited by Nancy Scheper-Hughes and Philippe Bourgois, 339–342. Malden, MA: Blackwell Publishing, 2003.

Bourdieu, Pierre. *Masculine Domination*. Translated by Richard Nice. Stanford, CA: Stanford University Press, 2001.

Bourdieu, Pierre. *Outline of A Theory of Practice*. Cambridge, MA: Cambridge University Press, 1977.

Bourdieu, Pierre. *Pascalian Meditations*. Translated by Richard Nice. Stanford, CA: Stanford University Press, 2000.

Bourdieu, Pierre. "Social Space and Symbolic Power." *Sociological Theory* 7, no. 1 (Spring 1989): 14–25. http://dx.doi.org/10.2307/202060.

Bourdieu, Pierre. "The Forms of Capital." In *Handbook of Theory and Research Sociology of Education*, edited by John G. Richardson, 241–258. New York: Greenwood Press, 1986.

Bourdieu, Pierre and Loïc Wacquant. *An Invitation to Reflexive Sociology*. Chicago: University of Chicago Press, 1992.

Bourdieu, Pierre and Loïc Wacquant. "Symbolic Capital and Social Classes." *Journal of Classical Sociology* 13, no. 2 (May 2013): 292–302. https://doi.org/10.1177/1468795X12468736.

Bourgois, Philippe and Jeff Schonberg. *Righteous Dopefiend*. Berkeley: University of California Press, 2009.

Boyatzis, Richard E. *Transforming Qualitative Information: Thematic Analysis and Code Development*. Thousand Oaks, CA: SAGE, 1998.

Breslau, Naomi. "Outcomes of Posttraumatic Stress Disorder." *Journal of Clinical Psychiatry* 62, suppl. 17 (2001): 55–59. www.psychiatrist.com.

Brigden, Noelle K. "Gender Mobility: Survival Plays and Performing Central American Migration in Passage." *Mobilities* 13, no. 1 (March 2017): 111–125. https://doi.org/10.1080/17450101.2017.1292056.

Brigden, Noelle K. *The Migrant Passage: Clandestine Journeys from Central America*. Ithaca, NY: Cornell University Press, 2018. Kindle edition.

Briskman, Linda and Sarah Cemlyn. "Reclaiming Humanity for Asylum-Seekers: A Social Work Response." *International Social Work* 48, no. 6 (November 2005): 714–724. https://doi.org/10.1177/0020872805056989.

Brown, Anastasia and Charles Wheeler. "Immigrating the Spouse and Children of Refugees Asylees." United States Conference of Catholic Bishops. www.usccb.org.

Bruneau, Thomas, Lucía Dammert, and Elizabeth Skinner. *Maras: Gang Violence and Security in Central America*. Austin: University of Texas Press, 2011.

Calavita, Kitty. "Immigration, Law, and Marginalization in a Global Economy: Notes from Spain." *Law & Society Review* 32, no. 3 (1998): 529–566. https://doi.org/10.2307/827756.

Calavita, Kitty and Valerie Jenness. "Inside the Pyramid of Disputes: Naming Problems and Filing Grievances in California Prisons." *Social Problems* 60, no. 1 (February 2013): 50–80. https://doi.org/10.1525/sp.2013.60.1.50.

Calvo, Janet M. "A Decade of Spouse-Based Immigration Laws: Coverture's Diminishment, but Not Its Demise." *Northern Illinois University Law Review* 24, no. 2 (Spring 2004): 153–210.

Calvo, Janet M. "Spouse-Based Immigration Laws: The Legacies of Coverture." *San Diego Law Review* 28 (1991): 593–644. https://digital.sandiego.edu.

Campbell, John L., Charles Quincy, Jordan Osserman, and Ove K. Pedersen. "Coding In-depth Semistructured Interviews: Problems of Unitization and Intercoder Reliability and Agreement." *Sociological Methods & Research* 42, no. 3 (August 2013): 294–320. https://doi.org/10.1177/0049124113500475.

Capps, Randy, Faye Hipsman, and Doris Meissner. *Advances in U.S.-Mexico Border Enforcement: A Review of the Consequence Delivery System*. Washington, DC: Migration Policy Institute, 2017. www.migrationpolicy.org.

Caputo-Levine, Deirdre D. "The Yard Face: The Contributions of Inmate Interpersonal Violence to the Carceral Habitus." *Ethnography* 14, no. 2 (June 2013): 165–185. https://doi.org/10.1177/1466138112457299.

Carey Jr., David and M. Gabriela Torres. "Precursors to Femicide: Guatemalan Women in a Vortex of Violence." *Latin American Research Review* 45, no. 3 (2010): 142–164. https://doi.org/10.1017/S0023879100011146.

Carswell, Kenneth, Pennie Blackburn, and Chris Barker. "The Relationship Between Trauma, Post-Migration Problems and the Psychological Well-Being of Refugees and Asylum Seekers." *International Journal of Social Psychiatry* 57, no. 2 (March 2011): 107–119. https://doi.org/10.1177/0020764009105699.

Cartwright, Hannah C., Lindsay M. Harris, Liana M. Montecinos, and Anam Rahman. "Vicarious Trauma and Ethical Obligations for Attorneys Representing Immigrant Clients: A Call to Build Resilience Among the Immigration Bar." *AILA Law Journal* 2, no. 1 (April 2020): 23–40. https://digitalcommons.law.udc.edu.

Castañeda Salgado, Martha Patricia. "Feminicide in Mexico: An Approach Through Academic, Activist and Artistic Work." *Current Sociology* 64, no. 7 (November 2016): 1054–1070. https://doi.org/10.1177/0011392116637894.

Center for Gender & Refugee Studies. *Asylum: Frequently Asked Questions*. https://cgrs.uchastings.edu. Accessed March 24, 2023.

Center for Gender & Refugee Studies. "Central America: Femicides and Gender-Based Violence." https://cgrs.uchastings.edu. Accessed May 17, 2023.

Center for Gender & Refugee Studies. "*Matter of L-R-*." https://cgrs.uchastings.edu. Accessed April 3, 2023.

Center for Gender & Refugee Studies. "*Matter of R-A-*." https://cgrs.uchastings.edu. Accessed May 21, 2023.

Chacón, Jennifer and Susan Bibler Coutin. "Racialization Through Enforcement." In *Race, Criminal Justice, and Migration Control: Enforcing the Boundaries of Belonging*, edited by Mary Bosworth, Alpa Parmar, and Yolanda Vázquez, 159–175. Oxford: Oxford University Press, 2018.

Chan, K. Jacky, Marta Y. Young, and Noor Sharif. "Well-Being After Trauma: A Review of Posttraumatic Growth Among Refugees." *Canadian Psychology/Psychologie Canadienne* 57, no. 4 (November 2016): 291–299. https://doi.org/10.1037/cap0000065.

Chantler, Khatidja. "Gender, Asylum Seekers and Mental Distress: Challenges for Mental Health Social Work." *British Journal of Social Work* 42, no. 2 (March 2012): 318–334. https://doi.org/10.1093/bjsw/bcr062.

Chatham, Joe. "Border Doomsday: Ten Days Until the End of Title 42." Federation for American Immigration Reform. May 1, 2023. www.fairus.org.

Chavez, Leo R. "A Glass Half Empty: Latina Reproduction and Public Discourse." *Human Organization* 63, no. 2 (Summer 2004): 173–188. https://doi.org/10.17730/humo.63.2.hmk4momfey10n51k.

Chavez, Leo R. "The Condition of Illegality." *International Migration* 45, no. 3 (2007): 192–196. https://doi.org/10.1111/j.1468-2435.2007.00416.x

Chavez, Leo R. *The Latino Threat: Constructing Immigrants, Citizens, and the Nation.* Stanford, CA: Stanford University Press, 2008.

Chishti, Muzaffar, Julia Gelatt, and Doris Meissner. *Rethinking the U.S. Legal Immigration System: A Policy Road Map.* Washington, DC: Migration Policy Institute, 2021. www.migrationpolicy.org.

Cho, Eunice. "More of the Same: Private Prison Corporations and Immigration Detention Under the Biden Administration." ACLU. October 5, 2021. www.aclu.org.

Cleaveland, Carol. "How the Immigration and Deportation Systems Work: A Social Worker's Guide." *Journal of Sociology and Social Welfare* 44, no. 3 (September 2017): 55–73. https://doi.org/10.15453/0191-5096.3880.

Cleaveland, Carol and Vicki Kirsch. "'They Took All My Clothes and Made Me Walk Naked for Two Days So I Couldn't Escape': Latina Immigrant Experiences of Human Smuggling in Mexico." *Qualitative Social Work* 19, no. 2 (March 2020): 213–228. https://doi.org/10.1177/1473325018816362.

Colbert, Victoria. "Murder and Machismo: Behind the Motivations of Salvadoran Women Asylum Seekers." Master's thesis, University of San Francisco, 2019. 1–89. https://repository.usfca.edu/thes/1194.

Correa-Cabrera, Guadalupe. "Mexico's Economic Dilemmas and Democratic Challenges in an Era of Reform." *Latin American Politics and Society* 54, no. 4 (Winter 2012): 179–188. https://doi.org/10.1111/j.1548-2456.2012.00177.x.

Correa-Cabrera, Guadalupe. "Security, Migration, and the Economy in the Texas-Tamaulipas Border Region: The 'Real' Effects of Mexico's Drug War." *Politics & Policy* 41, no. 1 (February 2013): 65–82. https://doi.org/10.1111/polp.12005.

Coutin, Susan Bibler. "Being En Route." *American Anthropologist* 107, no. 2 (June 2005): 195–206. https://doi.org/10.1525/aa.2005.107.2.195.

Coutin, Susan Bibler. "Borders and Crossings: Lessons of the 1980s Central American Solidarity Movement for 2010s Sanctuary Practices." In *Critical Dialogues in Latinx Studies: A Reader*, edited by Ana Y. Ramos-Zayas and Mérida M. Rúa. Loc. 862 of 15617. New York: New York University Press, 2021.

Coutin, Susan Bibler. "Confined Within: National Territories as Zones of Confinement." *Political Geography* 29, no. 4 (May 2010): 200–208. https://doi.org/10.1016/j.polgeo.2010.03.005.

Coutin, Susan Bibler. "Contesting Criminality: Illegal Immigration and the Spatialization of Legality." *Theoretical Criminology* 9, no. 1 (February 2005): 5–33. https://doi.org/10.1177/1362480605046658.

Coutin, Susan Bibler. "Falling Outside: Excavating the History of Central American Asylum Seekers." *Law & Social Inquiry* 36, no. 3 (Summer 2011): 569–596. https://doi.org/10.1111/j.1747-4469.2011.01243.x.

Coutin, Susan Bibler. *Legalizing Moves: Salvadoran Immigrants' Struggle for U.S. Residency.* Ann Arbor: University of Michigan Press, 2003.

Coutin, Susan Bibler. "Smugglers or Samaritans in Tucson, Arizona: Producing and Contesting Legal Truth." *American Ethnologist* 22, no. 3 (August 1995): 549–571. https://doi.org/10.1525/ae.1995.22.3.02a00050.

Coutin, Susan Bibler. "The Rights of Noncitizens in the United States." *Annual Review of Law and Social Science* 7 (December 2011): 289–308. https://doi.org/10.1146/annurev-lawsocsci-102510-105525.

Coven, Phyllis. "Considerations for Asylum Officers." Phyllis Coven to All INS Asylum Officers. Memorandum. U.S. Immigration and Naturalization Services, Office of International Affairs. May 26, 1995. https://2009-2017.state.gov.

Cox, Adam B. and Cristina M. Rodríguez. *The President and Immigration Law*. Oxford: Oxford University Press, 2020. Kindle edition.

Crepet, Anna, Francesco Rita, Anthony Reid, Wilma Van den Boogaard, Pina Deiana, Gaia Quaranta, Aurelia Barbieri, Francesco Bongiorno, and Stefano Di Carlo. "Mental Health and Trauma in Asylum Seekers Landing in Sicily in 2015: A Descriptive Study of Neglected Invisible Wounds." *Conflict and Health* 11, no. 1 (January 2017): 1–11. https://doi.org/10.1186/s13031-017-0103-3.

Cruz, José Miguel. "Police Misconduct and Democracy in Latin America." *AmericasBarometer Insights*, no. 33 (2010): 1–5. www.vanderbilt.edu.

Cruz, José Miguel. "Police Misconduct and Political Legitimacy in Central America." *Journal of Latin American Studies* 47, no. 2 (May 2015): 251–283. https://doi.org/10.1017/S0022216X15000085.

Davis, Diane. "The Political and Economic Origins of Violence and Insecurity in Contemporary Latin America: Past Trajectories, Future Prospects." In *Violent Democracies in Latin America*, edited by Enrique Desmond Arias and Daniel M. Goldstein, 35–63. Durham, NC: Duke University Press, 2010. Kindle edition.

Davis, John. "Border Crisis: CBP's Response." US Customs and Border Protection. www.cbp.gov. Last modified June 30, 2023.

De Genova, Nicholas. "Migrant 'Illegality' and Deportability in Everyday Life." *Annual Review of Anthropology* 31, no. 1 (June 2002): 419–447. https://doi.org/10.1146/annurev.anthro.31.040402.085432.

De Genova, Nicholas. "The Legal Production of Mexican/Migrant 'Illegality.'" *Latino Studies* 2, no. 2 (August 2004): 160–185. https://doi.org/10.1057/palgrave.lst.8600085.

De Genova, Nicholas and Nathalie Peutz. *The Deportation Regime: Sovereignty, Space, and the Freedom of Movement*. Durham, NC: Duke University Press, 2010. Kindle edition.

del Bosque, Melissa. "Facial Recognition Bias Frustrates Black Asylum Applicants to the US, Advocates Say." *The Guardian*. February 8, 2023. www.theguardian.com.

del Carmen Gutiérrez Rivera, Lirio. "Security Policies from a Spatial Perspective: The Case of Honduras." *Iberoamericana* 11, no. 41 (2011): 143–155. https://doi.org/10.18441/ibam.11.2011.41.143-155.

Demertzis, Nicolas. "The Drama of the Greek Civil War Trauma." In *Narrating Trauma on the Impact of Collective Suffering*, edited by Ron Eyerman, Jeffrey C. Alexander, and Elizabeth Butler Breese, 133–161. New York: Routledge, 2015.

Desjarlais, Robert. *Shelter Blues: Sanity and Selfhood Among the Homeless*. Philadelphia: University of Pennsylvania Press, 1997.

Desmond, Matthew. "Becoming a Firefighter." *Ethnography* 7, no. 4 (December 2006): 387–421. https://doi.org/10.1177/1466138106073142.

Doyle, Crystal. "Isn't Persecution Enough—Redefining the Refugee Definition to Provide Greater Asylum Protection to Victims of Gender-Based Persecution." *Washington and Lee Journal of Civil Rights and Social Justice* 15, no. 2 (Spring 2009): 519–560.

Doyle, Kerry E. "Guidance to OPLA Attorneys Regarding the Enforcement of Civil Immigration Laws and the Exercise of Prosecutorial Discretion." Kerry E. Doyle to All OPLA Attorneys. Memorandum. US Department of Homeland Security, US Immigration and Customs Enforcement. April 3, 2022. www.ice.gov.

Dreby, Joanna. "Children and Power in Mexican Transnational Families." *Journal of Marriage and Family* 69, no. 4 (November 2007): 1050–1064. https://doi.org/10.1111/j.1741-3737.2007.00430.x.

Drysdale Walsh, Shannon. "Engendering Justice: Constructing Institutions to Address Violence Against Women." *Studies in Social Justice* 2, no. 1 (2008): 48–66. https://doi.org/10.26522/ssj.v2i1.967.

Drysdale Walsh, Shannon and Cecilia Menjívar. "'What Guarantees Do We Have?' Legal Tolls and Persistent Impunity for Feminicide in Guatemala." *Latin American Politics and Society* 58, no. 4 (Winter 2016): 31–55. https://doi.org/10.1111/laps.12001.

Eagly, Ingrid and Steven Shafer. "A National Study of Access to Counsel in Immigration Court." *University of Pennsylvania Law Review* 164, no. 1 (December 2015): 1–91.

Edwards, Alice. "Transitioning Gender: Feminist Engagement with International Refugee Law and Policy 1950–2010." *Refugee Survey Quarterly* 29, no. 2 (March 2010): 21–45. https://doi.org/10.1093/rsq/hdq021.

Erikson, Kai. *A New Species of Trouble: The Human Experience of Modern Disasters*. New York: W.W. Norton, 1994.

Executive Office of Immigration and US Citizenship Immigration Services. "Asylum Eligibility and Procedural Modifications." *Federal Register* 84, no. 136 (July 2019): 33829–33845. www.govinfo.gov.

Farmer, Paul. "An Anthropology of Structural Violence." *Current Anthropology* 45, no. 3 (June 2004): 305–325. https://doi.org/10.1086/382250.

Farmer, Paul. "On Suffering and Structural Violence: A View from Below." *Daedalus* 125, no. 1 (Winter 1996): 261–283.

Farmer, Paul. *Pathologies of Power: Health, Human Rights, and the New War on the Poor*. Berkeley: University of California Press, 2004. Kindle edition.

Farmer, Paul, Bruce Nizeye, Sara Stulac, and Salmaan Keshavjee. "Structural Violence and Clinical Medicine." *PLoS Medicine* 3, no. 10 (October 2006): 1686–1691. https://doi.org/10.1371/journal.pmed.0030449.

Fassin, Didier and Richard Rechtman. *The Empire of Trauma: An Inquiry into the Condition of Victimhood.* Princeton, NJ: Princeton University Press, 2009.

Felitti, Vincent J., Robert F. Anda, Dale Nordenberg, David F. Williamson, Alison M. Spitz, Valerie Edwards, Mary P. Koss, and James S. Marks. "Relationship of Childhood Abuse and Household Dysfunction to Many of the Leading Causes of Death in Adults: The Adverse Childhood Experiences (ACE) Study." *American Journal of Preventive Medicine* 14, no. 4 (May 1998): 245–258. https://doi.org/10.1016/S0749-3797(98)00017-8.

Felmingham, Kim, Leanne M. Williams, Thomas J. Whitford, Erin Falconer, Andrew H. Kemp, Anthony Peduto, and Richard A. Bryant. "Duration of Posttraumatic Stress Disorder Predicts Hippocampal Grey Matter Loss." *Neuroreport* 20, no. 16 (October 2009): 1402–1406. https://doi.org/10.1097/WNR.0b013e328330ofbc.

Fernández-Kelly, Patricia and Douglas S. Massey. "Borders for Whom? The Role of NAFTA in Mexico-US Migration." *ANNALS of the American Academy of Political and Social Science* 610, no. 1 (March 2007): 98–118. https://doi.org/10.1177/0002716206297449.

Fitzgerald, David. *Refuge Beyond Reach: How Rich Democracies Repel Asylum Seekers.* New York: Oxford University Press, 2019. Kindle edition.

Forsyth Barbra H., Martha Stampleton Kudela, Kerry Levin, Deirdre Lawrence, and Gordon B. Willis. "Methods for Translating an English-Language Survey Questionnaire on Tobacco Use into Mandarin, Cantonese, Korean, and Vietnamese." *Field Methods* 19, no. 3 (August 2007): 264–283. https://doi.org/10.1177/1525822X07302105.

Foucault, Michel. *Discipline and Punish: The Birth of Prison.* New York: Vintage Books, 1995.

Foucault, Michel, Arnold I. Davidson, and Graham Burchell. *The Birth of Biopolitics: Lectures at the Collège de France, 1978–1979.* New York: Palgrave Macmillan, 2008.

Gao, Rui. "Revolutionary Trauma and the Representation of the War: The Case of China in Mao's Era." In *Narrating Trauma on the Impact of Collective Suffering,* edited by Ron Eyerman, Jeffrey C. Alexander, and Elizabeth Butler Breese, 53–77. New York: Routledge, 2015.

General Assembly. *Protocol Relating to the Status of Refugees.* October 4, 1967. www.ohchr.org.

Gerken, Christina. "Credibility, Trauma, and the Law: Domestic Violence–Based Asylum Claims in the United States." *Feminist Legal Studies* 30, no. 3 (August 2022): 255–280. https://doi.org/10.1007/s10691-022-09493-7.

Gill, Nick and Jo Hynes. "Courtwatching: Visibility, Publicness, Witnessing, and Embodiment in Legal Activism." *Area* 53, no. 4 (November 2020): 569–576. https://doi.org/10.1111/area.12690.

Gilman, Denise and Luis A. Romero. "Immigration Detention, Inc." *Journal on Migration and Human Security* 6, no. 2 (June 2018): 145–160. https://doi.org/10.1177/2331502418765414.

Glebbeek, Mary-Louise and Kees Koonings. "Between Morro and Asfalto: Violence, Insecurity and Socio-Spatial Segregation in Latin American Cities." *Habitat International* 54, no. 1 (May 2016): 3–9. https://doi.org/10.1016/j.habitatint.2015.08.012.

Godoy, Angelina Snodgrass. "'La Muchacha Respondona': Reflections on the Razor's Edge Between Crime and Human Rights." *Human Rights Quarterly* 27, no. 2 (May 2005): 597–624. https://doi.org/10.1353/hrq.2005.0018.

Godoy, Angelina Snodgrass. *Popular Injustice: Violence, Community, and Law in Latin America*. Stanford, CA: Stanford University Press, 2006.

Godoy-Paiz, Paula. "Women in Guatemala's Metropolitan Area: Violence, Law, and Social Justice." *Studies in Social Justice* 2, no. 1 (January 2009): 27–47. https://doi.org/10.26522/ssj.v2i1.966.

Gomez, Danette. "Last in Line—The United States Trails Behind in Recognizing Gender-Based Asylum Claims." *Whittier Law Review* 25, no. 4 (Summer 2004): 959–988.

Gonzales, Roberto G. and Leo R. Chavez. "'Awakening to a Nightmare': Abjectivity and Illegality in the Lives of Undocumented 1.5-Generation Latino Immigrants in the United States." *Current Anthropology* 53, no. 3 (June 2012): 255–281. https://doi.org/10.1086/665414.

Grégoire, Laurent, Isabelle Gosselin, and Isabelle Blanchette. "The Impact of Trauma Exposure on Explicit and Implicit Memory." *Anxiety, Stress, and Coping* 33, no. 1 (January 2020): 1–18. https://doi.org/10.1080/10615806.2019.1664477.

Guenther, Lisa. "Critical Phenomenology." In *50 Concepts for a Critical Phenomenology*, edited by Gail Weiss, Ann V. Murphy, and Gayle Salamon. Evanston, IL: Northwestern University Press, 2020. Kindle edition.

Gurwitsch, Aron. *Phenomenology and the Theory of Science*. Evanston, IL: Northwestern University Press, 1974.

Haggerty, Bill, US Senator for Tennessee. "Haggerty, Tillis, and Colleagues Lead Bill to End Asylum Abuse and Punish Illegal Immigrants Who Fail to Show Up for Asylum Court." July 28, 2022. www.hagerty.senate.gov.

Hamlin, Rebecca. *Crossing: How We Label and React to People on the Move*. Stanford, CA: Stanford University Press, 2021.

Harris, Lindsay M. "Asylum Under Attack: Restoring Asylum Protection in the United States." *Law Review* 67, no. 1 (Fall 2020): 121–189.

Harris, Lindsay M. "Untold Stories: Gender-Related Persecution and Asylum in South Africa." *Michigan Journal of Gender & Law* 15, no. 2 (2009): 291–348.

Harris, Lindsay M. "Withholding Protection." *Columbia Human Rights Law Review* 50, no. 3 (Spring 2019): 1–78. https://ssrn.com.

Harris, Lindsay M., Hannah C. Cartwright, Liana Montecinos, and Anam Rahman. "Vicarious Trauma and Ethical Obligations for Attorneys Representing Immigrant Clients: A Call to Build Resilience Among the Immigration Bar." *AILA Law Journal* 2, no. 1 (April 2020): 23–40. http://dx.doi.org/10.2139/ssrn.3832077.

Harris, Lindsay M. and Hillary Mellinger. "Asylum Attorney Burnout and Secondary Trauma." *Wake Forest Law Review* 56, no. 4 (February 2021): 733–824. https://ssrn.com.

Harvey, David. *A Brief History of Neoliberalism*. Oxford: Oxford University Press, 2005.

Hennessy-Fiske, Molly. "Border Patrol's Largest Holding Area—Known to Migrants as 'The Kennel'—Is Overwhelmed." *Los Angeles Times*. April 3, 2019. www.latimes.com.

Hesson, Ted. "Close to 1,000 Migrant Children Separated by Trump Yet to Be Reunited with Parents." *Reuters*. February 2, 2023. www.reuters.com.

Heyman, Josiah. "Constructing a Virtual Wall: Race and Citizenship in US–Mexico Border Policing." *Journal of the Southwest* 50, no. 3 (Autumn 2008): 305–333. https://doi.org/10.1353/jsw.2008.0010.

Heyman, Josiah, Jeremy Slack, and Emily Guerra. "Bordering a 'Crisis': Central American Asylum Seekers and the Reproduction of Dominant Border Enforcement Practices." *Journal of the Southwest* 60, no. 4 (Winter 2018): 754–786. https://doi.org/10.1353/jsw.2018.0015.

Hite, Adeline and Álvaro Montenegro. "Guatemala's Corrupt Are Threatening to Erase Its Historic Anti-Corruption Legacy." Washington Office on Latin America. January 8, 2020. www.wola.org.

Hoffman, Todd. Executive Assistant Commissioner, Office of Field Operations, CBP Email to Directors of Field Operations El Paso, Laredo, San Diego, and Tucson. "Metering Guidance Memo." April 27, 2018. www.dhs.gov.

Hondagneu-Sotelo, Pierrette. "Feminism and Migration." *Annals of the American Academy of Political and Social Science* 571, no. 1 (September 2000): 107–120.

Hondagneu-Sotelo, Pierrette. "Gendered Transitions." In *Gendered Transitions: Mexican Experiences of Immigration*, 53–97. Berkeley: University of California Press, 1994.

Hueben, Elizabeth A. "Domestic Violence and Asylum Law: The United States Takes Several Remedial Steps in Recognizing Gender-Based Persecution." *UMKC Law Review* 70, no. 2 (Winter 2001): 453–470.

Human Rights Watch. "Deported to Danger: United States Deportation Policies Expose Salvadorans to Death and Abuse." February 5, 2020. www.hrw.org.

Human Rights Watch. "Honduras: Events of 2019." 2020. www.hrw.org.

Human Rights Watch. "Mexico: Overhaul Police Forces." July 24, 2020. www.hrw.org.

Hume, Mo. "The Myths of Violence: Gender, Conflict, and Community in El Salvador." *Latin American Perspectives* 35, no. 5 (September 2008): 59–76. https://doi.org/10.1177/0094582X08321957.

Humphrey, Michael. "Citizen Insecurity in Latin American Cities: The Intersection of Spatiality and Identity in the Politics of Protection." *Crítica Contemporánea. Revista de Teoría Política*, no. 2 (November 2012): 101–118. www.colibri.udelar.edu.uy.

Huntington, Samuel P. "The Hispanic Challenge." *Foreign Policy* (March/April 2004): 30–44. https://doi.org/10.2307/4147547.

Husk, Sarah A. "Curing What Ails US (Asylum Law): Dismantling the Mythology of 'Private Violence' Undergirding *Matter of A-B-*." *Social Justice & Equity Law Journal* 4, no. 2 (2021): 1–33. https://willamette.edu.

Imbriano, Jesse. "Opening the Floodgates or Filing the Gap?: Perdomo V. Holder Advances the Ninth Circuit One Step Closer to Recognizing Gender-Based Asylum Claims." *Villanova Law Review* 56, no. 2 (2011): 327–362.

Instituto Nacional De Estadística. *Revisión de la Metodología para Medir la Pobreza Monetaria en Honduras*. January 2020. www.ine.gob.hn.

International Organization for Migration. "Latest Migrant Tragedy in Texas Highlights Crisis Along Deadliest Migration Land Route." www.iom.int. Last modified September 30, 2022.

Jackman, Mary R. "Violence in Social Life." *Annual Review of Sociology* 28, no. 1 (August 2002): 387–415. https://doi.org/10.1146/annurev.soc.28.110601.140936.

Jenkins, Janis Hunter. "The State Construction of Affect: Political Ethos and Mental Health Among Salvadoran Refugees." *Culture, Medicine and Psychiatry* 15, no. 2 (June 1991): 139–165. https://doi.org/10.1007/BF00119042.

Johnson, Heather L. *Borders, Asylum and Global Non-Citizenship: The Other Side of the Fence*. Cambridge: Cambridge University Press, 2014.

Jokela-Pansini, Maaret. "Complicating Notions of Violence: An Embodied View of Violence Against Women in Honduras." *Environment and Planning C: Politics and Space* 38, no. 5 (August 2020): 848–865. https://doi.org/10.1177/2399654420906833.

Jokela-Pansini, Maaret. "Spatial Imaginaries and Collective Identity in Women's Human Rights Struggles in Honduras." *Gender, Place & Culture* 23, no. 10 (July 2016): 1465–1479. https://doi.org/10.1080/0966369X.2016.1204998.

Jütersonke, Oliver, Robert Muggah, and Dennis Rodgers. "Gangs, Urban Violence, and Security Interventions in Central America." *Security Dialogue* 40, no. 4–5 (September 2009): 373–397. https://doi.org/10.1177/0967010609343298.

Jutt, Minha. "'Build Back Better': Domestic Violence-Based Asylum after the 'Death to Asylum' Rule." *University of Kansas Law Review* 70, no. 3 (February 2022): 561–592.

Katz, Jack and Thomas J. Csordas. "Phenomenal Ethnography in Sociology and Anthropology." *Ethnography* 4, no. 2 (September 2003): 275–288. https://doi.org/10.1177/146613810343001.

Katz, Matt and Jose Olivares. "A Look at Immigration Courts Under the Biden Administration." May 24, 2021. In *WNYC Studios: The Takeaway*. Podcast. www.wnycstudios.org.

Kaysen, Debra, Gerald Rosen, Marilyn Bowman, and Patricia A. Resick. "Duration of Exposure and the Dose-Response Model of PTSD." *Journal of Interpersonal Violence* 25, no. 1 (January 2010): 63–74. https://doi.org/10.1177/0886260508329131.

Kerwin, Donald. "The Faltering US Refugee Protection System: Legal and Policy Responses to Refugees, Asylum-Seekers, and Others in Need of Protection." *Refugee Survey Quarterly* 31, no. 1 (March 2012): 1–33. https://doi.org/10.1093/rsq/hdr019.

Kinkaid, Eden. "Re-Encountering Lefebvre: Toward a Critical Phenomenology of Social Space." *Environment and Planning D: Society and Space* 38, no. 1 (February 2020): 167–186. https://doi.org/10.1177/0263775819854765.

Kitchin, Rob. "'Out of Place', 'Knowing One's Place': Space, Power and the Exclusion of Disabled People." *Disability & Society* 13, no. 3 (June 1998): 343–356. https://doi.org/10.1080/09687599826678.

Kleinman, Arthur. "The Violences of Everyday Life: The Multiple Forms and Dynamics of Social Violence." In *Violence and Subjectivity*, edited by Veena Das, Arthur Kleinman, Mamphela Ramphele, and Pamela Reynolds, 226–239. Berkeley: University of California Press.

Kleinman, Arthur. *Writing at the Margin: Discourse Between Anthropology and Medicine*. Berkeley: University of California Press, 1997. Kindle edition.

Kleinman, Arthur and Robert Desjarlais. "Violence, Culture, and the Politics of Trauma." In *Writing at the Margin: Discourse Between Anthropology and Medicine*, edited by Arthur Kleinman, Loc. 2278–2282. Berkeley: University of California Press, 1997. Kindle edition.

Kocher, Austin. "Glitches in the Digitization of Asylum: How CBP One Turns Migrants' Smartphones into Mobile Borders." *Societies* 13, no. 6 (June 2023): 1–15. https://doi.org/10.3390/soc13060149.

Kraut, Alan M. *Silent Travelers: Germs, Genes, and the Immigrant Menace*. Baltimore, MD: Johns Hopkins University Press, 1995.

Lederer, Jenny. "'Anchor Baby': A Conceptual Explanation for Pejoration." *Journal of Pragmatics* 57 (October 2013): 248–266. https://doi.org/10.1016/j.pragma.2013.08.007.

Lee, Erika. *America for Americans: A History of Xenophobia in the United States*. New York: Basic Books, 2019.

Lens, Vicki. *Poor Justice: How the Poor Fare in the Courts*. Oxford: Oxford University Press, 2015. Kindle edition.

Levenson, Deborah T. *Adiós Niño: The Gangs of Guatemala City and the Politics of Death*. Durham, NC: Duke University Press, 2013.

Levinson, Reade, Kristina Cooke, and Mica Rosenberg. "Special Report: How Trump Administration Left Indelible Mark on U.S. Immigration Courts." *Reuters*, March 8, 2021. www.reuters.com.

Li, Susan S. Y., Belinda J. Liddell, and Angela Nickerson. "The Relationship Between Post-Migration Stress and Psychological Disorders in Refugees and Asylum Seekers." *Current Psychiatry Reports* 18, no. 9 (July 2016): 82. https://doi.org/10.1007/s11920-016-0723-0.

Llewellyn, Cheryl. "(In)Credible Violence: An Analysis of Post-Alvarado Domestic Violence Asylum Cases in the United States." *Journal of Women, Politics & Policy* 41, no. 2 (2020): 170–193. https://doi.org/10.1080/1554477X.2019.1674023.

López, Ana Ricoy, Abigail Andrews, and Alejandra Medina. "Exit as Care: How Motherhood Mediates Women's Exodus from Violence in Mexico and Central America." *Violence Against Women* 28, no. 1 (January 2022): 211–231. https://doi.org/10.1177/10778012211992875.

Loyd, Jenna M. and Alison Mountz. *Boats, Borders, and Bases: Race, the Cold War, and the Rise of Migration Detention in the United States*. Berkeley: University of California Press, 2019. Kindle edition.

Lumsden, Karen and Heather Morgan. "Media Framing of Trolling and Online Abuse: Silencing Strategies, Symbolic Violence, and Victim Blaming." *Feminist Media Studies* 17, no. 6 (April 2017): 926–940. https://doi.org/10.1080/14680777.2017.1316755.

Lustig, Stuart L., Niranjan Karnik, Kevin Delucchi, Lakshika Tennakoon, Brent Kaul, Dana Leigh Marks, and Denise Slavin. "Inside the Judges' Chambers: Narrative Responses from the National Association of Immigration Judges Stress and Burnout Survey." *Georgetown Immigration Law Journal* 23, no. 57 (January 2008): 57–83.

Manwaring, Max G. *A Contemporary Challenge to State Sovereignty: Gangs and Other Illicit Transnational Criminal Organizations (TCO's) in Central America, El Salvador, Mexico, Jamaica, and Brazil.* Carlisle Barracks, PA: US Army War College Strategic Studies Institute, 2007.

Markel, Howard and Alexandra Minna Stern. "The Foreignness of Germs: The Persistent Association of Immigrants and Disease in American Society." *Milbank Quarterly* 80, no. 4 (December 2002): 757–788. https://doi.org/10.1111/1468-0009.00030.

Marouf, Fatma. "Executive Overreaching in Immigration Adjudication." *Tulane Law Review* 93, no. 4 (April 2019): 707–785. https://scholarship.law.tamu.edu.

Marshall, Grant N., Terry L. Schell, Marc N. Elliott, S. Megan Berthold, and Chi-Ah Chun. "Mental Health of Cambodian Refugees 2 Decades After Resettlement in the United States." *Journal of the American Medical Association* 294, no. 5 (August 2005): 571–579. https://doi.org/10.1001/jama.294.5.571.

Marzouk, Julie. "Ethical and Effective Representation of Unaccompanied Immigrant Minors in Domestic Violence–Based Asylum Cases." *Clinical Law Review* 22, no. 2 (Spring 2016): 395–443. https://digitalcommons.chapman.edu/.

Massey, Doreen. *For Space.* London: SAGE, 2005.

Massey, Douglas, Karen A. Pren, and Jorge Durand. "Why Border Enforcement Backfired." *American Journal of Sociology* 121, no. 5 (March 2016): 1557–1600. https://doi.org/10.1086/684200.

Mayorkas, Alejandro. "Guidelines for the Enforcement of Civil Immigration Law." Alejandro Mayorkas to Tae D. Johnson. Memorandum. US Department of Homeland Security. September 30, 2021. www.ice.gov.

McAleenan, Kevin K. Commissioner of CBP, to Todd C. Owen, Executive Assistant Commissioner for Field Operations, and Carla L. Provost, Chief of US Border Patrol. Memorandum. "Implementation of the Migrant Protection Protocols." January 28, 2019. www.cbp.gov.

McKinnon, Sara L. *Gendered Asylum: Race and Violence in U.S. Law and Politics.* Champaign: University of Illinois Press, 2016. Kindle edition.

McRobbie, Angela. "Notes on 'What Not to Wear' and Post-Feminist Symbolic Violence." *Sociological Review* 52, no. 2_suppl (October 2004): 99–109. https://doi.org/10.1111/j.1467-954X.2005.00526.x.

Meffert Susan M., Karen Musalo, Dale E. McNiel, and Renée L. Binder. "The Role of Mental Health Professionals in Political Asylum Processing." *Journal of the American Academy of Psychiatry & the Law* 38, no. 4 (December 2010): 479–489.

Meissner, Doris, Donald M. Kerwin, Muzaffar Chishti, and Claire Bergeron. *Immigration Enforcement in the United States: The Rise of a Formidable Machinery*. Washington, DC: Migration Policy Institute. 2013. www.migrationpolicy.org.

Memon, Amina. "Credibility of Asylum Claims: Consistency and Accuracy of Autobiographical Memory Reports Following Trauma." *Applied Cognitive Psychology* 26, no. 5 (September 2012): 677–679. https://doi.org/10.1002/acp.2868.

Menjívar, Cecilia. *Enduring Violence: Ladina Women's Lives in Guatemala*. Berkeley: University of California Press, 2011. Kindle edition.

Menjívar, Cecilia. "Liminal Legality: Salvadoran and Guatemalan Immigrants' Lives in the United States." *American Journal of Sociology* 111, no. 4 (January 2006): 999–1037. https://doi.org/10.1086/499509.

Menjívar, Cecilia and Leisy Abrego. "Legal Violence: Immigration Law and the Lives of Central American Immigrants." *American Journal of Sociology* 117, no. 5 (March 2012): 1380–1421. https://doi.org/10.1086/663575.

Menjívar, Cecilia, Andrea Gómez Cervantes, and Daniel Alvord. "The Expansion of 'Crimmigration,' Mass Detention, and Deportation." *Sociology Compass* 12, no. 4 (Spring 2018): 1–15. https://doi.org/10.1111/soc4.12573.

Menjívar, Cecilia and Daniel Kanstroom. Introduction to *Constructing Immigrant "Illegality": Critiques, Experiences, and Responses*, edited by Cecilia Menjívar and Daniel Kanstroom, 1–36. Cambridge: Cambridge University Press, 2013.

Menjívar, Cecilia and Shannon Drysdale Walsh. "Gender-based Violence in Central America and Women Asylum Seekers in the United States." *Translational Criminology* 16 (Winter 2019): 12–14.

Menjívar, Cecilia and Shannon Drysdale Walsh. "The Architecture of Feminicide: The State, Inequalities, and Everyday Gender Violence in Honduras." *Latin American Research Review* 52, no. 2 (August 2017): 221–240. https://doi.org/10.25222/larr.73.

Michalowski, Raymond. "Border Militarization and Migrant Suffering: A Case of Transnational Social Injury." *Social Justice* 34, no. 2 108 (2007): 62–76.

Migration Policy Institute. "U.S. Spends More on Immigration Enforcement than on FBI, DEA, Secret Service & All Other Federal Criminal Law Enforcement Agencies Combined." January 7, 2013. www.migrationpolicy.org.

Miller, Banks, Linda Camp Keith, and Jennifer S. Holmes. *Immigration Judges and US Asylum Policy*. Philadelphia: University of Pennsylvania Press, 2015.

Missing Migrants Project. "4,530 Missing Migrants Recorded in the Americas (Since 2014)." International Organization for Migration. Accessed June 23, 2023. https://missingmigrants.iom.int.

Montoya-Galvez, Camilo. "Migrant Crossings Along U.S.-Mexico Border Plummeted in June Amid Stricter Asylum Rules." *CBS News*. July 12, 2023. www.cbsnews.com.

Moodie, Ellen. *El Salvador in the Aftermath of Peace: Crime, Uncertainty, and the Transition to Democracy*. Philadelphia: University of Pennsylvania Press, 2011.

Musalo, Karen. "Personal Violence, Public Matter: Evolving Standards in Gender-Based Asylum Law." *Harvard International Review* 36, no. 2 (Fall 2014/Winter 2015): 45–48. https://cgrs.uchastings.edu.

Musalo, Karen. "A Short History of Gender Asylum in the United States: Resistance and Ambivalence May Very Slowly Be Inching Towards Recognition of Women's Claims." *Refugee Survey Quarterly* 29, no. 2 (March 2010): 46–63. https://doi.org/10.1093/rsq/hdq026.

Musalo, Karen. "The Struggle for Equality: Women's Rights, Human Rights, and Asylum Protection." *Southwestern Law Review* 3 (2019): 531–538. https://repository.uclawsf.edu.

Nanasi, Natalie. "Domestic Violence Asylum and the Perpetuation of the Victimization Narrative." *Ohio State Law Journal* 78, no. 3 (2017): 733–771. http://dx.doi.org/10.2139/ssrn.2727287.

National Association of Immigration Judges. "The Immigration Courts: Nothing Like What You Have Imagined." YouTube video. 4:03. Posted October 8, 2019. www.youtube.com/watch?v=wfZtqHtNyTY.

National Association of Immigration Judges. "National Association of Immigration Judges." www.naij-usa.org/. Accessed May 13, 2022.

National Association of Social Workers. "Code of Ethics of the National Association of Social Workers." www.socialworkers.org. Accessed June 29, 2023.

National Coalition Against Domestic Violence. "National Statistics." Accessed May 31, 2023. https://ncadv.org/STATISTICS.

National Immigrant Justice Center: A Heartland Alliance Program. *Basic Procedural Manual for Asylum Representation Affirmatively and in Removal Proceedings*. November 2022. https://immigrantjustice.org. 1–79.

National Immigrant Justice Center: A Heartland Alliance Program. "NIJC Condemns the Biden Administration's Asylum Ban." May 10, 2023. https://immigrantjustice.org.

Nayak, Meghana. *Who Is Worthy of Protection?: Gender-Based Asylum and U.S. Immigration Politics*. Oxford: Oxford University Press, 2015. Kindle edition.

Obama, Barack. "Letter from the President—Efforts to Address the Humanitarian Situation in the Rio Grande Valley Areas of Our Nation's Southwest Border." The White House. June 30, 2014. https://obamawhitehouse.archives.gov.

Obinna, Denise N. "Seeking Sanctuary: Violence Against Women in El Salvador, Honduras, and Guatemala." *Violence Against Women* 27, no. 6-7 (May 2021): 806–827. https://doi.org/10.1177/1077801220913633.

Ogilvie, Sarah A. and Scott Miller. *Refuge Denied: The St. Louis Passengers and The Holocaust*. Madison: University of Wisconsin Press, 2010.

Ogrodnik, Corinne and Silvia Borzutzky. "Women Under Attack: Violence and Poverty in Guatemala." *Journal of International Women's Studies* 12, no. 1 (January/February 2011): 55–67.

Oh, Yuna. "When Republican House Judiciary Committee Members Amplified White Nationalist Conspiracy Theories." America's Voice. June 6, 2023. https://americasvoice.org/blog/when-republican-house-judiciary.

Oishi, Nana. *Women in Motion: Globalization, State Policies, and Labor Migration in Asia*. Stanford, CA: Stanford University Press, 2005.

Olavarrieta, Claudia Díaz and Julio Sotelo. "Domestic Violence in Mexico." *JAMA* 275, no. 24 (June 1996): 1937–1941. https://doi.org/10.1001/jama.1996.03530480079051.

Opalinski, Andra. "Pouring Rights Contracts and Childhood Overweight: A Critical Theory Perspective." *Journal for Specialists in Pediatric Nursing* 11, no. 4 (October 2006): 234–243. https://doi.org/10.1111/j.1744-6155.2006.00075.x.

Organization for Economic Co-operation and Development. "Key Issues Affecting Youth in El Salvador." Accessed March 29, 2023. www.oecd.org.

Overgaard, Søren and Dan Zahavi. "Phenomenological Sociology: The Subjectivity of Everyday Life." In *Encountering the Everyday: An Introduction to the Sociologies of the Unnoticed*, edited by Michael Hviid Jacobsen, 93–115. New York: Palgrave Macmillan, 2009.

Owen, Karen K., Elizabeth J. Obregón, and Kathryn H. Jacobsen. "A Geographic Analysis of Access to Health Services in Rural Guatemala." *International Health* 2, no. 2 (June 2010): 143–149. https://doi.org/10.1016/j.inhe.2010.03.002.

Pain, Rachel. "Intimate War." *Political Geography* 44 (January 2015): 64–73. https://doi.org/10.1016/j.polgeo.2014.09.011.

Paley, Dawn. "Drug War as Neoliberal Trojan Horse." *Latin American Perspectives* 42, no. 5 (May 2015): 109–132. https://doi.org/10.1177/0094582X15585117.

Peck, Alison. *The Accidental History of the U.S. Immigration Courts: War, Fear, and the Roots of Dysfunction*. Berkeley: University of California Press, 2021.

Pedraza-Farina, Laura G., Spring Miller, and James L. Cavallaro. *No Place to Hide: Gang, State, and Clandestine Violence in El Salvador*. Cambridge, MA: Harvard University Press, 2010.

Perlin, Jan. "The Guatemalan Historical Clarification Commission Finds Genocide." *ILSA Journal of International & Comparative Law* 6, no. 2 (Spring 2000): 389–414.

Pierce, Sarah. *Obscure but Powerful: Shaping U.S. Immigration Policy through Attorney General Referral and Review*. Washington, DC: Migration Policy Institute. 2021. www.migrationpolicy.org.

Potocky, Miriam and Mitra Naseh. *Best Practices for Social Work with Refugees and Immigrants*, 2nd ed. New York: Columbia University Press, 2020.

Prieto-Carrón, Marina, Marilyn Thomson, and Mandy Macdonald. "No More Killings! Women Respond to Femicides in Central America." *Gender & Development* 15, no. 1 (February 2007): 25–40. https://doi.org/10.1080/13552070601178849.

Rahbari, Ladan and Mahmoud Sharepour. "Gender and Realisation of Women's Right to the City in Tehran." *Asian Journal of Social Science* 43, no. 3 (January 2015): 227–248. https://doi.org/10.1163/15685314-04303002.

Ramji-Nogales, Jaya, Andrew I. Schoenholtz, and Philip G. Schrag. "Refugee Roulette: Disparities in Asylum Adjudication." *Stanford Law Review* 60, no. 2 (November 2007): 295–411.

Ramji-Nogales, Jaya, Andrew I. Schoenholtz, and Philip G. Schrag. *Refugee Roulette: Disparities in Asylum Adjudication and Proposals for Reform*. New York: New York University Press, 2011.

Rascoe, Ayesha and Ryan Benk. "1,500 Service Members Will Be Deployed to the U.S.-Mexico Border This Week." NPR. May 7, 2023. Audio and Transcript. www.npr.org.

Riva, Sara. "Across the Border and Into the Cold: *Hieleras* and the Punishment of Asylum-Seeking Central American Women in the United States." *Citizenship Studies* 21, no. 3 (January 2017): 309–326. https://doi.org/10.1080/13621025.2016.1277981.

Rizzo, Salvador. "How Many Migrants Show Up for Immigration Court Hearings?" *Washington Post*, June 26, 2019. www.washingtonpost.com.

Robbins, Stephen and Matthew Archambeault. "Dysfunction: A Historical Look at the Immigration Courts with Professor Alison Peck." May 23, 2021. In *Redirect: Immigration Law and Perspectives*. Podcast. https://redirectpod.libsyn.com/alison-peck.

Robinson, Kim. "Voices from the Front Line: Social Work with Refugees and Asylum Seekers in Australia and the UK." *British Journal of Social Work* 44, no. 6 (September 2014): 1602–1620. https://doi.org/10.1093/bjsw/bct040.

Romero, Mary. "Crossing the Immigration and Race Border: A Critical Race Theory Approach to Immigration Studies." *Contemporary Justice Review* 11, no. 1 (March 2008): 23–37. https://doi.org/10.1080/10282580701850371.

Ronderos, Katherine. "Poverty Reduction, Political Violence and Women's Rights in Honduras." *Community Development Journal* 46, no. 3 (July 2011): 315–326. https://doi.org/10.1093/cdj/bsr038.

Rose, Joel and Marisa Peñaloza. "Migrant Deaths at the U.S.-Mexico Border Hit a Record High, in Part Due to Drownings." NPR. September 29, 2022. www.npr.org.

Roth, Kenneth. Foreword to *Annihilating Difference: The Anthropology of Genocide*, edited by Alexander Laban Hinton, ix–xii. Berkeley: University of California Press, 2002.

Ruiz, Héctor. "No Justice for Guatemalan Women: An Update 20 Years After Guatemala's First Violence Against Women Law." *Hastings Women's Law Journal* 29, no. 1 (Winter 2018): 101–124. https://repository.uclawsf.edu.

Rumbaut, Rubén G. "Pigments of Our Imagination: On the Racialization and Racial Identities of 'Hispanics' and 'Latinos.'" In *How the United States Racializes Latinos: White Hegemony and Its Consequences*, edited by José A. Cobas, Jorge Duany, and Joe R. Feagin, Loc. 460–1257 of 8702. New York: Routledge, 2009. Kindle edition.

Saatcioglu, Bige and Canan Corus. "Exploring Spatial Vulnerability: Inequality and Agency Formulations in Social Space." *Journal of Marketing Management* 32, no. 3–4 (November 2015): 230–251. https://doi.org/10.1080/0267257X.2015.1103775.

Sanford, Victoria. *Textures of Terror: The Murder of Claudina Isabel Velásquez and Her Father's Quest for Justice*. Oakland: University of California Press, 2023.

Sangalang, Cindy C., David Becerra, Felicia M. Mitchell, Stephanie Lechuga-Peña, Kristina Lopez, and Isok Kim. "Trauma, Post-Migration Stress, and Mental Health: A Comparative Analysis of Refugees and Immigrants in the United States." *Journal of Immigrant and Minority Health* 21, no. 5 (October 2019): 909–919. https://doi.org/10.1007/s10903-018-0826-2.

Santa Ana, Otto. *Brown Tide Rising: Metaphors of Latinos in Contemporary American Public Discourse*. Austin: University of Texas Press, 2002.

Sassen, Saskia. *Expulsions: Brutality and Complexity in the Global Economy*. Cambridge, MA: Harvard University Press, 2014. Kindle edition.

Sassen, Saskia. "Women's Burden: Counter-Geographies of Globalization and the Feminization of Survival." *Nordic Journal of International Law* 71, no. 2 (January 2002): 255–274. https://doi.org/10.1163/157181002761931378.

Schacher, Yael. "Biden's Announced Asylum Transit Ban Undermines Access to Life-Saving Protection." *Washington Post*, January 23, 2023. www.washingtonpost.com.

Schacher, Yael. "Refugee Protection Act of 2022: Asylum and Refugee Protection Fit for the Twenty-First Century." Refugees International. December 22, 2022. www.refugeesinternational.org.

Schacher, Yael. "Return of the Repressed: Asylum in the 1920s and Today." *Journal of American History* 109, no. 2 (September 2022): 375–387. https://doi.org/10.1093/jahist/jaac240

Scheper-Hughes, Nancy. *Death Without Weeping: The Violence of Everyday Life in Brazil*. Berkeley: University of California Press, 1993. Kindle edition.

Scheper-Hughes, Nancy and Philippe Bourgois. Introduction to *Violence in War and Peace: An Anthology*, edited by Nancy Scheper-Hughes and Philippe Bourgois, 1–27. Oxford: Blackwell, 2004.

Schmalzbauer, Leah. "Disruptions, Dislocations, and Inequalities: Transnational Latino/a Families Surviving the Global Economy." *North Caroline Law Review* 88, no. 5 (June 2010): 1857–1880.

Schutz, Alfred. *The Phenomenology of the Social World*. London: Heinemann Educational Books, 1972.

Seelke, Clare Ribando. *Mexico: Background and U.S. Relations*. Congressional Research Service. March 21, 2022. https://crsreports.congress.gov.

Seelke, Clare Ribando and Joshua Klein. *El Salvador: In Brief*. Congressional Research Service. April 29, 2022. https://crsreports.congress.gov.

Sharma, Nandita. "Anti-Trafficking Rhetoric and the Making of Global Apartheid." *NWSA Journal* 17, no. 3 (Fall 2005): 88–111.

Shorack, Marna, Elizabeth G. Kennedy, and Amelia Frank-Vitale. "A State of Mistrust: Questionable Homicide Numbers, a Murky Police Purge, and a Pervasive Distrust of Authorities in Honduras Reveal Deep State Failures that Enable Violence and Impunity." *NACLA Report on the Americas* 52, no. 4 (Winter 2020): 404–409. https://doi.org/10.1080/10714839.2021.1840168.

Silove, Derrick, Patricia Austin, and Zachary Steel. "No Refuge from Terror: The Impact of Detention on the Mental Health of Trauma-Affected Refugees Seeking Asylum in Australia." *Transcultural Psychiatry* 44, no. 3 (September 2007): 359–393. https://doi.org/10.1177/1363461507081637.

Singer, Audrey, Jill H. Wilson, and Brooke DeRenzis. *Immigrants, Politics and Local Response in Suburban Washington*. Washington, DC: Brookings Institution, 2009. www.brookings.edu.

Skeggs, Beverly. "Feminist Ethnography." In *Handbook of Ethnography*, edited by Paul Atkinson, Amanda Coffey, Sara Delamont, John Lofland, and Lyn Lofland, 426–442. London: SAGE, 2007.

Skeggs, Beverly. *Formations of Class and Gender: Becoming Respectable*. London: SAGE, 1997.

Specht, Harry and Mark E. Courtney. *Unfaithful Angels: How Social Work Has Abandoned Its Mission*. New York: Free Press, 1995.

Staudt, Kathleen. "Gender, Governance, and Globalization at Borders: Femicide at the US-Mexico Border." In *Global Governance: Feminist Perspectives*, edited by Shirin Rai and Georgina Waylen, 234–253. New York: Palgrave Macmillan, 2008.

Staudt, Kathleen. *Violence and Activism at the Border: Gender, Fear, and Everyday Life in Ciudad Juárez*. Austin: University of Texas Press, 2009. Kindle edition.

Strom, Kimberly and Wallace J. Gingerich. "Educating Students for the New Market Realities." *Journal of Social Work Education* 29, no. 1 (Winter 1993): 78–87. https://doi.org/10.1080/10437797.1993.10778800.

Stumpf, Juliet P. "Crimmigration: Encountering the Leviathan." In *The Routledge Handbook on Crime and International Migration*, edited by Sharon Pickering and Julie Ham, 237–250. London: Routledge, 2017.

Stumpf, Juliet P. "The Crimmigration Crisis: Immigrants, Crime, and Sovereign Power." *American University Law Review* 56, no. 2 (December 2006): 367–419.

Taft-Morales, Maureen. *Guatemala: Political and Socioeconomic Conditions and U.S. Relations*. Congressional Research Service. March 20, 2019. https://crsreports.congress.gov.

Tahirih Justice Center. *Ensuring Equal and Enduring Access to Asylum: Why 'Gender' Must Be a Protected Ground*. September 9, 2021. www.tahirih.org.

Taylor, Steve, Divine Charura, Glen Williams, Mandy Shaw, John Allan, Elliot E. Cohen, Fiona Meth, and Leonie O'Dwyer. "Loss, Grief, and Growth: An Interpretative Phenomenological Analysis of Experiences of Trauma in Asylum Seekers and Refugees." *Traumatology* (March 2020). https://doi.org/10.1037/trm0000250.

Thapar-Björkert, Suruchi, Lotta Samelius, and Gurchathen S. Sanghera. "Exploring Symbolic Violence in the Everyday: Misrecognition, Condescension, Consent and Complicity." *Feminist Review* 112, no. 1 (February 2016): 144–162. https://doi.org/10.1057/fr.2015.53.

Tichenor, Daniel. *Dividing Lines: The Politics of Immigration Control in America*. Princeton, NJ: Princeton University Press, 2002.

Tichenor, Daniel. "Two-Tiered Implementation: Jewish Refugees, Mexican Guestworkers, and Administrative Policies." Chapter 6 in *Dividing Lines: The Politics of Immigration Control in America*. Princeton, NJ: Princeton University Press, 2002.

Torres, M. Gabriela. "State Violence." In *The Cambridge Handbook of Social Problems*, Vol. 2, edited by A. Javier Treviño, 381–398. New York: Cambridge University Press, 2018.

Torres, Rebecca M. "A Crisis of Rights and Responsibility: Feminist Geopolitical Perspectives on Latin American Refugees and Migrants." *Gender, Place and Culture* 25, no. 1 (March 2018): 13–36. https://doi.org/10.1080/0966369X.2017.1414036.

Transactional Records Access Clearinghouse. *Asylum Decisions and Denials Jump in 2018*. November 29, 2018. https://trac.syr.edu.

Transactional Records Access Clearinghouse. *Historical Immigration Court Backlog Tool: Pending Cases and Length of Wait by Nationality, State, Court, and Hearing Location*. https://trac.syr.edu. Accessed February 23, 2023.

Transactional Records Access Clearinghouse. *Immigration Court Asylum Backlog*. https://trac.syr.edu. Accessed October 18, 2022.

Transactional Records Access Clearinghouse. *Immigration Processing Delays Prompt Record Number of Mandamus Lawsuits in Federal Court*. May 15, 2023. https://trac.syr.edu.

Transactional Records Access Clearinghouse. *The Impact of Nationality, Language, Gender and Age on Asylum Success*. December 7, 2021. https://trac.syr.edu.

Transactional Records Access Clearinghouse. *Judge-by-Judge Asylum Decisions in Immigration Courts FY 2017–2022*. October 26, 2022. https://trac.syr.edu.

Transactional Records Access Clearinghouse. *A Sober Assessment of the Growing U.S. Asylum Backlog*. December 22, 2022. https://trac.syr.edu.

Transactional Records Access Clearinghouse. *Speeding Up the Asylum Process Leads to Mixed Results*. November 29, 2022. https://trac.syr.edu.

Transactional Records Access Clearinghouse. *Too Few Immigration Attorneys: Average Representation Rates Fall from 65% to 30%*. January 24, 2024. https://trac.syr.edu.

Trial International. "Children Born as a Result of Wartime Rape Get Their First Legal Recognition in Bosnia and Herzegovina." https://trialinternational.org. Last modified September 8, 2022.

United Nations. "Global Issues: Refugees." www.un.org. Accessed March 23, 2023.

United Nations Conference of Plenipotentiaries. *Convention Relating to the Status of Refugees*. April 22, 1954. www.ohchr.org.

UN Refugee Agency. "Figures at a Glance 2020." www.unhcr.org. Accessed November 8, 2021.

United States Holocaust Memory Museum. "Holocaust Encyclopedia: Voyage of the St. Louis." https://encyclopedia.ushmm.org. Last modified July 12, 2021.

US Citizenship and Immigration Services. "American Baptist Churches v. Thornburgh (ABC) Settlement Agreement." www.uscis.gov. Last modified September 3, 2009.

US Citizenship and Immigration Services. "Benefits and Responsibilities of Asylees." www.uscis.gov. Last modified March 8, 2018.

US Citizenship and Immigration Services. "Check Case Processing Times." https://egov.uscis.gov /.

US Citizenship and Immigration Services. "I-730 Refugee/Asylee Relative Petition." www.uscis.gov/i-730. Last modified March 28, 2023.

US Citizenship and Immigration Services. "Obtaining Asylum in the United States." www.uscis.gov. Last modified May 25, 2023.

US Citizenship and Immigration Services. "Temporary Protected Status." www.uscis.gov. Last modified June 21, 2023.

US Citizenship and Immigration Services. "The 180-Day Asylum EAD Clock Notice." www.uscis.gov. Last modified September 2022.

US Citizenship and Immigration Services, Department of Homeland Security; Executive Office for Immigration Review, Department of Justice. "Circumvention of Lawful Pathways." *Federal Register* 88, no. 94 (May 2023): 31314–31452. www.federalregister.gov.

US Citizenship and Immigration Services, Department of Homeland Security; Executive Office for Immigration Review, Department of Justice. "Circumvention of Lawful Pathways, a Proposed Rule by the Homeland Security Department and Executive Office for Immigration Review." *Federal Register* 88, no. 36 (February 2023): 11704–11752. www.federalregister.gov.

US Customs and Border Protection. "CBP One Mobile Application." /www.cbp.gov. Last modified June 28, 2023.

US Customs and Border Protection. "Nationwide Encounters." www.cbp.gov. Last modified June 14, 2023.

US Customs and Border Protection. "Southwest Border Unaccompanied Alien Children FY 2014." www.cbp.gov. Last modified November 24, 2015.

US Department of Health and Human Services, Administration for Children and Families, Office of Refugee Resettlement. *Benefits and Services Available for Asylees Through HHS' Office of Refugee Resettlement (ORR)*. www.acf.hhs.gov. Last modified September 2022.

US Department of Homeland Security. "DHS Announces Family Reunification Parole Processes for Colombia, El Salvador, Guatemala, and Honduras." July 7, 2023. www.dhs.gov.

US Department of Homeland Security. Fact Sheet: Implementation of the Credible Fear and Asylum Processing Interim Final Rule. May 26, 2022. www.dhs.gov.

US Department of Homeland Security. *Fact Sheet: U.S. Government Announces Sweeping New Actions to Manage Regional Migration*. www.dhs.gov. Last modified May 11, 2023.

US Department of Homeland Security Office of Immigration Statistics. Refugees and Asylees: Refugee and Asylees 2021 Data Table. September 26, 2022. www.dhs.gov.

US Department of Homeland Security Office of Strategy, Policy, and Plans. "Agreement Between the Government of the United States of America and the Government of the Republic of Guatemala on Cooperation Regarding the Examination of Protection Claims." *Federal Register* 84, no. 224 (November 2019): 64095–64099. www.federalregister.gov.

US Department of Homeland Security Office of Strategy, Policy, and Plans. "Agreement Between the Government of the United States of America and the Government of the Republic of Honduras for Cooperation in the Examination of Protection Claims." Federal Register 85, no. 85 (May 2020): 25462–25468. www.federalregister.gov.

US Department of Homeland Security / US Citizenship and Immigration Services and U.S. Department of Justice / Executive Office for Immigration Review. "I-589 Application for Asylum and Withholding of Removal Form." www.uscis.gov. Last modified March 1, 2023.

US Department of State. *Report on Proposed Refugee Admissions for Fiscal Year 2021*. October 27, 2020. www.state.gov.

US Department of State. "Secretary Antony J. Blinken and Secretary of Homeland Security Alejandro Mayorkas at a Joint Press Availability." April 27, 2023. Video. www.state.gov.

US Immigration and Customs Enforcement. "Alternatives to Detention." www.ice.gov. Last modified July 6, 2023.

US Immigration and Customs Enforcement to All OPLA Attorneys, Memorandum. "Litigating Domestic Violence-Based Persecution Claims Following *Matter of A-B-*." July 11, 2018. https://immpolicytracking.org.

Van Damme, Ellen. "Corruption, Impunity and Mistrust: Moving Beyond Police Gatekeepers for Researching Gangs." *Journal of Aggression, Conflict and Peace Research* 13, no. 2–3 (August 2021): 125–135. https://doi.org/10.1108/JACPR-01-2021-0572.

Van der Kolk, Bessel A. "The Body Keeps the Score: Memory and the Evolving Psychobiology of Posttraumatic Stress." *Harvard Review of Psychiatry* 1, no. 5 (January/February 1994): 253–265. https://doi.org/10.3109/10673229409017088.

Van der Kolk, Bessel A. "Trauma and Memory." *Psychiatry and Clinical Neurosciences* 52, no. S1 (September 1998): S52–S64. https://doi.org/10.1046/j.1440-1819.1998.0520s5S97.x.

Villiers Negroponte, Diana. "The Surge in Unaccompanied from Central America: A Humanitarian Crisis at Our Border." Brookings Institution. July 2, 2014. www.brookings.edu.

Vogt, Wendy A. "Crossing Mexico: Structural Violence and the Commodification of Undocumented Central American Migrants." *American Ethnologist* 40, no. 4 (November 2013): 764–780. https://doi.org/10.1111/amet.12053.

Vogt, Wendy A. "Dirty Work, Dangerous Others: The Politics of Outsourced Immigration Enforcement in Mexico." *Migration and Society* 3, no. 1 (June 2020): 50–63. https://doi.org/10.3167/arms.2020.111404.

Wadhia, Shoba S. "Prosecutorial Discretion in the Biden Administration: Part 5." *Yale Journal on Regulation*, April 4, 2022. www.yalejreg.com.

Wadhia, Shoba S. "The Role of Prosecutorial Discretion in Immigration Law." *Connecticut Public Interest Law Journal* 9, no. 1 (2010): 243–299. https://elibrary.law.psu.edu.

Walby, Sylvia. "From Private to Public Patriarchy: The Periodisation of British History." *Women's Studies International Forum* 13, no. 1–2 (1990): 91–104. https://doi.org/10.1016/0277-5395(90)90076-A.

Walby, Sylvia. "Theorising Patriarchy." *Sociology* 23, no. 2 (May 1989): 213–234. https://doi.org/10.1177/0038038589023002004.

Wald, Carolyn M. "Does Matter of A-R-C-G- Matter That Much?: Why Domestic Violence Victims Seeking Asylum Need Better Protection." *Cornell Journal of Law and Public Policy* 25, no. 2 (Winter 2015): 527–556.

Warren, Priscilla F. "Women Are Human: Gender-Based Persecution Is a Human Rights Violation Against Women." *Hastings Journal on Gender and the Law* 281, no. 5 (Summer 1994): 281–315.

Wasem, Ruth Ellen. "More than a Wall: The Rise and Fall of US Asylum and Refugee Policy." *Journal on Migration and Human Security* 8, no. 3 (September 2020): 246–265. https://doi.org/10.1177/2331502420948847.

Waslin, Michele. "The Impact of Immigration Enforcement Outsourcing on ICE Priorities." In *Social Control and Justice: Crimmigration in the Age of Fear*, edited by Maria João Guia, Maartje van der Woude, and Joanne van der Leun, 127–141. The Hague: Eleven International Publishing, 2012.

Waslin, Michele. "The Use of Executive Orders and Proclamations to Create Immigration Policy: Trump in Historical Perspective." *Journal of Migration and Human Security* 8, no. 1 (March 2020): 54–67. https://doi.org/10.1177/2331502420906404.

White House. "Mexico and United States Strengthen Joint Humanitarian Plan on Migration." May 2, 2023. www.whitehouse.gov.

Willen, Sarah S. "Toward a Critical Phenomenology of 'Illegality': State Power, Criminalization, Abjectivity Among Undocumented Migrant Workers in Tel Aviv, Israel." *International Migration* 45, no. 3 (August 2007): 8–38. https://doi.org/10.1111/j.1468-2435.2007.00409.x.

Willis, Paul E. *Learning to Labor: How Working Class Kids Get Working Class Jobs*. New York: Columbia University Press, 1981.

Wilson, John P. and Boris Drozdek. *Broken Spirits: The Treatment of Traumatized Asylum Seekers, Refugees and War and Torture Victims*. New York: Brunner-Routledge, 2004.

Wolf, Sonja. *Mano Dura: The Politics of Gang Control in El Salvador*. Austin: University of Texas Press, 2017. Kindle edition.

Wolf, Sonja. "Mara Salvatrucha: The Most Dangerous Street Gang in the Americas?" *Latin American Politics and Society* 54, no. 1 (Spring 2012): 65–99. https://doi.org/10.1111/j.1548-2456.2012.00143.x.

Woodward, Kath. "Hanging Out and Hanging About: Insider/Outsider Research in Boxing." *Ethnography* 9, no. 4 (December 2008): 536–560. https://doi.org/10.1177/1466138108096991.

World Bank Gender Data Portal. "International Homicides, Female (per 100,000 female)." https://data.worldbank.org. Accessed January 6, 2024.

World Bank Gender Data Portal. "International Homicides, Male (per 100,000 male)." https://data.worldbank.org. Accessed January 6, 2024.

Y de los Ríos, Marcela Lagarde. Translated by Charlie Roberts. Preface to *Terrorizing Women: Feminicide in the Américas*, edited by Rosa-Linda Fregoso and Cynthia Bejarano, xi–xxv. Durham, NC: Duke University Press, 2010.

Youngs, Gillian. "Private Pain/Public Peace: Women's Rights as Human Rights and Amnesty International's Report on Violence Against Women." *Signs: Journal of Women, Culture & Society* 28, no. 4 (Summer 2003): 1209–1229. https://doi.org/10.1086/368325.

Zeigler, Sara L. and Kendra B. Stewart. "Positioning Women's Rights Within Asylum Policy: A Feminist Analysis of Political Persecution." *Frontiers: A Journal of Women Studies* 30, no. 2 (January 2009): 115–142. https://doi.org/10.1353/fro.0.0051.

Zolberg, Aristide R. "The Archaeology of 'Remote Control.'" In *Migration Control in the North Atlantic World: The Evolution of State Practices in Europe and the United States from the French Revolution to the Inter-War Period*, edited by Andreas Fahrmeir, Olivier Faron, and Patrick Weil, 195–222. New York: Berghahn Books, 2003.

Zylinska, Joanna. "The Universal Acts: Judith Butler and The Biopolitics of Immigration." *Cultural Studies* 18, no. 4 (July 2004): 523–537.

INDEX

abjectivity, 9, 10 16, 135
Abrego, Leisy, 28, 29, 147, 180
Alana (interviewee pseudonym): and coyotes, 106; journey to the US, 105
Alba (interviewee pseudonym): gang extortion and violence, 73–74; life in El Salvador, 73; and police, 73, 75
Alejandra (interviewee pseudonym): domestic violence, 80, 82, 126; family relationships, 81–82; journey to the US, 103; life in Guatemala, 77
Alexander, Jeffrey C., 23, 124, 126, 129, 139, 141
Alondra (interviewee pseudonym): detention, 111; journey to the US, 108
Alvarado Peña, Rodi. See *Matter of R-A-*
Amaia (interviewee pseudonym): detention in *hielera*, 109; journey to the US, 107–8
American Baptist Churches v. Thornburg, 142
"anchor baby," 105. *See also* fertility; xenophobia
Ariana (interviewee pseudonym), 53
Ashcroft, John, 41
asylum: affirmative, 36, 47, 49, 169, 181, 183, 226n139, 238n22; application (Form I-589), 36, 41, 45, 47, 53, 54, 89, 94, 148, 162, 171, 183, 184, 192, 206; bars to, 36, 94, 162, 222n52; criminalization of, 11, 22, 103, 180; criteria for, 3, 12, 32, 34, 35–36, 39, 46, 74, 86, 87, 94, 122, 126, 145, 147, 157, 161, 170, 173, 181, 190, 191; defensive, 5, 10, 22, 36, 37, 152, 154; denial rates, 31; difference between refugees and asylum seekers, 3, 35; filing deadline, 36, 94; gender not a category for protection, 39–44; grant rates, 7–8, 12, 31, 86, 157, 190; history of, 19, 31, 33–35, 39–45; lack of congressional action, 31, 50; public opinion and, 19, 38, 145. *See also* asylum seekers; immigration court; internal relocation; nexus; particular social group; *non-refoulement*; protected ground
asylum officers, 2, 8, 22, 35, 36, 232n38; and affirmative asylum process, 2, 36, 169; and credible fear interview, 22, 37, 117. *See also* affirmative asylum; credible fear; US Citizenship and Immigration Services
asylum seekers (applicants): and affirmative asylum, 36, 169; after denial, 10, 88, 159, 172, 177, 182–83; after being granted asylum, 17, 25, 47, 94, 145, 161, 168, 173, 175, 176, 183–86; and children, 17, 24, 25, 30, 51, 54, 57, 61, 68, 69, 75, 95, 106–7, 108, 109, 110, 112, 123, 128, 130, 133, 134, 138, 145, 146, 151–52, 155, 157, 164, 174, 175, 176, 183–85, 201, 205; credibility of, 83, 86–87, 126, 133, 136, 170, 173, 191; and credible fear interviews, 5, 22, 37, 101, 111, 116–17, 136; criminalization of, 11, 22, 30, 103–4, 111, 120–21, 180;

269

asylum seekers (*cont.*)
decisions to migrate, 27, 51, 55, 78, 83, 91, 102; detention of, 11, 12, 22, 37, 101, 102, 103, 109, 114, 181; education levels, 51, 56, 57, 59, 62, 67, 68, 83, 131; employment in home country, 53, 55–57, 62–63, 68, 77, 80, 82, 83, 98, 101, 128, 135; employment in US, 24, 77, 97, 116, 123, 132, 134, 138, 146, 175, 181; as feminists, 172–73; and housing, 134, 145, 146; as "illegal," 30, 103, 105, 177, 181; and Immigration and Customs Enforcement, 150–52; and legal fees, 49, 88, 146, 154; legal outcomes for, 11, 156, 159, 182–83; and legal representation, 4, 15, 123, 153–54; and legal status, 8–10, 28–29; no right to appointed counsel 19, 32, 36, 104, 153; number of, 2, 6–8; obtaining evidence, 83, 92, 123, 138, 154, 155–56, 171, 173–74, 191; preparation for court, 24, 95, 146, 149, 155; and public opinion, 19, 138, 145; relationship with lawyers, 95, 154–55, 158, 160; and smugglers, 24, 106–7; surveillance of, 118, 147, 152, 159; verbal abuse of, 22–23; work permits, 10, 19, 29, 49, 146, 180, 184. *See also* asylum; compounded marginalization; detention; domestic violence; gangs; immigration enforcement; persecution; private violence; prosecutorial discretion; US-Mexico border crossing; trauma
attorney. *See* immigration attorneys

Barak, Maya, 139, 146, 154, 174
Belinda (interviewee pseudonym): and gangs, 129; life in the US, 134, 175; trauma, 130
Biden, Joseph (or Biden administration), 153, 188, 240n57; asylum grant rate, 7, 157; asylum policies, 45–47, 83, 120, 187–89; prosecutorial discretion, 46–49

Bishop, Sarah, 36, 49
Board of Immigration Appeals (BIA), 11, 88, 94, 97, 127, 159, 176, 177, 182, 183, 224n108, 240n50; creation of, 38; and *Matter of A-R-C-G-*, 41–42; and *Matter of L-R-*, 41–42; and *Matter of R-A-*, 40–41
bond, 5, 12, 111, 113, 114, 115, 116, 118, 150
Bookey, Blaine, 42
Border Angels, 113
border crossing. *See* US-Mexico border
borders (international), 3, 6, 9, 11, 13, 29, 34, 50, 104, 118, 119, 177, 193
Bosnia, 122
Bourdieu, Pierre, 20–21, 55, 77, 91, 178–79. *See also* symbolic violence
Bukele, Nayib, 66–67
Bush, George W. (or Bush Administration), 41, 224n107

Calle 18 gang. *See* gangs
Camila (interviewee pseudonym), 109
Canada: and asylum laws 8, 35
Carina (interviewee pseudonym), 116
Catalina (interviewee pseudonym): and post-traumatic stress disorder, 128–29, 134
CBP. *See* US Customs and Border Protection
CBPOne mobile app, 46, 188–89; and facial recognition 46. *See also* Biden, Joseph; US Customs and Border Protection; US-Mexico border
Central America: civil wars; 14, 21, 25, 33, 51, 58, 63, 79, 83, 84, 178, 192; context of violent crime in, 3, 7, 10–11, 14, 18, 25, 53, 58; failure to protect women, 4, 14, 19, 22, 23, 25, 50, 52, 53, 56, 59–60, 64–67, 70, 72–73, 75, 76, 78, 85–88, 90, 93, 94, 96, 98–100, 125, 130, 133, 135, 137, 141, 167, 168, 173, 187, 192; and gang violence, 20, 52; men in, 58, 79, 180; neoliberal economic policies, 25, 56, 59–60, 139; poverty, 6, 12, 14, 16, 20, 21,

23, 25, 42, 52, 56, 58–60, 61–62, 63, 65, 73, 75, 79, 83–84, 98, 123, 124, 125, 127, 132, 137, 139, 141, 178, 187, 192; refugees 32; trust in police, 72–73; US role in conflict, 120, 125, 139, 141, 187; walled communities in, 20, 60, 75, 78. *See also* corruption; El Salvador; Guatemala; Honduras; impunity; Nicaragua
Chavez, Leo, 10, 148, 159, 180
Clinton, William (or Clinton administration), 39
Cold War, 13, 33, 76, 98, 177, 193
Colel (interviewee pseudonym): and gang violence, 51
compounded marginalization, 11–12, 24, 29, 30, 33, 38, 49, 103, 147, 179, 180, 181, 183, 186, 192
Congo, 122
Congress. *See* US Congress
corruption, government, 20; police, 12, 28, 58, 70, 73, 96, 133, 165, 200, 204
Coutin, Susan, 10, 20, 29, 142
COVID-19, 27, 61, 134, 205, 209, 271; and courtrooms, 47; and Title 42, 45, 188
credible fear: interview, 2, 22, 37, 111, 113, 116–17, 136, 155, 188, 222n61, 232n38; legal standard, 5
crimmigration, 22, 102, 152
Cuba, 188
cultural trauma, 23, 124–26, 129, 138–39, 141, 143. *See also* domestic violence; structural violence; symbolic violence

deportation (or removal), 1, 5, 9, 10, 11, 12, 17, 19, 25, 29, 36, 37, 38, 40, 44, 46, 47, 49, 86, 94, 102, 103, 104, 113, 115, 116, 117, 121, 139, 145, 146, 148, 150–52, 154, 159, 163, 176, 179–80, 182–84, 188
detention, 11, 12, 15, 22–23, 92, 102–3, 104, 108, 111, 116, 119, 145, 180–81, 190; alternatives to, 118; conditions, 109, 110–13, 120–21; for-profit, 114; interviews of asylum seekers in, 116–17; standards, 110, 111; transfers, 113–15. *See also hieleras*; immigration enforcement; *perreras*
domestic violence, 28, 40, 62, 77, 78, 110, 132–34, 140, 174, 185, 204; and Central American laws, 65, 91; as a "family matter," 95–97, 99, 135; as ground for asylum, 38, 40–43, 45, 83, 86, 95–99, 240n50; family complicity in, 80–82; lack of shelters, 82, 96; in the United States, 18. *See also* social services
Drysdale Walsh, Shannon, 65, 80

Elisa (interviewee pseudonym): and gang violence, 68–69; life in Honduras, 68; and police, 70–71
El Salvador: asylum backlog, 153; asylum grant rates, 157; civil war, 21, 63, 66, 79, 120, 125, 135, 136, 142; deaths following deportation, 37; extra-judicial killings, 63, 66; failure to protect women, 21; feminicides, 64; gang violence, 27, 63, 133; MS-13, 74; murder rate, 64; police, 72; remittances to, 61; state of exception, 67; truth commission, 66
Esmerelda (interviewee pseudonym): and credible fear interview, 117; surveillance of, 118
executive branch, 19, 150; impact on asylum policy, 19, 31, 34, 35, 39–50, 190, 206
Executive Office of Immigration Review (EOIR), 1, 208, 236n23
expulsions, 6–7

family separation, 25, 130, 180, 183, 184–85; and Trump administration, 190
family unification, 192, 240n57; following grants of asylum, 184–85
Farmer, Paul, 16, 60
Felicia (interviewee pseudonym): life in Honduras, 57
female genital mutilation (FGM), 8, 39–40

feminicide, 63–65, 79–80, 81, 122
feminism, 10, 11, 14, 15, 20–21, 30, 31, 34, 42, 54, 77, 91, 172–73, 178, 196, 207–8
fertility: Latina fertility as threat, 104–5, 121
Fitzgerald, David Scott, 13, 28, 32, 34, 50, 119
Foucault, Michel, 9

Gabriela (interviewee pseudonym): life in Honduras, 57
gangs: Calle 18, 74; and class solidarity, 59; control of territory, 20, 73–75; extortion (*la renta*), 5, 19, 29, 39, 52, 53, 58, 59, 62, 72, 73, 75, 108, 116, 117, 128, 129, 159, 160, 178; and "girlfriends," 53, 64, 75; home invasions, 5, 6, 12, 16, 23, 72, 123, 129, 175; kidnapping, 19, 23, 39, 51, 52, 67, 123, 132, 192; and lesbians, 29, 55, 75; male domination of, 20, 58; MS-13, 47, 57, 62, 67, 73–74, 114, 115, 116, 127, 128, 132, 163; and poverty, 52, 58, 60, 75; racialized images, 52; rape, 20, 52, 53, 55, 68, 72, 75, 114, 132, 136–37, 156; recruitment by, 20, 23, 52, 53, 58, 61, 64, 123, 150; relationship to neo-liberalism, 52, 56, 59, 60, 75; and state failure, 63–64, 125; tracking victims, 27, 74; and US Special Forces, 79; vulnerability of women, 20, 53–54, 56, 59
Garland, Merrick, 45
gender-based violence (persecution): 4, 122, 162; and asylum, 7–8, 31, 32, 34, 35, 39–42, 45, 49, 50, 77, 86, 94, 112, 143, 153, 172, 177, 189–90, 206; and domestic partners, 12, 18, 20, 21, 132, 167; failure to prosecute, 81; as family issue, 30; and gangs, 53; and journey to US, 107; social contexts of, 12, 14, 21, 23, 52, 56, 58, 64–65, 79, 84, 124, 127, 168, 178; and state failure to protect, 4, 14, 23, 72, 75–76, 80, 91, 123, 137, 141. *See also* domestic violence; gangs; "private violence"

Greece: drowning deaths, 32, 193; Kos, 34; Kurds, 34
Godoy-Paiz, Paula, 79
Gonzales, Roberto, 10, 148, 159, 180
Guadalupe (interviewee, pseudonym): apprehension by Border Patrol, 110; father's murder, 27; journey to the US, 102; life in El Salvador, 1, 101; treatment by Border Patrol, 110, 112
Guatemala: asylum backlog, 153; asylum grant rates, 7, 157; attitudes towards women, 13, 21, 40, 42, 54, 81, 87, 127, 178; child labor, 83; civil war, 51, 59, 79, 99, 120, 142; colonialism, 79; feminicides, 64, 65, 79, 122; gangs, 59, 63; income inequality, 83; indigenous people, 51, 58, 99, 168; laws to protect women, 65, 87; male hegemony, 21; militarism, 21; murder rate, 64; police, 63, 72, 85, 161; poverty rate, 58; refugees, 32; violence against women, 13, 54, 81, 127

Haiti, 120, 188; interception of migrant boats, 34
Harvey, David, 59
hieleras (holding cells), 15, 22, 103, 109, 111, 113–14, 116, 120. *See also* detention
Holocaust, 33, 125, 129. *See also* refugees: Jewish
Hondagneu-Sotelo, Pierette, 14
Honduras: asylum backlog, 153; asylum grant rates, 157; failure to protect women, 21, 72, 80, 91; feminicides, 21, 64, 65; gangs, 54; laws and policies to protect women, 65, 91, 99; military coup, 21; militarism (*mano dura*), 63; murder rate, 64; police, 54; poverty rate, 58, 65; refugees, 32; treatment of/attitudes towards women, 54; and war on drugs, 91
human smuggling, 8, 22, 24, 74, 106–8, 120, 154, 181, 188, 192; *coyotes*, 106–8

human subjects, 203
Huntington, Samuel, 105

ICE. *See* US Immigration and Customs Enforcement
illegality, 9, 11, 15, 16, 103, 104, 105, 180, 181, 199; and asylum seekers, 13, 24, 30, 138, 146, 157, 177; and compounded marginalization, 30, 147. *See also* crimmigration; liminal legality
immigrants: legal channels, 32; racialization of, 11, 15, 23, 34, 104, 111, 121, 139, 180, 181. *See also* asylum seekers; refugees
immigration attorneys (lawyers), 3–4, 18, 37, 43, 95, 113, 114, 126, 133, 151, 154, 157, 169, 201–2, 206, 208, 184, 190, 191, 196, 202, 207, 209; legal fees, 123, 148, 153, 174, 181; legal representation rates, 5, 154; relationship with clients, 139–40, 155; and trauma, 6, 136, 139–40. *See also* Executive Office of Immigration Review (EOIR); US Department of Homeland Security (DHS)
immigration court, 2, 3, 10, 15, 19, 31, 32, 37, 77, 206, 210; and Attorney General, 19, 38, 150; backlog in, 2, 83, 142, 153; description of, 1, 47, 88–89, 93, 144, 149; history of, 37–38; interpreters, 169–70; lack of independence, 19, 150, 190; political influence in, 38, 190; reform of, 37, 189; remote/virtual hearings, 149, 161, 170, 172, 210; removal proceedings, 15, 47–49, 114, 145, 146, 154, 168–69, 183; and symbolic violence, 147. *See also* Board of Immigration Appeals (BIA); Executive Office of Immigration Review (EOIR); immigration attorneys; immigration judges; interpreters; US Attorney General
immigration enforcement: and anti-immigrant images, 103–5, 111; arrests, 5, 13, 15, 22, 28, 49, 102, 103–5, 108, 113, 150, 158, 159, 174, 177, 180, 181, 183, 204; "Deportation Regime," 105; deterrence strategy, 108, 119–20; and national security, 22, 103–4, 108, 120; Operation Gatekeeper, 119; "remote control," 119; state sovereignty, 15, 104; at the US-Mexico border, 15, 22, 103–4, 108, 119. *See also* crimmigration; detention; US Customs and Border Protection; US Immigration and Customs Enforcement; US-Mexico border
immigration judges 8, 13, 19, 21, 37, 47, 149, 161, 170, 181, 182, 188, 191, 202, 206, 207–10, 237n44; assessment of credibility, 36, 86, 136, 137, 171, 182; asylum grant rates, 12, 31, 86; and Attorney General, 19, 38, 43, 50, 76, 78, 84, 86, 150, 156, 190; bias, 3, 95, 157; and prosecutorial discretion, 47–48; and trauma, 136, 139–40, 165; Trump appointees, 4, 157. *See also* Executive Office of Immigration Review (EOIR); immigration attorneys; immigration courts; US Department of Justice (DOJ)
Immigration and Naturalization Service (INS): and *American Baptist Churches v Thornburgh*, 142; asylum guidance, 35, 86; dissolution of, 40; and *Matter of R-A-*, 40
immigration system, 32; reform, 119, 188–189, 232n45. *See also* asylum; immigrants; refugees
impunity, 20–21, 64, 65, 72, 79–80, 91, 99, 192
India, 122, 154
Ines (interviewee pseudonym): and gangs, 150; and ICE, 152; and immigration court, 150–51, 177; journey to the US, 108
interpreters, 1, 36, 47, 88–89, 117, 144, 149, 162, 168–70, 172, 201. *See also* immigration court

internal relocation, 28, 93; as criteria for asylum, 35, 43, 60, 1656, 221n49
Isabel (interviewee pseudonym): life in Guatemala, 98
Ixema (interviewee pseudonym): and detention, 114; and gangs, 114; and transfers, 114–15

Jacinta (interviewee pseudonym): leaving children behind, 107
Japan, 122, 125, 139
Juanita (interviewee pseudonym): life in El Salvador, 57
judges. *See* immigration judges

Kassindja, Fauziya, 39, 40. *See also* female genital mutilation
Kleinman, Arthur, 123, 125, 126

lawyers. *See* immigration attorneys
legal violence, 28–30, 45, 102–3, 147, 174, 180–81
lesbian, gay, bisexual, and transgender community (LGBTQI+), 29, 55, 75, 189
liminal legality, 8–9, 147, 179
Lula (interviewee, pseudonym): and gang violence, 30; and LGBTQI+ persecution, 29

Mabela (interviewee pseudonym): and incest, 131; journey to the US, 132; life in Guatemala, 55, 130–31
machismo or *machista* culture, 21, 42, 58, 77, 78, 167
Mano Dura (Iron Fist), 63. *See also* El Salvador
Mara Salvatrucha-13 (MS-13), 47, 57, 62, 67, 73–74, 114, 115, 116, 127, 128, 132, 163
Maria (interviewee pseudonym): and life in El Salvador, 57; and living in the US, 130
Massey, Doreen, 60
Matter of A-B-, 44, 98

Matter of A-R-C-G-, 41–44
Matter of L-R-, 41
Matter of R-A-, 39–41
Menjívar, Cecelia, 8, 9, 13, 20, 28, 29, 54, 55, 65, 80, 81, 127, 147, 178, 179, 180
Mercedes (interviewee pseudonym): life in Honduras, 54–55; as single mother, 54
Mexico, 3, 5, 7, 10, 11, 14; asylum grant rates, 157; border enforcement by, 119, 120; crime, 53; domestic violence laws, 65; feminicides, 64, 99; gangs, 20, 52; gender-based violence, 21, 28; laws and policies to protect women, 65–66, 96, 125; migrants' journey through, 24, 46, 107–8, 150; murders in Ciudad Juárez, 122; murder rate, 64; neoliberalism, 59–60; North America Free Trade Agreement (NAFTA), 63, 119; police, 72, 73; poverty, 58, 61, 79; violence, 25, 39, 178, 187; war on drugs, 63. *See also* Migrant Protection Protocols; US-Mexico border
Migrant Protection Protocols (MPP or "Remain in Mexico"), 5, 44, 45
Miller, Stephen, 157
MS-13. *See* Mara Salvatrucha-13
Musalo, Karen, 8, 34, 35, 40

National Association of Immigration Judges (NAIJ), 37
Nayak, Meghana, 31, 177, 181
neo-liberalism, 14, 23, 25, 52, 56, 59–60, 61, 73, 75, 119, 123, 139, 141, 187, 192
nexus, 36, 42, 221–22n51. *See also* asylum: criteria for
Nicaragua: asylum seekers, 141–42; and Biden administration, 188
Nicaraguan Adjustment and Central American Adjustment Act of 1997 (NACARA), 142
non-refoulement, 22, 34, 120. *See also* asylum

non-state actors: and private violence, 10, 11, 13, 49, 66, 76, 147, 180, 228n55; and asylum definition, 49, 50, 191, 24, 31, 42
North American Free Trade Agreement (NAFTA), 63, 119

Obama, Barack (or Obama administration), 41, 120, 153, 224n107, 224n118
Operation Gatekeeper, 119. *See also* immigration enforcement; US-Mexico border

particular social group: as a criterion in asylum cases, 1, 5, 36, 46, 54, 76, 86–87, 93, 94, 96–97, 100, 160, 166, 172, 182, 191 230n37; definition, 33, 34–35, 50, 221n50; evolving case law, 39–43. *See also* asylum; *Matter of A-R-C-G-*; *Matter of R-A-*
Paula (interviewee pseudonym): and asylum hearing, 88; and domestic violence, 86–87; life in Guatemala, 85; and particular social group, 97; and police, 85
Peck, Alison, 38
permiso, 10. *See also* work authorization
perreras (dog kennels), 111, 113, 120, 121. *See also* detention
persecution: as criterion for asylum, 5, 3, 14, 22, 32, 35–36, 37, 40, 50, 86, 95, 102, 111, 117, 120, 126, 137, 161, 190–91; and gangs, 67, 74, 133, 171; and gender or domestic violence, 4, 13, 16, 21, 31, 32, 33, 34, 41–43, 49, 78, 83, 86–87, 98, 100, 160, 172–73; state-sponsored, 13, 130, 141, 177, 193; and trauma, 136–138, 139. *See also* credible fear; "private violence"
police: corruption, 12, 14, 20, 58, 67, 73–74, 96, 163, 165, 200; distrust of, 52, 53, 54, 62, 68–73, 204, 210, 211; failure to protect women, 2, 19, 40, 42, 51, 52, 62, 75, 32, 85–86, 88, 90–94, 98, 122, 130, 131, 133, 144; failure to protect poor, 60, 70; rape by, 135, 172–73, 192; women threatened if they report to, 27, 54, 107, 156, 170–71
post-traumatic stress disorder (PTSD), 16, 124, 126, 128, 133, 136, 137, 201, 203, 204, 239n31; and compounded marginalization, 30
poverty, 6, 12, 14, 16, 20, 21, 23, 25, 42, 52, 56, 58, 60, 61–63, 65, 68, 73, 75, 79, 84, 98, 123, 125, 127, 130, 132, 137, 139, 141, 178, 187, 192, 234n11, 235n42
"private violence," 3, 4, 11, 12, 13, 20, 21, 31, 39, 52, 77–78, 84, 97, 167–68, 178, 180, 182, 189, 190–91; and Obama, Barack, 41; and Sessions, Jefferson, 43–44, 83, 98, 150, 224n108
prosecutorial discretion, 46–49, 169, 182, 183, 209, 226n139, 238n22
protected ground, 16, 36, 39, 42, 221n50, 232n38. *See also* asylum: criteria for

race, 200, 231–32n30; and definition of refugee, 3, 5, 33, 35, 36, 50, 221n50, 221n51
rape, 11, 12, 13, 16, 19, 21, 23, 29, 32, 39, 41, 42, 44, 51, 52, 55, 56, 58, 64, 67, 68, 69, 70, 71, 72, 73, 75, 76, 77, 78, 80, 85, 86, 90, 98, 107, 108, 114, 116, 117, 122, 126, 128, 131, 132, 135, 136, 148, 156, 160, 163, 167, 168, 172, 174, 177, 178, 188, 192; as "private" or "cultural," 31, 49; as a weapon, 20, 33, 53, 63, 79, 81. *See also* gangs; gender-based violence; police
Reagan, Ronald (or Reagan administration), 34, 141; and Haitians, 34, 120
refugees, 3, 9, 31, 33–35, 111, 137, 141, 181, 188, 189, 193; definition, 16, 23; Jewish, 33, 120; worldwide numbers, 32, 118. *See also* asylum
Refugee Act of 1980, 35, 120; and gender, 34, 39; passage of, 34
Refugee Protection Act, 190–191

Renata (interviewee pseudonym): and activism, 133, 138; and gang violence, 133; and gender-based violence 132; and PTSD, 133
Reno, Janet, 40
reparations, 124, 125; in Japan, 122; in Bosnia, 122

sanctuary, 3, 28, 32, 142
Sanford, Victoria, 64
Sassen, Saskia, 6, 118
Sessions, Jefferson: and "private violence," 43–44, 83, 98, 150, 224n108. See also *Matter of A-B-*; *Matter of A-R-C-G-*
Skeggs, Beverly, 77
slow violence, 146, 174
social services: in countries of origin, 21, 23, 56, 60, 79, 80, 83, 98, 123, 127; post-asylum eligibility, 65, 75
social work/social workers, 5, 17, 132, 136, 154, 186
Staudt, Kathleen, 72, 76
structural violence, 55, 56, 60–61, 72, 74–75, 102, 145, 178. See also cultural trauma; symbolic violence
symbolic violence, 21, 25, 52, 54–56, 70, 72, 76, 80, 91, 102, 103, 126–27, 131, 137, 141, 146, 147, 178–80, 187. See also cultural trauma; structural violence

Tabbador, Ashley, 37, 38
Temporary Protected Status (TPS), 138, 150
Teresita (interviewee pseudonym): and asylum hearing, 1, 2, 88, 94; and particular social group, 93; and reasons for fleeing, 91, 92, 94, 98, 99; testimony, 89–89, 92
Title 42 of the Public Health Act: and Biden, Joseph, 46; and Trump, Donald 45, 187, 188
trauma: and asylum process, 5–6, 13, 32, 35, 125–26, 136, 165, 169, 173, 182, 207;

collective, 122, 192, 233n6; and collective identity, 23, 25, 124, 142, 192; and credibility, 136–37, 191, 206, 222n53; cultural, 23, 124–26, 129, 138, 139, 141, 143, 234n22; daily lived experience, 16, 30, 123, 182, 186; recognition of, 122, 124, 138–39, 141, 147; resilience, 17, 123–24, 133; social context of, 17, 20, 137; symptoms of, 9, 11, 16, 24, 126–30, 148, 203. See also asylum seekers; compounded marginalization; post-traumatic stress disorder (PTSD); reparations
Truman, Harry S (or Truman administration), 33
Trump, Donald J. (or Trump administration): and asylum denial rates, 45,157; and asylum policies, 5,17, 42, 43, 44, 46, 83, 120, 153, 187, 189; and child separation, 190; and immigration judges, 157; and referral power, 43; and xenophobia, 45, 157

unaccompanied minors, 120
United Nations, 66; and 1951 Convention Relating to the Status of Refugees, 33; and 1967 Protocol, 33
United Nations High Commissioner for Refugees (UNHCR), 31, 34, 35, 89, 118
US Attorney General, 45, 83, 98, 142, 190; creation of BIA, 38; and immigration courts, 38; and immigration judges, 19, 150, 156; referral power, 38, 43. See also *Matter of R-A-*; *Matter of A-R-C-G-*
US Border Patrol, 12, 22, 37, 103, 105, 106, 108, 109, 110, 112, 114, 119, 121, 136, 154; apprehension of asylum seekers, 5, 36, 102, 103, 150, 177, 181; treatment of asylum seekers, 12, 50, 112, 113, 114, 115. See also detention; immigration enforcement; US-Mexico border
US Citizenship and Immigration Services (USCIS): and affirmative asylum 2,

36; application processing times, 185, 220n11; asylum officers, 46
US Coast Guard, 34. See also *non-refoulement*
US Congress, 19, 31, 33, 34, 46, 50, 189, 190, 192–93, 232n45
US Customs and Border Protection (CBP), 44, 102, 103, 104, 112, 116, 121. See also immigration enforcement; US Border Patrol; US-Mexico Border
US Department of Homeland Security (DHS), 41, 45, 46–47, 118, 188, 208; attorneys, 2, 4, 6, 13, 36, 47, 60, 86, 88, 92–94, 136, 149, 160, 161, 162, 165–69, 170; creation of, 40; detention, 114
US Department of Justice (DOJ): and immigration courts, 1, 19, 38, 45, 190, 236n23
US Department of State (DOS), 2, 188
US Immigration and Customs Enforcement (ICE), 9, 116, 118, 147, 148, 150–52, 153, 158, 159, 174, 176, 177, 181, 183–84. See also detention; immigration enforcement
US-Mexico border: apprehension and detention at, 12, 24, 28, 30, 36, 114, 146, 176, 180, 181, 201; and asylum processing, 22, 32, 37, 45–46, 105, 111, 112–13, 118, 157; border crossing, 5, 22–23, 30, 101, 102, 106, 108, 110, 134, 144, 150, 181, 192, 202, 204; enforcement, 15, 45, 119–20, 187–88; migrant deaths, 107; militarization, 102, 118–19; murders, 76, 122; national security, 13, 103, 120, 177; terrain, 105–8, 119. See also detention; *hieleras;* human smuggling; immigration enforcement; *perreras;* US Customs and Border Protection

Valeria (interviewee pseudonym): asylum hearing, 78, 96, 97, 176; and domestic violence, 95, 96, 98, 100; going underground, 183; life in the US, 159, 160, 174; trauma, 96, 127, 128, 129, 130
Venezuela, 188
voluntary departure, 113

Wacquant, Loïc, 91
women's rights, 8, 14, 15 34, 52, 64, 65, 78; in El Salvador, 67; in Guatemala, 65; in Honduras, 65, 90, 91, 99; in Mexico, 65; in the United States, 18
work authorization (Employment Authorization Document, or *permiso*), 10, 45, 47, 49, 88, 142, 146, 181, 183, 184, 220n11, 226n139, 238n22

xenophobia, 104
Ximena (interviewee pseudonym): and domestic violence, 27–28

Yesica (interviewee pseudonym): asylum hearing, 172, 173; life in Honduras, 172; and police violence, 172
Yolanda (interviewee pseudonym): and gang violence, 67

ABOUT THE AUTHORS

CAROL CLEAVELAND is Associate Professor in the Department of Social Work at George Mason University. She has been researching Latino immigration since 2004, with publications focusing on day labor incorporation and resistance; PTSD among Latina immigrants; Latina survivors of human smuggling, and most recently, the impact of COVID-19 on food insecurity and housing stability among Latino immigrants in a suburban neighborhood. She received her PhD in Social Work from Bryn Mawr College. Cleaveland lives in Baltimore, Maryland with her life partner.

MICHELE WASLIN is Assistant Director of the Immigration History Research Center at the University of Minnesota. Previously she worked at the Institute for Immigration Research at George Mason University. She has more than twenty years' experience working in immigration-related policy and research organizations in Washington, DC and Chicago, Illinois. Waslin has written extensively on immigration policy. She received her PhD in government and international studies from the University of Notre Dame. She lives in Minneapolis, Minnesota with her husband.

Printed in the United States
by Baker & Taylor Publisher Services